Design Discourse

HISTORY | THEORY | CRITICISM

Edited and with an Introduction and Closing Essay by

Victor Margolin

The University of Chicago Press

Chicago and London

The University of Chicago Press, Chicago 60637
The University of Chicago Press, Ltd., London

Compilation, introduction, and closing essay © 1989 by
 Victor Margolin
Remaining essays © 1984, 1985, 1986 by The Board of Trustees of
 The University of Illinois

98 97 96 5

Library of Congress Cataloging-in-Publication Data

Design discourse : history, theory, criticism / edited, and with an •
 introduction and closing essay, by Victor Margolin.
 p. cm.
 Bibliography: p.
 ISBN 0-226-50513-8 (alk. paper).—ISBN 0-226-50514-6
 (pbk. : alk. paper)
 1. Design. I. Margolin, Victor, 1941–
 NK1505.D47 1989
 745.4—dc20 89-33920
 CIP

♾ The paper used in this publication meets the minimum
requirements of the American National Standard for Information
Sciences—Permanence of Paper for Printed Library Materials,
ANSI Z39.48-1984.

To my parents

Contents

SECTION III **WRITING DESIGN HISTORY**

Acknowledgments and Sources

Many people have contributed to the completion of this volume. First, my colleagues at *Design Issues*—my fellow editors: Leon Bellin, Steve Bloom, Dennis Doordan, Martin Hurtig, and Larry Salomon—shared with me the decision to publish these articles and contributed to their final form. Tad Takano, assisted by numerous design students at the University of Illinois, Chicago, was responsible for the design of the first six issues, from which the articles in this anthology have been drawn. Faith Van Alten and Bonnie Osborne, assistant editors, handled all the details of getting the journal out. Others on the journal staff who directly or indirectly made the publication of these articles possible include William Hafeman, Connie White, and Tam Schiller. I would also like to acknowledge the financial support of the Design Arts Program at the National Endowment for the Arts, which granted the funds to launch *Design Issues*, and of the University of Illinois, Chicago, which has continued to provide assistance to the journal.

Richard Buchanan and Marco Diani (now members of the *Design Issues* editorial board), along with Dennis Doordan read an initial draft of my introduction and offered many useful suggestions. Several people at the University of Chicago Press have been extremely helpful. Thanks also to my colleague Peter Hales for his excellent photographs; all were taken on Morgan Street near the University of Illinois campus.

I also wish to express my appreciation of the colleagues throughout the world with whom I have shared many stimulating and provocative discussions about design. Lastly, I thank my wife Sylvia and daughter Myra for their encouragement of this enterprise.

Most of the essays in this volume first appeared in the journal *Design Issues: History, Theory, Criticism*:

Vol. 1, no. 1 (Spring 1984): Clive Dilnot, "The State of Design History, Part I," pp. 3–23; Dieter Rams, "Omit the Unimportant," pp. 24–26; Frances C. Butler, "Eating the Image," pp. 27–40;

Gert Selle, "There is No Kitsch, There is Only Design!" pp. 41–52; Hanno H. J. Ehses, "Representing Macbeth," pp. 53–63.

Vol. 1, no. 2 (Fall 1984): Clive Dilnot, "The State of Design History, Part II," pp. 3–20; Maurizio Morgantini, "Man Confronted by the Third Technological Generation," pp. 21–25; Clive Ashwin, "Drawing, Design and Semiotics," pp. 42–52.

Vol. 2, no. 1 (Spring 1985): Richard Buchanan, "Declaration by Design," pp. 4–22; Abraham A. Moles, "The Comprehensive Guarantee," pp. 53–64.

Vol. 2, no. 2 (Fall 1985): Maurizio Vitta, "The Meaning of Design," pp. 3–8; Robin Kinross, "The Rhetoric of Neutrality," pp. 18–30; Richard Porch, "The Digital Watch," pp. 46–49.

Vol. 3, no. 1 (Spring 1986): Andrea Branzi, "We Are the Primitives," pp. 23–27; Abraham A. Moles, "The Legibility of the World," pp. 43–53.

Vol. 3, no. 2 (Fall 1986): Cheryl Buckley, "Made in Patriarchy," pp. 3–14; Jack H. Williamson, "The Grid," pp. 15–30; François Burkhardt, "Tendencies of German Design Theories in the Past Fifteen Years," pp. 31–36; Ellen Lupton, "Reading Isotype," pp. 47–58; Marco Diani, "The Social Design of Office Automation," pp. 73–82.

Design Discourse

Victor Margolin

Introduction

Design Studies as a New Discipline

Design is all around us: it infuses every object in the material world and gives form to immaterial processes such as factory production and services. Design determines the shape and height of a shoe heel, the access to computer functions through software, the mood of an office interior, special effects in films, and the structure and elegance of bridges. Richard Buchanan, whose essay on design rhetoric appears in this anthology, considers design to be an architectonic art that can unify other, more narrowly conceived arts and crafts: "Design is what all forms of production for use have in common. It provides the intelligence, the thought or idea–of course, one of the meanings of the term *design* is a thought or plan– that organizes all levels of production, whether in graphic design, engineering and industrial design, architecture, or the largest integrated systems found in urban planning."*

Marco Diani, another contributor to this anthology, goes even farther in his call for a science of design that can provide the organization for immaterial processes as well as material objects. According to Diani, an architectonic science of design which integrates research from many different disciplines is necessary "to manage the architecture of complexity which is the most important and vulnerable element of a society dominated by computer-mediated work." In his call for an integrative design science, Diani echoes the pioneering work of Herbert Simon, a leading figure in the fields of computer science, organizational development, and artificial intelligence. In a seminal lecture of 1968, Simon offered a definition of design that has since been widely quoted:

> Everyone designs who devises courses of action aimed at changing existing situations into preferred ones. The intellectual activity that produces material artifacts is no different fundamentally from the one that prescribes remedies for a sick patient or the one that devises a new sales plan for a company or a social welfare policy for a state. Design, so construed, is the core of all professional training: it is the principal mark that distinguishes the professions from the sciences.[1]

1) Herbert Simon, "The Science of Design: Creating the Artificial," in *The Sciences of the Artificial* (Cambridge: MIT Press, 1969), 55-56. The essay was reprinted in *Design Issues* 4, nos. 1-2, as part of a debate with Norbert Wiener on the interrelations between design, technology, and society.

Simon was optimistic about the emergence of a "science of design," which he called 'artificial' to distinguish it from the natural sciences. His broad definition of design provides a framework for a different perception of design problems and a reorganization of design practice according to new paradigms. It addresses the proliferation of unprecedented situations that demand integrative design approaches for which no professional preparation exists. In short, the emergence of new problems is outstripping our ability to solve them.

But we still do not know how to translate a broad definition of design such as Simon's into pragmatic terms; this is essential if we are to generate realistic proposals for reorganizing design practice. We presently divide design in the narrowest sense into discrete forms of practice such as industrial design, graphic design, stage design, interior design, or fashion design. This tends for the most part to separate more artistically oriented ways of designing from those connected with engineering or computer science, which are technologically based. It also segregates the design of objects from the design of immaterial products like techniques and services, which are the province of fields such as industrial engineering and urban planning.

There are, of course, some good reasons why these practices were separated in the first place, and the issue is *not* to meld them all into a new, comprehensive profession that is at once everything and nothing. Rather it is to define new points of contiguity and to facilitate greater collaboration between different types of designers, while making it possible for individual designers to address a greater range of problems than most now do.

Compared to professionals in law, medicine, and the natural sciences, designers of all kinds have given very little thought to their own self-definition. There is, in fact, much disagreement about what the task of a designer is. Victor Papanek, for example, criticized the designer's role in the production of consumer goods, and posed the challenge to industrial designers of solving problems related to education, the handicapped, and Third World countries.[2] Buckminster Fuller confronted designers with the prospect of a "comprehensive design science" but, despite the fact that he was personally able to transcend conventional boundaries between engineering, industrial design, and architecture, he had no strategy for moving the design professions in this direction. While much has been written about design, particularly in the postwar period (as my essay on postwar design literature in this anthology indicates), this writing has been fragmented, not integrated within the context of a coherent definition of what designing is. Although we can easily imagine what a legal scholar might contribute to the profession of law (as is evident in the recent development of critical legal theory), or what a scholar of medicine might offer to his or her profession, we still have little understanding of how a design scholar might be

2) See Victor Papanek, *Design for the Real World: Human Ecology and Social Change* (New York: Pantheon, 1972).

VICTOR MARGOLIN

able to bring theory, criticism, or history to bear on issues central to the design professions, whether these issues relate to practice, education, or even public perception of design and designers.

We clearly need a new discipline of design studies to train such scholars. The first problem that confronts anyone proposing to develop such a discipline is that design training is extremely fragmented. Industrial design, graphics, interiors, crafts, and fashions are most often located in art schools or university art departments. Architecture is a hybrid of art and technology, residing between the art school on one hand and the engineering school on the other. Engineering is defined as a technologically-based form of design which has nothing to do with the arts. It is also often separated from computer science, a more conceptual form of technologically-based design.[3] And the design of processes or services is confined to schools of urban planning, social work, or business. Because of these divisions, the aspects of design that various professionals have in common are not emphasized, and numerous people whom we might call designers are isolated from one another in their professional preparation. Such separation is then extended into practice, where teams of professionals who should work together to solve common problems often must overcome misconceptions, or ignorance of each other's work. Aside from the fact that educational divisions foster modes of thought that separate different types of designing, they also produce fragmented definitions of what design is, and thus inhibit bold formulations that could assert a more comprehensive presence for design in society.

Added to the divisions between different forms of design, there is inadequate recognition that the study of design is a valuable practice. The history, theory, and criticism of design are still insufficiently promoted as subjects of study in their own right, although architecture is, to some extent, an exception. There is scarcely a separate university program in design studies anywhere in the world, nor do we find many professional programs–whether for graphic design, product design, or even engineering or computer science–that have theoretical or research components. For design to be taken seriously by educators, policymakers, and the public, we must develop a body of serious and useful research which can make the benefits of studying design's history, theory, and criticism more evident, not only to educators and professionals but also to the public. This latter audience is particularly important because it is members of the public that both commission and make use of design, as consumers or as taxpayers who support public works and other civic programs. Businesses employ engineers and industrial designers to develop new products, graphic designers to create their identity programs, architects to design their buildings, and interior designers to do their offices.[4] Public agencies hire architects and planners and might well create more projects for designers if they had a better

3) John Chris Jones makes an interesting connection between software and crafts. He says that the process of designing software is similar to traditional craftsmanship because it involves much "fitting, adjusting, adapting of existing designs, and much collaboration, with little chance of a bird's eye view such as a drawing board affords." From "Softechnica," in *Design After Modernism: Beyond the Object*, ed. John Thackera (London and New York: Thames and Hudson, 1988), 219.

4) The contribution of all forms of design to overall corporate strategy has been recognized by various companies such as Olivetti and IBM. For a statement of IBM's design policy, see Thomas J. Watson, Jr., "Good Design is Good Business," in *The Art of Design Management: Design in American Business* (New York: Tiffany and Company, 1975 [The Tiffany/ Wharton Lectures]), 57-79.

understanding of what designers could do for them, or if designers had a stronger sense of what they themselves might propose.

Though we do not yet have a good model for a new discipline of design studies, a large number of books and articles, including the essays published in this anthology, are presently scattered among various fields and disciplines and must still be integrated within a design studies framework. My essay at the end of this anthology gives a good indication of how much material has been produced and points out that many books have yet to be translated, and thus made relevant to new audiences. The next step is to begin mapping the field of design itself according to a broadened definition, and to start organizing existing research into related areas.

At the same time, design studies needs arenas of debate where new ideas can be presented and questioned, and where issues of the discipline can be defined. As one contribution to that effort, a group of colleagues at the University of Illinois at Chicago–Leon Bellin, Martin Hurtig, Larry Salomon, Sy Steiner, and myself–founded *Design Issues* in 1982 as a forum for sophisticated processes of argumentation.[5] We joined a field of at least four other scholarly design journals: *Visible Language, Culture Technique, Design Studies*, and *Information Design Journal*, each of which has a different orientation. As a group they reinforce the need for research and intellectual debate in design fields. *Design Issues* remains committed to drawing in researchers with backgrounds in history, sociology, literary criticism, psychology, engineering, philosophy, rhetoric, and design practice, among many. Our intention is to challenge conventional formulations of what designers do and to explore intellectual strategies that contribute to a critical understanding of what design is and how it functions in society.[6]

Because design's broad role in society has not been well conceptualized hitherto, design still seems a marginal subject to most people. If by studying design in a narrow sense we were only looking at an isolated set of objects and techniques that did not much affect the way social life was conducted, then this would indeed be so. But if we recognize design as a more significant practice with broader influence, then knowledge about it has greater value to us.

Herbert Simon called for a rigorous *science of design*, but we must bear in mind that the methods and goals of any practice are conditioned by values outside its functional domain. That point is taken up by Maurizio Vitta, a contributor to this anthology, who speaks of a *culture of design* that includes not only the production of useful objects (and here we should add processes, services, and techniques as well), but also their distribution and consumption. The culture of design embraces "the totality of disciplines, phenomena, knowledge, analytical instruments, and philosophies that the design of useful objects must take into account, inasmuch as those objects are produced, distributed, and used in the context of

5) Our model was the architectural journal *Oppositions*. I was the editor of the first six *Design Issues*, from which the material in this anthology has been selected. We now have an editorial board. Sy Steiner passed away in 1984. Dennis Doordan of the University of Illinois, Chicago, Marco Diani of Northwestern University and the C.N.R.S. in Paris, and Dick Buchanan have joined the board.

6) Clive Dilnot makes the crucial distinction between "design *and* society" and "design *in* society." See his article, "Design as a Socially Significant Activity: An Introduction," *Design Studies* 3, no. 3 (July 1982): 139-46. Dilnot also points out, rightly, that we must first decide what we mean by "design" before we can discuss its social role. This problem is central to his two-part essay on design history in this anthology.

7) Most attempts to develop theories of design have focused on refinement of methodology rather than on an analysis of how design operates in society. Theorists have tended to look at design ahistorically, likening it to a science, whether natural or artificial, rather than to a social practice that is defined in part by its historical results. See, for example, Siegfried Maser, "A Few Comments on the Problem of a Design Theory," *Design Papers 2* (Halifax: Nova Scotia College of Art and Design, 1979), and Jay Doblin, "A Proposed Theory of Design," in *Design and Planning*, ed. Martin Krampen (Waterloo: University of Waterloo Press, 1965), 49-52. We can contrast Doblin's quest for a design theory that explains consumer preferences with Mihaly Csikszentmihalyi and Eugene Rochberg-Halton's study of how people give meaning to objects, *The Meaning of Things: Domestic Symbols and the Self* (Cambridge: Cambridge University Press, 1981). In the first instance, people were tested as part of a sociological study and their responses were generalized for marketing purposes, while in the second the authors based their conclusions on extensive individual interviews that explain the particular reasons why people respond to objects as they do.

8) See, for example, Paul Feyerabend, *Against Method* (London: New Left Books, 1970), David Dickson, *The Politics of Alternative Technology* (New York: Universe Books, 1974), and Stanley Aronowitz, *Science as Power: Discourse and Ideology in Modern Society* (Minneapolis: University of Minnesota Press, 1988).

VICTOR MARGOLIN

9) Maser and other modernist theorists believe that rationality defines qualitative norms for design theory, hence science and technology provide the appropriate models for it. According to Maser, "It follows that a design theory must be developed with the help of models provided by communications theory." From Siegfried Maser, "A Few Comments on the Problem of a Design Theory," 28.

10) Touraine, a French sociologist, may have been the first to use the term "postindustrial." However, Touraine's concept of postindustrial society is at the opposite end of the political spectrum from Bell's. Touraine's book, published just after the student rebellions of 1968, is motivated by his resistance to social control, whereas Bell's supports the management of society by a technocratic elite. See Alain Touraine, *La Société Post-Industrielle* (Paris: Éditions Denoël, 1969; English edition *The Post-Industrial Society: Tomorrow's Social History–Classes, Conflicts and Culture in the Programmed Society* [New York: Random House, 1971]), and Daniel Bell, *The Coming of Post-Industrial Society: A Venture in Social Forecasting* (New York: Basic Books, 1973). For a critique of Bell's vision of the service economy, see Jonathan Gershuny, *After Industrial Society? The Emerging Self-Service Economy* (Atlantic Highlands, N.J.: Humanities Press, 1978).

11) Katherine McCoy sets her optimistic prediction for industrial design's future against a backdrop of future trends based on the popular forecasts of John Naisbitt and others. McCoy defines industrial design as a profession with "a forward-looking focus" and says that, "When people look to the future, they are more open to new ideas, to innovation. They are more open to industrial design's contribution." See Katherine J. McCoy, "Industrial Design in the Post-Industrial Age: The Evolution of a Profession." *Innovation* 3, no. 3 (Fall 1984): 4-6. Nigel Cross, on the other hand, looks more closely at a possible shift to "post-industrial design" that incorporates not only changes in production but also sex roles, design methods, planning theory, and work patterns. Of the two articles, McCoy's is an enthusiastic forecast that makes little reference to the real issues of postindustrialization, while Cross draws on the literature in design methods and other fields to outline the features of a new design paradigm. See Nigel Cross, "The Coming of Post-Industrial Design," *Design Studies* 2, no. 1 (January 1981): 3-8.

economic and social models that are ever more complicated and elusive."

The concept of a culture of design, which informs much design thinking in Italy where Vitta lives, reinforces the point that design is an activity which is defined to some degree by the social milieu in which it operates. Therefore we cannot conceive of any theory of design that is independent of a theory of society.[7] Many scholars would argue that theory itself is ideologically grounded and cannot produce *natural* models of either designing or society. David Dickson, Paul Feyerabend, and Stanley Aronowitz, among others, have extended this argument to apply to science and technology, challenging the once dominant premise that these disciplines are value-free.[8] Creating design theory then becomes a matter of argument, and part of a broader debate about social theory in general. Both types of theory are important because they help us to become more knowledgeable about why and how we do things. Since we don't agree on a single theory of society, it is equally impossible to postulate only one theory of designing. We can use a broad definition of design such as Herbert Simon's for establishing relations between different types of designing, but we cannot assume that a single model will characterize the design process for everyone.[9]

With the recognition of design's wider role in society, we can begin to make a place for design discourse within the larger debates about social theory, notably those that center on the transition from an industrial to a postindustrial society and from a modern to a postmodern culture. Since Alain Touraine published *La Société Post-Industrielle* in 1969 and Daniel Bell's *The Coming of Post-Industrial Society* appeared in 1973, debates about the future role of the service sector, the value of information versus hard goods as an economic commodity, the relation of technical knowledge to social policy formation, and many allied topics have been widespread.[10] What little writing there is about design in "postindustrial" society has been uneven, and has not tended to address the complexities of the debate on postindustrialization.[11]

Likewise, design has not been sufficiently integrated into debates about modernism and postmodernism in a way that fully expresses the deepest issues of cultural transformation forming the core of these debates.[12] Neither Jürgen Habermas, Jean-François Lyotard, Gianni Vattimo, or other leading philosophers involved in the debates on modernism and postmodernism have recognized design as a central representation of cultural values. In his massive two-volume work, *The Theory of Communicative Action*, Habermas, who has produced the most highly-developed argument for the continuity of Enlightenment rationality to date, develops a typology of social action that makes no reference to designing as a central human activity, although elsewhere he does have such a category for art.[13] Likewise, Lyotard and other critics of Habermas who postu-

12) The integration of design into the modernism/postmodernism debates is happening gradually. Tomás Maldonado, former director of the Hochschule für Gestaltung in Ulm, gives design an important place in his defense of modernity. See *Il Futuro della Modernità* (Milano: Feltrinelli, 1987) and his earlier work, *La Speranza Progettuale: Ambiente e Società* (Torino: Einaudi, 1970), particularly the last chapter, "Verso una prassiologia della progettazione"; the English edition is *Design, Nature, and Revolution: Toward a Critical Ecology*, translated by Mario Domandi (New York: Harper and Row, 1972). As for postmodernism, the Centre de Création Industrielle at the Centre Pompidou in Paris has, under its director François Burkhardt, begun to develop some of its exhibits and publications around the postmodernism debate. The most noteworthy of these was "Les Immatériaux," curated by the philosopher Jean-François Lyotard. See also the special issue of *Cahiers du CCI 2* (1986) on "Design: Actualités Fin de Siècle." English translations of several of the articles were included, along with a number of other contributions in *Design After Modernism: Beyond the Object*, ed. John Thackera. "Designing the Immaterial Society" was the subject of a special double issue of *Design Issues*, guest-edited by Marco Diani. Here one finds articles by philosophers, sociologists, historians, artists, and designers that address the issue of immateriality, a theme of importance to many postmodernists. See *Design Issues* 4, nos. 1-2.

13) Habermas speaks of a relationship between the cognitive, moral-practical, and esthetic-expressive domains. Art is clearly in the third category—but where does design fit? For a concise statement of Habermas's position, see his now well-known essay, "Modernity— An Incomplete Project," in *The Anti-Aesthetic: Essays on Postmodern Culture*, ed. Hal Foster (Port Townsend, Wash.: Bay Press, 1983), 3-15.

14) Although Lyotard's *The Postmodern Condition*, which was first published in a French edition in 1979, did much to focus initial debates about postmodernism in Europe and the United States, there is now an extensive and heterogeneous literature on the subject. See Jean-François Lyotard's *The Postmodern Condition: A Report on Knowledge* (Minneapolis: University of Minnesota Press, 1984 [Theory and History of Literature, vol. 10]), *Les Immatériaux* (Paris: Éditions du Centre Pompidou, 1985), and *Le Postmoderne Expliqué aux Enfants* (Paris: Galilée, 1986); Fredric Jameson, "Postmodernism, or

late a more fragmented and less rational society don't make design visible as a distinct sphere of cultural transformation.[14] The low profile of design in the industrial/postindustrial and modernism/ postmodernism debates indicates that most scholars do not yet see design as a contribution to the modeling of new theoretical paradigms, nor is the understanding of design enhanced very much by the debates themselves.

These lacunae do not reflect an inherent marginality of design; rather they are an indication of its weak conceptualization. As we consider prospects for the new discipline, we should bear in mind that many areas of study which are now serious academic disciplines went through a phase that preceded the development of theories and clearly articulated issues and debates. Art and architectural history, literature, sociology, anthropology, history, and political science are good examples.[15] Within these disciplines, changes have come from scholars who demanded more rigorous methods of research, often looking towards disciplines such as the sciences for examples of theory and methodology which they could apply. We can take literature and art history as examples of how this process has worked. The study of literature has in past years attracted researchers from areas as diverse as sociology and psychoanalysis. Now it is a center of critical debate that serves as a model for a number of other disciplines, in which architecture and ethnography are included.[16] Art historians, likewise, are witnessing a convergence of history, theory, and criticism that is shaking the foundations of the profession and opening up new links to scholars of literature, psychoanalysis, political theory, feminism, and the broader field of history.[17] Design holds the same promise for critical reflection as art and literature, but has yet to attract widespread attention because practitioners and scholars have not produced a persuasive argument for its centrality to social life.

A program in design studies could benefit greatly from the current strains on traditional disciplinary barriers and the multitude of new theories in the humanities and social sciences that have emerged in recent years.[18] Structuralism, poststructuralism, representation, feminism, reception theory, semiotics, deconstruction, and reader-response theory are just a few of the recent nodes around which intellectual inquiry is being organized. These new approaches have helped to break down traditional boundaries of subject matter and provided methods for addressing the many new questions that scholars are asking of their subjects.

This proliferation of new nodes of inquiry can also be brought to bear on the study of design, as it has influenced architecture, literature, art, film, anthropology, and sociology. We can see in reception theory and reader-response theory, for example, ways of better understanding the role of the design user. Reception theory makes clear the importance of the wider context in which a literary work

VICTOR MARGOLIN

The Cultural Logic of Capital," *New Left Review* 146 (July–August 1984): 53-92; and Hal Foster, ed., *The Anti-Aesthetic*. Two concise accounts of postmodern theory and positions are Andreas Huyssen, "Mapping the Postmodern," in his collection of essays, *After the Great Divide: Modernism, Mass Culture, Postmodernism* (Bloomington and Indianapolis: Indiana University Press, 1986), 179-221, and Matei Calinescu, "On Postmodernism," from *Five Faces of Modernity: Modernism, Avant-Garde, Decadence, Kitsch, Postmodernism* (Durham: Duke University Press, 1987), 265-312.

5) For the histories of particular disciplines, see David Watkin, *The Rise of Architectural History* (Chicago: University of Chicago Press, 1980), Gerald Graeff, *Professing Literature: An Institutional History* (Chicago: University of Chicago Press, 1987), and Annemarie De Waal Malefijt, *Images of Man: A History of Anthropological Thought* (New York: Knopf, 1974).

6) Good examples of literary theory's impact on architectural thinking can be found in the special issue which Marco Diani and Catherine Ingraham edited of *Thresholds*, the journal of the School of Architecture at the University of Illinois, Chicago. See "Restructuring Architectural Theory," *Thresholds* 4 (Spring 1988), particularly the essays by Paul Jay, Mark Taylor, Sharon Willis, Peter Eisenman, and Patrizia Lombardo. For the influence of literary studies and other disciplines on ethnography, see James Clifford, *The Predicament of Culture: Twentieth-Century Ethnography, Literature, and Art* (Cambridge: Harvard University Press, 1988).

7) Changes that art history in the United States has been undergoing were discussed in a special issue of the *Art Journal*, edited by Henri Zerner. See "The Crisis in the Discipline," *Art Journal* 42, no. 4 (Winter 1982). New developments in Britain are discussed in A. L. Rees and F. Borzello, eds., *The New Art History* (Atlantic Highlands, N.J.: Humanities Press International, 1988), while recent French theories are presented in Norman Bryson, ed., *Calligram: Essays in New Art History from France* (Cambridge: Cambridge University Press, 1988). The latter title is part of a developing series on new art history and criticism whose general editor is Bryson.

8) See, for example, the essays in *Innovation/Renovation: New Perspectives in the Humanities*, ed. Ihab Hassan and Sally Hassan (Madison: University of Wisconsin Press, 1983).

9) See Robert Jauss, "Literary History as a Challenge to Literary Theory," in *New Directions in Literary History*, ed. Ralph

functions.[19] It shows that meaning results from a negotiation between the producer of a literary work and his or her audience. It exposes the inadequacy of a communications theory model, which posits an objective message whose meaning remains intact during the process of transmission between sender and receiver. Reception theory recognizes the complexity of communication and allows the receiver some autonomy in interpreting the literary work. However, Roland Barthes and others have gone so far as to negate the role of the author altogether and to place the responsibility for interpreting a work of literature solely on the reader. Following this line of reasoning, critics such as Jonathan Cullers, Jane Tompkins, and Stanley Fish have developed a theory of reader response which, like the work of Barthes, concentrates on the reader's initiative in producing meaning from a literary text.[20] To relate this theory to design, we can note that the deemphasis of a designer's intentions is particularly relevant to flexible designs such as computer software, where the user interacts with a set of possibilities in order to meet his or her needs. As Tom Mitchell states, "In place of the concept of design as simply a means of producing objects, develops an understanding of designing as a continuous and non-instrumental thought process, a creative act in which everyone, designers and non-designers alike, may participate equally."[21]

Reader-response theory can also play an important role in understanding the way consumers or users of design establish a relation to objects in ways other than the ones marketing studies reveal. A pioneering work in the study of user response is Mihaly Csikszentmihalyi and Eugene Rochberg-Halton's *The Meaning of Things: Domestic Symbols and the Self*. The authors, who interviewed more than 300 people, describe the motivation for their study as follows: "We wanted to examine the role of objects in people's definition of who they are, of who they have been, and who they wish to become. For despite the importance of objects, little is known about the reasons for attachment to them, about the ways they become incorporated in the goals and actual experience of persons."[22] Czikszentmihalyi and Rochberg-Halton have made a contribution to design understanding by bringing their training in social psychology and sociology to bear on the question of how people use objects. Other books such as Mary Douglas and Baron Isherwood's *The World of Goods*, Jean Baudrillard's *Le Système des Objets*, Judith Williamson's *Decoding Advertisements*, William Leiss's *The Limits to Satisfaction*, Wolfgang-Fritz Haug's *Critique of Commodity Aesthetics*, and *Material Culture and Mass Consumption* by Daniel Miller have also made clear how methods and theories from different disciplines can open up new topics for design study. I cite further examples in my essay on postwar design literature.

Like these books, many of the essays in this anthology are attempts to ground design study in some of the recent theories that

Cohen (Baltimore: Johns Hopkins University Press, 1974), 11-42.

20) Barthes's essay "The Death of the Author" unequivocally states the argument for open reading. See Roland Barthes, *Image-Music-Text*, selected and translated by Stephen Heath (New York: Hill and Wang, 1977), 142-48. For an excellent introduction to reader-response theory see Jane P. Tomkins, ed., *Reader-Response Criticism: From Formalism to Post-Structuralism* (Baltimore and London: Johns Hopkins University Press, 1980).

21) Tom Mitchell, "The Product as Illusion," in *Design After Modernism*, ed. John Thackera, 214.

22) Mihaly Csikszentmihalyi and Eugene Rochberg-Halton, *The Meaning of Things: Domestic Symbols and the Self* (Cambridge: Cambridge University Press, 1981), x.

are opening up new directions in research. The authors' definitions of design and approaches to understanding it are extremely diverse, and occasionally in conflict. The convergence of some of their positions is coincidental, but also indicative of new tendencies in design thinking. The essays are drawn from the first six *Design Issues* and were published between 1984 and 1987. I have grouped them into three sections. In the first, "After the Modernists," the authors are united only in their departure from or opposition to modernist conceptions of design. In the second, "The Interpretation of Design," the focus is on how we give meaning to design. Here too we can see strains of resistance to earlier theories that presumed the possibility of communicating universal values in an objective manner. The essays on design history in the third section, "Writing Design History," have been grouped separately, not to assert that they are epistemologically different from theory or criticism–for any good history will be grounded in a theory of its subject and will embody a critical perspective–but to emphasize the importance of understanding how the study of design's past depends on assumptions of what it currently is. *I* believe neither in a sharp demarcation of past and present nor in a separation between different ways of thinking about design, which might be implied in the division of history, theory, and criticism. It is noteworthy that these divisions are collapsing in other disciplines such as literature and art history; so too, they should not be maintained as the discipline of design studies matures.

After the Modernists

I use the term "modernist" instead of "modernism" in the title of this section because I do not wish to presume a fundamental break between the paradigm of modernism and whatever follows it. Modernism is for me a much broader term than modernist. Most scholars would agree that modernism as a paradigm began with the Enlightenment, if not before. By modernists, however, I mean those designers who tried to align design thinking with the scientific and technological values that were developing between about 1900 and the late 1960s. These would include early designers for industry such as Peter Behrens, avant-garde artist-designers like Alexander Rodchenko and El Lissitzky, theorists of design methods such as Bruce Archer, engineer-designers like Buckminster Fuller, and design educators like Walter Gropius at the Bauhaus, Emil Ruder at the Basle Kunstgewerbeschule, and Tomás Maldonado at the Hochschule für Gestaltung in Ulm. While it is difficult to characterize this group as a whole, one can nonetheless find common elements in the ideologies of its members. All believed that advances in science and technology were evidence of social progress and provided paradigms for design thinking. They thought that communication could be objective and that optimum solutions to design problems could be found. Many felt that design, if rationally con-

ceived, could help to solve social problems and did not itself create such problems. And most assumed that goods should be mass produced by industry.

This belief in a steadily improving, coherent world was shattered by World War I. It was revived after the war, but began to crack again by the late 1920s. Throughout World War II, however, rationalism was inherent in the organization of efficient production methods by the Axis powers as well as by the Allies. Following the war, this belief was again revitalized in civil society. It began to crumble in the 1960s, fueled by student revolts around the world and by the emergence of a 'counterculture' in various countries. Design thinking too was affected; the model of a rational planning process that can produce a well-designed and well-ordered world has been in disarray since then. At the same time, the rapid introduction of new technology, accelerated in the 1970s by enormous advances in the design of macro- and microcomputers, has necessitated a fundamental realignment of human-machine relations.

While the essays included in this section do not outline a coherent new design paradigm, they nonetheless challenge the modernist one: some by direct criticism, as we see in Gert Selle's essay, and others by formulating design responses to new social and technological conditions, as we find in the essays by Vitta, Diani, Morgantini, Branzi, and Moles. Several of the authors make direct or indirect reference to postmodernism and to specific postmodern theorists, but their definitions of postmodernism and the situation it has created for design vary.

For Maurizio Vitta, an important characteristic of postmodernism is the growing role of images in contemporary culture. Through the power of communications media, and particularly advertising, images become a persuasive means of motivating people to act. Vitta cites Jean Baudrillard and Mario Perniola, who see the world becoming a repository of simulacra—empty images or signs—but he also makes reference to the more positive theory of symbolic communication advanced by anthropologist Mary Douglas and economist Baron Isherwood. They argue that the social exchange of goods is essentially a symbolic process which enables people to communicate through the medium of objects. Vitta calls attention in his essay to the problem which the symbolic identity of objects creates for designers. Design, he says, does not occur in a neutral field in which the designer's contribution is universally recognized and accepted; rather it is a contradictory intervention into a society that demands objects with use-value on the one hand, but is preoccupied with converting them into ephemeral simulacra on the other: "But remaining within the usual scope of design, the designer's centrality is confirmed because the *consumption* of the use-object requires that it be continually transformed while it remains faithful in substance to its original function; and the task of expressing the cultural, esthetic, or semiological values that interact behind that trans-

formation is the designer's specific duty." Vitta departs radically from the modernists, who believed that objects were simply expressions of function or use-value. But he points out the danger of a postmodernism that places such a high emphasis on the circulation of empty signs.

Andrea Branzi is more accepting of the sign as the dominant artifact of postmodern culture. Following Jean-François Lyotard's thesis in *The Postmodern Condition* (1982), Branzi believes that master narratives or overarching social beliefs have collapsed and that we are experiencing a retribalization of individuals into smaller units. Here he elaborates on Lyotard's concept of society as an aggregate of fragmented groups that invent their own language games in order to communicate. Branzi sees this as a positive phenomenon: "Symbolic worlds proliferate and become differentiated. The very process that multiplies the codes and the symbolic resources of the individual, and that weakens the integrity and the plausibility of that person's familiar world, also enormously widens the field of various possibilities perceived by individuals." Design is thus a way of constructing the self, a means of reinforcing one's identity. Branzi shifts its central purpose from the modernist's concern with function to one of expression. It is a means of codifying new social rituals that result from the retribalization he foresees. Branzi characterizes humans in postmodern culture as "primitives" because "our condition is that of those who, having fallen from an airplane into the middle of the Amazon territory, find themselves operating with technologically advanced elements still on board, as well as with natural materials of the forest." He thus sharply rejects the modernist belief in progress as the driving force in design.

Branzi, a designer, has stated his position in objects as well as words. The series of chairs and couches he calls "domestic animals" are polemical works that combine pieces of raw wood or twigs with industrial materials.[23] He has also designed furniture and small household objects for the Memphis group, in accordance with their belief that objects should have a strong, intrusive presence in the domestic environment.[24] In his conceptual projects, Branzi has paid more attention to the design of domestic spaces than to the projection of large urban ones because he believes the latter task is no longer a legitimate one for designers.[25]

The work of Branzi and Vitta represents two strands of contemporary Italian design theory. Maurizio Morgantini offers a third. Defining objects as prosthetic devices that extend human capabilities, he focuses on the consequences which the new generation of intelligent objects has brought about. Morgantini calls these objects prostheses of the mind. They are the third generation, following prostheses of the limbs and the senses. This new generation marks "the still nebulous and equivocal encounter between human and silicon intelligence." Morgantini believes that this encounter creates an unprecedented situation for designers. A keyboard or control panel

23) For a discussion of these objects see Andrea Branzi, *Domestic Animals: The Neoprimitive Style* (Cambridge: MIT Press, 1987).

24) This is the direct opposite of the Braun company's Dieter Rams's philosophy. He believes that objects should be unobtrusive and should not contribute to the 'fireworks' of society. See Rams, "Omit the Unimportant," in this anthology.

25) At the international ICSID design conference in Milan in 1983, the modernist theme was derived from architect Ernesto Rogers's statement that designers could create anything "from a spoon to a town." Speaking as a panelist, Branzi said that the designer's role was to produce objects that ranged "from a spoon to a spoon."

VICTOR MARGOLIN

now comes between the actor and the results of his or her action. Prostheses of the mind do not operate as simply as a knife extends an arm; instead they complicate the relationship between a person and an action by serving as intermediaries directing the workings of intelligent machines. Humans interface with keyboards or display panels to determine the operations of machines, which may be removed in space or time from the point where they initiated. As Morgantini states: "Man is no longer surrounded by objects to be moved, but rather surfaces to be tactilely grazed, and therefore, by events that are provoked by simple actions and are to be observed in their development." A new esthetic dimension now supplements the physical forms of objects. This dimension is immaterial. Its beauty or terror is created by the magical feedback of intellectual and sensory experiences that the user invokes through a keyboard or control panel. And forms themselves are no longer bound by the functions of mechanical shapes— such functions are increasingly compressed into miniaturized parts, thus liberating the designer to create forms that communicate more symbolically or metaphorically. The next challenge for designers, says Morgantini, is to move beyond the object to design "biotronic environments," artificial landscapes with self-regulating light, air, and sound. Such environments are now possible because of advances in electronic and sensor technology which can be made responsive to the changing phases of body and psyche.[26]

Like many theorists of postindustrialism and postmodernism, Morgantini recognizes the possible utility of flexible manufacturing systems for "overcoming the concept of mass production itself." He is in agreement with Branzi as well as with François Burkhardt, who discusses postmodern design theory here in the West German context. Burkhardt shares Morgantini's recognition of individual consumer choice as a characteristic of postindustrial society, and adds that design in a cybernetic culture can also facilitate small-scale production operations. The capacity of flexible manufacturing arrangements to change the design process by giving the consumer a new power of choice is the pragmatic side of the argument that diversity, not uniformity, is a characteristic of postmodern culture.

Burkhardt is especially concerned that a new postmodern theory expose the weaknesses of functionalism, which prevailed in Germany for many years as the master narrative of design. Unlike the modernists, he does not want technology, with its implied universal values, to be a determinant for design. He favors a postmodern theory "that could avoid the one-sidedly truncated rationalism and straightening of the design products onto an education for a monoculture." Burkhardt believes that the modernist obsession with objects that embody universal values has overshadowed a recognition of regional cultural identities as a rich source of object forms.[27] He also criticizes the minimalist esthetic of the modernists, which he believes impoverishes the human environment. Like Branzi, he ar-

) Morgantini's design for the RAI studio in Rome is a good example of such a project. The Italian designer Clino Castelli has given the name *design primario* to his process of designing physical environments, which have been commissioned by Herman Miller and Fiat, among others. For a brief description of *design primario* see John Thackera, "Designing Without Form," *Design* (August 1985): 38-39. See also Clino Castelli, *Il Lingotto Primario* (Milano: Arcadia, 1985). Morgantini's work is discussed in *Descendants of Leonardo Da Vinci: The Italian Design* (Tokyo: Graphic-sha, 1987).

') Regionalism is also a strategy for architectural theorists who want to escape both the reductionism of modernist buildings and the superficiality of many postmodern structures. See Kenneth Frampton, "Towards a Critical Regionalism: Six Points For an Architecture of Resistance," *The Anti-Aesthetic: Essays on Postmodern Culture*, edited by Hal Foster (Port Townsend, Wash.: Bay Press, 1983), 16-30. This essay has been rethought by Frampton and published as "Place-form and Cultural Identity," in *Design After Modernism*, ed. John Thackera, 51-66.

gues that the modernist's abhorrence of symbolic expression must be countered by a new postmodern design.

Gert Selle, who occupies one of the theoretical positions described by Burkhardt, attacks all attempts by designers to impose their taste on the consumer. In the essay included here, Selle, who writes from a Marxist perspective, celebrates what he calls "beautiful everyday objects." In this regard he is not a postmodernist, but is definitely antimodernist in his opposition to the professional designer's will to control the forms of daily life. Selle celebrates the public's resistance to this tendency.[28]

In the exhibition, "Genial Design of the '80's: Objects of Desire and Daily Use," for which the essay presented here originally served as the introduction, he included such objects as an inflatable "E.T." ("Extra Terrestrial"), a garden chaise with a flower pattern, and a table lamp with tassels.[29] Rather than glorify the postmodern products introduced by current avant-garde designers, Selle states: "The real avant-garde was already long on the warehouse shelves before 'Memphis' and others acted as if our product environment had for once to be brought to life and made playful, colorful, and all new." He rejects the idea of kitsch, which originated as a derogatory term for bourgeois taste, preferring not to make a normative distinction between taste preferences.[30] His populist polemic echoes the research of Csikszentmihalyi and Rochberg-Halton, who conclude in *The Meaning of Things* that people select objects in order to give meaning to their lives. Selle defends popular taste against designers' attempts to impose norms of esthetic or moral value on the public: "This design, more than any other, permits people to determine what use value and identity representation mean to them. They decide on their kind of friendship to the things in the framework that this open beauty covers and, of course, in the framework of differing socially defined expectations and possibilities of expression."

Through his criticism of all design avant-gardes, whether modernist *or* postmodernist, Selle empowers ordinary people to exercise their own taste which, he says, they do in accordance with their personal life projects. It is within this intricate web of the everyday that we must ultimately place theorists of postmodern design such as Branzi, Morgantini, and Burkhardt who, in Selle's terms, still want to create the scenarios of daily life for the public. Although these theorists all believe that flexible modes of manufacturing will give the consumer a greater range of product options, Selle would argue that people are already exercising their power of choice, oblivious or resistant to the projects of design professionals and theorists.

But Selle is more concerned with the exercise of taste than with the complex social problems brought about by the steady introduction of new technology and resultant changing patterns of life. He has faith in the ability of ordinary people to regulate their lives according to their own needs, but other theorists believe that a new

28) The function of design and other forms of culture as representations of resistance is developed by Dick Hebdige in *Subculture: The Meaning of Style* (London and New York: Methuen, 1979). Hebdige makes a cogent argument for the manipulation of cultural forms as one of the primary means of empowerment for socially marginalized groups.

29) The polemics of Selle's exhibition become more pronounced when we compare it with the ambitious display of "good design" presented at the Philadelphia Museum of Art several years ago. See the catalog, *Design Since 1945*, ed. Katheryn B. Hiesinger and George Marcus (Philadelphia: Philadelphia Museum of Art, 1983). Herbert Gans writes in that catalog, "'Design Since 1945' is for this sociologist, a treasure trove of progressive upper-middle class culture and a collection of its more typical artifacts."

30) We can consider this a radical, rather than a liberal, position. The liberal view acknowledges kitsch as worthy of approbation but still defines it as bad taste. For an example of the latter, see Gillo Dorfles, *Kitsch: The World of Bad Taste* (New York: Bell Publishing Company, 1968).

VICTOR MARGOLIN

master narrative of design is necessary to address those problems whose complexity has outstripped our ability to solve them. This is particularly true of scholars who are concerned with the hard facts of sociological analysis. Marco Diani invokes Herbert Simon's proposal for a science of design that would unite a necessarily broad approach to the special problem of office automation. Diani states that the design of new office products does not in itself lead to greater productivity and a satisfied work force. He claims that "conventional theoretical tools of analysis and methods of design are inadequate for dealing with the fundamental changes and unprecedented novelties characteristic of the third office revolution." In design competitions, recognition is given to designs for office equipment, but Diani poses the question of whether "design" should only be limited to hardware or whether, by rethinking the term, we can use it more effectively in an interdisciplinary framework for solving more complex problems. Among the issues he raises are the loss of human participation in decision-making, the abstraction of procedures, intensification of the work tempo, and changing patterns of socializing. Specialists concentrate on one or another of these problems, but we lack generalists who perceive the office as a complex interplay of humans and machines. This, Diani claims, is an appropriate mission for a science of design.

Like Diani, Abraham Moles confronts problems that transcend conventional notions. In particular he stresses the challenge posed to designers by the expansion of the service sector in the economies of developed nations[31]: "In short, designers are no longer creators of *objects* but of *environments*. The design task is to reconceptualize the various shells that surround human beings in order that a means of deriving the greatest possible satisfaction from their position in the world and the possibility for attaining a specific quality of life is not made more and more remote." Just as the office with all its component parts—hardware, software, and work processes—forms a larger problem for the designer to address, the product, as Moles considers it, also belongs in an environment that must be designed to insure its continued usability. Moles makes the salient point that individuals relate to functions rather than objects. When a person is unable to use a product effectively, either because of its complexity or because it malfunctions, then the relationship breaks down. The designer must therefore be concerned with the product environment or set of conditions that sustains a satisfying relation between the object and the individual.[32]

Moles sees the design of product services as a way of achieving this. He envisions design as an integrative discipline whose objective is to facilitate what he calls the life project of each individual. Human motivation, according to Moles's own theory of action, derives from a favorable cost-benefit analysis of human acts.[33] These acts can be broken down into segments, each of which has a cost and a potential return to the individual. Noting that "the quality of life is

Marketing strategists have been speaking for a few years about service design. In Italy, the leading advocate is Augusto Morello, while in the United States Theodore Levitt was among the first to relate techniques of product planning to service provision. See Augusto Morello, "Il Designer Liberato," *Modo* 61-62 (August–September 1983): 49-51, and Theodore Levitt, "The Industrialization of Service," in his collection of essays, *The Marketing Imagination* (New York: The Free Press, 1986), 127-40.

I introduced the term "product environment" in an article, "The Product Environment and the New User: Expanding the Boundaries of Design," *Design Issues* 4, nos. 1-2 (1988): 59-64. A full discussion of Moles's theory of action, which is the basis for much of his thinking about design, can be found in Abraham Moles, *Théorie des Actes: Vers Une Ecologie des Actions* (Paris-Tournai: Casterman, 1971).

impaired by the failure of a particular tool or object," Moles proposes a "comprehensive guarantee" for product maintenance and repair. This is a service function which falls within the larger scope of the product environment.

Both Moles and Diani exemplify Herbert Simon's definition of design as "changing existing situations into preferred ones." Their concerns as design theorists are broader than the object. They are aware that human action is mediated by an extensive system of objects, laws, procedures, and techniques. If designers are truly concerned with making preferred social action possible, then it is necessary to take all these elements into account as part of their projects.

As the diverse opinions of the authors included in this first section indicate, the state of design after the modernists is still too uncertain to serve as a grounding for a new science of design. What remains to be developed is the manner in which advanced technology and planning theories will be diffused through society at large. The gap between the trained and the untrained, the wealthy and the poor, those who can navigate through the shoals of the information environment and those who can't, grows steadily wider. It was a mistake of the modernists to believe that the public would or could simply fall into line with their proposals for a new order. Today, it is evident that such is not the case. Therefore design debates must continue to address the need for social models that accurately represent and can aid in easing wide disparities of awareness, motivation, and privilege.

The Interpretation of Design

The essays in this section address the question of how users assign meaning to designed objects, among which I also include images. I have titled the section to reflect the conviction of most authors included here that objects do not have fixed meanings which are the same for everyone. This is in sharp contrast to the modernist ideology, which embodied a design norm modeled on the perceived characteristics of science and technology. This led to the Manichean division of design into good and bad examples of the norm.[34] The early modernists of the 1920s conceived the user of design as someone whose needs would be met by clarity of communication, systematic organization, and purity of form. Initially geometry provided the preferred vocabulary for architecture, products, and graphic design. Wassily Kandinsky made an early attempt to relate the square, circle, and triangle to appropriate colors and emotional states and preached about this to his students at the Bauhaus, while El Lissitzky believed that a vocabulary of geometric forms would provide the basis for all designing.[35] In the 1960s, information theory, which had first been formulated by engineers to explain the problem of sending messages efficiently from one source to another, replaced geometric order as the normative model

34) The Museum of Modern Art has been a primary enforcer of this distinction through its collections, exhibitions, and publications. See "Declaration of Function: Documents from the Museum of Modern Art's Design Crusade, 1933-1950," introduction and commentary by Sidney Lawrence, *Design Issues* 2, no. 1 (Spring 1985): 65-77. Despite such critical analyses, a product or poster in a MOMA exhibit or in its collection remains a hallmark of distinction for designers.

35) See *The Life of Vasilii Kandinski in Russian Art: A Study of 'On the Spiritual in Art,'* edited by John E. Bowlt and Rose-Carol Washton Long (Newtonville, Mass.: Oriental Research Partners, 1980 [ORP Russian Biography Series, no. 4]) and El Lissitzky, "Element and Invention" in Sophie Lissitzky-Küppers, *El Lissitzky: Life, Letters, Texts* (London: Thames and Hudson, 1980), 349-51.

VICTOR MARGOLIN

) This transition was first noted by Robin Kinross in his contribution to this anthology.

for many designers. Electrical circuits supplanted circles, squares, and triangles as the dominant metaphors of design.[36] As Jeremy Campbell has written in his history of information theory:

> Thus information emerged as a universal principle at work in the world, giving shape to the shapeless, specifying the peculiar character of living forms and even helping to determine, by means of special codes, the patterns of human thought. In this way, information spans the disparate fields of space-age computers and classical physics, molecular biology and human communication, the evolution of language and the evolution of man.[37]

) Jeremy Campbell, *Grammatical Man: Information, Entropy, Language, and Life* (New York: Simon and Schuster, 1982), 16.

Information theory's formulation of a precise message transmitted directly from a sender to a receiver confirmed the modernist faith in a design that was objective and unequivocal. The designer could thus send an unadulterated message to a user, whether through a poster that was organized on a grid layout or through an arrangement of controls on a record player. Information theory actually played a large part in the curriculum of the Hochschule für Gestaltung in Ulm, which was an important center of research on rational design methods in the 1950s and 1960s.[38]

) Abraham Moles, one of the first scholars in France to call attention to the wider implications of information theory, also taught the subject in Ulm.

In recent years, however, the belief in natural models that provide normative standards for human action has been severely criticized. Roland Barthes made the important point in 1957 in his book *Mythologies* that our perception of what is natural in human life is in fact conditioned by our willingness to believe it so. "Semiology has taught us that myth has the task of giving an historical intention a natural justification, and making contingency appear eternal," Barthes wrote.[39] This premise has been used to criticize technology, the practice of science, and, recently, the American legal system.

) Roland Barthes, "Myth Today," in *Mythologies* (New York: Hill and Wang, 1972), 142.

The demythologizing of science and technology as models for design practice has prepared the way for a broader, more open process of assigning meaning to designed objects. In this regard, the theory of rhetoric, which grounds the communication process in argument and persuasion rather than objectivity, has been particularly useful. Richard Buchanan states in the essay included in this section that: "Design is an art of thought directed to practical action through the persuasiveness of objects and, therefore, design involves the vivid expression of competing ideas about social life." Through his claim that design is rhetorical rather than natural, Buchanan helps us to recognize modernist design as simply one argument among many rather than as a practice with inherent normative values. He also enables us to look more closely at the relation between designed objects and users. If, as Gert Selle points out, users do not choose the objects that designers think are good for them, then why do they choose what they do and why do they prefer *their* choices to others?

Buchanan defines three elements of a design argument: the *logos* or technological reasoning, which he says is the backbone of the ar-

gument; the *ethos* or character of an object; and the *pathos*, its emotional quality. While design is often discussed primarily in terms of its emotional or esthetic effects, Buchanan is emphatic in recognizing the centrality of technology in the design—not as something that signifies a normative value, but as something selected for a specific purpose: "However, if technology is in some fundamental sense concerned with the probable rather than the necessary—with the contingencies of practical use and action, rather than the certainties of scientific principle—then it becomes rhetorical in a startling fashion." By granting technology such an important place, Buchanan challenges Jean Baudrillard's assertion that we are increasingly surrounded by empty signs. He would claim instead that a design argument "involves all aspects of the making of objects for use, so that design itself, whatever the type of object produced, is not an art of adornment, but a rhetorical art that creates objects persuasive in every aspect." [40]

If we can recognize design as an art of persuasion, then we can better understand the various forms of resistance to designers and what they create. This is not to claim the impossibility of arguing in a normative way for solutions to problems, but to recognize that these solutions can easily be perceived by the public as proposals to be resisted or refuted rather than as projects that are inherently superior. [41] Buchanan states, for example, that avant-garde designers have very little authority over mass audiences because the experimental objects they propose "lack virtue or trustworthiness as judged by the standards of a mass audience who suspect themselves to be the butt of a joke."

While designers such as Dieter Rams and his staff at Braun aim to overcome the untrustworthiness of avant-garde objects with a user-friendly approach based on unobtrusive form and clarity of design, Buchanan sees this, too, as an argument that may be technologically persuasive but at the same time offers little defense against the visual fireworks of the avant-garde, or even (though this is unstated) against the historicist or decorative designs produced for mass markets throughout the world.

In his essay for this anthology, Rams attempts to reduce the design argument to one of efficiency: "People do not buy a specific product just to look at it, rather because it performs certain functions. Its design must conform in the best possible way to the expectations that result from the function the product fulfills." Rams believes that forms which try to do anything but express a product's function "are nothing more than designers' escapades that function as self-expression instead of expressing the product's functions." One cannot argue with Rams's concern for function, but Buchanan would see efficiency as only one part of the product's argument, the result of its *logos*. At the same time, Rams also wants product form to possess the *ethos* of functionalism; likewise the *pathos* or emotional effect should be inobtrusive, so as not to infringe on the com-

40) From a rhetorical point of view, a sign that is empty for an audience may be part of a producer's strategy, i.e., the glut of goods on the market and the advertisements for them exist because producers want to make money by selling their products, no matter how meaningless their tactics of persuasion seem to be.

41) A good example of resistance to a design proposal is the Strategic Defense Initiative. This is a matter in which a segment of the public has intervened because the design outcomes affect their lives. At another level, consumer groups protest against products that have harmful personal or ecological effects. A good example of how the public's design values can conflict with those of designers is the criticism of passenger safety that Ralph Nader mounted against the American automobile industry in the 1960s. This led to major changes in car design. See Ralph Nader, *Unsafe at Any Speed: The Designed-in Dangers of the American Automobile* (New York: Grossman, 1965).

VICTOR MARGOLIN

munication of functionality. While Rams articulates his concern for function as the primary principle of design, he also sets up an opposition between function and those qualities of product character or esthetics of which he disapproves. "I don't support dull or boring design but I do take a stand against the ruthless exploitation of people's weaknesses for visual and haptic signals, which many designers are engaged in. The festival of colors and forms and the entertainment of form sensations enlarges the world's chaos." Here Buchanan's description of a design argument can help us to understand that there is no inherent conflict between function and expression; instead, these are separate elements that can be brought into relation rather than set in opposition.

If we are able to recognize the clean product form of a Braun product as an esthetic choice rather than the optimal expression of efficiency, we can begin to imagine other alternatives. Richard Porch writes in his critique of the digital watch that the "machine esthetic" of late twentieth-century product design, which is embodied in the digital watch, promises "high levels of performance" and provides "no romantic notions of user appeal or tactile quality." At the same time, he notes a trivialization of the watch by marketing executives who offer "a host of largely useless extra functions."

What Porch challenges is precisely the digital watch's argument of technological efficiency, which he says outstrips the needs of the user. "Do we really need such split-second accuracy in our daily activities? Or do we think so, simply because the technology makes it available and advertising tells us we do?" He recalls the esthetic pleasure of traditional watches, which "had an aural signature (ticking), required minor attention (winding), and were vaguely anthropomorphic (two *hands* on a clock*face*)." By contrast the esthetic of the digital watch seems to him cold and unengaging. Porch sees its panoply of extra functions as the dark side of the modernist faith in technology. He makes his strongest critical points by emphasizing the *ethos* or qualities of the digital watch which he dislikes, rather than by disparaging the watch's functionality or its form. He shows how marketing executives have sought to transform its *logos* or technological argument into qualities of character (extra functions) and esthetics (clean silent forms), and he tells us why he finds these unsatisfying. His essay exemplifies the possibilities for interpretive criticism, which must explain the arguments embodied in objects in order to make value statements about them.[42]

Although Buchanan uses tangible products such as furniture, utensils, and appliances as examples in his discussion of design rhetoric, the principles he describes apply as well to graphic design, which includes magazines, posters, timetables, directional signs, and other means of communication that we can also define as objects. For Abraham Moles, the principal function of graphic design is efficiency, which we can consider a technological characteristic. Moles defines the graphic designer as a "sign engineer who precisely

Criticism of product and graphic design, as opposed to architecture, is just beginning to gain recognition as a distinct practice. Steven Heller has been a leading proponent of graphic design criticism, both in his columns for *Print* magazine and in his role as editor of the *AIGA Journal of Graphic Design*. As we define design criticism more clearly, we can construct a lineage of critical writing to serve as a precedent for future work. Among those who would surely be included in this lineage are Horatio Greenough, Richard Redgrave, John Ruskin, William Morris, Louis Mumford, and Reyner Banham.

designates the symbolic aspects of the environment to prepare us for real actions." He sees the world as a text to be deciphered, and the graphic designer as one skilled in this interpretive process who provides a system of mediation to orient the individual. As with the "comprehensive guarantee" which Moles espouses for product maintenance, graphic design's primary aim is to help the individual or social actor fulfill his or her life project by facilitating action.

The environment as Moles sees it has two sides, a material one which comprises the physical objects of daily life, and "a side of signs" which consists of symbolic elements that represent things or actions. Together, these signs constitute an elaborate diagram from which we fashion "a sort of intelligible discourse." Moles is acutely aware that, in societies where information increasingly governs action, life "is lived more and more inside an ideographic world where we prepare our actions not with the objects themselves, but with the signs that designate them." It is this growing mediation of action by symbol systems that both Diani and Morgantini have noted as characteristic of intelligent objects and their concomitant work processes.

On the one hand, the extensive power that Moles envisions for the graphic designer raises questions. To what degree can the designer really be an intermediary between an environment with a set of fixed characteristics, and the social actor? Is graphic design really an objective process that can reliably translate such characteristics into messages for the benefit of the individual? On the other hand, we can observe a growing layer of mediating systems of signs such as computer software, instruction books, complicated regulations, bureaucratic forms, maps and diagrams, and other paraphernalia of a complex society. Here there is a clear need for professionals to help make this welter of signs intelligible.[43] And is it the *world* that is being made intelligible, or simply the systems of signs that increasingly substitute for it?

Robin Kinross is less sanguine than Moles about the objectivity of information. He questions the distinction that is usually made between design to inform and design to persuade. Using the example of a railroad timetable, he notes that: "As soon as the move from concept to visible manifestation is made, and especially to a manifestation as highly organized as a timetable, then the means used become rhetorical." Railroad timetables, he observes, which might be seen as purely informative, "are designed to say something persuasive about the nature of the organization that publishes them." In challenging the purported neutrality of the timetable, Kinross raises larger questions about the belief of modernist designers that communication is an objective process. He notes that after World War II, information theory became a central model for social and political modernists in order to assert that "human transactions might have the same order and essential simplicity as an electrical circuit."

43) Richard Saul Wurman reinforces this point in his article "Design for Understanding," *AIGA Journal of Graphic Design* 6, no. 2 (1988): 1, 16.

VICTOR MARGOLIN

Ultimately, Kinross is concerned that we not lose the awareness that all communication is ideologically grounded, even if it is transmitted in forms that purport to be free of ideology. The point he raises becomes particularly significant in light of the issues raised by Diani, for example, about the way in which new office technology changes the work process, and in light of the expectation of Moles that graphic designers can be trusted to make the world intelligible to the public.

Ellen Lupton, like Kinross, also challenges the modernist belief in objectivity. Her focus is on Isotype, the sign system which the Austrian philosopher and social scientist Otto Neurath began to develop in the 1920s. Lupton explains Neurath's belief that "pictorial signs would provide a universal bridge between symbolic, generic language and direct, empirical experience." She shows how his philosophical positivism supported his belief that experience could be codified in pictorial signs that would be valid across countries and cultures. Lupton sees a fallacy in Neurath's idea that vision is an autonomous faculty of perception which is outside of cultural and historical conditioning. Such an idea also suggests that there are certain modes of codifying experience which are more true than others. She sees Isotype as "the attempt to eclipse interpretation with perception, to replace reading with seeing."

The distinction between interpretation and perception is central to Lupton's critique of Isotype. She is, first, questioning its instrumentality by asking whether it is really universally valid. Then she challenges its rejection of multiple readings of experience. "In the spirit of interpretation," she says, "meaning is not an innate quality of forms or an automatic reaction of the brain; it is discovered by relating signs to one's own personal and cultural experience, and to other signs. . . . To interpret is to recognize that signs are not absolute, neutral, and fixed, but are, rather, in historic flux." This does not mean that all interpretation need be as individually conditioned as reader-response theorists claim, for most graphic communication is on a less complex level than an open-ended literary text. But Lupton raises the point that people have their own ways of understanding and that these must be taken into account if communication is to be effective.

Like Kinross, she rejects the mechanistic communication models of the modernists. She believes that history and culture create the context for all communication and she disavows "gestalt esthetics," which privileges geometric forms and theories of objective perceptual effects as the basis for design theory.[44] She does not believe that all interpretation is purely subjective and thus not able to be shared with others, but she wants to break down "the traditional distinctions between perception and interpretation, between objectivity and subjectivity." She is therefore not against pictorial codes, but disagrees with Neurath's positivist faith in the possibility of a uni-

[44] For an excellent critique of gestalt theories see Lupton's article, "The Mystique of the Visual Language," *AIGA Journal of Graphic Design* 5, no. 3 (1987): 9.

versal pictorial language that functions as an analog for human experience.

Frances Butler also opposes the graphic designer's isolation of visual perception as the primary mode of audience response. Designers continue to create abstract designs, she says, "despite demonstrations that it is the precise, unusual, and personally engaging phrase and image that is remembered whereas the abstract is either paraphrased or forgotten." Her critique of modernists and postmodernists alike derives from her perception that graphic design is unable to provide images that correspond to what she considers legitimate human feelings and concerns. "While designers devise abstract logos, patterned surfaces, and abstruse gestural symbolism and play about with variations on the geometries of the grid or indulge in quasi sadomasochistic punk complete with flying pieces of cooked meat and chained women, the graphic design audience looks to this, which is, in both its print and its video forms, its only really public imagery, for information on the components of personal identity and social life in the late twentieth century."

Butler believes we need to bring back lost qualities of communication from the oral culture that preceded our current, literate one. The image was once a powerful tool for evoking memory, for providing models of conduct, and for uniting communities in shared beliefs. It activated not only the perceptual apparatus of sight but a full sensory awareness that established "a connection with imagery wherein what is seen is what is real." In oral cultures there was no means of documenting information for recall, so that images had to serve as mnemonic devices, evoking memories of feelings and acts. For Butler, both modernist abstraction and the postmodernist separation of visual stimuli from lived experience limit the potential of public communication to transmit visual models of values and behavior.

Implicit in Butler's critique of graphic design training and practice is her feeling that designers tend to be more concerned with the production of visually stimulating images than with engaging an audience in reflecting on how to live. She rejects this obsession with stylistic avant-gardism and shifts the focus of designing to the production of more realistic images that can gain an audience's trust.

Butler's conviction that the power of visual communication declined in the shift from oral to literate culture is reinforced by Jack Williamson's history of the grid, whose meaning has radically changed from the medieval period to the present. Originally the grid was a commanding symbolic device that represented the interrelationship between spiritual forces and earthly life. As Williamson points out in his analysis of the fifteenth-century manuscript, *Très Belles Heures de Notre Dame*, the medieval grid "establishes a visual relationship between depicted objects and events, removed from one another in space and time but spiritually linked by God,

who acts behind outer historical events to bring about world redemption through Christ's incarnation, death, and resurrection." Renaissance thinkers and those who followed them rejected this symbolism and began to use the grid as a means of visualizing abstract relationships between points and lines. Williamson sees the grid thus coming to represent "the *process* of rational thinking itself." This was true for modernist graphic designers, especially Swiss designers of the postwar years such as Emil Ruder and Josef Müller-Brockmann, for whom the grid became a means to create orderly arrangements of typography and photographs on a page. Williamson also notes that for postmodernists in the 1970s, "the grid no longer acted as the invisible logic 'behind' the composition, but was often visually exposed and used as a subordinate decorative element." Even though the grid is a structural device, a means of ordering, and not a realistic image, its transformation from a symbolic structure to a design element marks a transition from a world that was formerly rich in shared symbolism to one in which signs are as likely to be empty vessels as carriers of meaning. Williamson makes it clear that the grid does not shape belief but instead embodies the values of the culture. He views the postmodern grid as an attempt to destroy "the field of the rational mind." It has now come to signify for him a disorientation, a detachment from the rational world. Such a reading thus reconnects design to the philosophical debate between modernists and postmodernists about the nature of reality. But the grid no longer has the symbolic power that it had in the medieval period, and the argument about its meaning is now a marginal one, confined essentially to designers who have turned their disagreements about it into an issue of style.

Hanno Ehses rejects the stylistic emphasis of many designers and focuses instead on rhetoric as the central issue in making design statements. As an antidote to the modernist model of communication as the objective transmission of a message from a sender to a receiver, Ehses believes that "all human communication is, in one way or another, infiltrated rhetorically," and that "design for visual or verbal communication cannot be exempt from that fact." Like Buchanan, who states that physical objects are rhetorical just as speech is, Ehses believes in the possibility of a rhetoric that can enhance visual communication, just as verbal rhetoric is used to make speech more effective. As a parallel to the vocabulary of abstract geometric forms favored by the modernists, Ehses turns to rhetorical figures such as irony, hyperbole, personification, and synecdoche, which can aid designers in creating visual concepts. "The essence of a rhetorical figure," he says, "is an artful departure from the ordinary and simple method of speaking." Its purpose is to amplify a message and give it greater impact. Whereas designers who used information theory as a model for visual communication in the past thought that objectivity was the aim of communication, Ehses

thinks that persuasion is at the heart of communication, and therefore that the aim of rhetoric is to "affect interaction in both a rational and emotional way."

However, he does not advocate rhetoric at the expense of semiotics, the theory that "explains the principles that underlie the structure of signs and their utilization within messages." Rhetoric, though, is "the art of persuasion" that "suggests ways to construct appropriate messages."[45] For Ehses, theory always has a pragmatic intent. He believes that communication can be more effective when designers transform their intuitive development of concepts for design projects into an articulate awareness of the processes and the means available to them.

Though Lupton and Butler do not write explicitly about rhetoric, they share Ehses's belief that effective communication must be addressed to an audience's responsive capacities. It is not so much universal signs and symbols that designers need to develop, but rather specific forms of address that can evoke responses from extremely diverse audiences. And Kinross argues that, in fact, there is no universal communication. Behind all messages, he says, is ideological intent. The value of rhetoric in transcending the limitations of modernist communication theory, which all of these authors seek to do, is in the recognition that no communication is objective. It is always uniquely motivated and contingent on a unique response.

This premise is also implicit in Clive Ashwin's attempt to articulate a theory of drawing, whose discourse, he says, "has remained in an unnecessarily primitive and undeveloped state compared with other fields such as law or medicine." Ashwin is particularly concerned with drawing for design–logotypes, illustration, diagrams, and other visual forms that have an informative as well as an expressive function. Semiotics, which distinguishes between kinds of signs and between various functions of communication, provides him with a mode of analysis with which to categorize types of drawing. Like Ehses, he employs theories that were originally developed to analyze verbal discourse. Ashwin recognizes the difficulty of applying linguistic concepts to drawings, but he demonstrates through his initial differentiation of drawing types that this can be fruitful. By making us more aware of how to analyze drawings, Ashwin helps us to understand their ideological and rhetorical intent. Referring to architectural renderings, for example, he says that such drawing "is, therefore, an *idealized* image appealing as much to the interpretant's sense of order and propriety as to the demand for a true visual account of how the completed building is likely to appear." Conversely, drawings with more intentional emotional appeal such as magazine illustrations may also transmit "some important piece of information or value that will influence attitudes and future action."

To summarize this section, we can say that, excepting Rams and

45) Ehses has written extensively on semiotics and rhetoric as grounding for graphic design training. See, for example, the following: "Semiotic Foundations of Typography," *Design Papers* 1 (Halifax: Nova Scotia College of Art and Design, 1976), "A Semiotic Approach to Communication Design," *Canadian Journal of Research in Semiotics* 4, no. 3 (Spring–Summer 1977): 51-77, "Rhetoric and Design," *Icographic* 2, no. 4 (March 1984): 4-6, "Design and Rhetoric: An Analysis of Theater Posters," *Design Papers* 4 (Halifax: Nova Scotia College of Art and Design, 1986), and "Rhetorical Handbook: an Illustrated Manual for Graphic Designers," *Design Papers* 5, ed. Ellen Lupton (Halifax: Nova Scotia College of Art and Design, 1988).

VICTOR MARGOLIN

Moles, the authors included are striving to conceptualize design as a more contingent and subjective process than the modernists envisioned. They do not see the goal of design as exclusively rational, but rather as the satisfaction of a broad range of human needs. These can be individual as well as social, emotional as well as instrumental, adversarial as well as consensual.

Writing Design History

Given the previously cited difficulty of defining "design," it is not surprising that design historians continue to be hampered by a limited conception of what it is. If we consider a broad definition of design such as Herbert Simon's "science of the artificial," we can imagine a history of design which has much more to do with engineering, planning, and computer science than what we now have. But an enlarged design history would also need to pay more attention to crafts and domestic objects produced in the home, if we heed Cheryl Buckley's feminist argument that: "To exclude craft from design history is, in effect to exclude from design history much of what women designed." Design history thus finds its dominant focus in the middle range of mass-produced objects, which locates it between high technology and handmade crafts. The two authors included in this section are well aware of design history's present limitations. As Clive Dilnot points out, those who first entered the field in the early 1970s–primarily art historians–wanted to keep design history "open and relativistic." They were thus reluctant to specify what should be studied, or to address the question of "what the role of this history might be." The result, Dilnot says, "is that design history, in the sense of a single, organized discipline with defined aims and objects, *does not exist*."

But even if historians were more eager to establish boundaries for the field, they would still confront the fact that design remains almost invisible, to a large extent because it has not, as Dilnot puts it, "pursued the historical, cultural, or philosophical-analytical study of itself." Certainly it is easier to construct a history of a field whose practitioners have long reflected on what they do than it is to write about something as inchoate as design, particularly since the term can potentially cover such a diverse range of activities. Consequently, no vision of design cuts across all these activities and makes relations between them possible.[46]

Nonetheless, Dilnot wants us to move in this direction. He seems to agree with Buchanan that design is an architectonic art that can "organize the efforts of other arts and crafts, giving order and purpose to production." Dilnot makes the salient point that design history's subject matter is much broader than what professional designers actually do. On the one hand, he thinks that past achievements of professional designers "pale by the side of the colossal vernacular design effort that built much of the world, at least, before

45) The field of material culture studies comes the closest to recognizing the plurality of design, but its own ideological and methodological biases have confined most research to pre-twentieth-century American topics.

the beginning of this century," but he also recognizes that "the age of vernacular designing is over," and we are forced "to accept design in its industrial sense." It is easy, he says, to become complacent by measuring success or failure according to professional standards rather than those of the larger society: "At the most extreme, a history of design in the industrial period that essentially celebrates the succession of 'name' designers and the rise of the design professions, but that carefully selects its images, eschews real critical comment."

Dilnot finds it essential to analyze how design works, how it achieves its effects, and how it represents ideological values. He believes that industrial capitalism has defined the practice of design. Design, he says, has become "the evidence of the complex ways in which both rulers and ruled have projected ideas about technology, progress, and, above all, ways of life into objects and environments." This is remarkably close to Buchanan's definition of design as a form of rhetorical argument, except that Buchanan sees the result of diverse design arguments as pluralism, while Dilnot emphasizes industrial capitalism as the matrix which sets the parameters for design activity. In fact, he regards design as the primary agent for casting capitalism's values in form.

Dilnot's concept of form, however, embodies much more than esthetics. He has little use for the connoisseur's approach to objects, believing that form should prompt questions about why we organize our material lives as we do. The better we understand the process by which values are transformed into material culture, the more we can consider alternative transformations. This is what makes the study of design important. "Without the grounding that only historical study can give," Dilnot argues, "prescriptions for design are incidental; they cannot be redeemed because they lack the necessary immersion in real historical complexity." The design historian can also give more credence to theory by embedding it in a historical process. This is an approach which can best combat the modernist tendency to mythologize theory into a metalanguage whose principles exist outside of historical determination.

Cheryl Buckley is also interested in the matrix that frames design activity. As a feminist, she sees this matrix as a patriarchy, which "has circumscribed women's opportunities to participate fully in all areas of society and, more specifically, in all sectors of design, through a variety of means–institutional, social, economic, psychological, and historical." Buckley claims that design historians have contributed to the dominance of patriarchy by not acknowledging it as a determining force in design practice. With some exceptions, they have placed greater value on the mass-produced objects that men have designed than on designs by women which have included much work done in the home, such as embroidering, weaving, and knitting. These activities, says Buckley, "allowed women an oppor-

tunity to express their creative and artistic skills outside of the male-dominated design profession."

She agrees with Dilnot that industrial capitalism is a matrix which shapes design practice, but she links capitalism to patriarchal values that have specifically confined women's role in designing. Like Dilnot she would most likely be in sharp disagreement with Buchanan, who states: "Hence, instead of regarding the history and current practice of design as the inevitable result of dialectical necessity based on economic conditions or technological advance, we may do well to regard the apparent confusion of our product culture as a pluralistic expression of diverse and often conflicting ideas and turn to a closer examination of the variety and implications of such ideas." For Buckley the "dialectical necessity" is patriarchy, which she wants to expose in order to liberate historians from stereotypical thinking about women as designers. She is not satisfied to simply call attention to "women worthies," historian Natalie Zeman Davis's term for women who are recognized for their achievements in a patriarchal culture; rather she calls for a radical rethinking of the way scholars construct historical categories. She opposes the dominant emphasis on professional designers, mostly male, as the primary agents of design activity, and concomitantly she contests the hierarchy that elevates mass-produced goods above crafts, that stresses the exchange-value of goods over their use-value, and that divides labor by sex, "which attributes to women certain design skills on the basis of biology."

Buckley also challenges the enormous influence that modernist design theory has had on design history, particularly criticizing its stress on innovation and experimentation as the most important features of design. She points out that historians rarely study design which is not innovative, meaning that design by women, "which often falls under the label of traditional, has been especially ignored." Buckley's feminist critique of modernism is central to a revision of history writing since it is grounded in a fundamental rethinking of the social relations between men and women. Feminist theory must therefore also play a significant role in the debates about postindustrial society and postmodernism which are shaping the way we think about the past as well as the present and future. Through a better understanding of gender and how it has influenced the patterns of social life, we can more effectively reexamine the models of production and communication that have dominated modernist design thinking.

Design history is still too new a field to have engendered critical debate about its practices as extensively as, for example, art history and literature have.[47] But Dilnot and Buckley have helped to launch this debate by demanding a methodology that recognizes design as the material embodiment of social and economic values. Both authors resist the focus on great designers and designs that has heavily

[47]) Probably the earliest articles to identify critical issues in design history can be found in *Block*, the cultural journal published at Middlesex Polytechnic in England. See Fran Hannah and Tim Putnam, "Taking Stock in Design History," *Block* 3 (1980): 24-25, 30-34; Tony Fry, "Design History: A Debate?" *Block* 5 (1981): 14-18, and "Cultural Politics, Design and Representation," *Block* 9 (1983): 40-49. See also Judy Attfield, "Feminist Designs on Design History," *FAN* 2, no. 3 (December 1985): 21-23.

influenced design history writing, and they confront the marginality of this approach by linking design to issues of economics, power relations, and social ideology.

Conclusion

As Dilnot and Buckley have clearly stated, design is more than a practice that professionals engage in; it is a fundamental human activity that is conducted in many varied ways. Design is as much an expression of feeling as an articulation of reason; it is an art as well as a science, a process and a product, an assertion of disorder and a display of order. By learning to look insightfully at the array of designed objects, services, and techniques in society we can begin to recognize the manifestations of social values and policies. In design we can see the representation of arguments about how life ought to be lived. Design is the result of choices. Who makes those choices and why? What views of the world underlie them and in what ways do designers expect a worldview to be manifest in their work?

The authors in this anthology engage the subject of design in a number of ways. Some relate it to current debates about social and cultural transformation, while others suggest ways that critical theories from various disciplines can contribute to a discourse about what design is and how we can interpret it. The work of all these authors provides ample evidence of the broad range of aspirations, opinions, and analytic strategies that design discourse can include. They are contributing to a new discipline of design studies and are beginning to map a terrain that many others will traverse in the years to come.

After The Modernists

Maurizio Vitta

The Meaning of Design

What is the meaning of design today? On what cultural expecta-
tions is the cultural identity of this discipline still trying to define
itself with adequate conviction, based? These questions, in them-
selves legitimate, have by this time become unavoidable if for no
other reason than the increasing importance design is assuming in
our society. It is therefore worth the trouble to confront them and
at least try to hypothesize some kind of answer, if only in the most
general fashion.

When design is discussed in Italy, the slightly vague but far from
insubstantial concept of *the culture of design* is evoked. This
phrase is meant to suggest the totality of disciplines, phenomena,
knowledge, analytical instruments, and philosophies that the
design of useful objects must take into account, inasmuch as those
objects are produced, distributed, and used in the context of
economic and social models that are ever more complicated and
elusive. A general theory of "the culture of design" does not yet
exist. But it is discussed so much because a need for it is felt and
because designers today are called upon to face problems that, in
practice, involve cultural questions that are rather broad and
remote from the traditional scope of design. On the other hand, it
would be very difficult, if not downright misleading, to build the
hypothesis of a theory of design without comparing it with a cor-
responding and mirror-image theory of the object that considers
the purpose of designed, produced, and distributed objects from
the point that they are consumed, owned, and used. And because
our civilization is made up of material things, without which it
would not even exist, to assume that in the comparison of those
two theories – which are related like the two faces of the same coin
– many more abundant and significant consequences could arise
than might be imagined does not seem unreasonable.

Use-objects and their consumption are being examined with
ever greater insistence, given the enormous importance they have
assumed in daily existence. But the attempts to define their cul-
tural position and to establish what is or should be their relation to
human beings have made evident the abstract, almost surrealistic
character that material objects, multiplied by industrial produc-
tion and spread through the capillary system of mass consumption

31

have taken. In their book *The World of Goods*, anthropologist Mary Douglas and economist Baron Isherwood offer an approach to what is defined as the "anthropology of consumption." The authors maintain that one must begin by considering consumption "as an integral part of the same social system which explains the urge to work, which in its turn is a component of the social need to enter into relations with others and to have available communication materials which allow relations with others to take place." From this point of view, goods (including objects) are communication instruments, "communication signs, as much as the invisible part of the iceberg which is the global social process."[1] Until now, economic theory has explained consumption through the theory of the satisfaction of needs, or else, after Veblen, through the theory of envy and ostentation. But Douglas and Isherwood negate the possibility of understanding the phenomenon in all of its complexity while limiting motivations to survival on the one hand and to competitive ostentation on the other. In their opinion, "all material goods are endowed with social significance" and allow the individual to make contact with his or her own culture, to express it in rational categories.

Not taken into consideration in *The World of Goods* is the work of Jean Baudrillard, the French sociologist who for years has been studying the phenomena of the production, consumption, and use of objects. This omission is strange if one acknowledges that Baudrillard has confronted the problem by vigorously underlining the role played by *images*, that is, by signs and communication instruments. Objects have definitely taken on such a role by this time. His point of departure is the "fantastic evidence of consumption and abundance, constituted by the multiplication of objects, services, and material goods," whose logic – which is social logic – is not that of the individual appropriation of the use-value of objects, but, on the contrary, that of the production and manipulation of social meanings. Hence, the process of consumption is "the process of significations and communications," which immediately implies a "process of classifications and of social differentiations." According to Baudrillard, objects, multiplying beyond measure, have lost all of their functional identity and are transformed into *simulacra* of themselves. These are reduced to empty forms, deprived of their original meaning. They become mere informative instruments that consitute the language through which the social mechanism that produces them is expressed. Even more, the situation has reached a point – thanks also to the pressure of advertising, which is a primary factor in this mechanism – such that it is not the image of the consumed object that predominates, but that of the consuming subject.[2] As Mario Perniola writes, the demand of consumers in effect is turned more and more toward the image of themselves as presented by advertising; thus the object, deprived of its functional justification and having

1) Mary Douglas and Baron Isherwood, *The World of Goods* (New York: Basic Books, 1979).

2) See especially Jean Baudrillard, *Le Système des Objets* (Paris: Gallimard, 1966) and *La Société de Consommation: Ses Mythes, Ses Structures* (Paris: Gallimard, 1974). Baudrillard has continued to occupy himself with the problem in more recent texts also. For an analysis of the object as a system of communication, see *Communications* no. 13 (1969), which is dedicated entirely to that argument.

MAURIZIO VITTA

become a *simulacrum* of itself, ends by transferring its own image onto the individual who consumes it and who, at that moment, becomes completely identified with the manner in which it is consumed.[3]

As can be seen, these analyses start with different assumptions and conclude with different assessments. Douglas and Isherwood tend to accept the state of affairs; Baudrillard and Perniola emphasize the phenomenon's negative character. But the model for the production and consumption of objects presented by these authors remains substantially the same. The entire process appears transformed into a vertiginous merry-go-round in which the traditional sociological and economic pairs – subject/object, use-value/exchange-value, form/function – get confused and lost. All that emerges is the object's social value defined by the nature of the present profit-based system, measurable by fairly uncertain parameters, such as prestige, price, name, trademark, or, more often, gadget character (a three-speed electric razor, for example, or a television with an electronic clock). Furthermore, the fact that such elements form a sign system through which society expresses its own significations "to make cultural categories visible and stable," as Douglas and Isherwood write, does not diminish the alienating effect of this process. The result, nevertheless, remains the loss of identity for the individual who is submerged on one side in an avalanche of goods whose continual exchange becomes obsessive; on the other side, he or she is constrained to use these goods not for their functionality but as images of himself or herself to be projected toward the outside world as the sole contact with others.

That transformation of the use-object, into a kind of phantasm whose existence is nothing but a psychological projection of social relations ever more estranged from their original reality, is not at all new. The first symptoms of it can be traced back to the polemics about extravagance that raged in Europe during the eighteenth century; and Karl Marx denounced this transformation in its realistic terms when, talking about the "fetishistic character of commodities," he averred in *Das Kapital* that "that which for men takes on the phantasmagorical form of a relation between things is only the already determined social relations which exist between the same men."[4] Similar consciousness, however, appears very diffuse among European intellectuals of the nineteenth and twentieth centuries. They were disconcerted by the ever more *féerique*[5] character taken on by objects in Universal Expositions, beginning with the London Exposition of 1851, and were above all distrustful of the "massification" of existence produced by the American-developed concept of a mass market. "Today forcefully coming out of America are indifferent things, the appearance of things, the semblance of life . . ." wrote Rainer Maria Rilke in a letter to Witold von Hulewicz. Freud, for his part, in *Civilization and Its*

3) Mario Perniola, *La Società dei Simulacri* (Bologna: Cappelli, 1983).

4) Karl Marx, *Das Kapital* book 1, chapter 1.

5) The *Guide* to the Paris Exposition of 1867 contains the statement, "Il veut contempler un coup d'oeil féerique et non pas des produits similaires et uniformement groupes."

Discontents, compared modern man to a type of "Prosthesis God," equipped with innumerable artificial accessories that, however, "are not part of him and which from time to time give him a lot of trouble." And even the Italian futurists, though they exalted the machine and the artificial object, did not fail to notice the vaguely spectral nature of the objects surrounding them, which, in an enigmatic and disquieting manner, reproduce our social and affective relationships. In *Vengono: Dramma di Oggetti (They are Coming: A Play of Objects)*, F.T. Marinetti spoke of the "strange fantastic life" and of the "mysterious suggestions" of certain pieces of furniture, placing on the stage only eight chairs, an armchair, and a table.

All of those reflections about objects have obvious and direct connections with the practice and the theory of design. In a world dominated by things – the abstract images of which have the specific task of expressing the reality of social relationships, in more or less intelligible terms – the function of designers becomes contradictory. On the one hand, indeed, in a reflected manner, they enjoy the same central role as that of the objects they design; on the other hand, their cultural character, although endowed with great prestige today, runs the risk of taking on the fragility and flimsiness of designed objects themselves. That explains the tendency toward the transformation of the traditional designer-creator, who often only survives as a purely spectacular image, into a coordinator of a series of activities that result in the design but that go from production to distribution, marketing, and so forth. Italian design already counts various examples of that type, and there might be many more if fashion designers were also included in that category.[6] But remaining within the usual scope of design, the designer's centrality is confirmed because the *consumption* of the use-object requires that it be continually transformed while it remains faithful in its substance to its original function; and the task of expressing the cultural, esthetic, or semiological values that interact behind that transformation is the designer's specific duty. It is at this precise point that the idea, though still vague, appears of that "culture of design," which should make it possible to face the problems involved in designing today. If the questions raised by the predominance of objects in our society have forced the most varied disciplines to interrogate themselves and to supply still largely sectorial answers, the same need is reflected in the designing moment that precedes their production. And if the latter need were satisfied, design would become a crossing and a diffusion point of the most diverse fields, that is, a sort of frontier discipline, dynamic and adventuresome, in which the small and the grand strategies of intervention in and transformation of everyday life would be incessantly verified, assimilated, or rendered superfluous.

It is at this point, however, that it is necessary to settle accounts

6) See *E'Design* (Florence: Alinari, 1983). This is the catalog of the exhibition held in Milan under the direction of Anty Pansera the same year.

MAURIZIO VITTA

with the nature of the *simulacrum* or sign that the object by this time has taken over in society. And here is the other pole of design's contradiction. The role that the designer shares with the object, in addition to its centrality, is also illusory, so that the same threat of disillusion and of rapid consumption hangs over him as well. If the object is nothing but image, its design will be an image-design; and if the image is ephemeral, bound to the present, pure "form of the goods," design will be abstract, obsessed with fashion, "made merchandise." Thus, at the very moment when the sphere of the designer's intervention is taking shape, and is delineated in all of its complexity, his or her role runs the danger of fading into an ambiguous mist in which it may even be reduced to a mere signature placed on the products. In that case, it is the image of the designer that will be *consumed*, and his or her cultural character will vanish, along with the use-function of the object.

That contradiction of course reveals a tendency, not an irreversible situation. Furthermore, its nature is more social than cultural, and it results from the knot of economic interests that closes around the production of use-objects. Nevertheless, it is always insidiously present in the exercise of design, and it seems to show a temporary weakening only in those cases in which the object to be designed is requested by public bodies and therefore openly declares its own collective usefulness. On the other hand, it does not seem that attempts to escape the market's logic, such as those advanced as hypotheses in Italy during the past years, have been very useful.[7] The fate of these attempts has been more or less identical with that of similar experiments carried out for the same reasons in the field of art; the transformation of products into merchandise has equally taken place at an even higher level, as has happened, for example, with conceptual art, arte povera, earth art, and so forth.

The characteristic aspect of design to emerge from such an analysis seems to be marked by a fertile incoherence, by a precarious *coincidentia oppositorum* that continually reveals its greatness and its weakness. And why should it not be so? If the *culture of design* is meant to explain the *culture of the object*, it must of necessity share the object's fate. And, as the object in our system is at the same time a sign of social identification, a communication instrument, a use-image, an oppressive *simulacrum*, a fetish, and a tool, design cannot help but be an instrument of social analysis, an area of intervention in everyday life, a language, a fashion, a theory of form, a show, a fetishism, a merchandise. Both its strength and its weakness lie in its being at the same time a crucial point in the social development of daily life and a marginal aspect of production, a source of culture, and a confirmation of the prevailing values. For the present, nothing can be done but to remain perfectly aware of that contradiction, even though it is a "painful awareness" (and here the Hegelian term seems rather appropriate).

7) See Andrea Branzi, *La Casa Calda: Esperienze del Nuovo Design Italiano* (Milan: Idea Libri, 1984). This book was translated into English as *The Hot House: Italian New Wave Design* (Cambridge, MA: MIT Press, 1984). These attempts included a return to spontaneous design or to mass creativity, removing design from the contamination of the merchandising of products in a kind of "design for design's sake," and unveiling the banality of the use-object, which is rendered macroscopic and paradoxical.

To solve that contradiction completely is certainly beyond the scope of design and of culture in general. As William Morris already perceived, social change alone makes possible a different and more balanced relationship with things. But each cultural system indeed puts itself into a dialectical relationship with the society that has expressed it; design is no exception to the rule. In fact, its nature as a discipline closely related to daily life confers on it an authoritativeness that other fields of knowledge lack. That increases the social responsibility of the designers, but, at the same time, it establishes their cultural legitimacy on more solid bases than was previously thought. And that is probably the consideration from which to start when reflecting purposefully on the meaning of design.

Translated from the Italian by Juliette Nelles

Andrea Branzi

We Are the Primitives

This article was originally published in Italian in *Modo,* June 1985.

We are the primitives in two ways at least: analogically and linguistically. We are analogically primitive because our condition is that of those who, having fallen from an airplane into the middle of the Amazon territory, find themselves operating with technologically advanced elements still on board, as well as with natural materials of the forest. The ideological parachute no longer works, and the transformations we accomplish in that jungle are meant to realize an accelerated renewal circuit rather than a design for global progress.

Culture and design no longer are forces that slowly but heroically move the world toward salvation through logical and ethical radicalism. They are mechanisms of emotions and adaptations of changes that fail to drag the world toward a horizon; they only transform it into many diffuse diversities. Progress no longer seems to be valued; instead, the unexpected is valued. The grand unitarian theorems no longer exist, nor do the leading models of the rational theologies. What exists is a modernity without illuminism. We are witnessing a definitive and extreme secularization of design, within which design represents itself and no longer is a metaphor for a possible unity of technologies and languages.

Human nature and the artificial nature of mechanisms, information, and the metropolis cohabit in sensorial identification, just as the Indian who identifies with the forest. That neoprimitive condition is not a design in the sense that it does not wish to be the latest trend of avant-garde fashions; but it is precisely a condition into which various languages and already diffuse attitudes fuse. To perceive that condition helps move postmodernism out of reactionary equivocations and, probably, gives greater freedom and awareness to our mode of designing. The communication of the primitive, indeed, achieves its maximum efficiency inside a closed system: It operates by archetypes and myths, working inside a circuit of users capable of perceiving its metaphorical keys and subject to its specific energy. Outside those conditions, the culture of the primitive is nothing but a formal repertory that currently is heeded and used by a large number of operators, artists, and designers.

A password has not yet become effective, and already we detect the symptoms of a great attention paid to neoprimitive languages,

to the extent that we have had to make a selection among the many possible examples of that latent condition. There also exists, therefore, a so-called neoprimitive linguistic fashion that pays great attention to languages, to anatomical aspects and artifacts of primitive men, to African ethnic groups, to technological animism, and to primitive ethic. This fact coincides with a need of both users and designers. The first sees stable signs, powerful but liberating, in the neoprimitive style. Designers are seeking the original key to their own identities, the building code of their own languages, setting themselves up as possible tribal heads.

The design panorama that awaits us in that extreme secularization of design consists of an ensemble of linguistic families grouped around ever more numerous family heads who will assemble around their own expressive minor archetypes and aggressive followers. That tribalization of cultural society is at once a result of the neoprimitive condition and awaiting the fall of the old cultural tinsels in front of a new and different civilization. Similar to the good savage, we are naked while awaiting the worse or the better.

"The last things which can be done always are endless," (Joseph Conrad). The 1980s. Complexity, real and theoretical, is spreading. Lacking in the postindustrial society is that unified symbolic

From the series "Animali Domestici," by Andrea Branzi.

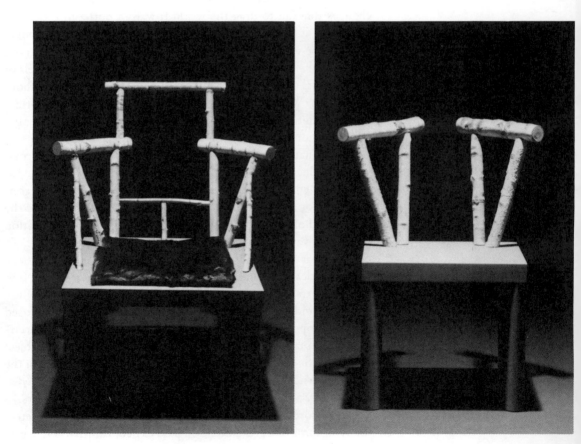

ANDREA BRANZI

universe capable of integrating various institutional environments and the individuals in them. Symbolic worlds proliferate and become differentiated. The very process that multiplies the codes and the symbolic resources of the individual, and that weakens the integrity and the plausibility of that person's familiar world, also enormously widens the field of various possibilities perceived by individuals.

The range of choices becomes wider and more fluid. There occurs not only the disintegration of the strong type of identity, but also the development of a new weak identity, which is flexible, open to change, intimately differentiated, and reflexive. The weak identity considers every choice as temporary and reversible and becomes the object of "different biographies," at the border, but only at the border, of pathological dissociation.

Simultaneously, an extremely refined and receptive new sensitivity makes its way in. It is based on a kind of zero-degree rational thought and a new definition and interpretation of magic. That is what we could define as neoprimitivism and, even better, using an aberrant neologism, as ultimatism. The recovery of magic, of ritual, of the mysterious (even though in a certain sense secularized) derives indeed from an extreme and last condition that significantly opposes itself to the originating condition of the primitive. The complete fullness (religious) of the latter is made vain by the complete vacuum (ethical and philosophical) of the postmodern condition.

It is the disintegration of the legitimatizing Great Tales that brings us back to a common ground on which there is played the new (and as old as the world) game of identity. In the swollen hyperspace of the postmodern, it is possible to reach numerous opposite poles: from the ironic lightness of detachment to the appealing involvement with the archetype, with the ancestral form, with the totemized object.

Complexity may also lead (as the last shore or as the first of the last solutions) to the mystery and the alchemy of encounters, to the uncontrolled and uncontrollable truth of the chance god.

In a word, it is the advent of magic as the first of the last possibilities, as a dimension to be completely relived and reinterpreted, and that may arise from our relation with ourselves and with others, objects, and the world. This magic is closer to the inexpressible individual sphere than to its collective rationalization (as in primitive societies). Within that dimension, an essential part is played by the rediscovered centrality of the body. During the 1980s, indeed, the body invaded social experience. Love for one's body grows exponentially, and interest in one's physical well-being increases. The neoprimitive body, a new magic object, is a phenomenon resulting from an emancipation process that plants its own roots into the innovative ferments of the 1970s.

The past of our societies is marked by a principle of transcen-

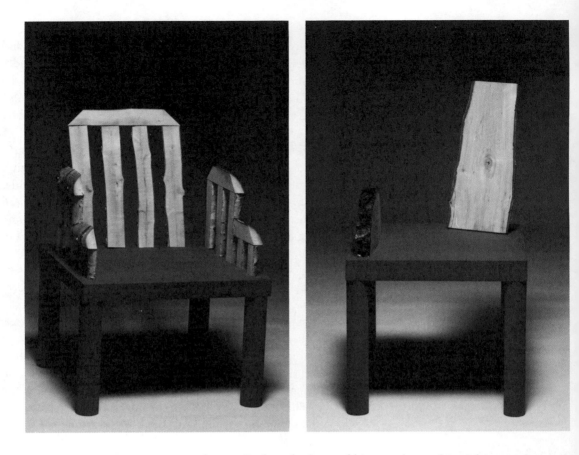

From the series "Animali
Domestici," by Andrea Branzi.

dence, God or the laws of history, located in either case beyond
daily social relations. In the face of that principle, the body could
not but be lived as a limit, as the product of a fall, as a degraded
nature to be opposed to the spirit.

Toward the end of the 1970s, with the failure of global horizons
and designs, a new turn occurred in connection with our bodies.
In today's history, having abandoned the hope of improving life
and the world in a complex manner, we are becoming convinced
that the important thing is to better our own psychophysical con-
dition.

The body becomes one of the constructive elements of identity,
which escapes the uncertainty and the fragmentation of the con-
temporary universe. In addition, the crisis in the relations of social
and secular integration of identity implies the increased impor-
tance of the body, that is, of the spatial perception of oneself, as if
the certainty regarding our being here were to be reinforced by a
body that is healthy, protected, and cared for.

And through the body the tendency to a new ritualism starts.
The ritualism is a sort of neoprimitivism in which it becomes sur-
face to be decorated, a symbolic point of communication, an
object to be cared for, a pretext for small but fundamental daily
rites, and an instrument of seduction for ourselves even before
being so for others. This new way in which the body is lived

ANDREA BRANZI

directly involves the problem of dress as representation of self, within a precise image culture.

The look-generation, as an extreme case, passing from one disguise to the other, offers a conception of the body as a surface, as a representation, as an image, as a language to interpret through the continuous multiplication/subtraction/superposition of signs and signals that, in some cases, leads to neotribalization, the notorious subcultures of the young. In a more general manner, fashion becomes a magic dimension that we follow to reinforce our own identity and by which we remain bewitched.

The body thus becomes the central point of expression of that emerging phenomenon defined as neoprimitivism, and that, in reality, represents one of the extreme poles of the postmodern condition.

Translated from the Italian by Juliette Nelles

Maurizio Morgantini

Man Confronted
by the
Third Technological Generation

This article was originally published in *Interni* 329, April 1983.

Immersed as we are in an artificial landscape, sickened by excessive abstraction, we find ourselves surrounded by an historical hoard of objects with which we entertain various and often ambiguous relationships. An elementary school teacher once said to me that, although the bear has always been endowed with claws — a natural weapon of defense as well as offense — man had to invent and build these weapons for himself: thus we have the knife with all its heterogeneous ancestors and great-grandchildren. One may therefore consider objects as functional extensions of man which can be cataloged into three different generations: prostheses of the limbs, of the senses, and of the mind.

For many centuries, or millennia, man has been making prostheses of the limbs, such as knives, spades, bows and arrows, shelter and clothing, buildings for defense in general, machines for writing, automobiles, and aeromobiles; he therefore cuts more easily, digs, sews, changes places more rapidly and kills from afar.

In the course of the past century, man has realized objects belonging to the second generation: prostheses of the senses. Helped by a more sophisticated technology, he has built telephones, television sets, and machines to reproduce images and sounds, thus giving substance to very hidden dreams.

The third generation of objects, the most recent and disquieting, marks the still nebulous and equivocal encounter between human and silicon intelligence. Confronted by objects that are an extension of mental faculties derived from the spreading application of electronic technology, design has found itself faced with problems that have substantially upset its methodology: designing is no longer a question of concealing mechanisms, wires, and valves or of troubling itself to make one object look like another. Designing has become, instead, an ambiguous celebration of a broad technological effect that places the functional power of the machines and the reduction of their physical dimensions side by side.

Therefore, a certain kind of design has found itself in difficulty. Sick of protagonism, assisted by supporting sciences and pseudo-sciences, it has been incapable of metabolizing electronics and processes of miniaturization and therefore, of overcoming its

Fig. 1) Direct rapport between man and machine; (photo by Arkadij Sajecht, 1931)

43

Fig. 2) Prototype of a unified telephone designed for Sit Simens by Maurizio Morgantini and Luciano Pirovano.

traditional sphere of action. It has also been unable to overcome the climate of suspicion generated by many objects (such as calculators, keyboards, and plasma television sets which are by now devoid of thickness) that are progressively losing their atavistic three-dimensionality or even their own body. Electronics, with the enormous possibility of feeding on itself, has modified objects, functions, forms, and project and building techniques, as well as changed the relationship between us and the objects. Prostheses are no longer directly activated but, instead, are interfaced by artificial intelligence in a way that is both simple and obtusely infallible: the oven regulates itself according to the food being cooked, the vacuum cleaner travels by itself the whole length of the house, the landing gear pops out of the airplane's belly at the optimum moment of the landing maneuver.

Who can forget the classic submarine hero of naval battles in American movies? With his T-shirt spotted with grease and his skin shining with sweat and at the order of "rapid immersion," he would turn the fly-wheels, which were directly connected to the valves regulating the intake of the water: he would carry out a direct mechanical relationship with the objects. Today that very same sailor would be dealing with small levers or buttons requiring the lightest touch: between the action and the effect, various interfaces, which have become stratified, are used to amplify signals, activate servomotors, initiate autodiagnostic processes, and link an event with other surrounding events.

Man is no longer surrounded by objects to be moved, but rather surfaces to be tactilely grazed, and, therefore, by events that are provoked by simple actions and are to be observed in their development. In many cases the keyboards have already been superseded by acoustical sensors that allow man to impart orders

Fig. 3) Time machine: "agitated" clock designed by Daniel Weil and presented in the 1982 Memphis collection.

MAURIZIO MORGANTINI

to the machines by voice. Such events correspond to the re-establishment of a different relationship to the assembled fragments of the artificial landscape; this relationship may be contemplative, esthetic, self-gratifying, or baroque. The modern astronaut will probably look like Ludwig in that he will not have manual or tactile contact with the objects around him, but he will contemplate them, and his ship will be more similar to the Nautilus of Jules Verne than to the spaceship of "Alien," with that touch of class conferred by the paradoxical presence of the pendulum clock.

At any rate, prognosticating the perceptible reduction of objects to zero is no longer the issue, nor is it that design will be deprived of objects to be given form. A chapter of design's history is simply coming to a close. In the last analysis, this ending is rather recent and circumstantial: design, understood as a more or less mediated and filtered functional expression, is a 19th-century heritage that has lasted until the present with the complicity of an esthetic terrorism and with a planned moralism already destined to succumb.

Fig. 4) Prostheses of the limbs: a series of knives for cutting, skinning and engraving; (photo by Ezio Frea.)

How can one then explain the most recent tendencies, which are so distant from the "future" prefigured in the last decades? The men of the last century, those conscious of being at the threshold of a future populated by machines, accomplished an encyclopedic recovery of the past: *neoclassic* has therefore been an ultrafine flour of positivistic flavor. We men of the present at the dawn of the computer era have been sucked up by a future that generates only apparent throbbings toward the past and instead tend to recover whatever may be filtered from the dream, singling out the myth beyond whatever has been built. For these reasons, dreamy and dreamt-up objects are proliferating around us. They poetically reaffirm the automony of our intelligence from the artificial one which, not by chance, we have worked to remove from our own body. The violent emotion we experience every time we look at the pyramids, those terrestrial symbols of mystery, is due perhaps in part to our hope that they might be truly useless, truly

Fig. 5) Prostheses of the mind: pocket calculator, Canon.

Fig. 6) Upside-down pyramid: the missing part of the sand-glass (from "Didactic Monuments" by Maurizio Morgantini and Charlie Botteghi).

great, beautiful, magical, or dreamy precisely because they have no practical function.

Beyond the useful and the useless, design is intuiting a more evolved dimension sublimated by the artificial landscape, well beyond the narrow confines of a planned territory tied too much to design and the procedural limits of the designable, which is only a part of what can be planned. For a long time, the environment has been understood as a motionless abstraction far from life and its rhythms. To plan a biotronic environment, it will be necessary to consider factors over and beyond objects, light, air, and sounds — self-regulating, dynamic elements in harmony with man who lives in that environment; to plan environments and objects for the man of the present, involved as he is with a technology in rapid and irregular development, will have to mean, moreover, the beginning of a different relationship with chaos which is moralistically and stubbornly being kept outside the door. For the desks overloaded with objects and kitchens crammed with optionals, the concept of flexibility and modularity no longer suffices and the mesh of nothing but an abstraction, a pretext for dominion over the postproject, inadequate and too narrow. Chaos, kept until

Fig. 7) The objects lose their atavistic three-dimensionality: structure and mechanical parts of Divisumma 24, design by Marcello Nizzoli for Olivetti, 1956

MAURIZIO MORGANTINI

Fig. 8) . . . or even lose their own body: "a nebulous informatic object," by Alessandro Mendini, published in *Ufficiostile* n.4., 1982.

Fig. 9) Integral project of editorial offices TGI and TG2, of RAI (Radio-televisione Italiana), production by Morgantini Associates. The spatial organization of the editorial offices foresees the coexistence of "collective" tables (active terminals for various usages) together with integrated machines for the exploration of taped memories and the simultaneous communication with other centers of information. The "telematica" (control room - sets of monitors) allows a modality of work physically independent of coexistence in the same space: the office is then justified by the creative work of the group (brain storming) and by the decision-making dialectic of the inflow and outflow of information.

now outside the door, has however, always re-entered the house through the window and could really become a fundamental element of the project. That recent and diffused design, populated by relics of the future induced by technology (hi-fi sets and microwave ovens) and pregnant with restrictive frustrations derived from the imposition of mass production, is abdicating in favor of projects replanned from the roots up. Not by chance does the robotization of production plants mark the surmounting of "stamping" and introduce the variability of mass production, thus bringing about the possibility of overcoming the concept of mass production itself. As the possibilities and technological supports rise little by little in order to realize utopia, doubts also rise: for which utopia? Rather than the choice of a utopia, electronics and artificial intelligence will be able to bestow upon us the utopia of choice: "CHOICE" is that little word that, seen in the mirror — the real image — is always CHOICE.

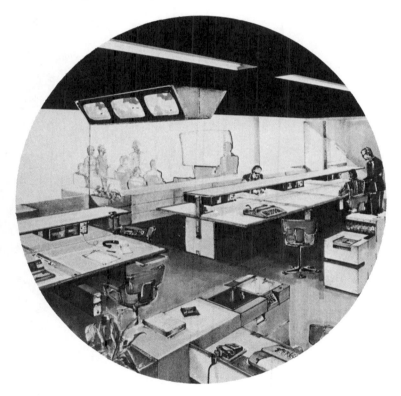

The possibility of turning the pyramids upside down requires the autonomous intelligence of equilibrium because the equilibrium will be variable, dynamic rather than static. Metaphorically and otherwise, we will be able to turn the pyramid upside down, an operation beyond the useful and the useless, which will permit Tom Robbins to write yet another book, Fiorella to telephone me, and the designers to invent a new, artificial landscape.

Translated from the Italian by Anthony C. Mastrobuono

François Burkhardt

Tendencies of
German Design Theories in the
Past Fifteen Years

This talk was originally given at the conference "Design im Wandel" ("Design in Change"), held at the International Design Center, Berlin, in 1984. The German version, which was published in the conference proceedings and retained the author's colloquialisms, was prepared for publication by Hans Ulrich Reck.

Design and the theory of design have a strong tradition in Germany. A debate about objectivity occurred around 1900, and between 1922 and 1927, another debate about functionalism had an especially strong influence abroad. During the Third Reich, the *social theory of design* and *biotechnology* were discussed. And then the Hochschule für Gestaltung in Ulm made a great contribution to the scientific basis of design theory between 1955 and 1968. Although Germany was once a leader in the theory of design, nothing is left of its former role in this area.

Since 1970, the positive traditions of grappling with design theory have been set aside and a total separation of theory and practice has prevailed. This is particularly astonishing when the Bauhaus concepts are considered. The explanation for this state of affairs is certainly due in part to specialization and the division of work. Business practice has led to a subdividing of design into specific fields: graphic design, textile design, product design, and so forth, but an integral theory of design has failed to develop and there lies the cultural loss. Through the scientizing of design, the theory of design has retreated into a very few institutions. Yet even in the design schools, design theory is no longer viewed as a theory of culture. A further specialization has been at the expense of research.

The attempts of various design institutes, such as the International Design Center (IDZ), Berlin, to publicize new tendencies ran aground from indifference. The tendencies met with interest, to be sure, as theory with special accents. But one never had the impression that the economy would seriously try to come to terms with a theory of design. In the Federal Republic of Germany, as in the German Democratic Republic, the drift has been toward a monoculture in which theory as a critical difference, as a process for developing and selecting alternatives, has no place.

Business and design base their theoretical contents on a tradition of expediency. German design has its roots in the "enlightenment" aims of rationalism, on which science and the economy are based. The unbounded optimism of this manner of thinking underpins the notion that no problems are unsolvable and that solutions can be found through reason, logic, and systematics. Reason

49

supposedly works in the interest of common social progress.

The strength of German design lay in the unity of positivistic science and quantifiable production. The fact that positivistic science did not worry about the ethical, anthropological, and social consequences of its research brought on the reproach that it gave up the claim to wholeness and left only a distorted picture of a dismembered world. Not until the 1968 student revolts, which placed in question economic development as a quantitative end in itself, was space created for a steadily renewed design critique, which also engendered a theory – without much influence on practice. At that time, forces putting another relationship between humans and products at the center of their deliberations developed.

After the closing of the Hochschule für Gestaltung in Ulm, the Institute for Environmental Planning (Institut für Umweltplanung) did much to research and present consumer interests. The International Design Center, Berlin, attacked the problem of exploiting the difference between the given and the not-yet-present. New approaches were also developed by the Hochschule für Gestaltung in Offenbach.

Unconventional thinking, intellectual mobility, and the overall view of the designer – an essential point, incidentally, of the Ulm program – were lost the moment the design schools established specialized departments. The design departures and the analyses of design processes became more and more schematic. The structural models and the planning technocracy that dominated the architecture of the 1970s fixed the course of planning methods at the cost of grasping problems in their entirety. The new approaches to design theory in the Federal Republic of Germany during the past 15 years should be reviewed against this background.

Wolfgang Fritz Haug's *Kritik der Warenästhetik (Critique of Commodity Aesthetics)* of 1970 reflected the political situation of the Left and the criticism of consumer society. "Commodity esthetics" denotes the functional relationship between humans and products given by the industrial capitalist production and the reality domain of the product as merchandise. Behind the theories of Fritz Haug stood his political interest in finding a radical path to the representation of consumer interests.

In 1972, there appeared Bazon Brock's *Theorie des Sozio-Design (Theory of Socio-Design)*, another work primarily on design theory that proceeded from the social behavior of groups. Brock said that the material components of our living environment have a considerable influence on our behavior. He asked: Of what nature must the material constituents of our environment be so that we can develop desirable forms of life? Theoretically, therewith the relation of style and social behavior is moved into the center.

And Victor Papanek has been developing and publishing *Design*

FRANÇOIS BURKHARDT

1) Papanek's ideas were first published in book form as *Design for the Real World: Human Ecology and Social Change* (New York: Pantheon, 1972). A revised edition appeared in 1985 (Chicago: Academy Editions, 1985). Ed. note.

systeme für die dritte Welt (*Design Systems for the Third World*), since 1972.[1] Papanek placed design methods *per se* in question and took the part of socially marginal groups. He said clearly that he was not interested in design or design theory. Papanek has pleaded for the comprehensive use of technologies in design and developed concepts that he deliberately did not want to defend but to propagate as supports for the users' "do-it-yourself." His reflections were strongly shaped by an ecological awareness. In his view, design methods have not developed an approach to the handling of vital problems. For design practice and design theory here, of course, designers are excluded from the production process to an unfeasible degree.

A fourth tendency is seen in the reflections of Jochen Gros, which, since 1975, were published under the title of *Theorie der sinnlichen Funktionen* (*Theory of Sensual Functions*). Gros wanted to free himself from the purposive rationalism of scientific thinking and to take into account more humanistic methods, especially those of cognition and psychology. He would like a design that is more strongly emotionally imprinted. He was one of the first in Germany to work for the idea of "redesign" and to develop theories for recycling processes in design. This led to the reflection that the consumer should work more with semifinished products and take over their completion. Moreover, he placed in question the circulation system of merchandise and endeavored to develop regional sales structures to eliminate retail trade.

Since 1977, Lucius Burckhardt has energetically pushed the idea of *invisible design* into the discussions, aiming at a suitable contemporary design concept. He has treated the design standards discernable in objects as style-forming constructions in the minds of viewers and users; these move in an everyday context of multiple cross-linked subsystems. For Lucius Burckhardt, to render visible has meant to show that designed objects are only the visible result of social processes that themselves remain invisible.

The next theoretical impetus came from the influence of Italian modernism, especially the influences of Alessandro Mendini's and Ettore Sottsass's theses, which, since 1980, have had a strong echo in a neomodern-interested scene of *Interieur-Design* in Germany. This neomodern theory arose against the background of radical design and the Milanese tradition since 1970. By way of "banal" design, the theory had been further developed into redesign and an esthetic of quotable kitsch and shapable ugliness. By then, it was a matter of a desacralization of mass produced objects that could not be assigned either to high culture or to the trivial consumer goods field. So-called "high art" had to be devalued. The designer's problem was to perceive everyday culture and to introduce elements of trivial culture into the design process in order to achieve a qualitatively new blend between high and trivial culture. One took over the esthetic of the suburbs and supermarkets,

reacted to the motley mixture of the mail order catalogs, and, from these style elements, endeavored to establish a new symbolic bond.

As the next influence, Gert Selle's thesis of "whole-world" design played a role. In 1983, the International Design Center, Berlin, presented a much-discussed exhibition of this approach. Selle attacked the professional tradition of design. Taste and morals of the user, he thought, should not be determined by the designer. He criticized the tutelage of the user by design and postulated the discovery of identity values of the anonymous everyday utility goods. Selle titled the exhibition of that time, "Genial Design of the 80s."[2] By geniality, he meant anonymous and trivial production for everyday mass requirements. Selle pleaded for learning from kitsch. He even went so far as to see the actual designers' avant-garde in mass production, and, with this argument, he turned against the deformation of the everyday by a neomodernism that pursued the pathos of its artistic production simply as a copy of earlier anonymous designs. In this he saw a chance for the avant-garde to find a closer proximity to the user.

The eighth tendency is the program of a *design between "good design" and "kitsch"*, which was formulated by a competition of the International Design Center, Berlin, in 1982 and documented in a brochure. The underlying theory was the notion that there were intermediate stages between the categories of good form and kitsch. Between these two arose a series of differentiations and transitions. The attentiveness to these differentiations would lead to avoidance of the pedagogical alignment of design, because, with such an alignment, the multiple social-use forms and users' inclinations would be monoculturally truncated.[3]

To this are connected the questions of a postmodern theory of design that could avoid the one-sidedly truncated rationalism and straightening of the design products onto an education for a monoculture. It would have to be a theory that opened up the concept of progress by sacrificing the concept of continuity. If one regards the architecture of the past few years and its postmodern ideology, it is possible to outline some points that may become important for a new theory of design and for the transformation of the production methods of design:

1. The alignment with the rationalistic concept must not lead to the surrender of design to the pressure of technical innovation.
2. Understanding the endeavor to consolidate the relationship of industrial society and modern culture is possible through functionalism. This static concept must be loosened. The functionalism of 1922 to 1927 cannot be maintained as a tradition.
3. The history of functionalism is not formed by the synthesis of all preceding developments from which definitive, binding guidelines can be derived for design.
4. Functionalism lives on a purism that has settled in the heads of

2) See Selle's notes for the "Genial Design of the 80s" exhibition, "There is No Kitsch, There is Only Design!" *Design Issues* I/1 (Spring 1984): 41-52. Ed. note.

3) A survey of the theoretical accounts presented by François Burkhardt can be found in the appendix to the comprehensive work *Design ist unsichtbar*, published by the Österreichisches Institut für visuelle Gestaltung (Wien: Löcker Verlag, 1981). For Selle's and Brock's approach, consult *Kunstforum International* 66/1983, "Zwischen Kunst und Design." For the critique of commodity esthetics, see Wolfgang Fritz Haug's book, *Kritik der Warenästhetik* (Frankfurt am Main: Suhrkamp Verlag, 1971), as well as the following discussions: *Warenästhetik, Beiträge zur Diskussion, Weiterentwicklung und Vermittlung ihrer Kritik* (Frankfurt am Main: Suhrkamp Verlag, 1975); Tillman Rexroth, *Warenästhetik - Produkte und Produzenten. Zur Kritik einer Theorie W.F. Haug's* (Frankfurt am Main: Scriptor Verlag, 1974). Haug's book has been published in English as *Critique of Commodity Aesthetics: Appearance, Sexuality and Advertising in Capitalist Society* (Minneapolis: University of Minnesota Press, 1986). Ed. note. Lucius Burckhardt's reflection on the invisible structures of design are made comprehensible in Lucius Burckhardt, *Die Kinder fressen ihre Revolution* (Köln: du Mont, 1985). For reflections on the intermediate categories between good design and kitsch, see *Gestaltung zwischen 'good design' und Kitsch* (Berlin: IDZ, 1984), with contributions by François Burkhardt, Lucius Burckhardt, Alessandro Mendini, Bazon Brock, and Hans Ulrich Reck.

FRANÇOIS BURKHARDT

its theoreticians. But the dependence on form functions appears today more as a hindrance than as a stimulus to design.

5. The establishment of product-language communication, which modernism has focused and fixed on internationality, has brought about the situation where culturally regional identities and peculiarities have been lost (one can picture this, for example, from the reception of the *Charter of Athens*).

6. The functionalistic reduction of forms to a minimum flattens sensual perception. The charms of an attractive emotional esthetic are missing. This can lead to a perception-conditioned impoverishment of the environment. Modernism has bluntly challenged the loss of means of symbolic expression. For this reason, postmodern design operates strongly with such symbolic means of expression.

These tendencies in architecture might be used for a postmodern design theory. The controversy with modernism is not a question of style. For a long time, there have been strongly postmodern tendencies in the fields of sociology, philosophy, psychiatry, and painting. These tendencies place in question the concept of modern emancipation as a continuation of the Enlightenment. The transition from a mechanical to a cybernetic culture poses questions to a changed society that, without doubt, cannot resort to the tradition of formerly valid life forms that have started to crumble. It seems to me that here design has an important field of function, a field that is economically usable precisely for the transformable means of producing relatively small and medium-scale operations, which can tie in more rapidly to new aspects of cultural development. Here the International Design Center, too, has reached its historical limit. It has become clear in the past 14 years that in Germany there is little interest in a design theory that is precisely so important today. And it is to be feared that the attempts by planners to restore prosperity will fall back into the old, now unusable patterns and thereby hamper the cultural development of design.

Postmodernism, in contrast, endeavors to develop, from the idea of discontinuity, concepts that promote a truly vital renewal. But for this, business and the public need to take a different approach to design theories. Theory is irreplaceable: It forms hypothetical schemes for a not-yet-existing practice; it endeavors to define things, which can then be tried in a realizable form. For theory, the idea of the utopian is always basic. Theory in projects aiming at the emancipation of society binds design into the utopian by developing models that yield an orientation for societal development. The planning processes to which design and design theory belong are nothing but instruments that establish a connection between an actual state and a desired one. But to describe a desired state, theoretical models must first be developed. The defining power for such models is utopian in the sense of societal

practice. Every product is based on a theory of *production*. It articulates interests. Contrary to the current economic and entrepeneurial view, this utopian content is no mere ideology. The joining of interests and theories can be established only by a common cultural theory. At present, an awareness that history does not simply run its course, but is made, is still lacking. Promoting progress, on its part, by a dialectic of endeavor, re-experience, and co-endeavor is necessary. This holds for the economic, as well as for the spiritual, attitude.

Translated from the German by Peter Nelles

FRANÇOIS BURKHARDT

Gert Selle

There is No Kitsch,
There is Only Design!

Theme and background

Notes for the exhibition "Genial Design of the '80s," at the IDZ (International Design Center), Berlin, April 22 to May 29, 1983.

The exhibition "Genial Design of the '80s: Objects of Desire and Daily Use" has aroused controversy. It did not hold to the usual criteria of design. It dealt with design for all. It showed beautiful everyday objects without condemning their consumption and without denouncing or indoctrinating their users. It stressed what design means today to the majority of the population in the Federal Republic (West Germany) and West Berlin and in other industrial countries: realization of a dream of luxury, beauty, belongingness, shelter, adventure, individuality, and cultural identity.

The exhibition thus intentionally remained as open to controversy as the facts to which it pointed. However, if one only criticizes this dream or ignores what, besides thoughtlessness and alienation, is still tucked in it, one not only strides heedlessly and arrogantly over the many who need this dream, one forgets one's own involvement in this product culture. The discovery that it has a history and a continuity is not made. This real product culture of the "mass-everyday" is not founded merely on deceit; it is not an "as if" culture, it is "lived" culture, and whoever calls it kitschy is making an absolute of a position based on educational tradition and normative interest, which would first have to be exposed to a critique of its ideology.

The exhibition was a provocation, because it violated the rule that the guidelines for dealing with objects, the nature of their beauty and their understanding, be prescribed by "progressive" designers. It is a professional tradition to think that the proper and moral use of things must never be left to the users. For more than 80 years, every designer with self-respect has considered himself a cultural guardian of any user whatsoever. He thinks that the users have to be led out of kitsch into the freedom of a rational use of goods specially designed for that purpose. In truth, however, the relations have been reversed; the mass user has mutely but consistently developed and implemented his own concepts and competencies, a process with still unforeseeable consequences that is stamped with confusion today by the theory and practice of design.

The fact is: the ordinary beautiful design of the world at large *is*

design, while all schemes of high design laden with hopes of cultural pedagogy have run into a void or have been absorbed by everyday-beautiful design. The leadership claim of an exemplary design has become extremely questionable. And it is surely wrong to look down sneeringly on the anonymous creators of everyday beauties as if they were not designers at all. They are. It is necessary to learn from them. This is already being done, shamefacedly or shamelessly as, for example, in the recent exhibition of competition projects "Fashioning between 'Good Design' and 'Kitsch' " at the IDZ, Berlin, 1983.

It is high time, therefore, to point out in an exemplary survey the fantastically beautiful design for all and to pose old questions anew. Violating the prevailing "official" standards of taste cannot be avoided here anymore than can challenging all institutions concerned with design questions and, of course, every designer who considers himself a pedagogue and an innovator. The IDZ exhibition showed nothing out of the ordinary, unless the intensity of wishing, the stubbornness, and the sense of beauty with which masses of ordinary users cling to their concepts and force designers to go along with them is considered extraordinary. The anonymous design for all has reached such a degree of esthetic perfection that attempts of avant-garde designers to create a postfunctionalist decorative product culture for connoisseurs and rich snobs recalls the folk tale in which the tortoise always gets there before the hare. The real avant-garde was already long on the warehouse shelves before "Memphis" and others acted as if our product environ-

ment had for once to be brought to life and made playful, colorful, and all new. A self-appointed designer avant-garde picking up charms from the motley creations of the world at large is not the same thing that the protagonists of Pop Art did when they turned soup cans and comic strip heroes into artistic material. Design for the everyday masses is something different from art production, which reflects this daily life. If designers today are playing around with bizarre everyday-esthetic motifs, then this is the belated "same concept" only insofar as they behave like artists. In reality, they concede that their earlier pedagogical intentions have been wrecked (the artists never had such intentions). And what they create that is new and colorful and what they want to decree for use has already been created before them and is in regular use. They expropriate, as it were, from their anonymous colleagues and the mass users that quantum of imagination that has always distinguished every universally beautiful design from esthetically and morally pretentious production.

Alessandro Mendini says this in plain words: "Why should one not make use of the intimate and mythical relation that exists in every mass society between human beings and the so-called 'ugly' object?"[1] The Italians and their German imitators lionize the everyday beauties and elevate them to new forms of individual artistic creation.[2] They forget that the consumer masses never deal with their beautiful things ironically, but use them seriously. From the concepts of the avant-garde that designs these beauties afterward, hardly anything can be reflected back to the everyday-beautiful and fantastically rich design; for this, after all, is the original, the socially lived and vitalized, serious form of design.

It is to this that the exhibition wanted to invite attention. The aim was to make visible the richness of ideas, the variety of forms, and the openness of meaning of such designs. These designs can compete very well with the most far-out avant-garde products, because, after all, they were their model and because, by reason of their mass presence in social use, they have a substantially more intense record of functioning behind them and promise ahead of them than any artistic high-class design.

The design of the world at large is mass-sensuous and concrete in use. It impresses all and is used in different life situations for different purposes by different people; for example, by the specialist, by the professor, by the cleaning woman, as well as by the wife of the chief physician, moreover by children and youth of all strata. If one pushes aside all prejudices, one must grant to this design offering that it combines high esthetic fantasy with social competence in its purpose. At the exhibition, the fascination of a very heterogeneous street public was observed as people turned to the objects of their desire and use through the show windows of the IDZ.

Design and use

The exhibition provoked the design profession because it exposed pre-

1) Allesandro Mendini, "Für ein Banales Design," in *Design aus Italien* (Hannover: Deutscher Werkbund, 1982), 279.

2) See "Möbel perdu," *Der Spiegel* 51 (1982).

judices on two levels: on the practice of "official" design and on the design and culture theories of product use.

In practice, no one likes to hear it said that he plans the development after the fact; being right is part of traditional design theory. One reason for the confusion and adherence to hard and fast positions is the fact that the role of design has remained to this day unknown and, indeed, laden with prejudices. Mendini, as theoretician of the Italian avant-garde, maintains that a sort of redesign of the everyday beauties creates things that are "meaning-charged" instead of "meaning-void." This is an error due to a practical misassessment of design for all. These things have already for a long time revealed their density of meaning in socially differentiating use. A reshaping of their image would at best be

disturbing; it is superfluous, like any prescribed guardian design. There is obviously present, too, a wrong assessment of the strength and resistance of the user masses: "The predilection for the garden dwarf and the flipper, the bowling alley and the little hashish pipe, for disco, horoscope, and the Suzuki is not, as the enlighteners thought, culpable immaturity or planned stultification of defenseless masses. Here, no historical residue cries aloud to be picked up. The poor victims of manipulation, however, silently but energetically refuse any indoctrination."[3]

This background forms the basis for criticizing the proposal once supported by the IDZ that through Socio-Design in the form of an "alteration of the material components of a life environment" it should be possible "to change social behavior."[4] Undoubtedly there are effects of design on life-styles. But it remains uncertain whether design can arbitrarily change habits in a short time through counterproposal or whether it is not rather the case that design and life-style are always so fused in a sociohistorical and biographical process that it is necessary to

3) Hans Magnus Enzensberger, "Verteidigung der Normalität," *Kursbuch* 68 (1982), 67.

4) See Bazon Brock, "Mode-Ein Lernenvironment zum Problem der Lebensinszenierung und Lebensorganization. Dazu ein Vorschlag zur Anwendung der Aussagen im Sozio-Design," in *Mode-das inszenierte Leben* (Berlin: IDZ, 1974). Brock has developed further and updated his ideas. See "Sozio-Design," in H. Gsöllpointner, et al., editors, *Design ist unsichtbar* (Wien: Löcker, 1981).

GERT SELLE

proceed on the assumption of hardly dissoluble correspondences: the esthetic offering, on the one hand, and the need and management of standards on the other. Pierre Bourdieu speaks of a "homology between... goods and groups" of society, of an agreement between the "logic of the production field" and the "logic of the consumption field," which always restores itself automatically on the basis of the differing social structural and cultural interests.[5] This is in fact a constraint of every designer, every producer, and every institution.

As long as it has been possible to speak of an industrial product culture and its esthetic in the mass-everyday, everyday design has grown along with this culture, and in periods of social stability just as in periods of social change, it has fused with life-styles and their forms of expression. Socio-Design, which effectively alters, will therefore encounter indifference, indeed, rejection wherever it maintains that beautiful design of the world at large is unsuitable, or that the forms of life on which it is based are false. Socio-Design could thus be unmasked as a construct of an authoritarian didacticism that has been practiced too often in the history of consumer education.

Enzensberger, in a thesis on the cultural obstinacy of the new *petit bourgeois* (kleinbürgerlichen) majorities, presents the contrasting view that it is pointless to postulate changes of behavior from a theoretical standpoint before one really knows whether the mass-everyday, in its many life-historical violations of interpretation and esthetic embodiment, is actually as disorganized and deficient as assumed. The design of the world at large forms a material framework of life, to be sure only *one*, namely that of individual reproduction. Life is formed by the working reality and by other factors independent of design, such as social status, cultural tradition, and overall social development. In this context, design for everyone has found its place, which it defends. To alter it would only mean to redesign a small part of the material life conditions, just those to which the masses have attainted access.

In history, the extraordinary stability of this design's manifestation is surprising. The exhibition could have extended back through objects of the '50s, mass Art Deco, and industrial Jugendstil into the original factory historicism.[6] What one sees today with one's own eyes is the apparently unbounded stage setting of a world of goods to which the critique of the commodity esthetic (Warenästhetik) has referred. What one does not see is the presumably high density of organization of the use of the things and their incorporation into social and individual biographies. It is unknown in West Germany, because it has never been investigated and represented, either historically or for the present.

In France, Bourdieu has seen to it that the modes of cultural behavior can be understood as a highly differentiated system of answers to the development within society. He therefore concludes: "Precisely the decisions of taste that seem especially 'irrational' from the viewpoint of the prevailing standards are inspired by the taste for the necessary,"[7] and, "Taste brings it about that one has what one wants, because one wants what one has, namely the properties and features

5) Pierre Bourdieu, *Die Feinen Unterschiede: Kritik der Gesellschaftlichen Urteilskraft* (Frankfurt: Suhrkamp, 1982), 595.

6) See Gert Selle, *Die Geschichte des Design in Deutschland von 1870 bis Heute* (Köln: DuMont, 1978).

7) Bourdieu, *Die Feinen Unterschiede.*

8) Bourdieu, *Die Feinen Unterschiede*, 286.

that are apportioned to one *de facto* and are assigned *de jure*."[8]

Social stratification is first of all independent of design; it cannot be dissolved through planned manipulation either. Stratifications of new social structures while old class and stratum-specific "utility models" still overlap make the scene unsurveyable. Simplifying social models for the interpretation of product use, motives, and effects, therefore, no longer holds today. With knowledge of Bourdieu's investigations, one would have to begin also in the Federal Republic to resubstantiate the esthetic difference within the everyday culture.

Even if one does not, like Bourdieu, suppose the motive of social distinction, of objectively caused compulsions and desires, of distinction for all esthetic behavior, every pleasure and every cultural expression, the defect remains that the use record of everyday beautiful design for German conditions still has to be written. Finally, this existing product culture is evidence of a broad participation of great masses of consumers in that dream of wealth and life, which in Germany, too, has always accompanied the battles of distribution. The fantastic design for all is at present a single currency, if not *the* cultural coin of modern mintage equally convertible by the *petit bourgeois* daily life of East and West.

Obviously, this design corresponds to the wishing and longing of the working people throughout the political systems. Its function, esthetics, and morality are not only proof of the unteachability of innumerable people, but also evidence of their desire, their convinced right of participation and their (however desecrated) imagination. Inherent in this everyday beauty, so often denounced but mass-experienced, is a dynamic that ought to inspire dread in those who seek to take possession of it for their own ends. A democratization of design has occurred, a democratization of which no Werkbund, no guardian of the arts, and no socio-designer either, could ever dream. A cultural revolution from below has silently taken place. In its long course from a formerly bourgeois product culture with clear stands and definite delimitation against what is beneath it, there has risen to the top a new *petit bourgeois* product culture, with fluctuating norms and openings, the future direction of which we do not yet know. However, the traditionally asserted position of the designer as responsible creator of life-styles by means of products' material esthetic is thereby shaken. Meanwhile, postulates age, and long-despised colleagues, realizers of the terribly beautiful design of the world at large, come into the focus of cultural history. They burst forth as the makers of the supply; the others enjoy indulgence and membership in the Werkbund or in the VDID (Association of German Industrial Designers). Now as before, they know morality to be on their side, but the changing of the guard took place long, long ago. The formerly despised non-design is the design for all.

Repellent or absurd as many of these things standing around us seem as set pieces of persons foreign to us in the everyday, actually they are serving there in the quest for sense and history at this moment and for

GERT SELLE

the duration of their use. We can sense this only dimly; at the moment there is hardly any alternative to this life-style.

The beautiful design of the world at large, therefore, may be called genial, because it factually redeems what "high" design promised in social function and formative use. Design for all in the hands of everyone offers that user friendliness and variety of meaning that relieves historical functionalism as the new assignment of the designer. This design, more than any other, permits people to determine what use value and identity representation mean to them. They decide on their kind of friendship to the things in the framework that this open beauty covers and, of course, in the framework of differing socially defined expectations and possibilities of expression.

This imaginatively beautiful design is adopted reverently as a matter of course or with a shrug of the shoulders, all depending on social status, available income, age, and educational capital of the users, and is fitted into the organization of life. From a distance, it would have to be described as a scarcely distinguishable sameness. From close up, however, it discloses an abundance of specific meanings and contexts of handling. These invisible properties realized exclusively in use can be grasped only by microsociological analyses, by case studies, by sympathetic observation in very small fields of the typical use of the object, by linkage with life history and social history, or in observant personal participation in the product culture. Certain fundamental statements of the commodity-esthetic theory could prove ambiguous or not as hermetic as in Haug's thesis that "the use value promised by the form and surface... [is] the one value, and use value demonstrated by the purchased object in operation [is] the other."[9]

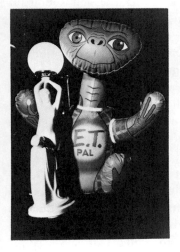

9) Wolfgang Fritz Haug, *Warenästhetik und Kapitalistische Massenkultur,* vol. 1 (Berlin: Argument, 1980), 174.

0) See Siegfried Giedion, *Die Herrschaft der Mechanisierung* (Frankfurt: EVA, 1982).

Living, functioning human beings succeed, perhaps, in piercing through all semblance to the core they themselves establish for the meaning of things. The guile of the betrayed user is now ready for discovery. Commodity-esthetic critical observations or new editions of a theory of social engineering of life-styles through design appear at present less current than questions of what long-term cultural tendency will be revealed under the magical esthetic cloak behind the fantasy of design of the world at large. Basically, it is a matter of pursuing further the history of mechanization of the everyday, which has been set forth with abundant material by Siegfried Giedion.[10] It was and is covered over again and again by regressive esthetic tendencies. Technical innovations, revolutions—what do they mean for material existence, for the everyday? What meaning is there in the hiding of technology behind "style," its soft packaging in fanciful, mostly backward-pointing forms? Microwaves in the "old German" stove or E.T. among the teddy bears seem to be symptoms of the need for reassurance or for the takeover of the weird into the accustomed world.

Is over-esthetization a trick of survival? An attempt to bridge over the desensualization of life? The Bauhaus once considered technical progress and the nature of man to be reconcilable. It created a humanly meant functionalism and a clear system of esthetics, which for

then-unforeseeable reasons was unable to prevail or prevailed only in a distorted form.

At present, design for everyone encompasses highly functional ensembles in altogether anachronistic esthetic costumes or costumes that seem to have been borrowed from the wardrobe of science fiction films. The unsuitable is trump. Perhaps the unsuitable is, on one hand, an expression of supercharging the project. In the age of microchips, it is no longer possible to express highly complex technical structures plastically. The telephone made of Plexiglas was a decorative expedient solution; the interior of a super-flat electronic pocket calculator remains just as boring as it is unintelligible. On the other hand, the contradiction between high technology and antiquated esthetics of use could point to a path of affirmation. It is not the first time in the history of design that this contradiction gapes open at moments when technology is being revolutionized. Neither the gas lamp nor any electric light has ever—before Peter Behrens—managed to make do without references to the past; even the automobile was only slowly able to free itself from the coach form. Is there an esthetic of delay?

The "Genial Design of the '80s" exhibition raises such questions anew. Designers and their theoreticians can hardly answer them, but they will become research fields for anthropology, social philosophy, and the history of technology. For example, a connection is cropping up between the material demonstrated by Giedion for progressive abstraction of work and life through mechanization and Rudolf zur Lippe's studies on the "Geometrization of Man."[11] Electronic apparatuses and programs are pushing their way into the game room and forcing hand and eye into new patterns of covariant perception and manipulation skills. The exhibition contains an example of suggestive attraction. No one yet knows what forms these new "technologies of sense perception" in everyday life will have for the nature of human beings. The designer knows it last of all. Is he also providing for an esthetic of acceleration?

11) See Rudolf zur Lippe, *Die Geometrisierung des Menschen in der Europaischen Neuzeit: Eine Ausstellung des Instituts für Praktische Anthropologie* (Oldenburg: Bibliotheks-und Informationssystem der Universität Oldenburg, 1982).

The unsuitability of the kitsch concept

At present, the final shedding of the kitsch concept suggests itself. It has become superfluous, a leftover from earlier periods of cultural delimitation. To be sure, it is necessary to face this imaginatively beautiful genial design of the 1980s critically, but not with the kitsch concept. A basic trait of unreality and escapism clings to this highly artificial environment. Certainly this product culture bears witness to everything but ecological sensitivity and economic logic. It not only makes experience and history possible, but also destroys them. Certainly it awakens needs and suffocates them at the same time. But it is the sole existing mass product culture of significance. It makes available a material with which the everyday can be organized esthetically as a social and personal ensemble in space and time. The everyday turns over much more slowly than it ought to according to the laws of commodity esthetics— therefore in the proper order of things. The attempts, repeated again

GERT SELLE

and again in history, of righteous pedagogues, mission-conscious designers, and cultural institutions to habituate people to better taste have been brilliantly withstood by the beautiful design of the world at large. So-called "good form" has entered into countless associations with this design and very nearly vanished in it. Only incorrigible cultural pedagogues are still preaching against kitsch.

The kitsch concept is an invention of the nineteenth century—taken into use at a time when bourgeois culture was already going downhill and positions had to be firmly established.[12] However, this bourgeois high culture has vanished today, except for remnants. Therewith ends at least the old necessity of culture delimitation. The parvenus know themselves what is suitable, and their measure of suitability has, as a new standard, taken the place of temperate restraint. To this extent the kitsch concept is obsolete; it no longer holds, despite the fact that many educated persons have at their disposal a learning history that is laden with this antiquated value concept and that permits them in their own life context to classify their personal environment acording to such criteria.

12) See Abraham Moles, *Psychologie des Kitsches* (München: Hanser, 1972).

However, it seems extremely doubtful whether a classification of the esthetic manifestations of contemporary product culture into *kitschy* or *non-kitschy* is a performance of insight. Taste judgments are standpoint judgments. It is from a value awareness that one observes and judges. Where a fixed coordinate system for social and individual value decisions is lacking, however, this judgment is irrelevant and noncommittal. One should at least first try to determine for oneself the position one objectively occupies: "To follow one's taste means to *sight* the goods that are objectively allocated to one's own social position and which harmonize with one another because they are approximately of equal rank," writes Bourdieu.[13]

3) Bourdieu, *Die Feinen Unterschiede*, 366.

Such an attempt would also make it possible to understand other people's positions and values. A sort of social-esthetic empathy would be needed in situations in which old, internalized value systems again and again play tricks on us. There simply is no absolute "good taste." It exists only in relation to a basis of social points of departure, that is, everyone who lives according to his taste *has* a "good taste," which, of course, can be distinguished from another "good taste." In the pluralistic permissive esthetic of our everyday, this is already experienced by countless individuals, while the guardians of the once-leading good taste do not trust their eyes.

Thus, "Genial Design of the '80s" is not a collection of kitsch examples, but a cool factual reference to esthetic orientations of large majorities who rightly protest against the thesis that all these beautiful objects laden with desire, memory, and experience are kitsch and, therefore, something inferior.

Failing to recognize that esthetic value awareness is based on a specific orientation, we may still, however, slip into another false appraisal, namely, the Camp esthetic described by Susan Sontag. The Camp esthetic is the allocation of the exaggerated and fantastic to an in-

14) Susan Sontag, "Anmerkungen zu 'Camp,'" in Susan Sontag, *Kunst und Anti-Kunst: Essays* (München: Hanser, 1980), 282.

15) Sontag, "Anmerkungen zu 'Camp,'" 284.

tellectual "manner of experience" that grasps and seizes certain phenomena from the province of the old kitsch concept as a special possibility of one's own identity formation. "The old-style dandy hated vulgarity. The new-style dandy, the lover of Camp, appreciates vulgarity."[14]

The adaptation of the exaggerated or the enjoyment of the apparent parody of seriousness by a certain stratum—I would like to say of parasitic users of imaginative design for everyone—only relates, however, to a small subculture in that great, immeasurable subculture of the earnest use of exaggeratedly beautiful goods. "Here Camp taste supervenes upon good taste as a daring and witty hedonism."[15] The terrible, beautiful design of the world at large, therefore, produces a tricky enlivening of feelings and becomes an ironic manner of experiencing the self.

Undoubtedly some educated visitors to the exhibition "Genial Design of the '80s" must have sensed such spasms with a certain horror, but also with secret fascination. (It was necessary for the exhibition to reckon with this misunderstanding.) At the same time, however, many "naive" visitors showed a direct, non-ironic interest in the things—which is evidenced, incidentally, by the pilfering statistics.

A distinction must be made between two cultural spheres of interest. The one points to dimensions of the game and remains a variant of the traditional bourgeois one-culture standpoint, from which one inclines hedonistically, noncommittally, and voyeuristically toward the alien fantastic and beautiful. The other is that of the immediacy and earnestness of mass use. The mass users do not play; they are serious with their imagination. They have only this one rich product culture. Thus, "Memphis" will perhaps lead to the manner of experience of Camp, but never to substitution for the naive models.

This means that the observer seriously concerned with cultural empathy must detach himself from the old kitsch concept *and* must avoid personal entanglement in the Camp esthetic, because anchorings hamper perception of the socio-esthetic facts. Comprehension of mass-effective design of the world at large will be acquired only by asking without reservation (which does not mean without criticism) what this design replaces, what it redeems, what sensuality it curtails, what sensuality it promotes, and where it dissolves norms, where it sets up new ones, whether and where in the alienation familiarity flashes up (and thereby history in the seemingly historyless), what it means in the hands of different users, and what it does not mean.

The much-disdained design for all is highly complex and springy in its nasty imaginativeness, warped absurdity, and apparent solidification. It deserves the close attention of those interested in esthetic perception, as it has outstripped all cultural competition and strivings for something better.

Conclusion

Never before has such a broad offering of everyday beauties been avail-

able to such large masses of users. The build-up, acquisition, and implementation of industrial product culture has taken place socially (and in part biohistorically) in long waves, interrupted by two world wars and long phases of shortage economy. The culture of beauty for all, today so obvious, has its history, is making history at the moment, and will continue to do so. To take design for all seriously, therefore, means to open our awareness to individual phenomena and to the totality of manifestations of this mass product culture from an historical viewpoint to consider what sociological and historical structural changes society is undergoing. Design problems are then suddenly no longer so important; at least they are relativized.

The old Köhler belief that design can change the world or even pro-

duce good human beings is then spoiled for us. Cultural pedogogic work can be performed only *in* this cultural reality, not against it, be it by teachers, designers, or institutions. Theoretical constructs based on exclusivity, such as the critique of commodity esthetics or more or less relativized postulates of a Socio-Design, must in the future be subjected to the test of experimental science. The revaluation process of design, which is mirrored in the universal presence of the everyday-beautiful design for everyone can no longer be checked by strengthened design measures, counter-propaganda or counter-education. This, after all, has long been attempted to no avail. Such activities would only be directed against the majorities who shape their lives with this design and who perhaps already use it much more freely and much less excitedly than many critics think.

The swing of the designer avant-garde to the fantastic of the everyday (or its flight into a new artificiality) is a forced act of adaptation, not a new departure. The entry into the postmodern could also mean that the age of the once irreconcilable two cultures, the lower and the upper, is over. The might of esthetic guardianship is thereby broken, even if the ward seems immature to many. A product culture—

opulent, hedonistic, valid for all, and open to interpretation by all—has prevailed with the normative power of the factual, even if the dubious aspect of this culture is ever so patently evident.

As for the morality of this fantastic world of phenomena in which everything is allowed that pleases and obtains its meaning in the plaiting of social relations and manners of expression, it must be emphasized that this mass-product culture so often represented as bad is, all in all, far more peaceful, more humane, more economical, and more rational than the weapons design that threatens us all. The beautiful design of the world at large probably acquires its special density of meaning in the awareness of crises, of political helplessness, and under the sense of anxiety. This peaceable withdrawal culture prevails among the working masses in West and East. A comparison between West German allotment garden colonies and the extended Datschen zones on the edge of East Berlin conveys—with all difference that one must furthermore still perceive—an image of high community in the push toward normality, in the esthetic language of privacy, in the quest for meaningful activity, in the placidity of enjoyment, and the forms of *petit bourgeois* joy of life. The Hollywood merry-go-round, gaudy and florid, here as well as there, is a culture symbol.

It is not so wrong, after all. On the far side of commodity character, squandering and artificiality, no general new high culture has ever arisen; the culture, namely, of which all social planners of the beautiful have always dreamed. Wherever we look around us, subculture reigns, the lower is turned up, the "wrong" is preferred to the "correct." Permeability prevails.

The masses are realizing long-cherished dreams. How they are doing this, what accrues to them in the use of the things, what consequence this cultural development has in detail—these questions must be posed anew, even if they seem to have been already answered long, long ago. Acknowledgement of cultural facts must finally take the place of shamefaced blocking out or unjustified discrimination.

The thematization of the everyday is not merely a fashion, as someone said at the opening of the exhibition. On the contrary, the everyday, based on historical insight into the contemporary culture experience, is to be regarded as a richly instructive field for future social action. Agnes Heller regards everyday life as the "secret leaven of history." In its development, she says, it often expresses "the changes that have arisen in the manner of production...before the *due* social revolution."[16] Now the fantastically beautiful "genial" design of the 1980s is part of everyday life. Therefore, paths of perception should be sought that open up presentient understanding and new accesses beyond hard and fast positions. Hitherto, one has found oneself as a design critic in the remarkable situation of knowing better one's head and proposing something other than what body and senses experience, while we are ourselves living in the midst of the real product culture.

Translated from the German by Peter Nelles

16) Agnes Heller, *Das Alltagsleben: Versuch einer Erklärung der Individuellen Reproduktion* (Frankfurt: Suhrkamp, 1978), 25.

GERT SELLE

Marco Diani

The Social Design of
Office Automation

*To the memory
of Raffaello Misiti,
mentor and friend
by example.*

I wish to thank Victor Margolin, Gerald
Mead, and Dennis Doordan for editorial
advice on a previous version of the text.

This essay is part of a research program
conducted during the past five years
under the joint auspices of the **Consiglio
Nazionale delle Ricerche**, Rome, Italy,
and the **Centre National de la
Recherche Scientifique**, Paris, France,
acknowledged for various forms of sup-
port, travel grants and, above all, free-
dom. I am deeply indebted to Professor
Sebastiano Bagnara, Dipartimento di
Filosofia e Scienze Sociali, Università di
Siena, who has spent long hours discus-
sing with me many of the ideas expressed
here.

1) The literature on the subject is immense
and growing at a speed which is, by any
account, out of control. See Tom Forester
(ed.), *The Microelectronic Revolution*
(Cambridge, MA, 1980); and *The Infor-
mation Technology Revolution* (Cam-
bridge, MA: MIT Press, 1986); Michael
L. Dertouzos and Joel Moses (eds.), *The
Computer Age: A Twenty-Year View*
(Cambridge, MA: MIT Press, 1979); and
Arthur Francis, *New Technology at
Work* (Oxford: Clarendon Press, 1986).

2) See, for instance, the data provided in
U.S. Congress, Office of Technology
Assessment, *Automation of America's
Offices* (Washington, DC: U.S. Govern-
ment Printing Office, 1985) especially
the first two chapters. See also, on the
same topic, the series *White Papers to
Management* produced for *Fortune* by
International Data Corporation: as of
October 1986, 31 papers have appeared
in an 11-year period.

Office automation, office of the future, paperless office: these are just a few of the most common terms used to describe the changes that have occurred in the offices during the last quarter of a century as a result of the introduction and widespread adoption of computer-based technologies.[1]

During that same period the labor force in the major indus-trialized countries moved into a majority of non-manual/non-industrial employment. Today, according to various sources, between 45% and 60% of the work force in the United States is employed in white collar occupations.[2] It is therefore no surprise that the technologies associated with the office of the future are considered to be capable of producing a profound impact on soci-ety as a whole, the economy, organizations, the nature of work, and the lives of individuals.

Without pretending to give a complete overview of all these complex trends, this paper will analyze and discuss some of these aspects and changes and show how a more historical and multidis-ciplinary study of the social and organizational consequences of office automation is required in order to cope with the new tasks of creating the artificial environment. Office automation reveals the need for a new basis for the *science of design*.[3]

Historical overview of the three office revolutions

The present wave of office automation is not the first technological revolution that has taken place in the office, and therefore in order to better understand its peculiar characteristics it is necessary to adopt an historical perspective. "Multidisciplinary research seems to take root only when it is directed toward an activist goal or a clear application area. Office technology has both these charac-teristics. An historical perspective is perhaps the ultimate integrat-ing force in a multidisciplinary field. Coupled with, for example, the economist's, political scientist's, sociologist's, or anthropolo-gist's skills in theory and method, the historical viewpoint adds richness and scope of vision to any policy field. History discour-ages naive predictions, tends to be cautious about the impacts of change, sees conflict where casual observers want to see continuity,

67

3) The expression was first used in a systematic way by Herbert A. Simon, Nobel Prize Laureate and Professor of Computer Science and Psychology at Carnegie-Mellon University, in his 1968 Karl Taylor Compton Lectures, delivered at MIT: see *The Sciences of the Artificial* (Cambridge, MA: MIT Press, 1969, revised 1981).

4) Peter G. W. Keen, "Office: Technology and People," Editor's Preface, *Office: Technology and People* I/1 (September 1982).

5) See Eugene Kamenka and Martin Krygier (eds.), *Bureaucracy: The Career of a Concept* (New York: St. Martin's Press, 1979), and Martin Albrow, *Bureaucracy* (London: The Pall Mall Press, 1970). A more sociological approach can be found in Michel Crozier, *The Bureaucratic Phenomenon* (Chicago: University of Chicago Press, 1964).

6) See Vincent E. Giuliano, "The Mechanization of Office Work," *Scientific American* 247/14 (September 1982): 148-152, now reprinted in Forester, *The Information Technology Revolution*, 298-311.

7) See Joan Wallach Scott, "The Mechanization of Women's Work," *Scientific American* 247/14 (September 1982): 166-169.

8) It is surprising to remark how little use is made of some extraordinary accounts of office life and values provided by some of the most eminent writers: not only Balzac and Dickens but, closer to us Franz Kafka, Albert Camus, Pierre Boulle, George Orwell, to mention just a few. This neglect is particularly disturbing because the same does not hold true for the industrial work, on one side, and for the more creative, intellectual or artistic, forms of activities. There are a few interesting exceptions: see Humbert Wolfe, "Public Servants in Fiction," in *Dialogues & Monologues* (New York: Alfred A. Knopf, 1929), 137-172; Vincent Crabbe, "Balzac et l'Administration," *Revue des Sciences Administratives* XX (1954): 287-358; Peter Savage, "Public Administration in Literature: a Bibliographical Essay," *Philippine Journal of Public Administration* 9 (January 1965): 60-70. See also Edmond Amran El Maleh, "Figures de la bureaucratie," in *L'Empire du Bureau 1900-2000* (Paris: Berger-Levrault/CNAP, 1984), 51-57.

and constantly reminds us that cause and effect are complex."[4]

Since the early nineteenth century, "office" and "bureaucracy" have grown together along similar development paths, molded as they were on the military models of the centralized states from which they were derived, France and Prussia most specifically.[5] It is only in recent years that their paths have become increasingly separated.

Throughout the nineteenth century, someone visiting an office would have seen more or less the same spectacle: an all male system, with strong hierarchical features in which the junior clerks handled both clerical and simple professional and managerial tasks. The assumption that they would slowly rise in the hierarchy assuming more seniority and managerial powers was tacit and implicit. There was no sharp distinction between the clerical and the managerial functions and working population.

Papers, pens, pencils, folders, and desks remained the main technological elements of the office for most of the nineteenth century. It was only in the last part of the century that an observer would have noticed some disparate signs of primitive "office mechanization" and by 1900 a number of mechanical devices had established a place in the office, introducing important modifications in office practice and organization.[6] The most notable innovations, Morse's telegraph, Bell's telephone, Edison's dictating machine, and, above all, the typewriter, appeared immediately as major elements of technological and social change.

Mechanization proceeded briskly: Already by the turn of the century more than 200,000 typewriters had been sold and more than 20,000 new machines were being produced every year. Mechanization represented a global change in the nature of office work: it not only allowed an increase in the size of offices and in the quantity of operations performed, but also, by separating even more the mechanical operation of writing and intellectual content, it allowed for very rigid distinction between clerical and managerial operations.

In a very short span of time, a series of major changes in the structure and composition of the office appeared, notably a large number of women entered the "office work force." In fact, the invention and rapid implementation of the typewriter set the stage for the creation of a segregated class of female typists who were not expected to perform any managerial activities. Socially and symbolically, office work was a more "acceptable" occupation for women than factory work. However, the traditional sex role stereotypes introduced a double distinction: woman's task was to be inferior and distinct from man's.[7]

This was the first Office Revolution. The powerful and detailed literary analysis of "office work" provided by some of the great nineteenth-century writers, like Honoré de Balzac and Charles Dickens, did not suit the new century.[8]

A second Office Revolution soon followed. Throughout the first half of the twentieth century, the expansion of industrial organizations and the increase in capital and financial resources produced a dramatic rise in the proportion of the labor force employed in offices and the appearance of an enormous number of innovations and refinements including, among the most important ones, electric typewriters, duplicating machines, and photocopiers. Clerks with specialized knowledge were required and, given the growing importance of the functions performed by offices in the general economy, a new concern for productivity became a primary preoccupation; scientific techniques of rationalization and standardization, the same that had been applied in the factory years before under the name of "scientific management," landed in the world of the office.

Office Automation, based on what scientists call the Information Technology Revolution[9] is the third and latest stage of the Office Revolution. The term office automation embraces all the current changes provoked by the fusion of several powerful information technologies – computers, telecommunications systems, and microelectronics – into new computerized systems of office work. The most visible symbol of the latest revolution in the office is the "Visual Display Terminal."[10]

Impacts of office automation

The "impact of office automation" has been a subject of almost continuous study since the introduction of the first commercial computers in the 1950s. Experts in various fields (social scientists, system designers, and planners) have examined the impact of office automation on job characteristics, managers, control and decision-making processes, employment, and quality of working life, to name just the most important topics. The results of these studies are controversial and, despite much discussion about how new technologies will affect the nature and conception of office work, very little is yet known of the effects that office automation will have. The only apparent consensus among experts is that *the third Office Revolution* is producing an even more dramatic alteration in the workplace than that created by the mechanization of office work and the expansion in office activities between 1890 and 1950, described above.

Twenty-five years ago, at the dawn of the third office revolution, *Automation,* a collection of essays, edited by Morris Philipson, exploring the implications of automation in the workplace appeared.[11] The list of contributors included academics from various fields, politicians, business and union leaders. Herbert A. Simon, an economist, and Norbert Weiner, the founder of cybernetics, recognized leaders in their respective fields, contributed two of the most important essays. Simon's essay was a semi-futuristic conjecture of the major changes that would be visible in

9) Definitions and interpretations abound: for the sake of simplicity and space, here it is meant the convergence of electronics, computing, and telecommunications which is producing a wave of technological innovations in every field, and in every way we work, live, and think, if one is to take seriously the claims of the prophets of "artificial intelligence." See, for more information and the extensive bibliographical references, Forester, *The Microelectronic Revolution,* and *The Information Technology Revolution,* and the results of a five-year research by Alan Westin, et al., *The Changing Workplace,* and *The Office Automation Controversy: Technology, People and Social Policy* (White Plains, NY: Knowledge Industry Publications, 1985 and 1984, respectively).

10) See Etienne Grandjean and Enrico Vigliani, (eds.), *Ergonomic Aspects of Visual Display Terminals* (London: Taylor and Francis, 1980), and the extensive bibliographies in Marvin Sirbu, *Understanding the Social and Economic Impacts of Office Automation* (Cambridge, MA: The Japan-USA Office Automation Forum, 1982), and Quentin Newhouse, Jr., *Issues in Human-Computer Interaction* (New York: Garland Publishing, Inc., 1986).

11) Morris Philipson (ed.), *Automation: Implications for the Future* (New York: Random House, 1962).

the "corporation of 1985." "By 1985 the departments of a company concerned with major clerical functions – accounting, processing of customers' orders, inventory and production control, purchasing, and the like – will have reached an even higher level of automation than most factories." As for the impact on work and skills, Simon saw two lessons currently being learned in factory and office automation: "(1) Automation does not mean 'dehumanizing' work. On the contrary, in most actual instances of recent automation jobs were made, on the whole, more pleasant and interesting, as judged by the employees themselves, than they had been before. In particular, automation may move more and more in the direction of eliminating the machine assembly line task and the repetitive clerical task. *It appears generally to reduce the work-pushing, man-driving, and expediting aspects of first line supervision.* (2) Contemporary automation does not generally change to an important extent the profile of skill levels among the employees. *It perhaps calls, on the average, for some upgrading of skills in the labor force, but conflicting trends are observable at different stages of automation.*"[12]

Norbert Wiener's essay dealt with the moral and technical consignments of automation with respect to cybernetic technique and the social consequences of this technique.[13] Wiener started paradoxically by saying that, in the advanced industrial societies, machines are more "hazardous" than the ones of the industrial past, because they have invaded the fields of techniques and communication.

"I find myself facing a public which has formed its attitude toward the machine on the basis of an imperfect understanding of the structure and mode of operation of modern machines. It is my thesis that machines *can and do transcend some of the limitations of their designers and that in doing so they may be both effective and dangerous* . . . [If, as is the case] machines act far more rapidly than human beings . . . even when machines do not in any way transcend man's intelligence, they very well may, and often do, transcend man in the performance of tasks. *An intelligent understanding of their mode of performance may be delayed until long after the task which they have been set has been completed.*"[14]

The basis of current considerations on office automation and, more generally, on the social implications of new technologies were already laid down more than a quarter of a century ago. The main, if not the only difference, is that today we could fill many more pages simply listing the essays dealing with real or imaginary impacts of automation. Paradoxically, though, dispassionate assessment is no more possible now than it was in 1960, not because we do not know enough, but because we know too much without having a clear conceptual organization of this knowledge. Moreover, polarization between technological optimists and pessimists is even more pronounced now than it was 25 years ago.

12) See Herbert A. Simon, "The Corporation: Will it be Managed by Machines?," in Philipson, *Automation*, 237-238. Emphasis added.

13) See Steve J. Heims, *John von Neumann and Norbert Wiener: from Mathematics to the Technologies of Life and Death* (Cambridge, MA: MIT Press, 1980), and David Noble, *America by Design* (New York: Alfred A. Knopf, 1977), and *Forces of Production: A Social History of Industrial Automation* (New York: Alfred A. Knopf, 1984). A long review by Marco Diani of some of these works is in *Design Issues* II/2 (Fall 1985): 81- 85.

14) Norbert Wiener, "Some Moral and Technical Consequences of Automation," in Philipson, *Automation*, 163-164. Emphasis added.

Marco Diani

15) Michael L. Dertouzos, "Individualized Automation," in *The Computer Age*, 38.

16) Judith Gregory and Karen Nussbaum, "Race against Time: Automation of the Office," *Office: Technology and People* I/2-3 (September 1982): 197-236. For a comprehensive look at the major questions concerning office automation, in particular whether there are alternatives to the way office automation is being introduced in the United States today, see Daniel Marschall and Judith Gregory (eds.), *Office Automation: Jekyll or Hyde?* (Cleveland, OH: Working Women Education Fund, 1983), which reproduces the highlights of the "International Conference on Office Work and New Technologies" convened in Boston, MA, in October 1982.

17) See, among the very "classic" assessments, C. Wright Mills, *White Collar: The American Middle Classes* (New York: Oxford University Press, 1953), Michel Crozier, *The Bureaucratic Phenomenon* (Chicago: University of Chicago Press, 1964).

18) For recent assessment of their role, see Harry J. Otway and Malcom Peltu (eds.) *New Office Technology: Human and Organizational Aspects* (London: Frances Pinter, 1983), in particular Niels Bjorn-Andersen, "The Changing Role of Secretaries and Clerks," 120-137.

19) See Raymond Panko, "Office Work," *Office: Technology and People* II/3 (October 1984): 205-238.

Consider, for instance, the following two perspectives on the impact of office automation: "Given its technical and economic advantages, the impact of the information revolution on automation promises to be substantial. It is my contention that it will in addition profoundly affect the quality of our lives and will in fact reverse some of the impersonal and dehumanizing consequences of the industrial revolution,"[15] or, ". . . office workers are in a race against time to protect their futures. Unless clericals organize to influence automation in the 1980s – while the technology is still in its formative stages – the health, well being, quality of working life, and employment of workers will be sacrificed for the sake of 'corporate progress.'"[16] In both cases the issues under consideration are the same: the effects of office automation on total employment, ergonomic questions arising from long-term use of video display terminals, and the effects of the new technology on the nature of office work.

One other noteworthy feature of the literature devoted to office automation is the variety of totally conflicting conclusions and guidelines reported by various authors. On one hand, office automation is described as a great liberating agent and, on the other, as a device that will reduce human freedom. The changes in tasks, job profiles, relations among employees, the way the work is supervised, career paths and organizational structure, role of management and of designers, all these findings vary dramatically according to which authors one reads. This situation only contributes to the growing confusion in discussions of automation, confusion that is reflected in the vagueness of the terminology employed in order to define the "Office of the Future" and its functions.

What is an office? What is office technology?

Although the terminology reflects a confused state of affairs, one can begin to gain some insights by approaching the subject from various perspectives. Three main definitions can be isolated: (1) *White collar workers*, as exemplified by numerous classic works of social scientists and historians,[17] are those whose work is nowadays made to operate under conditions and circumstances which are close to factory conditions and follow highly structured work patterns.[18] (2) *Office workers*, given the fact that automation and artificial intelligence are widespread in commercial and administrative settings, need a greater amount of knowledge than those of previous generations to operate and interact with such equipment. In that sense, the term *office worker* does not represent, by far, the totality of people working in office circumstances.[19] (3) *Information/knowledge workers*, supersedes the rigidity of traditional analysis and statistical classifications but, in practical use, is charged with an optimistic overtone that prevents a better understanding of the changes in the nature of work and the structure of

20) See Paul A. Strassmann, *Information Payoff: The Transformation of Work in the Electronic Age* (New York: The Free Press, 1985).

21) To get an idea of the "misery of the theory," see the results of the 52nd Annual Forum of *The Office: Magazine of Management, Equipment, Automation* 105/1 (January 1987), which contains a cross section of readers' views, articles by industry leaders and experts in various fields.

22) Abbe Mowshowitz, *The Conquest of Will: Information Processing in Human Affairs* (Reading, MA: Addison-Wesley, 1976). See also data in Sirbu, *Understanding the Social and Economic Impacts of Office Automation*.

23) Raymond Panko, "Spending on Office Systems: A Provisional Estimate," *Office: Technology and People* I/2-3 (September 1982): 177-194; and Rob Kling, "Social Goals in Systems Planning and Development" in Otway and Peltu (eds.), *New Office Technology*, 221-237.

24) See August Cakir, et al., *Visual Display Terminals: A Manual Covering Ergonomics, Workplace Design, Health and Safety, Task Organization* (Chichester: John Wiley & Sons, 1980).

25) See, for all these points, Jonathan R. Wainwright and Arthur Francis, "Office Automation: Its Design, Implementation and Impact," *PR*, 13, 1 (Fall 1984); European case studies, providing a different perspective on the subject, are analyzed in Marco Diani and Sebastiano Bagnara, "L'Organizzazione nel carico di lavoro mentale," *Studi Organizzativi* 1 (Winter 1984): 156-167; Sebastiano Bagnara, "L'affidabilità umana dei sistemi uomo-automazione," *Studi Organizzativi* 3-4 (Fall 1985): 81-101.

26) See, for instance, "Office Automation and the Quality of Worklife" in U.S. Congress, Office of Technology Assessment, *Automation of America's Offices*, 125-168, also, for the extensive bibliographical references. More information on the European Scene in Otway and Peltu (eds.), *New Office Technology*.

27) Rob Kling, "Social Analysis of Computing: Recent Empirical Research," *Computing Surveys* XII/1 (March 1980): 61-110.

organizations.[20] These definitions are fairly well adapted for the first two office revolutions.

The misery of theory

The technical overtone that seems to dominate the debates on automation of the office, at least from a quantitative point of view, has largely to do with the tendency of manufacturers to introduce product and system changes at a very fast pace in an increasingly turbulent but rapidly growing market, thereby creating a difficult climate of competition and uncertainty where little space is left for experimentation and accumulation of shared knowledge. Among the users, i.e. the buyers of equipment, there are no tested directions to follow or "scientific" principles to adopt, and difficult and negative experiences seem to confirm that office automation by itself does not produce, as an inevitable result, substantial gains, either in productivity, in a higher quality of working life, or more effective organization.[21] One author advanced the argument that in excess of 40% of new information systems were failures.[22] This lack of shared and cumulative information is even more important when it involves the economics of office automation, most visibly on the cost-benefit aspect of introducing new technologies.[23]

A change in recent years

Facing increasing difficulties and lasting conflictual situations, experts have assembled a large quantity of research in recent years that can be considered scientifically more sound, even though it has been difficult to keep the focus of the quality identical in all its aspects. At the beginning, much attention was devoted to the most visible "effects" of office automation. The scope of this attention was limited, almost completely, to the introduction of video-terminals in the workplace, and with an emphasis on health and psychophysical well-being of workers.[24] Gradually, the focus has shifted toward the analysis of more social, psychological, and cultural factors such as: (1) how office work changes in nature and quality, (2) when and how people modify their own social identity to cope with "new" jobs and technological tools, (3) which skills and qualifications have to be abandoned and which ones have to be developed, and (4) what outcomes will result from different strategies of office automation in large organizations.[25]

Research into these new areas yielded unequal results. While research on ergonomic aspects of office automation succeeded in producing recommendations and even standards for engineers and system designers,[26] no such an outcome can be found when research on organizational and sociological impact is reviewed and evaluated.[27] Despite the large number of studies, there is no accumulation of "homogeneous" results, and a general consensus regarding their significance is lacking. This can be attributed to the fact that most case studies stressed peculiarities rather than com-

MARCO DIANI

28) See, for instance, Rob Kling and William Scacchi, "The Web of Computing: Computer Technology and Social Organization," *Advances in Computers* Vol. 21 (New York: Academic Press, 1982).

29) Federico Butera and Joseph F. Thurman (eds.), *Automation and Work Design: A Study* (Amsterdam: North-Holland Publishing Co., 1984).

30) See Chapter 4, "The Architecture of Complexity" in Simon, *The Sciences of the Artificial*, 84-118.

monalities. As a matter of fact, distinctions between short-term and long-term effects of the strategies adopted in introducing computer-based technologies in the office are often not taken into account. Therefore *a more complex and sophisticated theoretical framework is needed.*[28] It is still unclear to what degree the social conflicts which may arise, the type of negotiations and their outcomes, and the degree of the consensus reached depend on: (1) the technological choice of office automation; (2) the strategy of introduction of office automation adopted; and (3) the interaction between the two previous factors, as suggested by the socio-technical approach.[29] Knowledge is lacking about whether differential subgroups in an organization can be identified as a function of the "cultural attitudes" toward change in work organization and communication flows that accompany office automation.

The consequences of these various systems of unsophisticated office automation now seem clear: after the "great fear" of the social and economic consequences, and after the excessive theoretical visions of sudden and radical changes, very little room was left for experimental and alternative uses of the new technologies.

Five problematic areas and a new role for design

The "office" has to be perceived as a metaphor for a pervasive, highly integrated form of work. The architecture of complexity constitutes a challenge for all the social actors – scientists, producers, ergonomists, and users – involved in office design and use because conventional theoretical tools of analysis and methods of design are inadequate for dealing with the fundamental changes and unprecedented novelties characteristic of the third office revolution.[30]

Symbols without decision

Information, technology, and artificial intelligence now make it increasingly possible to formalize the knowledge and ability required for any one job, or, rather, any class of work, thus facilitating their integration in a program that can command a machine or a series of machines. The importance of this change does not seem to have been appreciated. The more the activities are planned in advanced and contained in information processes, the less need there is for human decision at every single phase in the formalization or execution of the work system.

The use of information machines entails an increase in new symbols, which are not only difficult to learn, but also call for a special effort to be attributed correctly to what they conventionally designate. The problem lies in the fact that for the moment we possess only new symbols but not a new language, which could develop only if, in the designing of information machines, we take into consideration human behavioral patterns and new collective cultures.

Office work then, despite its technological possibilities, becomes an activity based on simple, binary-type actions with stimuli-reactions and information-rules to apply, which are already contained in the information program. At all levels of power, responsibility, and integration of the office system, managers, technicians, and employees find themselves in charge of monitoring work in which human decision-making is less and less evident.

Abstraction and solitude

With information technology, most operations, procedures, and acts at work become abstract and immaterial. Thus, symbols, figures, and languages of a "varied nature" become the essential mediating factors between the workers, their work, and previous knowledge, and their very community, professional culture, and aspirations.

In addition to distinctions in category and other differences (in salary, company status, or career), the center of gravity in office work is shifting toward a series of functions which call for intensified mental and cognitive activity that can be called *cognitive mediation of work and of its social and organizational context.* Moreover, the stereotyped images of an intelligent, creative, and rewarding activity on the one hand, and of a repetitive and intellectually boring job on the other, are now giving way to a vision that is a hybrid product of the information revolution: despite job status and cultural differences, there now exists a series of tasks, both inside and outside the office, that are marked by the same standards, use the same symbolic mediation, and create the same sense of loss of identity when dealing with the intelligent processes of the machine.

The involuntary and paradoxical recomposition of work

Today machine and work procedures require not only a certain amount of mental commitment, which may vary with the complexity of the machines and the operator's knowledge and experience, but the ability to deal with a new component in the work load as well. The automation of the office has added a new "organizational load" to work, that is, a component dealing with the effects of the variables that define the organization of social relations and work in the office.

At the center of an ever-increasing number of office activities we find the processing, checking, and sometimes the analysis of symbolic data and mediating information produced by information-based systems. The borderline between jobs and their respective cultures now has a tendency to disappear, giving way to a much vaster group of activities in which the work is carried out in similar conditions, with processes of the same kind, content, and intelligibility, and, above all, in similar organizational contexts.

This recomposition of work, often presented as one of the promises of office automation, carries with it, however, an unforeseen consequence: one's perception of the conditions of work and the weight of the organization – once its "mechanical" and material side disappears – vanishes from immediate view, while the abstraction inherent in the new conditions of work alters one's psychological sense of the work itself. The work may indeed recompose with the new information technologies, but the meaning of each activity becomes murkier and more inaccessible, both for individuals and for the organization.

Cognitive pressure and accelerating tempos

Despite the widespread belief underlying much useless research into the social consequences of office automation, the process of symbolic abstraction and mediation of work is not an "unexpected consequence" but an intrinsic element in information technology. The alteration of the experience, content, and finality of a job takes place independently of the way in which the office system is conceived, planned, and introduced. The most dramatic example, perhaps, is the rapidity of access to information and the speed of its processing, which make possible a considerable increase in the number of operations and lead to an intensification of the work tempo. In addition, given the formalization and abstraction of the work processes inside programs, employees are now more isolated and often find it impossible to ask a colleague for advice or information.

Modifications in the social life of the office

A kind of silent revolution is now producing profound changes in the social life of the office as it affects the identity of individuals and groups. One of the fundamental bases of the ideology of work, therefore, may become nothing but an empty myth: the community (the work group), which is still absolutely necessary for the efficient running of an organization, is being detached from the technological base on which office work rests. The form of collective organization, inherited from a developmental phase and based on the need to gather in the same space management, machines, and workers, has now basically been compromised by the possibility of office automation. What will happen in the office, if, for example, employees no longer need or have a chance to mingle at the workplace, or if they no longer have any control of the deeper significance of both individual and collective work?

In such a context the new problems have shifted away from the positive and negative myths of office automation and are focused on how to plan and manage an organization and work which have become abstract for all three of the most important levels: the individual-cognitive, social, and managerial.[31]

31) See James W. Driscoll, "How to Humanize Office Automation," *Office: Technology and People* 1/2-3 (September 1982): 167-176.

32) A theoretical debate on the nature and the role of design in a period in which we move from "industrial" to "post-industrial" societies has started only in recent years. A future issue of this journal, *Designing the Artificial Reality*, will address some of these questions. See Patrick Whitney with Cheryl Kent (eds.), *Design in the Information Environment: How Computing is Changing the Problems, Processes and Theories of Design* (New York: Alfred A. Knopf, 1985); the special issue of *MODO* (English edition, May 1986), devoted to the "Changing Workplace;" the special issue devoted to "Design for the End of the Century," *Cahier du CCI* 2 (November 1986), Centre de Création Industrielle, Paris. The IInd International Conference *Ergodesign 86*, Montreux, October 21-24, 1986, was devoted to the integration of ergonomics, industrial design, and manufacturing in the "evolution of the electronic workplace." But this new "consciousness" is still very weak, and not very influential.

33) A list of these disciplines would normally "include engineering, computer science, industrial psychology and sociology, ergonomics, technology assessment, management science, economics, system science, social and economic history, political science, and probably others." See Howard Rosembrock, et al., *New Technology: Society, Employment and Skills* (London: Council for Science and Technology, 1981). Naturally the author concluded that there is no study in which the different disciplines are brought in contact with one another: "until this is done, the results obtained within a single discipline are likely to be highly misleading" (ibid). See also Jonathan R. Wainwright and Arthur Francis, "Office Automation: Its Design, Implementation and Impact," *PR*, 13, 1 (Fall 1984); Claudio Ciborra, "The Social Costs of Information Technology and Participation in Systems Design," in Ulrich Briefs, Claudio Ciborra, Leslie Schneider (eds.), *Systems Design by the Users, with the User, for the Users* (Amsterdam: North-Holland Publishing Co., 1983); Marco Diani and Sebastiano Bagnara, "Unexpected Consequences of Participative Methods in the Development of Information Systems: The Case of Office Automation," in Etienne Grandjean (ed.), *Ergonomics and Health in Modern Offices* (London: Taylor and Francis, 1984), and Marco Diani, Sebastiano Bagnara, Raffaello Misiti, "Participation in Technological Change: Are There Only Unexpected Consequences? The Case of Office Automation," in Hal W. Hendrick and Ogden Brown, Jr. (ed.), *Human Factors in Organizational Design and Management* (Amsterdam-New York: Elsevier, 1984).

34) Jacques Vallée, *The Network Revolution: Confessions of a Computer Scientist* (Berkeley, CA: And/Or Press, 1982), 208. In the same vein, see the influential book by Joseph Weizenbaum, *Computer Power and Human Reason* (San Francisco: W. H. Freeman, 1976).

Prospective conclusion: a new role for design

New horizons appear from the standpoint of office automation and, after the "great debates" on the nature and the consequences of technology mentioned earlier in this text, the role of design will dramatically increase in the next few years, expanding its importance and thus requiring substantial changes in the nature of design.

If the main characteristics of the new technologies are their pervasiveness and their adaptability, then office work becomes the dominant structural form of work in post-industrial societies. Rapid technological change from human-, or machine-mediated work to computer-mediated work leads to changes in how workers adapt to their particular work environment. Concomitant with these technological shifts are societal and cultural transformations from industrial to post-industrial societies, reflecting changes from a society based on manufacturing and producing material goods to a society based on a service economy, i.e. non-material goods.[32] Under these new conditions, to design immediately becomes a more complex and multidisciplinary operation than in the recent past: what is, in fact, to be designed? Chairs, screens, or keyboards, as "traditional" ergonomics continues to do? Spaces and buildings, as architects have been doing increasingly in the last ten years, proclaiming, through the postmodernist vulgate their farewell to the remnants of our industrial societies? Who is going to decide on the content, mode of access and operation of programs and procedures that are the basis for so many organizations? What kind of competencies are going to be required to design working spaces, processes and products that are eminently cognitive and immaterial?

These questions call for a new science of design, resulting from interdisciplinary research, with contributions stemming from many different disciplines,[33] to manage the architecture of complexity which is the most important and vulnerable element of a society dominated by computer-mediated work. This new science of design must address more than problems of production because "the real problem is much larger than making offices more productive. The real problem is to decide right now which human quantities and freedoms are worth fighting for and which ones are not. Because, when we are through with this digital transformation, there won't be a stone left standing on another stone of our social edifice. There may still be a future, but there won't be an office to put in it."[34]

Abraham A. Moles

The Comprehensive Guarantee:
A New Consumer Value

The function of design must of necessity follow the development of industrial society, in other words, respond to its latent needs. Conventional designers can be considered timid, because they have accepted the role of auxiliaries to production. They remain intermediaries between consumers and producers, interpreters of specifications that have mainly been drawn up by other people.

An increasing number of people, influenced by such diverse personalities as the psychologist B.F. Skinner, the architect Richard Neutra, and the late art critic Gregory Battcock, agree that modifying the environment can strongly influence behavior. Acknowledging the extent to which the material features of the environment condition a person's behavior more definitely in philosophical terms, it remains clear that any manipulation of this environment is therefore a manipulation of the individual. This being the case, the person who fashions the environment and solves the equation between desirable behavior patterns and the setting in which people act attains a position of power as great as that of the politician.

On the other hand, designers have been able to retain a large degree of intrinsic autonomy when interpreting functional constraints and translating them into forms, if only because this process has never been subjected to malicious interference by the social body. Many philosophers and moralists have shown a concern for politics; very few have concerned themselves with design. In their minds, designers are mere actualizers or draftsmen giving material shape to ideas generated elsewhere. In reality, through ergonomics and experimental esthetics, designers have taken the burden as well as the hazards of demarcating the boundaries of the individual universe in the field of everyday life, thus ensuring at the very least a de facto technical analysis of these issues. In fact, designers have become a "demiurge," not only interpreting human values but also giving them concrete form.

Designers' tasks can be divided on the basis of simple criteria, the most important of which is the relationship between the various aspects of the environment and the individuals who interact with them; in other words, the proportion or the size of things that will be incorporated into the personal world of humans. The

following categories can be distinguished:

- *Design of individual objects*, which can be manipulated by human beings
- *Design of the setting* (what fashion magazines call everyday decor): the totality of the material objects that enclose individuals in a personal shell
- *Design of large-scale systems*: urban or work environments, the design of which were formerly the task of architects and urban planners.

Heretofore, what has been the traditional function of designing objects such as office lamps, potato grinders, typewriters, or furniture, and the underlying basis of design education is no longer important. Rather, we need to consider the design of the total environment that is attached to the successive and perceptible "shells" enclosing individuals at every moment and determining their relation to the world.

In short, designers are no longer creators of *objects* but of *environments*. The design task is to reconceptualize the various external shells that surround human beings in order that a means of deriving the greatest possible satisfaction from their position in the world and the possibility for attaining a specific quality of life is not made more and more remote. The latter is a concept that economists attempt to measure and politicians consider essential to justify their leadership.

This new task is more universal in function than the traditional analysis of an object's suitability or unsuitability for a given use. It requires a *dynamic analysis* that is related to the entire series of actions that the object has prompted in its users and to the object proper only in a subordinate way. Each of these actions reflect an overall *cost*, including the time spent, the bodily energy wasted, and the mental energy mobilized in concentrating on the object for its proper use. The planner's task then is to relate various cost aspects to the whole series of components of a global act (*actomes* in the terminology of a science of actions) that are verifiably connected with the object for the purpose of enabling individuals to change the outside world in their way.

The general cost of an action performed with an object

The performance of any action to obtain or use an item forces people to draw upon their vital energies. To acquire an object, to bring it into one's own sphere, the person must usually spend money, but this is not the only resource to be controlled. One must likewise incur a certain "general cost" (see figure). These costs are revealed by ergonomic analysis which demonstrates the consumption of time and physical energy involved in an action. Micropsychological analysis has shown that any action implies a call upon human psychological resources, as well. Thus, in order to purchase a coffee grinder, the consumer must expend:

- The cost of the product as it is determined by economists' con-

ABRAHAM A. MOLES

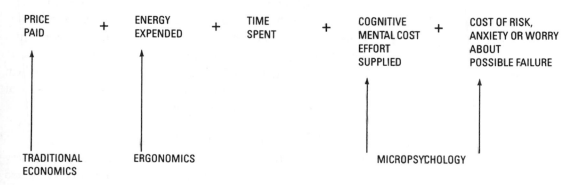

PRICE PAID	+	ENERGY EXPENDED	+	TIME SPENT	+	COGNITIVE MENTAL COST EFFORT SUPPLIED	+	COST OF RISK, ANXIETY OR WORRY ABOUT POSSIBLE FAILURE
TRADITIONAL ECONOMICS		ERGONOMICS				MICROPSYCHOLOGY		

cepts of the fair price

- The time needed to visit the store, make the purchase, and return home
- The often overlooked physical energy needed to make this trip: walking to the store, or going to the garage for the car, plus the effort, even if very slight, to drive it and to carry the product home
- The mental effort of making a choice, reaching a decision, learning how to operate a new device, and so forth
- A new source of worry, as the philosophers of alienation have clearly demonstrated, that has varying degrees according to the particular individual.

This example of purchasing a coffee grinder can be worked out numerically in specific cases. Market specialists, design analysts, and ergonomists can play a considerable role here. But this is not the chief purpose of the present analysis, which is to enumerate the heterogeneous elements of a situation which influence the individual's appraisal of it.

Every object can therefore be defined by the total actions it triggers, these bringing to the users some gratification of needs — to use behaviorist language — while implying the expenditure of resources (the cost, in its proper sense).

Most of the time the difference between *general benefit* and *general cost* constitutes what is called the *motivation* of an action. This simple though often criticized doctrine is only superficial insofar as the concepts of cost and benefit are themselves defined superficially, as they were in nineteenth-century economic theory.

In the coffee grinder example, a general cost was ascribed for *obtaining* it, then a general cost for *using* it, and possibly other costs for such requirements as cleaning, fitting the parts again, or putting it back on the shelf. Were this object, fallible as with every manufactured product, to break down, then the owner would become for a moment the servant of this very object. People switch their role from imposing deliberate acts on a mechanical slave (for example, automobile or coffee grinder) to that of being a temporary slave of the object itself, insofar as one considers the

object to have no purpose other than its function and therefore no status in one's personal environment unless it functions properly. (I leave aside the so-called esthetic function of broken clocks, which aroused Voltaire's irony, because these only represent a shift of the functional role to the esthetic one.) People are therefore provisionally forced by the objects they own to repair them or find substitutes for them, consequently to take some sort of action, thus incurring another general cost.

The minimal general cost of breakdown

At a time when the society of production has turned into a society of services, compensating strategies, although always very limited in extension in comparison to the manifold actual situations that can occur, are needed. Such a strategy would require some of the following components:

- Mobile breakdown and repair squads
- Systematic collection of the defective object at the owner's home and proper delivery after repair
- Guarantee of replacement of defective parts
- A more extensive guarantee, including the labor required to repair the item
- Guarantee of replacement with an identical object to compensate for the loss of the object's use and damage caused
- Payment of the consumer's "price for time" for disturbance of the individual's "life project"
- Full guarantee of preventive maintenance for a duration known as the "insured period of life" of the article.

A concept that would sum up the above-mentioned modalities could be called properly a *total* or *comprehensive guarantee*. In fact, with its full extension, such a guarantee seems unusual and is practically never achieved.

Such a guarantee has social consequences. Future competition between manufacturers or suppliers could concentrate on these *compensation strategies*, which are related to the function of the object as an incentive for buying, rather than on the *price* of the goods. This latter approach reflects too narrow a concept of the role of mass-produced objects as they relate to the resources and the possibilities of the users.

The *comprehensive guarantee* clearly stresses how the quality of life is impaired by the failure of a particular tool or object. At present, the trend is to further impair the safety and permanence of the environment by tying the lost costs required for competitive mass production to a progressive lowering of the quality of raw materials used. In addition, this tendency is furthered by tying the lost costs to the disappearance of a step that is called *finish*, a process that implies the direct action of a skilled worker to adjust the product to its functional specifications. In this way, large manufacturing companies have reduced their prices by surreptitiously shifting some of the burdens that are bound to the use of complex

ABRAHAM A. MOLES

mechanical or electronical objects from their shoulders to those of the user. The user must take action if something goes wrong with the article, and this occurs with increasing probability. Due to the complexity of technical objects, the user is less and less able to react, except by going to the repair shop i.e. entering the clumsy process described above. This situation is aggravated by the fact that the location of the repairshop can be rather remote and, increasingly, today's complex machinery is covered by a casing which is more and more difficult for the common user to penetrate. One could say that a greater psychological distance has been introduced between the working apparatus inside the casing and the person who is supposed to master the object's use.

Faced with these social and psychological obstacles, which have been generated by the advent of more technologically based objects, the society of industrial complexity has invented a basic psychoeconomic device, the guarantee. In fact, a guarantee is the manufacturer's promise to service and repair the objects that it manufactured. This concept was practically ignored in the Third World until recently, and it has grown in connection with the concept of insurance.

We know that this is a promise of enormous psychological value, even if it often amounts to very little in practice. The word *guarantee* has a magical resonance and thus appears often in the sales literature of manufacturers.

In fact, scared by the very idea of the subsequent responsibility and the host of objects for which it will be held responsible, many of which could possibly be returned at any moment, the manufacturer has done its utmost to take back (in the small illegible lettering of the sale's contract), most of the things offered the customer (in large lettering in publicity), thereby attempting to allay its own fears.

Manufacturers have also been very successful in this shrinking of the guarantee with a series of gimmicks such as replacing faulty parts but charging for the labor costs (the main factor), or locating the place where the guarantee contract is actualized far from the place of present use, thus increasing the general cost of access to it and achieving an effect of systematic dissuasion. Behind this word *guarantee*, therefore, are accumulated several possible steps of restriction, the most important of which is certainly the unavoidable general cost incurred by the customer in order to benefit from the guarantee itself.

Rationale for a comprehensive guarantee

The concept of a comprehensive guarantee arises quite simply from the above remarks. When consumers purchase an object, they purchase the function of the object, as well. The consumers thus acquire a new field of possibilities. Inclusion of this new function in their environment thereby expands their personal universe in such a way that they tend to believe it is permanent or, at the

very least, has an extended life expectancy. People in industrial society no longer purchase things, but rather, an extension of their own personal power, whether it be for grinding coffee with a motor, driving a car, or conserving food.

The comprehensive guarantee will therefore be a contract attached to the bill of sale whereby, in return for the purchase price, consumers subscribe to a comprehensive "insurance" covering the future of the tool in its relation to themselves during a given period, which in practice represents the larger part of the probable life of the object.

Accordingly, such a guarantee is composed of:

- The supply of parts recognized to be faulty, or the supply of any conveniently substituted article
- The free replacement of these parts (labor guarantee)
- The compensation for deprivation of enjoyment, by replacement of the article with its functional equivalent during the period of repair
- The assumption of the general cost implied by the disturbance caused by any unspecified incident within the purchaser's personal sphere, including the unexpected waste of some part of his "time-budget"
- The reimbursement for the cost of the specific risk arising from uncertainty as to how the object should be properly used.

These aspects of the guarantee extend the concept through progressive stages to all aspects of the object's role in the private world of the individual.

Of course, most of these aspects have been covered in practice and from time to time for certain types of expensive industrial products, such as automobiles. But the remaining options are very rarely taken into account, except in very special forms of industrial negotiations (military contracts and sales modalities with a foolproof insurance of good functioning), and they are totally ignored in day-to-day producer-consumer transactions.

For example, a person with a bill of sale, acquires a color TV. This person has devoted some of his vital resources, less to a gleaming box than to the wonderful possibility of gaining an infinite source of information, entertainment, and esthetic pleasure through the display of colored pictures. For this person, the replacement of defective parts by the manufacturer is certainly a factor of self-assurance in the face of the staggering complexity of an electronic miracle. However, this replacement *demands* an amount of labor that the consumer is incapable of assessing and that, therefore, is beyond his scope of vision. Furthermore, to be deprived during the repair period of a way of life that has been deliberately chosen means that damage to one's lifestyle is suffered, and this damage can only be compensated for by the supply of a similar apparatus to replace the one in the repair shop. Again, owing to the disturbance of the consumer's normal flow of life (through the object's unexpected disappearance), the telephone

expenses, the costs of various errands, and the cognitive cost of putting trust in the merchant, the repairer, and the installer, the effective personal costs of problems arising in any object of the environment can seem *enormous* in relation to the commercial value of the object itself. These costs should be taken into account, for each represents an expense that micropsychology claims to be computable or, at least, possible to estimate, but which advertising interests pretend are included in the net price of the article.

Analyses conducted at the Institut de Psychologie Sociale des Communications concerning the diversity of goods show that the very concept of "repair," on which the foregoing description is based, is inadequate, for it implies that a breakdown can range from a regrettable incident to an extraordinary accident. When imagining such a range of consequences, the supplier of a comprehensive guarantee must substitute the concept of a *maintenance* process for one of repair. Nuri Bilgin has shown that maintenance behavior is, psychologically, the very opposite of repair behavior and that it implies a different structure of the industrial world. [1]

1) Nuri Bilgin, "From an Industrial Society to a Maintenance Society," *Impact of Science on Society* vol. 30, no.2, (1980): 121-132.

The idea of a comprehensive guarantee therefore leads to a redeployment of industrial production and distribution activities and to a complete revision of the very concept of service. It entails transferring labor, withdrawn from automated industries, to aftersale services. Among other consequences, this implies:

- The disappearance of the manufacturing gimmick known as planned obsolescence, which has been vehemently denounced by philosophers of industrial society such as John Kenneth Galbraith.[2] Indeed, it is no longer in the manufacturers' interests to inject flaws or weaknesses into the articles they sell, if they have to guarantee the efficiency anyway

2) See John Kenneth Galbraith, *The Affluent Society* (Boston: Houghton Mifflin, 1958), 295ff.

- Continuous service, that is the permanent presence of a technological environment surrounds the individual as a basic condition for a better quality of life
- The replacement of creative repair with preventive maintenance, that is, systematic control that eliminates the causes of breakdowns before they occur.

A secondary phenomenon will then develop. Stocks of goods that have already completed their guaranteed life duration, through the comprehensive process insured by the manufacturer and the salesperson, may still be in good shape and thus usable in a new status. The risk will be to the user, who will then take responsibility for the repair or renovation either by himself or herself (do-it-yourself, spare-time work) or by paying an expert repairer. This extends the idea of "second-class" products, in a second market, which nevertheless regulates the first one by its very presence. In this new cycle of goods, where elaborate design must play an essential part, the net input of raw materials will become greatly reduced; in other words, a technological civilization applying the comprehensive guarantee would noticeably reduce its consumption of raw materials in conformity with ideas

expressed by the Club of Rome and by some ecological movements.

Wider social consequences

The concept of a guarantee extended to all the aspects of detrimental costs incurred as by-products of using an object is simple in essence and almost commonplace. It creeps in as a mere extension of an already well-known concept, whereby the manufacturer offers an additional bonus to customers to increase the attraction of the sale and the confidence in the tool and its performance. Indeed, the manufacturer knows that it has to counterbalance this increasing complexity of industrial goods, which is dimly sensed by consumers, with a type of protection specifically bound to this new feature of the object in modern technological mass production.

After a more thorough analysis of the functions of objects in the human world, we see that successive extensions of this concept lead to a profound change in the very nature of our relationships with industrial goods. These changes are so deep and insistent that the concept itself becomes *subversive*. Carried to the limit implicit in micropsychological analysis, such change calls into question the very idea of industrial society as we know it. It suggests a transformation from a society that supplies goods to one that supplies services centered on goods. It is no longer a question of perfecting the supply of goods, but of changing the relationship between *homo faber* and *homo economicus*.

Primitive humans, acting as a part-time crafters, had complete control over the objects or tools they used to extend their range of capabilities. They made tools and decided when they were beyond repair, worn out and ready to be thrown away. Citizens of industrial society are confronted with objects, not their own handiwork, produced in distant places and injected into a sphere of life that is foreign to them. The intrinsic structural complexity and the manufacturing techniques that produced these objects put them beyond the consumers' powers of intervention. To consumers, the objects are "strange," beyond individual comprehension, and there is no control over them other than proper use. Industrial production draws a sharp distinction between *functional* knowledge, such as, "It is made for . . . ," and *structural* knowledge, such as, "It is made of" Part of this distinction is symbolized in the image of the sealed casing that separates by a legal convention (the wax seal of the manufacturer), the internal structure of the object from the exterior and its functions, thus creating two distinct realms in the object. The industrialist holds sway over the inside of the casing while the purchaser, as supposed owner, holds sway over the outside. The result is a divided kingdom.

Thus, since the industrial age, human beings have invested in the future through the purchase of objects that, as tools in the environment, hold out the possibility of a new functional power. They make possible the performance of actions larger and more sophisticated than previously. At the same time, people mortgage

ABRAHAM A. MOLES

their futures. If the product breaks down and the expenditure of effort seems worthwhile (for example, typing a text, measuring the time, traveling by car), by the desire for coherence with their surroundings, they feel impelled to repair it, put it in order, and thus restore the level of possibilities on which they had built a mental picture of "themselves in the world."

In contracts of industrial guarantee, there is an intermediate step: the idea of a fixed period for services, crystallized by a written paper and signed at the moment of the sale. The appended contract of guarantee always implies a specific time limit, that is, a date technically linked to the normal wear and tear of the product. In doing this, the manufacturers are wise. Statistics tell them that the watches, calculators, or cameras, even when not mishandled by consumers, do not last forever, but have a mortality or, at any rate, a morbidity ratio. Conversely, they know that all these objects have a *probable* period of life and reliability. For this they draw up firm statistics about the product. The consumers, on the other hand, know little or nothing of the nature of the statistics on which the manufacturers have based their policies. What consumers would like to believe — and what the whole market society encourages — is that the object is eternal, and only by adjusting one's reason can this illusion be disbelieved.

It is interesting in this respect to imagine what the role of consumer groups will be in promoting or limiting this desire for "relative eternity" in a social context that also has to take into account the new concept of the duration of objects for a definite period of life. This concept replaces the illusory idea of everlasting objects and the limitation of the waste of raw materials.

Because humans are incapable of building for eternity, it is obvious that the comprehensive guarantee must, at the start, be established for a fixed time limit. This limit must be generous in relation to expected use (indeed another basic axiom of the modern world is perfectibility of products, that they must be changed from time to time), but it must also allow for its own safety margin in light of breakdown statistics. In short, even with due maintenance, the guarantee cannot stretch out the life of the product indefinitely. By broadening the separation of powers between the manufacturers or repairers and the users, the very existence of this guarantee implies a *division of the very concept of property*. Assuming that such a contract of comprehensive guarantee exists, this implies that, for a certain length of time, manufacturers will supervise the objects sold, maintain them in good working order, and, in the case where the product breaks down despite this maintenance, provide an after-sale service and compensation for the loss of enjoyment incurred. In short, the manufacturer takes full responsibility for the entire functional life of the product, for a definite period, that begins when it enters the life world of its owner.

It is worth stressing again that the very idea of planned obsolescence, whereby manufacturers deliberately introduce latent

deficiencies in order to shorten the life of the product (with the idea of creating a need for replacing it and therefore bringing customers back into the market), is no longer valid. Why should a manufacturer who has guaranteed a product for a definite period create further causes of trouble when they come under his responsibility?

On the contrary, manufacturers should endeavor to limit all after-sale services by increasing the basic quality of the product at its initial stage, knowing that after-sale servicing is among the most costly investments. More subtly, their target for determining the quality level for a product's prospective life duration so that it can be properly insured, or reciprocally, of determining which life duration they can safely afford to guarantee without going bankrupt, should adjust the actual fault probability curve to the life duration for which manufacturers take responsibility. Although the curve of incident faults is well known in industry, a lot of new developments in research will be required to achieve this aim.

Insofar as consumer movements are calling for a progressive extension of the guarantee period, production faces a new set of circumstances. In a society where the manufacturer is made responsible for product servicing, he will try to engineer a system that provides an increased security of use or effective reliability.

The products that are leased or guaranteed must be checked, handled, and modified only by a network of repairers who are approved by the manufacturers, and serve as their representatives. On the other hand, the customers are more and more consumers and less and less owners in the conventional sense. There is no acknowledged right to change or interfere with the internal structure of the objects, unless the customers want deliberately to break the contracts that bind them to the producer. The inside and outside are therefore separated by a sacred frontier. The seal of guarantee is inviolable and, in a certain sense, secret. A similar evolution has taken place in the relationship of human beings toward their own bodies, the insides of which have progressively passed entirely under the jurisdiction of the medical profession.

The very concept of ownership must thus be matched with another concept, that of leasing, whereby ownership is only ownership for use, a functional ownership with a time limit (the leasing contract), but precisely with the same behavioral characteristics. Why then own objects, in the traditional sense, when ownership is only partial and limited by a major contract whereby individuals exchange some of their rights of misuse for a right to security (*jus abuti*)? What is the actual interest in purchasing products rather than leasing them inasmuch as the type of functional service they provide, at least for industrial products, is more or less the same? A world of rent, in which the very concept of property ownership becomes superfluous, can be envisaged.

Here a psychological conflict emerges. For the basic concept of ownership, the *jus uti et abuti* of Roman law, is deeply embedded

ABRAHAM A. MOLES

3) See Konrad Lorenz, *King Solomon's Ring* (New York: Crowell, 1952); Robert Ardrey, *The Territorial Imperative* (New York: Atheneum Press, 1966); and Abraham Moles, *Psychologie de l'Espace,* 2nd ed. (Tournai: Casterman, 1977).

in the very fabric of our societies, so deeply that ideologies that have tried to get rid of it have been obliged to come to terms with it. Indeed, psychological analyses, as well as psychoanalytic investigations, confirm that behind the concept of ownership of an object lies the more fundamental concept of *territorial imperative*.[3] Being human is to hold sway over a fraction of the world, however tiny, and the term *dominion* almost coincides with being in the world, expressed by the German term *Dasein*.

How can human beings come to terms with the very idea that, within their *Lebensraum* or personal sphere, there are subsidiary spaces that are removed from their authority? Which invisible spies could the industrial social power inplant in these subsidiary territories placed out of control by the new social contract? There is a source of conflict between the rational level — that of contracts, arrangements, and conscious interests — and the vehicles of human beings' rootedness in the world. In the end, a sacred element (sacred in the sense of inviolability, of threshold of mystery or imposition), which is of scientific origin, is injected into the private and personal world of dominion. It is born of technology and knowlege and is reflected in the frontier drawn between the specialist's field inside the casing and that of the outside part, which is the domain of the user.

The idea behind an absolute guarantee has, admittedly, little impact insofar as it becomes the exception rather than the rule. More precisely, to influence our way of life, it must represent the *dominant* mode of existence of goods, thus changing our mentality and behavior. This is not the case now. As shown above, if manufacturers plan a time limit on guarantees, they do so with a margin of error; they choose, by and large, a guarantee duration substantially shorter than the probable lifetime of the product. In fact, most, but not all goods, will obviously last longer than the guarantee period. They will survive and thereby become *second-rate* objects which, by definition, are devoid of guarantee. This is very clear, for example, in the secondhand car market where a multitude of cars have now lost their sacred character, being subject to do-it-yourself and secondhand repair mechanics, who play an enormous role in the United States or, in quite a different social context, in the developing countries. True, this is a problem of the future that is only enhanced by the comprehensive guarantee concept, but it might well become important and to a certain extent, influence designers of the future.

The important point raised here is that a comprehensive, functional guarantee is attached to the functions that it generates, not to the material object, thus calling up the vision of a society of functions rather than of objects that support them.

This implies a reconversion of the role of production itself vis-a-vis consumption, and it is obvious that the very image of the industrialist will undergo profound change. The growing emergence of consumer power inevitably means a demand for a

more and more comprehensive guarantee offered through the successive steps outlined above. As a result, there will also be a change in the idea of function whereby designers will need to take into account the micropsychological analysis of the object/user binome and deduce from each aspect of this interaction not only the conditions in which the object will fulfill what was traditionally called its function, but also the conditions of its permanence with respect to the role it is to play in the life of the user.

Designers find themselves becoming the scientific trustees of this role. It is by no means certain, in fact it is obviously unlikely, that industrial producers will agree without resistance to new forms of specifications that stretch their social role far beyond their present capacities. Such conceptions, even favored by the consumer market, would oblige producers to master all branches and aspects of the life of products in society, a task for which they are not actually prepared, even if, within a general conception of economy, "there is money in it." The confrontation between manufacturing power and the new consumer power is at all events the social nub of the new role of designers.

ABRAHAM A. MOLES

The Interpretation of Design

Richard Buchanan

Declaration by Design: Rhetoric, Argument, and Demonstration in Design Practice

Introduction

If one idea could be found central in design studies, it most likely would be communication.[1] Directly or indirectly, this idea and its related themes have animated more discussion of design theory and practice than any other. I refer not only to graphic design, where communication is an obvious goal and where the concepts of classical rhetoric are now being applied with promising results,[2] but also to the larger field of design, which ranges from industrial and product design to architecture and urban planning and for which there is no unifying theory of rhetoric. Although not so obvious at first glance, the themes of communication and rhetoric in this larger field exert strong influence on our understanding of all objects made for human use. Consider, for example, the numerous historical, sociological, esthetic, and cultural studies of design in recent decades: they are not obviously rhetorical, yet when dealing with the influence of designers and the effects of design on an audience of consumers or society at large,[3] move deeply into the domain of rhetoric. Similarly, these studies also involve a significant rhetorical component when they are concerned with the process of conceiving designs; the influence of a designer's personal attitudes, values, or design philosophy;[4] or the way the social world of design organization, management, and corporate policy shapes a design.[5] In addition, when studies of the esthetics of design treat form not only as a quality valuable in itself, but also as a means of pleasing, instructing, and passing information,[6] or, indeed, as a means of shaping the appearance of objects for whatever intended effect,[7] these studies are rhetorical also because they treat design as a mediating agency of influence between designers and their intended audience.

Ironically, a unifying theory of rhetoric remains surprisingly unexplored and, at the same time, most needed in the larger field of design, where communication is at least as significant as in graphic design. It is needed, first, because of the growing importance of technology in the twentieth century and the increasing distance between technologists and designers.[8] There is a general attitude that technology is only an applied science, rather than a part of design art, and this approach has led many to abandon hope

1) "Communication" is an ambiguous word often used casually and without regard to its many useful and sometimes conflicting meanings. This essay, is concerned with communication as rhetoric, the inventive and persuasive relation of speakers and audiences as they are brought together in speeches or other objects of communication. This is in sharp contrast, for example, to recent semiotic · theories of communication, which are essentially grammatical theories concerned with a system of natural or conventional signs and the meanings stored in them. It is also in contrast to Marxist or other dialectical theories that regard communication as significant only in relation to some economic or spiritual truth.

2) Gui Bonsiepe, "Persuasive Communication: Towards a Visual Rhetoric," in Theo Crosby, ed., *Uppercase 5*, (London: Whitefriars Press, Ltd., 1963). Gui Bonsiepe, "Visual/Verbal Rhetoric," *Ulm* 14/15/16 (1965). These are valuable early explorations of the theme, but more strongly influenced by semiotics than rhetoric. See also Martin Krampen, "Signs and Symbols in Graphic Communication," *Design Quarterly* 62 (1968): 3-31. An entire issue of *Icographic*, edited by Victor Margolin, is devoted to the theme "Persuasive Communication." See *Icographic* II/4 (February 1984). See also Hanno H. J. Ehses, "Representing Macbeth: A Case Study in Visual Rhetoric," *Design Issues* I/1 (Spring 1984): 53-63. This is a useful case study of invention in graphic communication, although it is limited to figures of speech and the grammatical viewpoint of semiotics.

3) Jonathan M. Woodham, *The Industrial Designer and the Public* (London: Pembridge Press, 1983).

4) Nikolaus Pevsner, *Pioneers of the Modern Movement, from William Morris to Walter Gropius* (London: Faber and Faber, 1936). See, for example, the chapter on "The Engineers of the Nineteenth Century." This book was subsequently published as *Pioneers of Modern Design*.

5) John F. Pile, *Design: Purpose, Form and Meaning* (New York: W.W. Norton and Company, 1979). John Heskett, *Industrial Design* (London: Thames and Hudson, 1980).

6) Pile, *Design*. See chapter 5, "Communication through Form."

7) David Pye, *The Nature and Aesthetics of Design* (New York: Van Nostrand Reinhold, 1978). Pye defines design as the art that "chooses that the things we use shall look as they do..." (p. 11). This is especially interesting when seen in the context of the long tradition of rhetoric as an art of appearances. Inevitably, Pye has committed himself to setting forth rhetorical criteria for good or proper appearance, involving taste, style, beauty, utility, and so forth.

8) The education of designers and technologists today often deepens the division. More effort is needed to develop an integrated philosophy of design education suited to the complex role of design in the modern world. See, for example, Tomas Maldonado, "Design Education and Social Responsibility," in Gyorgy Kepes, ed., *Education of Vision* (New York: George Braziller, 1965). See also Kenneth Frampton, "Apropos Ulm: Curriculum and Critical Theory," *Oppositions* 3 (May 1974).

9) Pile, *Design*, 2.

10) Such criticism is, of course, better developed in architecture, but too often lacking in other areas of design practice.

11) Grammatical theories often regard communication as the transfer of a state of mind from the speaker to the audience — a passing of information and emotion. However, rhetorical theories tend to regard communication as an invention of arguments (logical, ethical, or emotional) that induce belief or identification in an audience. The difference may seem slight, but the consequences of each approach are significantly different.

that technology can be seriously influenced and guided by human values and a discernment of beneficial ends in the human community. A suitable theory of rhetoric in design would be one in which technology is viewed fundamentally as a rhetorical problem, integrated within the perspective of a broader design art, however radical that may seem to technologists. The theory would suggest productive ways in which closer connections between technology and design art could be established.

As important as this is, however, there is a second reason why a theory of rhetoric in design is needed at this time. The classic concepts of design have been abandoned recently by many designers in favor of unruly, antagonistic, bizarre, or often inexplicable concepts that challenge and confuse the general public, as well as the field of design. Examples might include "punk" fashions, Memphis furniture, or the architectural designs of Arquitectonica in Miami. In almost every area of design, we encounter objects that have a strange and startling unfamiliarity that may provoke or even repel us. Although such reactions may suggest that the public lacks critical awareness about the nature of design, they also indicate a new weakness in design communication. John Pile contends that many people will accept any product simply because it is offered as the fruit of technological advance, whether or not it is well designed.[9] Nevertheless, there are also many who care about the products that surround them and who are thoughtful about the influence and the power of objects to enrich or impoverish the quality of their lives. For these people, the accepted forms of design communication may seem to be breaking down or designers may seem to have little interest in seriously communicating with the public. A suitable theory would be one in which the puzzling diversity of design communication as we encounter it in everyday products is made more intelligible, providing the basis for better public criticism and evaluation of design.[10]

The need for a broad theory of rhetoric in design was less urgent when technology seemed to be under rational control and designers worked within a generally accepted view of the way design should function in a well-ordered society. But now, as technology becomes increasingly specialized and isolated from design practice and as designers have so many conflicting and confusing opinions about their own practice, the need has special urgency. To bring these problems together in a single, comprehensive theory is a difficult challenge, but one that explains better than any other the rise of design studies as a serious field of inquiry.

Design as rhetoric

Communication is usually considered to be the way a speaker discovers arguments and presents them in suitable words and gestures to persuade an audience.[11] The goal is to induce in the audience some belief about the past (as in legal rhetoric), the present (as in ceremonial rhetoric), or the future (as in deliberative or

RICHARD BUCHANAN

political rhetoric). The speaker seeks to provide the audience with the reasons for adopting a new attitude or taking a new course of action. In this sense, rhetoric is an art of shaping society, changing the course of individuals and communities, and setting patterns for new action.[12] However, with the rise of technology in the twentieth century, the remarkable power of man-made objects to accomplish something very similar has been discovered. By presenting an audience of potential users with a new product — whether as simple as a plow or a new form of hybrid seed corn, or as complex as an electric light bulb or a computer — designers have directly influenced the actions of individuals and communities, changed attitudes and values, and shaped society in surprisingly fundamental ways. This is an avenue of persuasion not previously recognized,[13] a mode of communication that has long existed but that has never been entirely understood or treated from a perspective of human control such as rhetoric provides for communication in language.[14]

We all have a share in the natural impulse to make things for practical use, to make objects that will use nature to work for our purposes, but Aristotle's remarks on the rise of rhetoric as an art of persuasion have relevance to the art of design.[15] He points out that all humans have a share in rhetoric because all attempt to persuade one another of various ideas and beliefs. Yet, some do this randomly and by chance, whereas others do it out of familiarity and the kind of habit that arises from experience. But it is precisely because persuasion can be achieved in both ways, that it is possible to find the reasons why some efforts are successful and others are not, and, thus, the art behind successful persuasion can be discovered. A similar pattern may be suggested for design. Some designers have the familiarity and habit of craftspeople, specialized in working with different materials or meeting specific needs; others have the experience of scientific understanding that has enabled them to identify opportunities for practical applications of their knowledge. But because both avenues of design are possible today, we have a better perspective from which to identify the elements of art common to all the variations of design practice and to recognize design as something distinct from the labor of manufacturing products, as well as from those subjects that are useful and related, but not of the essence of the art.

The primary obstacle to such understanding is the belief that technology is essentially part of science, following all of the same necessities as nature and scientific reasoning. If this is true, technology cannot be part of design rhetoric, except as a pre-formed message to be decorated and passively transmitted. Design then becomes an esthetically interesting but minor art that is easily degraded into a marketing tool for consumer culture.[16] However, if technology is in some fundamental sense concerned with the probable rather than the necessary — with the contigencies of practical use and action, rather than the certainties of scientific

12) Rhetoric is both the practice of persuasive communication and a formal art of studying such communication, often in its most significant instances.

13) Of course, there have been many sociological and anthropological studies of the influence and effects of technology on social organization and culture, but none, to the author's knowledge, has specifically treated this subject as an example of persuasion.

14) Francis Bacon, *The New Organon and Related Writings*, ed. Fulton H. Anderson (Indianapolis: The Bobbs-Merrill Company, Inc., 1960). This fundamental work is the first to significantly use rhetoric to study the relation of science and technology. The goal of his new science, Bacon says, is not simply to understand nature but "to command nature in action." The focus of the work, however, is on the discovery of principles in nature, and subsequent studies have seen only this aspect, reducing technology to a handmaiden of science. No one has considered the implications of Bacon's work for a rhetoric of technology. However, valuable insights may be found in Richard McKeon, "The Uses of Rhetoric in a Technological Age: Architectonic Productive Arts," in Lloyd F. Bitzer and Edwin Black, eds., *The Prospects of Rhetoric* (Englewood Cliffs, New Jersey: Prentice-Hall, Inc., 1971), 44-63.

15) Aristotle, *The "Art" of Rhetoric*, trans. by John Henry Freese (Cambridge: Harvard University Press, 1967), 3.

16) Victor Margolin, "Consumers and Users: Two Publics for Design," in Christina Ritchie and Loris Calzolari, eds., *Phoenix: New Attitudes to Design* (Toronto: Phoenix, 1984), 48-55.

17) George Bugliarello and Dean B. Doner, eds., *The History and Philosophy of Technology* (Urbana and Chicago: University of Illinois Press, 1979). This excellent book is the result of an international symposium held in Chicago in 1973. To quote from the Editors' Preface, "Engineering schools continue to train generation after generation of possibly the most powerful agents of change that our planet has ever produced...." (p. vii).

18) Peter Caws, "*Praxis* and *Techne*," in Bugliarello and Doner, *The History and Philosophy of Technology*, 227-238. "Technology, after all, is not merely the theory of the practical arts; it is the practical arts themselves, regarded as an activity of reason — the *logos in the techne*, rather than the *logos of the techne*." (p. 227).

19) Aristotle, *Rhetoric*, 19.

20) David Dickson, *The Politics of Alternative Technology* (New York: Universe Books, 1974). This is published in Great Britain as *Alternative Technology and the Politics of Technological Change*. See, for example, chapter 2, "The Ideology of Industrialization."

principle — then it becomes rhetorical in a startling fashion.[17] It becomes an art of deliberation about the issues of practical action, and its scientific aspect is, in a sense, only incidental, except as it forms part of an argument in favor of one or another solution to a specific practical problem.[18]

Technologists discover ways to command nature in order to solve such problems and then attempt to persuade others that these solutions are likely to be expedient and lead to beneficial results. Their persuasion comes through arguments presented in things rather than words; they present ideas in a manipulation of the materials and processes of nature, not language. In addition, because there is seldom a single solution to a problem in human affairs dictated by the laws of nature, they do not provide necessary solutions. Solutions are only probable and can always be changed or set in opposition to others. In this sense, technology is part of the broader art of design, an art of thought and communication that can induce in others a wide range of beliefs about practical life for the individual and for groups.

This idea may be hard to accept, especially for technologists who see their primary affiliation, perhaps partly for reasons of social status, as science. But the bridge of exchange that exists between science and technology is not much different from the bridge that has existed between traditional rhetoric and the field of ethics and politics.[19] Rhetoricians are expert in persuasion, not ethical or political philosophy, even though effective persuasion may draw heavily from knowledge of such subjects. Such is the case for technologists. They are expert in a form of persuasive communication, not the natural sciences, despite that their manipulation of natural materials and processes may draw heavily from knowledge of such subjects.

Incidentally, technologists may also be scientists. The point, however, is not simply that technology is distinct from science. More important, it is that technology is fundamentally concerned with a form of persuasion and, as with traditional rhetoric, speaks from no special authority about the good life. It provides only resources that are used to support a variety of arguments about practical living, reflecting different ideas and viewpoints on social life. Technologists themselves hold such ideas and have pressed them on the human community in many ways.[20] Until their work is recognized as persuasive and part of the practice of design, their ideas will remain implicit or naively unexamined. This aspect of the significance of design, being acknowledged only slowly, has direct consequences for the understanding of the environment of postmodern design communication. Design is an art of thought directed to practical action through the persuasiveness of objects and, therefore, design involves the vivid expression of competing ideas about social life.

This situation is made more intelligible when viewed from a rhetorical perspective. For decades, technologists have tried to

RICHARD BUCHANAN

21) The Pullman community in Chicago is one example. Designed and built in 1893 to be a complete, harmonious environment for 14,000 workers and managers of the Pullman Company, it combined the latest technology and a concern for esthetic quality, attracting visitors from around the world who marveled at its advance over then contemporary planning. Within months of completion, however, workers protested the rigidities and mechanical regularities that the design promoted and George Pullman was attacked for forcing his personal values and ideas about social life on the residents. He could hardly imagine that such ideas, derived from the mechanics of building railroad carriages, were questionable when applied to everyday life. The workers' strike of 1894, caused by a variety of factors, was one of the most bitter and violent in American labor history. See note 40.

22) The impact of various Western technologies on Third World cultures provides some of the most striking illustrations of this. More important for our purposes, however, such examples give glimpses of what moments of our own cultural history may have been like under the influence of technological change.

23) John A. Kouwenhoven, *Half a Truth Is Better Than None: Some Unsystematic Conjectures about Art, Disorder, and American Experience* (Chicago: The University of Chicago Press, 1982). See "Design and Chaos: The American Distrust of Art," 231.

24) Dieter Rams, "Omit the Unimportant," *Design Issues* 1/1 (Spring 1984): 24-26. This is an excellent and economical statement of one design philosophy. (Note also how the rhetoric of Rams' *statement* parallels the rhetoric of the *products* that he and the Braun design group produce.)

25) Margolin, "Consumers and Users: Two Publics for Design," 49. Margolin's characterization of users, in contrast to consumers, is more like the kind of audience discussed here. The user, he says, is more likely "to define the worthwhile life in terms of the actuation of values rather than the ownership of goods." Of course, consumers are a kind of audience, too, and many designers conceive of their audiences as groups of consumers in a narrow sense.

persuade audiences of the expediency of their inventions and discoveries, producing objects that often seem to meet human needs and promote a better, well-ordered life. Yet, the life they have promoted has frequently proven to be harmful and discordant with human values. The concern is not with the outright failures of technological reasoning, but with those instances in which the result has been an inhuman mechanical order[21] or even a frustrating disorder and social chaos.[22] The concern rests with those examples where design has served as a tool to increase the power of political and social ideologies and has brought suffering rather than benefit, as with the weapons of war.

This is the postmodern environment, a period of disillusionment following exceptional confidence in the bright future promised by science and technology (as well as by various political philosophies and ideologies). It is based, in part, on the recognition by many that we have not gleaned from design (in the sense that it involves technology) a well-ordered life, and this perception has led to a dreadful and sometimes creative fascination with the unstable relationship between order and disorder.[23] Indeed, the nature of order in practical life is a central issue in postmodern design. In the relation of order and disorder, designers inventively explore new possibilities for practical life, and this relationship provides a way of distinguishing design voices in their current situation. Many continue to pursue classic ideals of orderly design, still seeking an harmonious integration of design and technology in the purposive activity of everyday life, even if their designs are consciously fashioned to be new expressions of older ideals.[24] Other designers look for order in new ways, and some even deliberately overturn conventional expectations of order, as if to challenge us to rethink the meaning of order in our lives. In all of these cases, however, design is a debate among opposing views about such matters as technology, practical life, the place of emotion and expression in the living environment, and a host of other concerns that make up the texture of postmodern, postindustrial living.

Elements of design argument

To examine this situation more carefully, several themes should be considered: one is the idea of the designer as a speaker who fashions a world, however small or large, and invites others to share in it. Another is the idea of an audience of users who may be persuaded to adopt new ways and means to achieve objectives in their lives.[25] Still another is the idea of practical life as the subject of design communication, however varied the conceptions of this may be and whether these conceptions are held consciously or are tacit and unexamined in the designer's mind. Most important, however, is the idea of argument, which connects all of the elements of design and becomes an active engagement between designer and user or potential user. This article suggests that the designer, instead of simply making an object or thing, is actually

creating a persuasive argument that comes to life whenever a user considers or uses a product as a means to some end.

Three elements of a design argument are applicable here; they involve interrelated qualities of technological reasoning, character, and emotion, all of which provide the substance and form of design communication. Designers draw on all three elements to some degree in every design argument, sometimes blending them with great subtlety in a product. Nevertheless, these elements may be analytically distinguished to reveal the different resources that are available for persuasion.

The first element, technological reasoning, is the logos of design. It provides the backbone of a design argument, much as chains of formal or informal reasoning provide the core of communication and persuasion in language. In essence, the problem of technological reasoning in design is the way the designer manipulates materials and processes to solve practical problems of human activity. Products are persuasive in this mode when, in addressing real needs, they meet those needs in a reasonable, expedient way. Technological reasoning is based, in part, on an understanding of natural and scientific principles that serve as premises for the construction of objects for use. It is also based on premises drawn from human circumstances, that is, from the attitudes and values of potential users and the physical conditions of actual use.

Both kinds of premises are evident even in the simplest objects. For example, all spoons use the same mechanical premise, employing the principle of the lever as a way to transport contents held in a small bowl (figure 1). They share several obvious human premises, which explain why they are all of a size that fits the human hand, are made of inexpensive materials, and rely on the hand for power. But they also use a variety of human premises that are not so obvious, but directly affect the specific form in which

Fig. 1) Utensils differ in the quality of character that they project while sharing the same mechanical premise.

RICHARD BUCHANAN

Fig. 2) This Krups coffee mill exhibits classic design values, emphasizing function while seeming neutral and unobtrusive. Character and emotion are important but carefully subordinated to use.

Fig. 3) This Memphis bookcase, Ginza, a robot made of wood and chrome, should be seen in color for full effect. Its emotional excitement and humor animates the environment. Design: Masanori Umeda.

26) Barbara Radice, *Memphis: Research, Experiences, Results, Failures, and Successes of New Design* (New York: Rizzoli International Publications Inc., 1984). Virtually a manifesto of Memphis design philosophy, it is couched in a relatively flamboyant and whimsical style that reflects Memphis attitudes. This style of writing may be contrasted to the efficient, economical prose of Dieter Rams' statement of Braun design philosophy, with the same result as comparing Braun and Memphis products.

the mechanical premise is presented. For example, there is a premise regarding the attitude of potential users toward tradition: two of the spoons are highly traditional and conventional within their respective Oriental and American cultural contexts, two are rather unconventional. There are similar premises regarding the value of decoration, the elegance or plainness of the social occasion of eating, and perhaps even subtle moral values that are associated with these aspects and that people are hardly aware of in objects so simple.

Premises drawn from human circumstances are what make technological reasoning an element of rhetorical art for communication with specific audiences rather than a deductive science concerned only with universal principles. Such premises serve to distinguish not only different audiences and the kinds of design arguments that are most likely to be persuasive with different groups, but they also characterize different approaches taken by designers themselves in the postmodern environment. Consider, for example, the Krups coffee mill and the Memphis bookcase, Ginza, by Masanori Umeda (figures 2 and 3). Both are functional in a broad sense of the term (although the usefulness ratio of materials used to space occupied in Umeda's bookcase seems to stretch the idea of function, perhaps intentionally). Yet in each case, the specific form of technological reasoning depends entirely on different human premises, premises held by designers and assumed to be persuasive with users.

Indeed, design is an art of communication on two levels: it attempts to persuade audiences not only that a given design is useful, but also that the designer's premises or attitudes and values regarding practical life or the proper role of technology are important, as well. The proof is a demonstration in a product. The coffee mill reflects classic design values suited to new ways of contemporary living. It is gentle and unobtrusive, subordinating the display of mechanical reasoning and other qualities to a concern for use. The object is neutral rather than coercive and, hence, allows users to integrate it into a variety of life-styles. It demonstrates that technology can serve without dominating, leaving users free to use the product in a variety of settings of their own choice.

In contrast, the Ginza bookcase reflects values of novelty, surprise, and emotion. Umeda's design playfully displays mechanical reasoning and virtually talks to us, commenting on itself with irony or satire — a robot holding books created by the unmechanical human mind? It intensifies the environment, not to dominate users, but perhaps to offer an example of vitality and spontaneity that encourages independence and self-expression, something important for many people in the postmodern environment. It demonstrates a lively mind controlling technology, not controlled by it. [26]

These are two important directions in postmodern design, but they both vividly demonstrate how the designer's argument is more than technological reasoning dressed up. The argument in

each is only partly controlled by mechanical premises, and if the logos or reasoning of the design is reduced to mechanics alone, the designer's real argument, which is a unique synthesis of mechanical and human premises, is lost. The human premises expressed in design logos, as varied as such premises are from audience to audience and from designer to designer, are fundamental sources of persuasion in all design arguments. They give intelligibility to designs that otherwise may seem to be superfluous indulgences. It is one thing for designers to throw up their hands at the prospect of designing products for the Amish, for whom all but the most basic forms of modern technological reasoning are unpersuasive. Yet this is different only in degree from the problem faced in every other instance of technological reasoning, where beliefs and values always condition products, whether they are recognized explicitly, are implicitly assumed, or are ignored completely.

Technological reasoning is persuasive in two ways, related to the two kinds of premises on which it is based. It is persuasive in process, as well as in the accomplishment of something useful. In the former, audiences are persuaded when the reasoning is clear and provides a likely solution to a problem. This involves active contemplation of a product before and during use. For a simple example, consider dividers designed to measure distances of a certain scale, perhaps on a chart or map (figure 4). The technological reasoning of the large brass and iron instrument is apparent at a glance. It depends, first, on a revolute pin joint that ensures a continuous relationship between two pointer arms by allowing motion with one degree of freedom. Second, there is the curved crossbar, attached rigidly to one arm by a bolt and passed through a slot in the second, maintaining stability of relation in the motion of the arms. Third, there is a spring, serving to prevent play in the crossbar due to any loosening of the bolt attachment; and, fourth, there is a wing nut that tightens on the crossbar and allows the relation between the pointer arms to be fixed at any specific distance.

In contrast, the reasoning of the smaller divider is not so readily apparent. The arms seem to work on a pivot post, but the mechanism that produces tension in their relation and fixes their relation at a given point is not obvious with a casual glance, as it is shielded by a small casing. When such reasoning is concealed, it speaks intelligently only to a small technical audience, perhaps as small as the engineers of the manufacturing company, and reaches a broader audience only in effective use. In complex modern systems, design logos is directed to two distinctly different audiences: specialists who can actually follow and judge the reasoning as a process and general users who are concerned only with results. This is a fundamental issue in design: whether and how much to involve a general audience of users in the process of technological reasoning.

There are obvious limits in the ability of audiences to follow complex trains of technological reasoning, but designers can use a

Fig. 4) Although similar in function, these dividers use quite different persuasive arguments.

RICHARD BUCHANAN

Fig. 5) This Braun cassette deck and hi-fi system masterfully displays technological reasoning in a fashion that is readily accessible to users. And it shows careful control of character and emotion. Design: Peter Hartwein.

27) Rams, "Omit the Unimportant," 25. "... items should be designed in such a way that their function and attributes are directly understood.... Of course, getting products to 'talk' by means of design is a demanding task."

28) Klaus Krippendorff and Reinhart Butter, "Product Semantics: Explaining the Symbolic Qualities of Form," *Innovation* 3/2 (Spring 1984). The entire issue is devoted to the theme "Semantics of Form."

variety of ways to convey this reasoning suggestively rather than directly. In complex systems, the alternative may be to suggest the logical connection of large sections, without attempting to convey the detailed reasoning of each part. This can be done through an articulation of functional components, as in the new classic design of the Braun cassette deck (figure 5).[27] Similarly, designers can present the control features of a complex system so carefully and clearly that audiences grasp the technological reasoning without actually seeing its details. This is essentially a metaphoric relationship, juxtaposing control knobs, buttons, and levers as an abstract, yet visually clear, symbolization of the real processes at work in a complex machine. The new area of product semantics is closely related to this aspect of persuasion in its attempt to engage the mind of the audience and make the workings of a product more readily accessible.[28]

Product semantics and similar approaches work within broader design arguments concerning the relationship between users and objects, but there are other approaches that serve quite different

arguments. For example, the Memphis table lamp, Ashoka, by Ettore Sottsass, not only directly displays the balance of forces used in supporting the light bulbs, a playful balance that is an important part of the design logos, but also metaphorically suggests the flow of electric current (figure 6). The ostentatious display of technological reasoning (or of pseudoreasoning, as in the case of functionless elements that are associated with machinery, such as basic geometric forms, pipes, struts, and so forth) is a significant feature of many postmodern products. The table lamp by Sottsass or the Bel Air armchair, by Peter Shire for Memphis, (figure 7) are examples. Such ostentation, however, is not simply a decoration; it is part of the logos. An audience is invited to consider the mechanical aspect of our world when they use such a product. In the case of the Ashoka table lamp or the Bel Air armchair, the audience is encouraged to participate actively in the argument of the design, to recognize and think about mechanical and geometric relations, rather than ignore them or take them for granted.

Consider the Quisisana ceiling lamp, by Ettore Sottsass, from the Memphis collection (figure 8). It also uses metaphor to suggest the flow of electricity and makes an ostentatious display of mechanics, but it engages users in a broader argument that expands the idea of function in everyday life. Not only do products function, humans function as well. This complex design argument, while meeting narrow demands of utility, also frees us from narrow purposive activity; it encourages our more complex imaginative processes, our emotional and intellectual functioning freed from an immediate task. It reminds us, perhaps, that imagination is the source of technological inventions and that a free play of imagination ought to be an ongoing part of daily life.

All of these approaches, however, are concerned more with the appearance and accessibility of technological reasoning than its truth or validity, which, in the case of design, is a question of

Fig. 6) Ashoka table lamp by Memphis. Design: Ettore Sottsass.

Fig. 7) This Bel Air armchair made of wood by Memphis, is upholstered in contrasting, bright color fabrics. Design: Peter Shire.

Fig. 8) Quisisana ceiling lamp by Memphis, with two light sources: a red bulb and a halogen lamp tilted toward the ceiling. Design: Ettore Sottsass.

RICHARD BUCHANAN

whether a product will actually work. Audiences will tolerate a great deal of discomfort and outright suffering if only a product will do something useful. This is evident in the early history of the automobile or the rise of medical technology, when general audiences cared little for an understanding of the details of products and wanted only results. But if practicality is the truth of design reasoning, and if such reasoning is contingent on so many factors of use that there is no way of judging its effectiveness in abstraction, we are reduced to estimates of probable success, the advice of experts, and a willingness to take chances. And, through all of this, there is also a continuing awareness of how often poor technological reasoning is concealed, much as a politician may cover a poverty of ideas and rational arguments with pleasant phrases and a forceful personality. This leads to consideration of the other elements of a design argument, elements that may conceal poor reasoning or, in fact, complement good reasoning and enhance the persuasiveness of a product and satisfaction in its use.

The second element is character or ethos. Products have character because in some way they reflect their makers, and part of the art of design is the control of such character in order to persuade potential users that a product has credibility in their lives. In essence, the problem is the way designers choose to represent themselves in products, not as they are, but as they wish to appear. Designers fashion objects to speak in particular voices, imbuing them with personal qualities they think will give confidence to users, whether or not the technological reasoning is actually sound. This may involve something so artless and extrinsic to design as a designer label, but in its significant aspect it involves qualities of character that are persuasive in any example of effective communication, such as good sense, apparent virtue, and goodwill toward the audience.

Character can be a subtle mode of persuasion, but it is exceptionally important for design. Consider the different qualities of character projected by some of the objects already discussed. The

Fig. 9) Bowl and quail sugar shaker, perhaps persuasive for the intended audience.

dividers (figure 4), for example, speak in very different voices. The larger instrument, by presenting its reasoning clearly and simply, is both intelligent and efficient in accomplishing something useful. It speaks in a sensible voice and displays the virtues of a practical, sturdy, plain character. In contrast, the character of the smaller instrument is a little more mysterious or remote and, perhaps, superficially more elegant. There is less direct connection between the technological reasoning of the design argument and its ethical aspect. This instrument, too, speaks in a sensible, intelligent voice, but such a quality comes more from the object being perceived as an instrument than from any immediate display of its own sensible workings. With respect to character, it persuades by looking authoritative, and authority is a virtue prized by many audiences over good sense or intelligence.

The problem of character in products is a fundamental issue of design in the postmodern environment and one on which designers and design critics have yet to focus precisely. It is in the area of ethos rather than technological reasoning or esthetics that some of the sharpest conflicts and differences are evident. Consider, for example, the vast range of mass-produced objects that fill our product culture and are regarded by many as kitsch (figure 9).[29] Such objects are persuasive not because they possess beauty, but because they show a concern for beauty. They speak in familiar, believable voices that display esthetic sensibility as a virtue, whether or not reality matches appearance. Perhaps most objects of mass culture are persuasive in a similar way, not because of any special substance or even clever emotional appeal, but because they speak in familiar voices, show concern for commonplace virtues and, hence, seem authoritative.

Ironically, designers who believe they are advancing cultural standards or challenging the imagination in constructive ways have relatively little authority with mass audiences. Their designs often seem hostile and intimidating or are so subtle that they go unappreciated. This is true of the avant-garde, whose works present an ethos of spirited, unruly, and sometimes intelligent imagination but that lack virtue or trustworthiness as judged by the standards of mass audiences who suspect themselves to be the butt of a joke. This is also true of designers such as those at Braun and Krups, whose designs are often so modest and unobtrusive that they almost go unnoticed. These designers compensate by emphasizing user-friendly products, using goodwill as the persuasive force of their ethos; modest as the Krups coffee mill is, it is also delightfully easy to use. Avant-garde designers most often ignore the problem or counter it by going even further in cultivating an eccentric ethos that is intended to appeal to a limited audience of supposed trend-setters. After all, the avant-garde has always been a character type, romantic, virtuous (by their own standards), and heroic in standing against conventional tastes, refined or otherwise. Yet both groups of designers continue to

29) Gert Selle, "There Is No Kitsch, There Is Only Design," *Design Issues* 1/1 (Spring 1984).

RICHARD BUCHANAN

grapple with the problem of ethos and virtue, and in the broader cultural debate, they are often the less persuasive voices.

Perhaps in frustration an audience otherwise sympathetic to sophisticated design ideas has come to prize the "camp."[30] For this audience, irony is the virtue that is most persuasive, and some designers now deliberately attempt to play on this by imitating objects of mass culture. However, such design arguments are only superficially amusing; in fact, they are nascently bitter expressions about the postmodern environment. They reach honest and direct statement perhaps only in recent punk styles, whose design argument is essentially one of protest.[31] The technological reasoning in punk styles is either destroyed outright or grudgingly presented, as in clothing, with rips and tears that are metaphoric expressions of what are perceived to be the moral consequences of contemporary life.

The third element of a design argument, emotion or pathos, is sometimes regarded as the true province of design, giving it the status of a fine art. Certainly, some designers think of themselves as essentially fine artists, and perhaps this is why they acquiesce in the equivocal role assigned them by those art historians for whom design is only a minor art concerned with decoration. But emotion is only a bridge of exchange with esthetics and the fine arts, just as technological reasoning is the bridge with the natural and social sciences and character is the bridge with ethics and politics. When emotion enters design, it is not an end in itself but a mode of persuasive communication that serves a broader argument. The problem for design is to put an audience of users into a frame of mind so that when they use a product they are persuaded that it is emotionally desirable and valuable in their lives. Design provides an organization of the way we feel in a direct encounter with our environment; it provides a clarifying and fulfilling experience that may even remind us of fine art, although the objective is practical and perhaps mundane.[32]

The resources for emotional persuasion are the same for all design arguments, coming from physical contact with objects or from active contemplation of objects before, during, and after use. Much feeling is conveyed in the experience of movement, whether in the gestures made in using an object or in the shift of visual attention across its lines, colors, and patterns. This is what makes the emotive argument of a design so powerful and persuasive: it collapses the distance between the object and the minds of the users, leading them to identify with the expressive movement and allow it to carry them where it will.

What helps to distinguish different design arguments is where the movement carries us. Consider the wrench pictured here (figure 10). Whatever the technological reasoning that requires such a configuration, the simple curve is so compelling that even people who would have no occasion to use the tool may feel something of its emotional appeal. It seems to send the mind of the observer

30) Susan Sontag, "Notes on 'Camp'," in *Against Interpretation* (New York: Noonday Press, 1966).

31) Dick Hebdige, *Subculture: The Meaning of Style* (London: Methuen and Co. Ltd., 1979).

32) John Dewey, *Art As Experience* (New York: Capricorn Books, 1958) 35. In this major statement of esthetic philosophy, Dewey attempts to restore continuity between artistic objects, which have been separated from the conditions of their origin, and the esthetic qualities of everyday experience found in encounter with our environment.

Fig. 10) The compelling curve of this wrench conveys subtle emotional persuasion.

Fig. 11) Handmade Moroccan cup and mass-produced Japanese vase give different qualities of space and motion.

33) Joshua C. Taylor, *To See Is To Think: Looking At American Art* (Washington, DC: Smithsonian Institution Press, 1975), 85. This is from an essay called "Persuasion." See also the essay "The Pure and the Impure" for esthetic theories that have interesting relevance to design.

Fig. 12) This handcrafted mask from Bali displays a persuasive emotional argument that transcends the rhetorical purpose for which it was designed. It becomes sculptural art and speaks to a universal audience.

back and forth in a dynamic balance that is visually satisfying and when the tool is held, physically satisfying as well. Emotion here, as in classic design, serves and enhances use, but it also defines the object as an independent, autonomous whole. The Krups coffee mill (figure 2) and the Braun cassette deck (figure 5) seem self-contained and self-sufficient. These can be contrasted with the tense quality of the Ashoka table lamp (figure 6). Although symmetrical, it seems to radiate outward in every direction. Similarly, Shire's Bel Air armchair (figure 7) and Sottsass's ceiling lamp (figure 8) reach beyond themselves and give overtones to the surroundings and perhaps to the social context in which they will be used. Emotion here intensifies the environment, perhaps capturing the social occasion of dining, even as the objects perform their simple functions. Instead of appearing self-sufficient, they seem to seek connections and relationships with other objects or people around them, because the emotional excitement is directed outward. Contrast both of these uses of emotion with the spirited, playful lines that are patterned on the cup (figure 11). The boundaries of the cup itself seem gentle, but the animation of the pattern holds us with surprising intensity; some elusive regularity or symmetry is sensed, but users are too caught up in the vitality to worry about balance. The cup seems to reach out to us, and we are tempted to pick it up. Emotion here has neither classic calm nor outwardly expanding excitement; instead, it involves a quiet and delicate play that reaches subtly into the mind of the user and sets loose the imagination.

It is surprising to realize how far we are led into figurative language to express the persuasiveness of lines. This occurrence is a sign of the strong identity achieved between observer and object in the emotional aspect of design. As the art historian Joshua Taylor remarked, "To say that a line in a painting twists and turns is, of course, a highly figurative statement. It does nothing of the sort. It is we who twist and turn looking at it."[33] How far such an identity can go in design is evident when understood that in the strength of a design argument's emotional appeal, objects for use are sometimes transformed into objects for pure contemplation, valuable in themselves rather than as the means to some other end. The vase and cup pictured (respectively from Japan and Morocco) and other objects previously discussed could be regarded as works of art, valued without regard to their use. And this is true for the handcrafted mask (figure 12), as well. Designed for practical use, with obvious control of the elements of technological reasoning and ethos that make it suitable to be worn in rituals and festivals important in the everyday life of the people of a so-called primitive culture, it makes use of an emotive argument that reaches deep into human nature and across cultural barriers; it compels us to quite a different kind of contemplation — if not of the beautiful, then of the grotesque and terrifying.

The emotional appeal of products ranges from the trivial to the

RICHARD BUCHANAN

profound, and in the postmodern environment the full range is encountered. Some designers use emotion in a superficial and coercive way. They try to excite the passions of potential customers with trivial gimmicks that have little connection with technological reasoning or character. The arguments of such designers are hardly arguments at all, but only attempts to impose unexamined attitudes and marketing messages on passive and captive audiences, without concern for whether the product actually accomplishes the purpose for which it was intended. Other designers, who make many of the objects of our product culture, rely on weak and often sentimental emotions that are adapted to the existing tastes of audiences and to popular beliefs about what is artful or beautiful (compare such objects in figure 9 with the unconventional Memphis porcelain table service by Matteo Thun in figure 13).

Fig. 13) Compare this Memphis porcelain table service with the bowl and sugar shaker in figure 9. The objects are, from left to right, a pepper shaker, Ontario; a toothpick holder, Erie; an appetizer holder, Superior; and a salt shaker, Michigan. Design: Matteo Thun.

The strongest designers, those who are most articulate if not always most persuasive, are concerned with discovering new aspects of the utility of emotional expression in practical life. Their products attract and hold audiences in surprisingly different ways, and in this lies the importance of emotion as a mode of persuasion. It offers no conclusive proof of a designer's ideas about technology or social life, yet it helps an audience to entertain new possibilities for practical living and to remain open to the technological reasoning and character of a product.

Purpose of design arguments

Having identified the elements of a design argument and shown how they are interrelated in a variety of products, the next question is, what do such arguments accomplish? Do design arguments accomplish the same things as rhetorical arguments in words?

To answer these questions, I want to return for a moment to the earlier discussion of the relationship between rhetoric and design. I suggested that our understanding of rhetoric has been limited to the rhetoric of words, but that the vast output of man-made objects in the present represents another, unrecognized mode of communication, a rhetoric of things. There seems to be little question that some kind of communication exists in designed objects. This is evident not only in the influence of rhetorical themes in shaping methodologies in the history, theory, and criticism of

design, but also in the growing body of specific information about how rhetorical considerations actually guide the practice of design.

The significant question, however, is what the nature of such communication is. Does a designed object communicate simply in the sense that it is a sign (or set of signs) of the conditions of its production, much as smoke is a sign of fire? Is an object communicative to the extent of its styling, which is expressive of emotion and esthetic qualities? Or, is there bound up in the idea of design a kind of communication that involves all aspects of the making of objects for use, so that design itself, whatever the type of object produced, is not an art of adornment, but a rhetorical art that creates objects persuasive in every aspect?

The primary obstacle to the latter view lies in our understanding of the nature of technology. If technology or technological reasoning is regarded merely as a deduction from scientific principles, there is no significant sense in which it can be seen as persuasive. Technological development would be regarded as an inevitable process growing out of scientific advance, and questions of value and social consequence would be regarded as irrelevant to the essence of design, more properly left to politicians and the public than included as a consideration for designers. However, as important as science is in the development of technology, the activity of technological reasoning inherently involves human values selected knowingly or unknowingly as important premises that directly affect the essential characteristics of objects, not just their superficial appearance. If this is correct, a rhetoric of design becomes a distinct possibility, even if its precise nature and qualities yet remain to be discovered. It is possible because technological reasoning, the core aspect of design that may appear objective and remote from human values and opinions, is, in fact, developed in terms of an audience. Its success is not judged theoretically by appealing to the knowledge of a small group of experts, but practically by appealing to the interests, attitudes, opinions, and values of users.

Based on this, the feasibility of a rhetorical study of designed objects has been shown in this article by applying the themes of rhetoric that are traditionally used in the study of verbal communication. The result is a concrete illustration of ways in which objects can be persuasive and designers can deliberately control the three elements of argument to shape objects and achieve some kind of persuasion. But what kind of persuasion is it? Surely it would be fatuous to suggest that we interact with objects in the same ways that we interact with words. If we did, what distinctive value would there be in words and why would human beings have instinctively or knowingly, and over such a long period of time, designed the language system as it is?

Persuasion in language can be oriented in any of three directions. It can be oriented to the past, as in a law court, where we are persuaded to make necessary judgments of fact. Also, it can be

RICHARD BUCHANAN

oriented to the future, as in political debate, where we are persuaded to make judgments about contingent courses of action. And, finally, it can be oriented to the present, as in a variety of social ceremonies, where we are persuaded to consider something as valuable or worthless and, hence, to praise or blame the matter offered for consideration. The latter is known as epideictic or demonstrative rhetoric and is perhaps the most puzzling of all rhetorical forms because it grows out of materials from the past and hints at possibilities for the future, yet is most concerned with attitudes in the present.[34]

Of these three orientations, design arguments and the rhetoric of things are most like demonstrative rhetoric. They are demonstrations or exhibitions, growing out of the past (as in traditional shapes and forms or in already known scientific principles that provide the premises for construction) and suggesting possibilities for the future (as in future activities that a given object may make possible), yet existing primarily in the present as declarations. Products are important to us in use and, hence, they exist significantly in a kind of omni-present. Unlike words, which can persuade people to specific judgments about the past or future and assert attitudes, ideas, and values that are recognized in the present, designed objects primarily assert their own existence and, through that existence, the attitudes that are an integral part of an object's present being.

In this respect, the products of design share a rhetorical status similar to works of fine art. As critic Harold Rosenberg said of the art object, "Its nature is contingent upon recognition by the current communion of the knowing. Art does not exist. It *declares itself.*"[35] What he means is that the existence of a work and its status as fine art is not something that can be taken for granted; a work in the present culture must declare itself to be a work of fine art and persuade an audience to recognize its status as such, otherwise there can be no way of distinguishing fine art from any other type of man-made object. As Rosenberg seems to suggest, designed objects declare a status other than fine art — the attitudes and values asserted are different, for the designed object declares that it is fit for use, whereas the work of fine art asserts a freedom from specialized utility — yet the rhetorical form is the same in both cases.[36]

If products affect and shape attitudes, they do so only through persuasive assertion, which may be recognized or not. Beyond this, users must then carry out their own deliberation about whether or how to use products in the future. For example, the Krups coffee mill (figure 2) is a gentle assertion or demonstration of an effective way to grind coffee. It is quite persuasive as an object, and the sources of that persuasion come from the character and emotion of the argument, as well as from its technological reasoning. Yet it is only an assertion; users may then begin their own deliberations about whether to buy it and how to use it in

34) Chaim Perelman and L. Olbrechts-Tyteca, *The New Rhetoric: A Treatise on Argument* (Notre Dame: University of Notre Dame Press, 1969), 47-51. Perelman argues that epideictic is central to the art of persuasion because it increases adherence to values and, hence, strengthens the disposition to action. The speaker establishes a sense of communion around values recognized by the audience.

35) Harold Rosenberg, *The Anxious Object: Art Today and Its Audience* (New York: The New American Library, 1964), 20. This important study of the fine arts falls well within the rhetorical tradition that regards painting, poetry, and other modes of fine art as epideictic rhetoric.

36) Rosenberg, *The Anxious Object*, 21.

their lives. In this case, the object is so gentle in its assertion and demonstration that how to combine it with other objects in a home environment can easily be seen. Indeed, one of its virtues is that it combines easily and well with many kinds and styles of objects. And the fact is, people have changed their daily routines because of what the product asserts and demonstrates that it can do for them. As trivial as this example may seem, the situation is little different for any order of design product or technological complexity: the assertoric rhetoric of the product quickly becomes part of the broader verbal rhetoric used in deliberating about the future or judging the past.[37] In effect, the product asks for recognition through all of the modes of argument that have been discussed, but then we are left, and even required, to place it in a broader social context where verbal rhetoric has full force in determining the implementation of the product.

Rhetoric and design as architectonic arts

One important implication concerns the nature of architectonic arts in our culture today. Architectonic arts are those that organize the efforts of other arts and crafts, giving order and purpose to production.[38] For example, architecture has long been an architectonic art with respect to the host of specialized disciplines involved in construction because it orchestrates their contributions and rationalizes their individual products into a single, whole product. In essence, it provides the thought or idea that is the soul of production. There are many indications, however, that architecture is only one form of a broader architectonic art that has emerged in the modern world. Indeed, the term *architecture* is used in a variety of new ways as a metaphor for structure and organization of many things other than buildings: for example, the architecture of computer systems or the architecture of the three vast, interconnected technological systems that distinguish our historical period, the electric power grid, the transportation system, and the communications system. The natural word for this new, modern architectonic art surely is *design*. Design is what all forms of production for use have in common. It provides the intelligence, the thought or idea — of course, one of the meanings of the term *design* is a thought or plan — that organizes all levels of production, whether in graphic design, engineering and industrial design, architecture, or the largest integrated systems found in urban planning.[39]

But if design is an architectonic art with respect to things, its efforts and products are guided in turn by another architectonic art that further integrates objects into social activities and even guides the practice of design at every turn. This architectonic art is rhetoric — not simply the old verbal rhetoric but, rhetoric as an art of thought. Rhetoric is architectonic with respect to thought as it is formulated and presented for an audience, whether in words, things, or actions.[40] This article has alluded in passing to some

37) Consider, for example, the role of public policy formation, a classic situation for verbal rhetoric, with regard to the development and implementation of technological systems. See, for example, Robert F. Baker, Richard M. Michaels, and Everett S. Preston, *Public Policy Development: Linking the Technical and Political Processes* (New York: John Wiley & Sons, 1975).

38) McKeon, "The Uses of Rhetoric in a Technological Age," 45.

39) Not accidentally, this list is quite similar to something in the Middle Ages that was called the quadrivium, the four arts of things that dealt with successively larger and larger integrative problems. The discovery of a modern quadrivium through a rhetoric of things is one of the most intriguing aspects of the rhetorical approach to design, suggesting again that design is a primary architectonic art in our culture.

40) The expansion of the art of rhetoric to architectonic status in the twentieth century follows our growing awareness of evidence for significant rhetorical considerations in many areas previously neglected. We are discovering, for example, that scientific discourse involves serious rhetorical features. For one study, see Ricca Edmonson, *The Rhetoric of Sociology* (London: The MacMillan Press Ltd., 1984). Evidence for a rhetoric of things is found in the demonstrations discussed in this paper. Evidence for a rhetoric of action is found in phenomena such as civil rights marches or other protest actions that are demonstrations of grievances or injustices. For the use of actions to communicate protest, see, for example, Saul Alinsky, *Rules for Radicals* (New York: Random House, 1971). In this respect, it is interesting to compare the rhetoric of George Pullman's demonstration in the buildings of the Pullman community and the worker's demonstration in their protest strike (see note 21).

RICHARD BUCHANAN

aspects of the architectonic art of rhetoric as it may unfold in verbal rhetoric, but this concept can be illustrated a litle more in the practice of design. Consider John Pile's definition of design, not as a noun but as a verb:

"We do not have an ideal word for the processes of choice and decision-making that determine how *things* are to be made. *Design* will have to serve us, although its many meanings — from *decorative pattern*, to the selection of sizes for plumbing pipes — can be a source of confusion. The word is used here to mean the making of decisions about size, shape, arrangement, material, fabrication technique, color and finish that establish how an object is to be made. The object can be a city or town, a building, a vehicle, a tool or any other object, a book, an advertisement or a stage set. Designers are people who make such decisions, although they will, most often, have some other name describing their specialized concern: architect, engineer, town planner or, possibly, craftsman."[41]

41) Pile, *Design*, 6.

This passage explicitly shows the sense in which design, through thoughtful decision-making, is architectonic with respect to things made for use, but it also implies the way in which rhetoric operates throughout the design process. When asking for the bases of decision in all of the areas that Pile identifies, we are at once caught in a web of human factors, attitudes, and values that are of central concern to rhetoric. The skillful practice of design involves a skillful practice of rhetoric, not only in formulating the thought or plan of a product, through all of the activities of verbal invention and persuasion that go on between designers, managers, and so forth, but also in persuasively presenting and declaring that thought in products. From the smallest, most incidental object to the largest, integrated technological system, designers are providing an amplification of ideas through man-made things.[42] Hence, instead of regarding the history and current practice of design as the inevitable result of dialectical necessity based on economic conditions or technological advance, we may do well to regard the apparent confusion of our product culture as a pluralistic expression of diverse and often conflicting ideas and turn to a closer examination of the variety and implications of such ideas.

42) Amplification is a well-known device in rhetoric, today usually meaning the expansion of a simple statement into more elaborate or complete language. However, Aristotle refers to it as a topic of invention and also as a form of argument specially suited to epideictic (demonstrative) rhetoric. Furthermore, he regards amplification not merely as a verbal device, but as a way of elaborating the qualities of a subject. See Aristotle, *Rhetoric*, 105, 343. As used in this paper, amplification is a way of elaborating the living environment to enhance the quality of life.

There is no reason to believe that the architectonic art of rhetoric is any better understood at present than the similarly emerging architectonic art of design. Rhetoric is undergoing a new development in the twentieth century, and designers are among those who are shaping it to meet modern problems. If designers can benefit from explicit talk about rhetorical concerns, those who are interested in rhetoric can benefit even more from studying how design continues to influence and shape society by its persuasive assertions. We are left with an inescapable conclusion that designers are discovering an entirely new aspect of demonstrative rhetoric that will significantly affect our understanding of rhetoric as a modern architectonic art.

Dieter Rams

Omit the Unimportant

Every industrial product serves a specific purpose. People do not buy a specific product just to look at it, rather because it performs certain functions. Its design must conform in the best possible way to the expectations that result from the function the product fulfills. The more intensive and explicit the product's use, the clearer the demands on design. That all sounds very obvious, but anyone who looks at our environment will discover a host of products whose design is not substantiated by any functional necessities. Often you can count yourself lucky if the design is not disturbing during use. Rigid functionalism of the past has been somewhat discredited in recent years. Perhaps justly so because the functions a product had to fulfill were often seen too narrowly and with too much puritanism. The spectrum of people's needs is often greater than designers are willing, or sometimes able, to admit. Functionalism may well be a term with a multitude of definitions; however, there is no alternative.

One of the most significant design principles is to omit the unimportant in order to emphasize the important. The time has come for us to discover our environment anew and return to the simple basic aspects, for example, to items that have unconstricted obvious-seeming functionalism in both the physical and the psychological sense. Therefore, products should be well designed and as neutral and open as possible, leaving room for the self-expression of those using them.

Good design means as little design as possible. Not for reasons of economy or convenience. Arriving at a really convincing, harmonious form by employing simple means is surely a difficult task. The other way is easier and, as paradoxical as it may seem, often cheaper, but also more thoughtless with respect to production. Complicated, unnecessary forms are nothing more than designers' escapades that function as self-expression instead of expressing the product's functions. The reason is often that design is used to gain a superficial redundance.

The economy of Braun design is a rejection of this type of approach. Braun products eliminate the superfluous to emphasize that which is more important. For example, the contours of the ob-

Fig. 1) With its blend of order, neutrality, and mobility, this Braun hi-fi construction is the expression of Braun design philosophy. The operating components that are seldom used are set in the back of the stereo. The entanglement of wires is concealed behind a cover so that the stereo may be placed in an open space. Design: Peter Hartwein.

111

ject become more placid, soothing, perceptible, and long-living. Much design today is modish sensation and the rapid change of fashion outdates products quickly. The choices are sensible: disciplined simplicity or forced, oppressive, stupifying expression. For me there is only one way: discipline.

Every manufactured item sends out signals to the mind or emotions. These signals—strong or weak, wanted or unwanted, clear or hidden—create feelings. But the most important factor is whether the item can communicate its use. Of course, a product's effect is also important. What sentiments does it evoke? People are very much directly influenced and emotionally moved by the design of items surrounding them, often without realizing this immediately.

My own experience can be summarized in two theses. First, items should be designed in such a way that their function and attributes are directly understood. For design, this is an opportunity and a challenge. Until recently, this task hasn't been taken very seriously and the opportunity hasn't been used enough. The self-explanatory quality of most products is low, especially in innovative fields where it is very important that a product's utility is understood without the frustrating continuous studies of user's instructions. Design riddles are impudent and products that are informative, understandable, and clear are pleasant and agreeable. Of course, getting products to "talk" by means of design is a demanding task. Creativity, experience, tenacity, ability, and diligence are necessary.

Second, the fewer the opportunities used to create informative design, the more design serves to evoke emotional responses. This is not always conscious but more or less instinctive, created by fireworks of signals that the products send out. Often these responses are so intense that they are confusing. I try to fight against them. I don't want to be dominated, nor do I want to be excited, stupified, or amazed. I refuse to be surprised by the steadily increasing dynamic of taste. I refuse, as well, to submit to widespread demands or structures of the market without asking for the product's use.

The latest design trends are intended to evoke emotions by trivial, superficial means. It is not a question of information for use, nor a problem of insight and perception in a broader sense. The issue is stimuli: new, strong, exciting, and therefore aggressive signals. The primary aim is to be recognized as intensely as possible. The aggressiveness of design is expressed in the harshness of combat to attain first place in people's perception and awareness and to win the fight for a front place in store display windows.

I don't support dull or boring design but I do take a stand against the ruthless exploitation of people's weaknesses for visual and haptic signals, which many designers are engaged in. The festival of colors and forms and the entertainment of form sensations enlarges the world's chaos. To out-do each other with new design sensations

Fig. 2) Input functions of this Braun pocket calculator are coded in green, output functions are in red. The clear legible display and the arched keys facilitate fast computations. If the power switch is left on, it automatically turns itself off after six minutes. Design: Dietrich Lubs.

leads nowhere. The alternative is to return to simplicity. And that requires working hard and seriously.

This task is not only for designers. Participation is required by all those involved in developing new products, and by the public as well. Aggressive individuality must be abandoned. We should not forego innovation, but reject novelty as the sole aim. Our culture is our home, especially the everyday culture expressed in items for whose forms I am responsible. It would be a great help if we could feel more at home in this everyday culture, if alienation, confusion and sensory overload would lessen.

Instead of trying to outdo our rivals, we designers should work together more seriously and thoughtfully. Designers are critics of civilization, technology, and society. But contrary to the many qualified and unqualified critical minds of our time, designers cannot stop there. They must continue to look for something new, something that ensues from the criticism and that can stand up against it. In addition, they cannot remain at the level of words, reflections, considerations, warnings, accusations, or slogans. They must transpose their insights into concrete, three-dimensional objects.

Of the many issues that confront designers, the increase of violence seems to be the most threatening. Destructive, aggressive tendencies are gaining momentum and counteract the idea on which design was founded. It is a frontal attack. I work in the hope of designing objects that are useful and convincing enough to be accepted and lived with for a long time in a very obvious, natural way. But such objects do not fit into a world of vandalism, aggression, and cynicism. In this kind of world, there is not room for design or culture of any type.

Design is the effort to make products in such a way that they are useful to people. It is more rational than irrational, optimistic and projected toward the future rather than resigned, cynical, and indifferent. Design means being steadfast and progressive rather than escaping and giving up. In a historical phase in which the outer world has become less natural and increasingly artificial and commercial, the value of design increases. The work of designers can contribute more concretely and effectively toward a more humane existence in the future.

Fig. 3) This Braun wall clock exemplified aesthetic functionality and adaptibility with an economical use of its resources and a distinctly legible clock face. It has a metal casing and a plexiglass cover. Design: Dietrich Lubs.

Richard Porch

The Digital Watch:
Tribal Bracelet
of the Consumer Society

The digital watch is a perfect example of the reductivist esthetic of modernism: We now look at the time instead of reading it. The early method, internalized in childhood, of reading the time from a clockface has been supplanted by a sidelong glance at a liquid-crystal display (L.C.D.). This economy of intellectually learned skills has come about with the change in technology, from flywheel to liquid-crystal microelectronics. Along with that change in technology has come a vastly higher level of timepiece accuracy and efficiency. Do we really need such split-second accuracy in our daily activities? Or do we think so, simply because the technology makes it available and advertising tells us we do? Does the advent of the digital watch mean that unpunctuality has been abolished? Now that people have apparently infallible timekeeping machines on their wrists, are they somehow more scrupulous about keeping to life's schedules?

The first wave of the new mode in timekeeping manifested itself in the early 1970s with the arrival of the light-up, light-emitting diode (L.E.D.) watch. If one wanted to read the time one had to press an uncomfortably small button, to make the time light up in miniature, neon-like numerals. With this kind of watch one could read the time at the bottom of a well, but virtually nowhere else. Liquid-crystal technology got around this by developing a permanent time read-out which used black digital numbers on a gray background. It was with the arrival of the L.C.D. watch that modern technology supplanted the idea of the wristwatch as jewelry and replaced it with the timepiece as functional instrument.

The widespread ownership of digital watches and the technology that created them are of cultural significance. Worn either as subliminal badges of efficiency, or as "tribal bracelets," digital watches seem to declare an unspoken allegiance to some sort of ethic of modernism. The old flywheel-movement watches were eminently more pleasing esthetically. They had an aural signature (ticking), required minor attention (winding), and were vaguely anthropomorphic (two *hands* on a clock*face*). The digital watch is a silent affair that requires no attention and has the visual appeal of an instrument more suited to the cockpit of a 747 than to something for your wrist. Such watches are now, to paraphrase Le

Corbusier's description of a house as "a machine for living in," merely machines for telling the time. And, like many other products in our society, they now also carry many enticing and entirely irrelevant extras with which to titillate and amuse the potential buyer, for example, day, date, bleep alarm, musical alarm, "space-invader" game, calculator/file function, compass, and of course, jogging odometers. There are children growing up today who have never owned a watch that simply tells the time.

I still miss the old Swiss timepiece that I stopped wearing when it became erratic (fatal in a consumer culture, as it spells superfluity for the object concerned), and I was too lazy to get it serviced. The trend was then fully underway for digital watches, so I thought it was a good opportunity to buy a new watch – a digital one. Who would have thought that I would miss the idiosyncracies of my old slim, 18-jewel Swiss timepiece? I was reminded of the late Charles Eames's lament over the advent of the styrofoam cup, how he missed the sensations of heat and cold that the new cup eliminated. As he perceptively pointed out, the "neutral" feel of the new material in the hand had a dulling effect (like the dentist's injection of novocaine into the gum), removing the tactile qualities of glass, china, or pottery. Of course, the plastic cup is both non-breakable and disposable, not to say inevitably cheaper. But for Eames, durability was also an infringement on sensation: The bounce of the plastic cup supplanted the heart-rending crack of china when dropped.

I miss the old Swiss timepieces because they were not universal in appearance. They looked by turn expensive, macho, kitsch, or just plain cheap. What they almost never looked like were futuristic identification bracelets, imposed on us by an alien race who wanted cruelly to remind us with split-second accuracy just how much time humans really waste.

If *you* are wearing a digital watch, can you remember exactly how you came by it? Was it an expensive birthday or Christmas present? A cheap holiday impulse buy? Or was it simply that you found it impossible to buy anything else? Perhaps we are all striving subconsciously to subscribe to the latest technological advances, and the arrival of the digital watch dovetailed nicely with acquisitive urges related to consumerism. In his book *Design for the Real World*, Victor Papanek pointed out that the "Reynolds Pen" (the world's first ball-point pen in 1945) was emblematic of a commitment to a product-future based on principles of functionality and performance, rather than on any innate decorative appeal.

In the digital watch, the modern world has found a product that signifies in its own machine-produced blandness, the world of mass-production, silent efficiency, "functional appeal," and universality. Digital watches, chunky, rectangular, and unattractive, are neutral and depersonalized, and are always finished off in some

sort of stainless steel case with matching strap. It is interesting to note that coating them in gold never seems to confer any greater sense of luxury or status on them, as it did with the flywheel model. (You know, like gold-plating a machine-gun – it's a bit pointless.) The all stainless-steel finish is entirely consistent with its function in product design, in the same way that the evocation of glass, concrete, and steel as "honest" and functionally appropriate materials are for their extensive use in modern architecture. It is in late twentieth century product design, with its emphasis on formal purity and form following function, that the early-modern notion of a machine esthetic has probably found the truest expression of its ideal. Thus we have in products like the digital watch the promise of high levels of performance and no romantic notions of user appeal or tactile quality.

At the turn of the century, Austrian architect Adolf Loos said in his influential essay "Ornament and Crime," "The evolution of culture is synonymous with the disappearance of ornament from architecture." That essay and its ideas had a seminal impact on esthetics in western culture. That essay, and the people who built on its themes (those of the Bauhaus and modern movements, for example), provided much of the moral and esthetic justification for everything we now see around us that is streamlined, smooth, reductivist, and starkly functional in visual impact—everything that is "modern."

But, unlike the esthetic purists of the Bauhaus and their strictly limited production runs of tubular furniture, it was never likely that late twentieth century marketing people would be content with a product that simply out-performed the opposition technically. In a uniquely modern way, their urge was to trivialize. Once the digital watch had captured the public's imagination and become a consumer icon, it was inevitable that the marketing people would want to reach as many user markets as demographically possible. To achieve this they started to ornament the watches, not with superfluous decoration but with a host of largely useless extra functions. The question of whether the individual actually requires anything of a watch other than its capacity to give the time, date, and (arguably) an alarm signal, was never addressed. Victor Papanek had a picturesque way of describing this marketing process: "sexing the product up." The eighteenth-century French philosopher Rousseau would have appreciated the thinking behind this ornamentation. As he well knew, once the basic needs of the individual have been satisfied, a whole universe of fresh ones would be opened up, requiring further satisfaction.

Perhaps I am too much a purist though, since digital watches are statistically more numerous than any other kind of timepiece; they must be what people want. People also seem to want the whole gamut of consumer gadgets, from "talking cars," with synthesized warning voices buried in the dashboard, to domestic

robots, and, ultimately, powerful home computers of great capacity. Ironically, the latter development was largely underwritten by the sale of combat and fantasy video games, sold to the young and impressionable so they might live out absurd, vicarious fantasies (via high technology) that serve as an outlet for aggression, competitiveness, and thwarted achievement.

The eventual outcome is a manufacturer's utopia, arrived at via a technologic-economic system advancing continuously on all fronts. The whole edifice is sustained by consumers who feel obliged to purchase, discard, and re-purchase all manner of meaningless products to define themselves as both individuals and peer group members; in other words, to be in on the latest trend you have to buy the latest product. Individual product character counts for naught. How well does it perform? Better than last year's model? But above all, does it have a day, date, alarm, calculator function with a heart-rate analyzer built in? The human capacity to take highly complex technological advances and reduce them to banal, marketable consumer devices continues apace (encouraged by the economic system), and produces, as it does so efficiently, an apparently endless stream of high-tech pacifiers for an increasingly acquisitive and undiscriminating consumer audience.

A backlash against modernism, which is what the digital watch symbolizes, has arisen in recent years. Postmodernism has had an impact in architecture through the work of the "born-again" modernists, such as Philip Johnson (the AT&T Building and others), Michael Graves (since 1974), and James Stirling (museum at Harvard), on both sides of the Atlantic. It has also spread to product design, as seen in the subversive antics of the Italian avant-garde design groups Memphis and Studio Alchymia. Postmodernism still uses modern technology, but puts a witty "mannerist" face on it, acknowledging, often in a startling way, that our obsession with formal purism is only an optional, not a mandatory, esthetic. So let's have digital watches in baroque cases, classical housings, or, alternatively, in Dali-esque, formless pouches. Better still, how about a digital watch whose read-out shows two liquid crystal "hands" circling 'round a dial covered with "digitized" Roman numerals and a synthesized "tick" instead of an alarm. In other words, use the technology to humanize, not de-humanize.

RICHARD PORCH

Abraham A. Moles

The Legibility of the World:
A Project of Graphic Design

*The apparent wealth
of a person badly hides
a great poverty.*
BACHELARD

*Adaequatio intellectus
ad rem.*
SPINOZA

1) See David C. McClelland, *The Achieving Society* (Princeton: Van Nostrand, 1961)
2) See Abraham Moles, *Quality of Life* (Strasbourg: Council of Europe, 1978)

Primacy of everyday life

What is everyday life? It is what remains when society has institutionalized everything, it is the *web of days*, it is the interstitial tissue of agendas. In a social system completely standardized by its institutions, then, everyday life would *no longer be the residue, but the main part*; because it is what fills life, it is the field of the person's autonomy, where he or she places a *personal project*, McClelland's need for achievement. Paying attention to the character of daily life and to its environmental framework will be the essential of social determination.[1] It is a fact that the web of days plays a greater part in the quality of life.[2] We expect the framework to be:

- *rich in stimuli* for limited generalized costs of access to the elements of that framework. In other words, we want the ratio of stimuli to generalized access costs to be as high as possible
- *stable*: It must prevent us from focusing our attention on the generalized access costs at the expense of our vital project. The world must be *legible* and to that end it must in a certain way be habitual (a place of habits)
- *free from pollution*; that is to say, free from parasitic, contradictory, or superfluous stimuli that contradict knowledge that in other respects is set up as an ideal-type for the purity of the environment
- *rapidly accessible* or instantaneous; that is to say, it must not burden the knowledge of stimuli, nor the access to goods, with a time or space delay, with an exaggerated decoding cost, nor anything else. This delay of access is among other things a kind of tax on time levied on the very substance of our person.

We must therefore find methods adapted to the study of that everyday life. One of them is *micropsychology*[3] which uses as a guide the concepts of micro-scenario and of generalized costs to permit the analysis of micro-anxieties, micro-pleasures, micro-structures, micro-events, or micro-decisions: the entire web of life.

3) See Abraham Moles, *Micropsychologie de la Vie Quotidienné* (Paris: Denoël Gonthier, 1976)

The symbolic and the graphic

The expression *design* overlaps that of an environment well-suited to the vital project of the individual. That environment has a mat-

erial side (recognition of the universal elements of daily life [quotidienneté]: door, stairs, street, and so forth) and a side of *signs*, symbolic element shapes (arrows, shingles, posters, signals, and so forth) which are there to represent things or actions. These can be qualified as graphic in the sense that they constitute an entire large *integrated diagram* within the framework of our life and translate the elements of that life into a sort of intelligible discourse. The door, the arrow, the corporate identity, the logotype, the traffic sign, is only the appearance, privileged and standardized, of a "knowledge through signs" of the world of things, products, and actions. Our existence then becomes more and more symbolic because it is lived more and more inside an ideographic world where we prepare our actions not with the objects themselves, but with the signs that designate them. That is correlated with a social change wherein all the communicational activity takes precedence over the purely material activity. Henceforth, the greater percentage of all human activity will result from participation in communication in the broad sense of the word.

Social function

Thus, we can anticipate the promotion of the role played by the graphic designer, into that of a *sign engineer* who precisely designates the symbolic aspects of the environment to prepare us for real actions. It is this application to the universe of that general principle of graphic design which allows us to achieve correspondence of the world of signs with personal lifestyle – to connect the symbolic aspects of successive landscapes or *ideoscenarios*, which form part of each individual's vital trajectory toward a temporary destination within the project pursued. It is really the social engineer who finds himself or herself in charge of converting to reality that equation between the *given of the world* and the *life project* – the equation, expressed in the most modest of meanings, of finding the lost and found office in the airport or the train station, cashing a check, or learning how to run a dishwasher with help from a manual.

Spaces of the graphic designer

Two very distinct spaces are proposed to the communication engineer in his or her graphic activity:

- *real space*: boulevards, hallways, streets, train stations, piers, sidewalks, stairs, shop windows, signs, household shells, offices, work places. A whole series of spaces and of volumes are symbolically marked, and therefore they become symbols; examples are the door, the elevator, the teller window
- *the printed page: a privileged and universal space*. The European DIN A4 format flat surface of paper, for example, or the standard size of a poster, a space made for viewing, which the graphic designer fills, using what the manufacturers of compo-

ABRAHAM A. MOLES

nents – the printer, the draftsman, the photographer – offer to the page make-up, which is the synthesis of a global form starting from particular elements.

Now, two fundamental processes exist for acquiring a knowledge of the environment:

1. exploration (scanning) through a *sequential* depletion of the signs, in an order imposed from the outside
2. exploration by *sampling*, either random or hierarchical (skimming), of deeper and deeper perception layers, from the obvious essential to the accessory, which is *a priori* perceived as being secondary.

Descriptive design, for its part, presents itself as a will of instantaneousness of the message; it offers a contrast, in that respect, with the page make-up, which is mainly a tactic for establishing a hierarchical order in an ensemble to be used up.

Universal tasks and rules of graphic engineering

1. To take an inventory of the world of actions, and to relate it to the sensorial (visual, sound, and so forth) symbols, on the basis of the identifiable forms they contain and which in turn will guide future action. Line, contrast, shape, right angle, texture, color are all graphic units which are *symbol atoms* (semes). These units will eventually lead to a dictionary of signs, a few attempts at which have already been made.[4]
2. To establish rules for the assembling of signs into symbols and of symbols in space, which govern an *ecology of signs*:
 - *density* (sign overload, incoherence, and so forth)
 - *rules of proximate order*: Markovian matrix of signs and graphemes
 - *rules of remote order*: repetitiveness, periodicity, space-time rhythms, large syntagmatic units (examples include lines, pages, blank spaces, chapters, or, outside the building and inside it, arrival/departure)
 - *syntaxes of interaction*: to go up, to come down, to go, to go out, to turn.

The theory of information then supplies a few elements. Here are some universal laws of the distribution of signs in space-time:

- the human receptor has a limited information capacity per time unit, that capacity governing the ratio among strategies of global apprehension, of sequential exploration, or of randomness
- symbols are freed from ambiguity by differentiating their connotative loads, or their similarities
- in an arrangement of signs or signals, the proximate order (from neighbor to neighbor), is independent of the remote order (determination of certain elements located at a great distance from one another)
- sign organizations are different levels of perception (signs/super-signs) and are independent of one another

4) See William J. Bowman, *Graphic Communication* (New York: Wiley, 1968) and Otl Aicher and Martin Krampen, *Handbuch der Zeichen Systeme* (Stuttgart: Koch, 1980)

- the relative frequencies of the signs offered must vary in the same manner, for both the consumer and the manufacturer of the message.

Tactics for adequating the world and man

Graphic design is, generally speaking, the science and the technique of establishing a functional equivalency between a message and its purpose. It attempts to maximize the impact of communication through the combined or disjointed means of the written message, the sign, or the image; and it measures, we have seen, the efficiency of each one of those messages, using the ratio of the degree of influence on one member of the target public to the means used to create and spread that message.

Graphic design's mode of access to the individual is the *contingency*. Humans wander through space-time, whether of the city or the printed page – where the graphic messages of the visualist appear. They encounter them, accept them, or reject them. On that contingency is based all the talent of the creative person, that user of fleeting moments, salvager of an interstitial availability of the individual in the spaces and times in which he or she acts and lives.

Graphic design has no ideology of its own, but it has *results*. It acts as a *social amplifier* of the messages, attempting to tell well what someone has to say: "go to such and such a place," "do such and such," "understand such and such a process," "accept such and such a value." If a problem of relationship exists between graphic design and society, it arises because of the multiplicity of its copies and of the combined effects of its styles, and not as a result of the message it carries.

The designer as a programmer of autodidaxis in the environment

Extolling the graphic designer in the name of his or her effectiveness implies new responsibilities, to the extent to which one is willing to become conscious of them. The designer is not merely limited to the world of advertising, for example, to the traditional role of a transformer of wishes into needs. That passage is the one from "phantasia" to "mimesis" that the visualist performs in the service of what has been called publicity, by introducing into it an element of social conformism. We know that the work of the graphic designer, spread over the city or the social space-time, classically fulfills a series of functions. These functions are:

- *information*: who does what, where, why, at what price
- *propaganda*: "do this, or that, under such and such conditions"
- *social consciousness*: "you belong," "belongingness is happiness"
- *consonance of humans with their goals*: We know, from the work of Enel, that an appreciable part of advertising fulfills the *a posteriori* role, after the purchase, of strengthening the person

ABRAHAM A. MOLES

5) See F. Enel, *El Cartel* (Valencia: Fernando Torres, 1977)

in his choice in relation to his image of what has value[5]

■ *an autodidactic function*: mode of use and behavior culture.

These truly are classical functions of the visualist at the service of the advertising agency. They schematize existing values, strengthen them, activate them. But we also know, and the professional milieu of graphic design cannot obliterate it, that such a manipulation of the human being is not without personal value for the graphic designer. The latter knows that the semantic message he or she first serves also always conveys a second, esthetic message, through which he or she is vindicated.

The graphic designer, through signs, advertising messages, posters, and notices, serves the beauty of the city through an art, minimal but present everywhere, that contributes to the quality of life independent of any degree of alienation the information transports. These effects are long-term, they mature over time and are not negligible. Hence, a dissociation and a contradiction takes place between the total short-term independence of the graphic designer with respect to the message he conveys – the viewer *serves any cause and is not capable of passing judgment on it* – and the long-term message that emerges from the multiplicity of these acts. It is in the latter, however, that the designer reassumes responsibility for style. In short, the graphic designer is not responsible for the content of a message, which is always imposed by others, but, rather, for a style and its social consequences. The clarity of Swiss typography, the traditional quality of a gothic typeface, the simplicity of naive design, the baroque, minimalism, all have multiple cultural values for the selection of which the designer is most certainly responsible. These cultural values mold and modulate the virtues of Banania (a cocoa breakfast drink) as well as those of a train schedule; these are the long-term, durable values, which truly contribute to the spirit of a culture.

Legibility of world: as a graphic design project

What then must one understand by graphic design of the environment? We are no longer speaking of the design of objects, products, or environmental elements in their basic functional structure. That is the province of the designer, properly speaking, and also of decorators, installers, or architects, depending on the scale of the elements to be treated in form or in appearance. Graphic design, on the other hand, addresses itself to the glance the individual casts on the world, a glance that precedes the action performed on the objects or beings on the environment. It is the taking into account, through symbols, of a language of the environment, of an expression of this language through forms that are signs before they are subjects of action. Thus a door offers itself to our comprehension as a standardized vertical rectangle even before it proposes the project of passing through it or of closing it.

The graphic designer assumes responsibility for communicating

the symbolic aspect of the world inasmuch as this aspect is preparatory to an actional aspect. Graphic design, because it deals with signs, brings the objects back to the state of what they are – tools or functions of behavior. In this way, the design of the environment conveys a social expressiveness. It takes into account volumes, surfaces, angles, and contours, and it acquires from them a certain visual reality which it standardizes, that is to say universalizes, in order to make it as easy as possible for the active person, the *actor*, to take this reality into account.

In a world which is the product of artifice, design more and more explicitly seeks to render the image of that world equivalent with the *use project* the individual may apply to it: It is in this equivalency that it finds the measure of its success. Wanting a legible world, design seeks to transform *visibility* into *legibility*, that is, into that operation of the mind that arranges things in the form of signs into an intelligible whole in order to prepare a strategy for action.

Life project and mastery of an intelligible environment
For a long time graphic design confined itself to urban or road signals, in those locations where people had to accomplish decisive acts within a short time span, through *multiple fork paths*; the maze of a railroad station, of an airport, or of a parking lot offers a familiar example. At the same time our world is becoming more and more ordinary, therefore filled with the *micro-tragedies* of everyday life, and the latter are assuming greater and greater importance in the web of what is lived. Graphic design as a *project of legibility of the world* little by little extends to all aspects of the environment.[6] There it rejoins what is simply design and combines with it in order to reduce the psychological cost, especially the cognitive cost of the use of objects and places as components of one's action. For that reason, graphic design is just as important to the housewife and to the passerby as it is to the ergonomist of the work stations or to the computer expert.

Graphic design of the environment avails itself of the use of signs and symbols and schematic representations of the fragments of the real world. It is built on the diagram as a simplified and abstract representation of the people and organisms of the environment. First it seeks ways to abstract them, to represent them, to index them, it seeks how to get to know and have people know them as a new discipline of education about the world. It makes use of arrows, rectangles, frames and lines, angles and circles, as raw materials of a symbolism that remains the intellectual emanation of the icon of what the symbols represent.

Symbols are designators and as such they are articulated into a natural language – but not always a sequential one. This contrasts with the languages of writing, which are indefinitely sequential and present themselves as a series of signs on a line, instead of a

6) See Hans Blumberg, *Die Lesbarkeit der Welt* (Frankfurt-am-Main: Suhrkamp Verlag, 1981)

ABRAHAM A. MOLES

hierarchy of elements on an ideogram or on the surface of a page. This language materializes itself in the raw materials of the visual field: the surfaces, the contours, the volumes, the ups and downs, the borders, and the pages. It attempts to articulate, through a basic standardizing of universalizing operations, the entirety of all those elements, forming a cultural wealth which is a correlate to the invasion of the world by artifice. It seeks to introduce a behavior in our contacts with this artificial world. It is by this ability to master this language that the graphic designer can impose on the world an educational value.

Toward a general method for studying the context of actions
The psychologist offers to the graphic designer, in that preliminary and tactical relationship between the perceived world and the world of actions, privileged methods for the analysis of everyday life. That is the idea of micropsychology, the idea of tracking down in a fine and attentive manner the details of a person's behavior, especially the idea of giving an account of and rendering explicit the whole complex of facts of life which, remaining above the threshold of perception (that is, of the perceptible) are, in the usual experience lived by the person, below his threshold of clear consciousness, that is to say which are either forgotten or obliterated – perhaps less for reasons of deep conflict than for the more banal ones of interferences of values and interests. Precisely because of that smallness and negligence, all those micro-events of the life flow have been precisely disdained, even rejected, by the compartmental psychologist involved with laboratory situations.

Micropsychology seeks to construct *micro-scenarios* which it will decompose, on the basis of what from now on is called "Theory of Actions or Praxeology,"[7] into intelligible sequences that attempt to give an objective report of everyday subjectivity. To the analysis of those sequences it relates, following a functional rationalism, the concept of generalized cost of the actomes or proxemes of the global action, a generalized cost which, leaving aside (without ignoring it) what the conventional economist would call the price of an act, an object or a service. Generalized cost stresses an aggregate of other price terms: elapsed time (therefore time lost), implied but neglected physical effort, mental effort, and the micro-anxiety of uncertainty about the unfolding of the immediate future.

In other words, micropsychology seeks to describe the generalized cost of actions in diverse behavior patterns along universe lines of the individual in the technological world offered to us. By that very fact, it seeks to suggest a value analysis brought down to the level of everyday life and a criterion for equating the environment with the vital (goal-oriented) trajectory of the acting subject. Micropsychology discovers that the "infinite diversity and the waving motion of the vital behavior patterns of each indi-

7) See Abraham Moles, *Théorie des Actes* (Tournai: Casterman, 1977)

8) Gaston Bachelard, *Cours Sorbonne*, 1956.

vidual in each situation" in fact obscures, as stated by Gaston Bachelard, "*a great poverty*,"[8] a broad stereotyping, a limitation in the repertory of elements of acts (actomes), something that justifies the intention of finding a scientific procedure to master the greater and greater abundance of their combinations. The historical validity of the individual is not infinite, but repetitive and combinatory.

If that is so, how will the graphic designer work as being responsible for, and a mediator in, the appearance of the fabricated world before that world is grasped by either the hands or the intelligence of the subject? Will he or she plan, design, the appearance and the legibility of that environment so as to reduce as much as possible embarrassment, hesitation, false maneuvers, ambiguities in the world of objects as compared to the subjective world? That reduction will increase the legibility of the world, so it is indeed a project for graphic design, and is the one that must be examined.

Environment as limitless context of our actions

Adopting that propelling idea of a legibility of the world Hans Blumenberg proposes, one should then consider the aggregate of successive environments our trajectory encounters in space-time, in a realistic world of everyday life – that scenery then constitutes the background against which the form of our action sequences and of our projects will stand out: a sort of immense, non-defined page unfolding around us. We perceive it in our field of consciousness as the frame where our actions are located, in what is beginning to be called the *action landscape* – a limitless text we must decipher through an effort, of which the "printing types" are the elements of the structure and the recognizable "signs," of which the "phrases" are the successive decors of our wandering, and of which the unfolding constitutes the very context of each person's life, something like a reading of the world.

A text more or less decipherable, more or less legible, more or less intelligible, is offered to us as a given in an active reading of every moment. To what extent would the legibility of that context condition the very development of our own action? Through that poetical metaphor, the task of the graphic designer clearly appears: *to increase the legibility of that environment*, something that will permit us to reserve our efforts for the accomplishment of our autonomous actions. To that end, it will be necessary:

- to act on the signs by reducing the number of their types
- to standardize them in order to increase their universality
- to bring out categories of environmental fragments (the decor, the teller-window, the road-crossing) by subjecting those elements to the spelling of a precise graphism
- finally, to ensure to that text the *sufficient redundancy* information theoreticians stipulate as one of the conditions of intelligibility.

There is thus an interesting parallel between the reading of a text

ABRAHAM A. MOLES

and the reading of the environment. It is not surprising that the same social engineer, the designer, will find there a closely related function on two different scales: the one when he or she sets up the text of a book, the other when he or she punctuates and standardizes the discourse the environment makes to the individual, as a perpetual conditioning of him or her. That metaphor was already present in the mannerist idea which saw the world as a vast labyrinth and therefore as a system of linear environments (the constraints of the labyrinth's wall) determining the path with knots and branchings-out: The individual walking through it is conditioned by the immediate landscape surrounding him. Faced with two different or contradictory perspectives, he or she must choose a way along a multi-branched path.

How can we increase the legibility of the world? The image just suggested offers a method of analysis in which the microspychology of everyday behavior will play an essential part:

1. in analyzing and crystallizing the immediate context that surrounds every one of the person's actions in a particular sequence tending toward a goal – in building, in other words, what we call micro-scenarios of everyday life
2. in reducing those multiple individual cases to a limited number of *type-scenes* in which difficulties, dilemmas, and conflicts of interest repeat themselves with variants of little relevance to the essential
3. in demonstrating, through analysis, that the limited and repetitive mental landscapes of action, may be objects of knowledge, thus reducing the apparently infinite diversity of reality.

Let us mention a few of these mental landscapes: the train traveler arriving in an unknown station, the shopper walking through the labyrinthine aisles of the supermarket, the tourist wandering through the picturesque center of a city. Each one of those persons really perceives that environment as a mental landscape of his immediate action, as a strolling about in a limitless corridor on the walls of which is written a text, the context of his action.

The designer, strategist of the minuscule in our relationship with things

For each one of those characters there emerge:

- *routines* of everyday life: to walk along a corridor, successively to explore with one's glance the windows of a pedestrian street, or the products of the supermarket basket
- *micro-decisions*: whether going to the right or to the left at the end of the alley, or choosing the food section rather than the drug department, the low level of importance of those decisions (hence the name micro-decisions) must not hide the conditioning mechanism through which the "supermarket landscape" or the "luggage checkroom landscape" will sub-determine the trajectory of each person as a function of his own value table

- finally, *information requests*: "Where is the lost and found window?" (good sense and custom telling us that it must exist somewhere, in the vast building where we are), and "what steps must I take to reach it?"

The signs which *la signaletique* (graphic communication, in its most comprehensive sense) precisely offers to us will be those intelligible symbols (because they retain in their form a small part of what they designate) introduced at points of hesitation, at points of decision, along the trajectory. It is those elements which will increase our comprehension of it and therefore the mastery we exert over it; which will decrease our micro-anxieties; in short, which will cause a decrease in what we shall call the generalized cost of the wandering act.

Numerous studies have now been completed on the function of generalized cost as regulators of everyday life actions. They all rest, on the one hand, on the simple idea, well established by pragmatism, that *generally* – except in very rare cases – *an individual acts to the extent in which the advantages derived from his or her actions exceed their drawbacks, or exceed the loss of resources those actions will cause* and, on the other hand, that the global cost implied in each one of those actions is less than the capital of generalized resources of that same individual. That amounts to postulating the existence of some *global capital* available to each person, a capital from which people can invest fragments into a given action, for a given response.

Indeed, micropsychology does not pretend to account for all human actions – to do so would be presumptuous – but it claims to explain the majority of actions in the majority of human beings: it proposes a sort of social behaviorism, explanatory elements of the total interaction between human beings and things.

Where it differs from conventional psychology in the analysis of everyday actions as a possible source of an economic system, is not in the principle of a *utilitarian causality*, which sees human actions as determined by the sum of an objective environment and by a subjective value table within a framework of limited resources, but in the emphasis it places on *micropsychological analysis*, insisting on the validity of those reasonings at the level of simple acts of daily life, as soon as those acts involve what we called above micro-decisions, and not a simple routine. Its originality is to bring out the fact that at that level what we are calling generalized costs and resources of the individual is very different in its nature from what traditional economics had looked at, and had wanted to include in the all-encompassing concepts of price and of capital.

To conclude, we shall summarize the analysis of the role of a micropsychological approach to the global project of the environment with ten design axioms:

1. The designer is a modest demiurge: He or she takes charge of

Abraham A. Moles

the daily environmental pattern in a hedonistic context where the measure of his action is the quality of life.

2. The designer is an environmental engineer, and his fields of action are characterized by two things, the scale of his perception of the shells in which humans are enclosed, and the types of sensorial aspects that he vouchsafes in his action.

3. In consumer society design is no longer concerned with a particular object, but with the totality of an environment on a given scale.

4. Everyday life is the designer's subject matter. It is what remains when society has institutionalized everything, it is the only field of interstitial freedom where the individual can challenge social dictatorship.

5. The function of the designer is to increase the legibility of the world. The world is a labyrinth that must be unravelled, a text that must be deciphered. Each individual scrutinizes it as his life unfolds.

6. Micropsychology is the rational study of the apparent irrationality of Man, which it brings back to an adequation in relation to his micro-values. It provides micro-scenarios of behavior in the face of an object or a product, and consequently the very basis of the act of design.

7. The industrial social system can no longer limit itself to the production of objects for a market, but must rather manufacture functions for an individual situated in a context of desires. It is the function, and not the object, that the industrial firm supplies. It is the function that is guaranteed to its possessor.

8. In an automated and computerized society the production function has become totally dissociated from the labor function. The factory manufactures without workers by using information processed by a creative function that produces a model.

9. There are two types of creativity. One can be termed absolute creativity. It obeys Gödel's theorem and it is capable of materializing only if an effort is made to transcend human thought in relation to the sum of knowledge it possesses already. The other is creativity through variations. It is based on the sum of modifications and combinations that one can impose on a pattern, a form, or a given configuration. It is capable of being executed by a computer if one takes the trouble to feed in an already known form and a program of variations.

10. Do we still need to invent? Would variational creation not suffice for a computerized civilization by indefinitely generating new forms that are simply combinative derivations of ancient forms adequately providing answers to all the briefs drawn up by our desires?

Translated from the French by Juliette Nelles

Robin Kinross

The Rhetoric of Neutrality

Introduction

"Information design" has emerged within recent years as a distinct area of practice and investigation, bringing together – among principal participants – graphic and typographic designers, text writers and editors, computer engineers, psychologists, and linguistic scientists. Risking oversimplification, one might say that the information design movement (though *movement* may be too strong a term for it) has been concerned about discovering what is effective graphic and typographic communication. It has been concerned with the needs of users rather than with the expressive possibilities present in design tasks. This is its point of difference with graphic design as usually practiced and taught. The movement is an international one, though centered in Britain and the United States. It has generated a good deal of literature, including, as forums for discussion, two specialist journals: *Visible Language* (from 1971, formerly the *Journal of Typographic Research*, started in 1967) and *Information Design Journal* (started in 1979).

This essay has two broad intentions.[1] First, to discuss, through detailed examination of some of the products with which information designers have been typically concerned, whether information can be neutral. And then to move on from this close criticism of examples to discuss the larger social and political dimensions present, even within the smallest and most mundane designed fragment. Thus, both explicitly and by example of the mode of argument employed, the essay makes some criticism of information design as it is so far developed.

Purity of information: some railway timetables

The starting point for this investigation is a passage in an article by Gui Bonsiepe that has been a principal source for recent work in visual rhetoric: "Informative assertions are interlarded [*durchsetzt*] with rhetoric to a greater or lesser degree. Information without rhetoric is a pipe-dream which ends up in the break-down of communication and total silence. 'Pure' information exists for the designer only in arid abstraction. As soon as he begins to give it concrete shape, to bring it within the range of experience, the process of rhetorical infiltration begins."[2]

1) The essay was originally presented as a paper at the first Information Design Conference, held at Cranfield, England in December 1984. The author is grateful to the editors of *Design Issues* for their criticisms of an earlier draft. In the text now published it seemed appropriate to the aims and content of the paper to retain as much as possible of its original colloquial manner.

2) Gui Bonsiepe, "Visual/Verbal Rhetoric," *Ulm* 14/15/16 (December 1965): 30. See also these articles by Bonsiepe: "Persuasive Communication: Towards a Visual Rhetoric," *Uppercase* 5 (1961): 19-34; "Semantic Analysis," *Ulm* 21 (April 1968): 33-37; and, more recently, by Hanno Ehses: "Representing Macbeth: A Case Study in Visual Rhetoric," *Design Issues* I (Spring 1984):53-63; "Rhetoric and Design," *Icographic* 2 (1984): 4-6. In an article that leads up to the present discussion, I have made some criticism of the claims for visual rhetoric and semiotics: Robin Kinross, "Semiotics and Designing," *Information Design Journal* 4 (in press).

3) Bonsiepe, "Visual/Verbal Rhetoric," 30.

This is a clear statement of position and one that seems unexceptionable. But then, three paragraphs further on, Bonsiepe apparently contradicts himself: "As examples of information innocent of all taint of rhetoric, we might take the train timetable or a table of logarithms. Granted this is an extreme case, but because it is an extreme case, it is very far from representing an ideal model. Fortunately communication is not tied exclusively to the perusal of address books [or directories]. It would die of sheer inanition if these were to be its exemplar."[3]

Taking up one of Bonsiepe's suggested categories of information, London North-Eastern Region (LNER) railway timetables can be considered: the first from 1928 (figure 1) and the second from a redesign shortly after this date (figure 2). These examples come from a publication of the Monotype Corporation, which made propaganda for their recently introduced Gill Sans typeface. The major change is, of course, that of typeface. A change of detail is the substitution of dashes for dotleaders in alternate rows; also, the two dots in each element of the leader are further apart. Otherwise, there is not much change.

Forty or so years later, in 1974 and now in the era of British Rail, things are much the same (figure 3): another variation on the theme of leaders, bold rather than medium as the standard for times, few horizontal rules, and station names now set in lowercase.

These timetables, by the simple fact that they organize and articulate and give visual presence to information, use rhetorical means. A dictionary definition of the term *rhetoric* yields the following: "The art of using language so as to persuade or influence others; the body of rules to be observed by a speaker or writer in order that he may express himself with eloquence."[4] It is the sec-

4) *Oxford English Dictionary*

Fig. 1) London North-Eastern Region timetable of 1928, as reproduced in *Monotype Recorder* 32 (Winter 1933).

TABLE 13—continued. LIVERPOOL STREET, FENCHURCH STREET, STRATFORD, ILFORD, ROMFORD, BRENTWOOD, SHENFIELD AND CHELMSFORD.

MONDAYS TO FRIDAYS INCLUSIVE.
(For trains on Saturdays see pages 63 to 68.)

D Calls at Stratford to take up passengers only.
F Calls at Ilford to take up passengers only.

SS Second class carriages are not run on these trains.

ROBIN KINROSS

TABLE 13—continued

56

LIVERPOOL STREET, FENCHURCH STREET, STRATFORD, ILFORD, ROMFORD, BRENTWOOD & WARLEY, SHENFIELD & HUTTON AND CHELMSFORD

MONDAYS TO FRIDAYS INCLUSIVE
(For trains on Saturdays see pages 63 to 69)

			S S											N			S S N		S S P						R	R					
		a.m.	a.m.		a.m.	a.m.	a.m.	a.m.	a.m.	a.m.	a.m.	a.m.	a.m.	a.m.	a.m.	a.m.	a.m.	a.m.		a.m.	p.m.	p.m.	p.m.		p.m.	p.m.	p.m.	p.m.	p.m.		p.m.
LIVERPOOL STREET dep.	1034	..	10 46	1045	1049	1111	..	1110	..	1125	1130	1139	1142	..	1153	1156	12 0	..	12 3	12 5	1219	1225	..	1233	1242		
Bethnal Green — — — — ,,	1038	1049	—	—	..	1114	..	—	1141	—	—	..	1211		12 7	..	—	1223		—	1237	..	—	1246					
Coborn Road for Old Ford ,,	1042	1053	—	—	..	1118	..	—	1145		1211	..	—	1227		—	1241	..	—						
FENCHURCH STREET ... dep.	—	1030	—	—	—	11 5	—	11 8	—	—	—	—	1138	—	—	—	1154	—	12 5	—	—	—	—	1235	—						
Leman Street — — — — ,,	—	1032	—	—	—	—	—	1110	—	—	—	—	—	—	—	—	1156	—	—	—	—	—	—	—							
Shadwell and St. George's East ,,	—	1034	—	—	—	—	—	1112	—	—	—	—	—	—	—	—	1158	—	12 9	—	—	—	—	—							
Stepney (East) — — — ,,	—	1037	—	—	1110	—	—	1115	—	—	—	1143	—	—	—	12 1	—	1212	—	—	—	1240	—								
Burdett Road — — — ,,	—	1039	—	—	1112	—	—	1117	—	—	—	1145	—	—	12 3	—	1214	—	—	—	1242	—									
Bow Road — — — ,,	—	1043	—	—	1115	—	—	1121	—	—	—	1148	—	—	12 6	—	1217	—	—	—	1245	—									
Stratford Market — — — arr.					1121		1121				1154					1222				1250											
Stratford { arr.	1046	1049	..	1057	1059	1120	..	1123	1126	1134	..	1149	1152	..	1212	1215	1215	..	1231	1245	..	1252							
{ dep.		1050	10858			11 0			1128	1136			1153	_1203_		1213	1216	_1210_	1232		1253										
Maryland Point — — — ,,		1052				11 2			1130	1138			1155			1215	1218		1235		1255										
Forest Gate for Upton — ,,		1055				11 5	1127		1133	1141			1158			1218	1221		1238		1258										
Manor Park for Little Ilford ,,		1058				11 8	1130		1136	1144			12 1			1221	1225		1241		1 1										
Ilford — — — — ,,		11 2				1113	1134		1140	1149		1210	12 6	1217		1224	1230		1245		1 6										
Seven Kings — — — ,,		11 6				1117	1138			1153			1210				1234		1249		1 10										
Goodmayes — — — ,,		11 9				1120	1141			1156			1213				1237		1252		1 13										
Chadwell Heath for Becontree ,,		1111				1124	1144			1159			1216				1240		1255		1 16										
Romford — — — ,,		11 13				1130	1150			12 5		1219	1222				1246		1 1		1 22										
Gidea Park and Squirrels Heath ,,		11 17				1134	1153			12 9			1225				1249		1 5		1 26										
Harold Wood — — — ,,		11 21				1138				12 8									1 9		1 30										
Brentwood and Warley — ,,		11 30				1145						1231	1235						1 16		1 41										
Shenfield and Hutton — ,,		11 36										1236	1240								1 47										
Ingatestone — — — ,,		11 43																12 55			1 53										
CHELMSFORD — — — arr.		11 52						1212				1238						1 18													

B Calls to take up passengers only
C Calls to set down passengers only
N Not after 29th September

P Commences 2nd October
R Runs Fridays 15th, 22nd and 29th September only
S S Second class carriages are not run on these trains

Fig. 2) London North-Eastern Region timetable, redesigned after 1928, using Gill Sans, as reproduced in *Monotype Recorder* 32 (Winter 1933).

5) *Oxford English Dictionary*

ond sense (the body of rules for eloquence) that seems to describe the case of the timetables. The system of tabular arrangement that these examples employ is like a figure of rhetoric: a framework for eloquent articulation. But is there any rhetoric involved if another definition (chronologically later and also more popular), such as "language characterized by artificial or ostentatious expression"[5] is considered? Not obviously, unless one regards the replacing of a leader composed of two dots by one made up of six dots as a sign of ostentation. And, perhaps, within the sober and hushed domain of the timetable, it is just that.

Another point of comparison is provided by the page from the Dutch railway timetables of 1970-71 (figure 4). The main feature is the use of color – lost, of course, in this reproduction. A green strip along the top of the page indicates that the user is in the section of the book that covers the northern and eastern parts of the country. Then red is used in the network diagram above the tables, to show further destinations after changing trains. In the tables, red is also used as the symbol for "Tempo" or intercity trains. Other differences from the British examples: the absence of any dotleaders, horizontal rules showing when a train stops for a minute or more, and the use of medium characters only – no bold – for the station names and the times.

Now, if small modifications in the form of dotleaders are regarded as ostentations, how can this deployment of color be described? It is hard to think of anything that is more like a rhetorical device than this use of color, especially within so tight and dry a context as a timetable. Color is perhaps like music: It can play on our senses. How, we do not quite know. But suddenly we are seduced. And is not this a rhetorical maneuver, in the sense of a set

London to Colchester, Walton-on-Naze and Clacton

Saturday service will apply Bank Holiday Mondays, 27 May, 26 August and 31 March

			B ①		A			WTₕₒ		
London Liverpool Street	d	18 22	18 40	18 42 19 00 19 04 19 30 19 34 20 04	20 05	20 30 21 04 21 30	22 04	23 00 23 06 23 55	..	
Ilford	d	18b15		18b34 19 18 19b38 20 18	19 58	21 18	22 18	23 20 23 38		
Romford	d	18b27		18b46 19 25 19b45 20 25	20 05 20 25	21 25	22 25	23 27 23 45		
Shenfield	d	18 49		19 10 19 41 20 03	20 31 20 44 21 41 21 53		22 41	23 46 00 19		
Ingatestone	d			19 15 19 46	20 46	21 46	22 46	23 51		
Chelmsford	d	19 00		19 23 19 31 19a54 20 14	20 40 20a54 21 04 21a54 22 03	21 29	22 55	23 44 23 59 00 33		
Hatfield Peverel	d			19 31 20 22			22 09			
Witham	d	19 11		19 36 19 41 20a26	20 49	21 15	22 14	23 06 23 56	00 44	
Kelvedon	d			19 46	20 54		22 19	23 11		
Marks Tey	10 d			19 51	20 54 21 00		22 25	23 18 23 21		
Colchester	10 a	19 25	19 31	19 52 19 58 20 21	21 01 21 08	21 29	22 35	23 26 23 29 00 13	00 58	
	d	19 26		19 36 20 00	21 10		22 37			
St. Botolphs	a			19 42						
	d			19 46						
Hythe	d			19 48						
Wivenhoe	d			19 52	21 16	22 43				
Alresford	d			19 56	21 20	22 47				
Great Bentley	d	19 38		20 00	21 25	22 53				
Weeley	d			20 04						
Thorpe-le-Soken	a	19 43		20 07 20 15	21 31	22 58				
Thorpe-le-Soken	d	19 44		20 18	21 34		23 03			
Kirby Cross	d	19 51		20 22	21 38		23 07			
Frinton	d	19 54		20 25	21 41		23 10			
Walton-on-Naze	a	19 57		20 28	21 44		23 13			
Thorpe-le-Soken	d	19 49	20 08	20 21	21 36	22 59				
Clacton	a	19 56	20 15	20 28	21 43	23 07				

Fig. 3) From the British Railways Board Passenger Timetable, 1974–75. Reproduced by permission of British Railways Board.

of rules for making information eloquent and more easily understandable, and then – more than this – for sweetening it and slipping it down our throats?

At this point it is helpful to return to the meanings of the term rhetoric, and to point to its sense of "the art of using language so as to persuade or influence others." A distinction is customarily made between design for information, for example, timetables, and design for persuasion, for example, advertising, above all. The argument of this essay is that this distinction cannot be a clear one. Looking again at Bonsiepe's theses, it seems that on the evidence of the examples discussed, his first perception was correct. As soon as the move from concept to visible manifestation is made, and especially to a manifestation as highly organized as a timetable, then the means used become rhetorical. Here another definition of rhetoric might be tried, the art of directed communication – directed, that is, both internally to organize the material communication and externally to persuade an audience. For there is an element of persuasion here, which can be brought out just by asking, why do transport organizations go to the trouble of having their timetables designed and, even more significantly, redesigned? These timetables are designed to say something persuasive about the nature of the organization that publishes them. When quoting the two passages from Bonsiepe, an apparent contradiction is highlighted. The contradiction is between his asserting that information without rhetoric cannot exist in the real world and his excluding the possibility that timetables could be rhetorical. In his second passage, Bonsiepe is wrong. Even if one takes rhetoric to mean artful persuasion, timetables can still enter this arena.

Using metaphor, the fusty British trains of 1960 (plush seats, patterned fabrics, carpets, lights with conical shades, little curtains

Fig. 4) Page from the Dutch national railway timetable (*Spoorboekje*) 1970-71; designed by Tel Design. Reproduced by permission of NV Nederlandse Spoorwegen.

Fig. 5) Page from a British Railways Eastern Region "Services to Germany" timetable, 1960. Reproduced by permission of British Railways Board.

– a substitute for the bourgeois interior awaiting the traveler at either end of the journey) can be contrasted with a Dutch train of the 1970s (seating of tubular steel, some tough synthetic seat materials, plain colors – a little severe but easy to construct and easy to keep clean). This is not, of course, to claim that these contexts can be inferred from the two timetables (figures 4 and 5); but it seems fair to say that the sense one has of each of these examples is of a piece with their respective contexts. And "the sense one has" of them is a consequence of the rhetorical devices they employ. All these examples impart information of times, destinations, buffet cars, and so on through the means of typography: typeface, type style, rules, dotleaders, symbols, spaces, and color. And these means constitute an "interlarding" (to use Bonsiepe's word) of information, and this interlarding provides the data of cultural reference.

The resonance of typefaces

To address more specifically the theme of the rhetoric of neutrality, it is useful to isolate one component of these timetables: the typefaces in which they are set. This is not to suggest that style of letterforms – typeface – is the most important thing in typography (in practice, it often seems to be the least important element). But the choice of typeface is often telling, in that it indicates the ideas and beliefs that inform the process of design.

In the progression from the first LNER timetable of 1928 to its

redesigned version, the change was essentially one of typeface: from a nineteenth-century serif typeface to Gill Sans, the sans serif designed by Eric Gill for the Monotype Corporation. It is instructive to read the explanation put forward by the anonymous writer in the *Monotype Recorder*, from which these examples come.[6] The typeface was chosen as a standard for LNER, the writer explained, as a way of giving all its printed matter and its signing a common identity. It was suggested that Gill Sans also possesses certain intrinsic virtues: It seems to perform well under the critical conditions of railway travel. To quote directly: "a passenger being jostled on a crowded platform on a winter evening, and trying with one eye on the station clock to verify the connections of a given train . . ."; without serifs and with lines of fairly consistent thickness, "it is so 'stripped for action' that as far as *glance* reading goes, it is the most efficient conveyor of thought."[7]

But the writer was careful to stop at this point. He or she (it may well have been Beatrice Warde, then in charge of the Monotype Corporation's publicity) went on to suggest that sans serifs are less legible than serif typefaces in extended passages of text, and rejected the idea that sans serifs have any necessary or special claim on the alleged Zeitgeist. This was the typical voice of the new traditionalism (as it has sometimes been termed) in British typography, at the moment when the voices of typographic modernism were just beginning to be heard.[8] For the new traditionalists, typography needed to be modern – to use mechanized processes and to cater to the needs of the modern world – but needed to avoid "modernism." The specter of *Das Modernismus* was kept at bay, in this case by the development of a sophisticated rival to the more rationally, geometrically conceived, new German sans serifs.

As exemplified by the timetables shown (figures 2, 3, 5), Gill Sans remained in use in Britain as the normal sans serif well into the 1960s. Its predominance was then disturbed by the arrival on the market of Univers, the typeface used in the Dutch timetable of figure 4. Univers was designed in Paris, beginning in 1954, by the Swiss Adrian Frutiger, and first became available as Monotype matrices in 1961. When it was new, Univers carried with it an aura: that of system. It was the first typeface whose total set of forms – the variants of weight and expansion or contraction – was conceived at the outset. The claim was made implicitly (in the name given to it) and to some extent explicitly (in publicity for it) that it was the typeface to meet all needs in any typesetting system in any language using Latin characters.

The fate of modernism
The changes of typeface in these timetables – the introduction of Gill Sans in the late 1920s and early 1930s, replacing nineteenth-century serif typefaces, and then the introduction of Univers

6) "An Account of the LNER Type Standardization," *Monotype Recorder* 32 (Winter 1933): 6-11.

7) "An Account of the LNER Type Standardization," 10.

8) For example, Jan Tschichold's programmatic statement "Was ist und was will die neue Typografie?" (1930) had appeared under the title "New Life in Print" in the journal of the advertising trade in Britain, *Commercial Art* (July 1930): 2-20.

Robin Kinross

Fig. 6) Letter of the Dessau
Bauhaus, designed by Herbert
Bayer, 1925, as reproduced in Jan
Tschichold, *Die neue Typographie*
(Berlin: Verlag des Bildungver-
bandes der Deutsche Buchdrucker,
1928).

(from the early 1960s) to replace earlier sans serifs such as Gill or the grotesques – are instances of larger historical shifts that underlie this subject. To put it rather portentously, one is here discussing the fate of modernism in the twentieth century: the attempted social and esthetic revolution that took off, shakily, from the continent of Europe in the 1920s and began to suffer drastic, almost fatal reversals in the 1930s (in Germany above all) but which struggled on, dispersed and diluted and which reemerged in the postwar world of the West and somehow, rather mysteriously, became a common visual currency during the 1950s and 1960s.

What has this to do with the rhetoric of neutrality and information design? My suggestion is that the assumptions and beliefs of information design can be traced to the period of heroic modernism (between the two wars) and that they spring directly from certain post-World War II mutations of the modern movement. Thus, in order to understand the present situation of information designers, one needs to investigate modernism and its history.

Fig. 7) Cover of the journal *Information* (Zurich, 1932), designed by Max Bill.

For example, consider this quotation from a famous artifact of modernist typography, the letterheading of the Dessau Bauhaus (in one of its several variations, figure 6): "an attempt at a simplified mode of writing: 1. from all the innovations in writing, this mode is recommended as the form of the future 2. text loses nothing when composed only of small letters, but becomes easier to read, easier to learn, essentially more scientific. 3. why for one sound – 'a,' for example – two signs, A and a; why two alphabets for one word, why twice the quantity of signs when just half of them would be enough?"

This example serves as a reminder of the faith of modernism: the belief in simple forms, in reduction of elements, *apparently* not for reasons of style but for the most compelling reason of need – the need to save labor, time, and money, *and* to improve communication. Text set in lowercase only is, it was suggested, "easier to read." If we smile at this declaration now (how difficult to

imagine any such statement on a present-day letterheading!), these ideas do become understandable when seen in the context of their time and place: Germany soon after World War I, when standardization was an economic imperative and when there were possibilities of social and political revolution. However, by the middle 1920s (the time of the Bauhaus letterheading) the utopian, revolutionary moment had passed, and economic and social life were attaining some degree of stability.

It is from this time in the progress of between-the-wars modernism that the theme to which information design is an heir comes to the fore: the mood of *Sachlichkeit* and a governing belief in science and technology. Thus, writing with small letters is "essentially more scientific."

Another document from the period provides further evidence: a journal published in Zurich, which gathered writers from across the spectrum of interests – economics, science, education, technics, and art – under the banner of *Information* (figure 7). In both form and content it is a typical product of the modern movement. This is not to suggest that with this journal the modern movement laid any exact claim on the word and the idea that now helps to bring information designers together, but merely that this strand of modernism's typical concern with information – "instructive knowledge" – is something that present-day information designers share too.

In alluding above to the "reversal" of the 1930s in Germany, one is, of course, simplifying and, it could be argued, falsifying. Revisionist historians have effectively disposed of the myth of some absolute break (in January 1933) between modernist in "good form" and Nazi kitsch.[9] It is clear that the modern movement in design, in Germany as elsewhere, was always a minority affair, just as it is obvious that German national socialism accepted and exploited elements of modernity: industrial production and technological advance. In the sphere of esthetics, however, national socialism arrived eventually at neoclassicism as its preferred style in architecture and also in typography. Thus, following a Nazi Party decree of 1941, gothic or blackletter ("the Jewish Schwabacher") was deposed as the standard letterform in Germany; the new standard was to be roman (Antiqua).[10] The words of the thousand-year Reich, like its public architecture, were to be lent authority borrowed from classical Rome.

The ambiguities of beliefs and forms of those years in central Europe force one to define what it was in the modern movement that is still alive in design now. For information design, specifically, one might separate out a commitment to the rational, the sceptical, the democratic socialist, the international as playing no part in national socialist modernization. This collection of beliefs and attitudes – including also more specific beliefs in simple forms and economies of effort – is something that information design

9) For English-language readers, this is most accessible in John Heskett's article "Modernism and Archaism in Design in the Third Reich," *Block* 3 (1980): 13-24. See also the recent survey by Jeffrey Herf, *Reactionary Modernism* (Cambridge: Cambridge University Press, 1984).

10) The decree is reprinted in Karl Klingspor, *Über Schönheit von Schrift und Druck* (Frankfurt am Main: Schauer, 1949), 44.

inherited from heroic modernism, but in transmuted form, over a gap of years in which World War II figured as an enormous convulsion. The after effects of this convulsion are described below, without a pretense of understanding precise causes.

Information design in the postwar world

In the immediate postwar situation, the ideals of modernism seemed to find a role again. In Britain, one thinks of the programs of the new Labour government in housing, health, and education and of the surrounding discussion and presentation. But with the economic recovery of the 1950s, ideals changed. The dream then envisioned an ideology-free or ideologically neutral world made possible by advances in technology, by an abundance of material goods, by the spread of representative democracy and the eclipse of rival political systems, and by mass education.[11] It was this dreamworld of the 1950s and the 1960s in the United States and Western Europe that provided the context for the spread of modernism in design. To return to the timetables, this was the context in which Univers – the universal, sans serif, sans-ideology typeface – could be designed and be so widely adopted. This was the context of the flourishing of Swiss typography: the style of technical advance, precision, and neutrality.[12]

If the word *information* can be used as a point of focus for some between-the-wars modernists, it also has specific connotations that date from after World War II in the United States. This is its use in the terms *information theory* and *information technology.*[13] The science of information is then laid onto the pattern of modernism: partly fitting with and confirming it, partly modifying it. The notable feature of the post-World War II concern with information is the way in which concepts developed in electrical engineering and computing have been generalized and dispersed, so that notions such as "message," "feedback," "redundancy," for example, could become part of anyone's mental baggage – in particular any designer's. This seepage from the laboratory into the wider world happened because such concepts could be of service. The idea was put forth that human transactions might have the same order and essential simplicity as an electrical circuit. One may suspect here a desire for the human world to be as amenable to understanding and control and as free from unpredictability as an electrical machine.

If information design can in many of its aspects be traced back to between-the-wars modernism, then the other large component in its formation would be this more recent matter of what has been called the information revolution. The clearest instance of the conjunction of these two strands – or overlaying of patterns – is in the work of the Hochschule für Gestaltung Ulm (HfG Ulm), the institution that fostered the work of Bonsiepe, which provided the starting point for this investigation.

11) The term *ideology*, though bedeviled by slippage in its meanings, seems impossible to avoid. In this context of the 1950s in the West, one thinks particularly of Daniel Bell's thesis of the "end of ideology," elaborated in his book of this title (Glencoe, IL: Free Press, 1960).

12) For more detailed discussion, see Robin Kinross, "Emil Ruder's *Typography* and 'Swiss Typography'," *Information Design Journal* 4 (1984): 147-153.

13) The founding text of information theory is C. E. Shannon and W. Weaver, *The Mathematical Theory of Communication* (Urbana: University of Illinois Press, 1949); for a popular account of the "information revolution," see, Jeremy Campbell, *Grammatical Man* (London: Allen Lane, 1983).

ROBIN KINROSS

14) The conflict-ridden history of this school lives on to obstruct attempts to document its work, but see a recent special journal issue on "The Legacy of the School of the Ulm," *Rassegna* 19 (September 1984).

15) Gui Bonsiepe, "A Method of Quantifying Order in Typographic Design," *Ulm* 21 (April 1968): 24-31. This article was also published in *Journal of Typographic Research* 2: (July 1968): 203-220. In a letter to me (11 October 1985), Bonsiepe explained that he was, then as now, interested in "the possibility of introducing arguments into the design discourse. And arguments are anything else than neutral." If it was wrong to seek a solution in information theory (with its neglect of the receiver or user), the problem remains a real one, unilluminated by decades of design methodology. In a letter to me (11 October 1985), Bonsiepe explained that he was, then as now, interested in "the possibility of introducing arguments into the design discourse. And arguments are anything else than neutral." If it was wrong to seek a solution in information theory (with its neglect of the receiver or user), the problem remains a real one, unilluminated by decades of design methodology.

The HfG Ulm was set up in the early 1950s to continue the Bauhaus tradition, though tempered and developed for the post-World War II world (and the special problems of reconstruction in West Germany).[14] For example, there was at first a Department of Information to educate students in skills of writing and radio broadcasting. But the real point of contact of the HfG Ulm with this argument is in the interest taken by some of its members in communication or information theory, cybernetics, and related areas of inquiry. A good example of these concerns is an article in which Gui Bonsiepe, using the Shannon formula, tried to quantify the respective degrees of order in two pages of an industrial catalog: the irrational, ad hoc approach to design in a printer's existing version (figure 8) and an Ulm-designed version of the same information, concerned to reduce variations of type size, text measure, picture size (figure 9).[15] In his conclusion, Bonsiepe ruminated on the possibility that the redesign was more *beautiful*, as well as more ordered than the original. Thus, this project com-

Fig. 8) Page from catalog (designed by its printer) investigated by Gui Bonsiepe, with the collaboration of Franco Clivio, as reproduced in *Ulm* 21 (April 1968). Reproduced by permission of Gui Bonsiepe.

bined the lessons of the new typography of Central Europe in the 1920s and 1930s with those of the Bell Telephone Laboratories in the 1940s.

The work of the HfG Ulm represents a marriage of modernism of form and appearance with highly developed theoretical interests. The marriage was a convenient one: Formal expression could diminish as the theoretical labor – the work of analysis – flourished. And this did seem to fit, at least for a time (the late 1950s and early 1960s), into the pattern of West Germany, in particular: the society of the "economic miracle." The analytical approach could find application in the complex tasks of coordinating the design of products of large concerns (a Lufthansa or a Braun). The style that issued out of the analysis worked too: to provide a sense of efficiency, sobriety, seriousness. These were the guiding values of the German post-World War II recovery. So one

Fig. 9) The catalog page redesigned (halftone pictures represented schematically), as reproduced in *Ulm* 21 (April 1968). Reproduced by permission of Gui Bonsiepe.

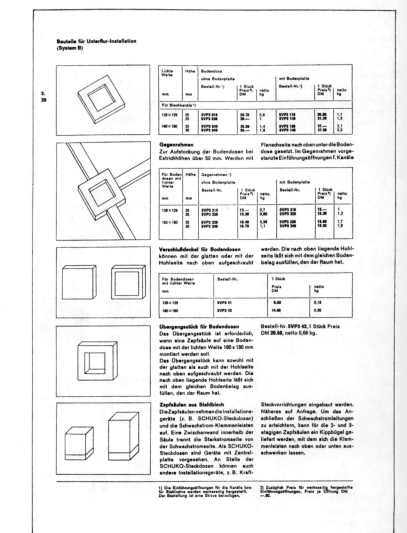

arrives again at the rhetoric of neutrality. If nothing can be free of rhetoric, what can be done to *seem* free of rhetoric? The style (for such it was) of the HfG Ulm was one response.

Coda

This historical excursion – proceeding via London North-Eastern Region railway in the 1920s, Central Europe in the 1930s, Ulm in the 1960s, and on up to the present – is intended to serve as a simple reminder that nothing is free of rhetoric, that visual manifestations emerge from particular historical circumstances, that ideological vacuums do not exist. In the context of the present rather intensely charged and volatile political atmospheres of even the "stable" Western nations, it may not be neccesary to labor such truths. The rhetorical interlarding that these cultures effect in their material and visual production hardly needs decoding. That is certainly so if one thinks of the more blatant products of the Western cultures of consumption: advertisements, above all.[16] But, among information designers, there has been a tendancy to escape from the assaults of the wider world, to deny any idea of rhetorical persuasion, and to take refuge in immaculate black machine casings. Indeed, the whole revolution of information technology seems to encourage the view that ideology becomes increasingly reduced – miniaturized – in step with the development of ever smaller and more powerful computing devices. Therefore, we need to keep awake, applying our critical intelligences outside, as well as inside, the black box: questioning and resisting.

16) "It is informally estimated within the advertising industry that on any given day the average American city-dweller takes in roughly 2,000 advertising messages;" thus Mark Crispin Miller, "Introduction: The Critical Pursuit of Advertising," *Word & Image* 1 (October-December 1985), 320.

Ellen Lupton

Reading Isotype

This essay developed from the exhibition "Global Signage: Semiotics and the Language of International Pictures," organized by the Herb Lubalin Study Center at The Cooper Union, New York, in spring, 1987. Its present form is the result of extensive advice from the editor.

*International System Of TYpographic Picture Education

Fig. 1)

1) Designers who have developed the Isotype tradition include Rudolf Modley, who brought pictorial statistics to America after working with Neurath in Vienna. See Rudolf Modley, *Handbook of Pictorial Symbols* (New York: Dover, 1976). The industrial designer Henry Dreyfuss compiled the *Symbol Source Book: An Authoritative Guide to International Graphic Symbols* (New York: McGraw-Hill, 1972). Both Dreyfuss and Modley have essays in Gyorgy Kepes, ed., *Sign Image Symbol* (New York: George Braziller, 1966). Martin Krampen made a survey of the theory and practice of symbol design *Design Quarterly* 62, [1965]). *Print* magazine devoted an issue to international pictures (November/December, 1962), and Nigel Holmes has designed pictographic identity programs for ongoing news events. See Nigel Holmes, *Designing Pictorial Symbols* (New York: Watson-Guptill, 1985).

Isotype* was developed by the Viennese philosopher and social scientist Otto Neurath beginning in the 1920s. The system uses simplified pictures to convey social and economic information to a general public and has been applied to sociological museums and to books, posters, and pedagogical materials (figure 1). Neurath hoped to establish a global standard for education and to unite humanity through one ordered, universally readable language of vision. His concept was continued after World War II by graphic designers internationally;[1] Isotype's legacy includes both the design of statistical charts and the more generalized production of visual symbol sets, from travel signage to corporate identity marks.

Isotype expresses a theory of language that continues to inform much graphic design education and practice. This theory was formally articulated through Neurath's research as a logical positivist, and found practical expression in Isotype. Neurath believed that language is the medium of all knowledge: empirical facts are only available to the human mind through symbols. He saw verbal language, however, as a disfiguring medium for knowledge, because he believed its structure and vocabulary fail to be a consistent, logical model of objects and relations in the physical world. Neurath held that vision is the saving link between language and nature, and that, hence, pictorial signs would provide a universal bridge between symbolic, generic language and direct, empirical experience. Neurath's theory of the universality of vision articulated an attitude common to many members of the avant-garde and the post-World War II design disciplines. The search for a scientific and autonomous language of vision has led designers to focus on the formal aspects of images, such that they often treat abstract visual pattern-making as an independent system of communication. For example, many design theorists have attempted to define the "language of vision" as a set of formal contrasts that operate independently of cultural or verbal conditioning.[2] The focus on form has isolated visual communication from verbal communication by describing visual experience as if it functions outside of culturally and historically determined systems of

145

2) See Gyorgy Kepes, *Language of Vision* (Chicago: Paul Theobold, 1944); Rudolf Arnheim, *Art and Visual Perception* (Berkeley: University of California Press, 1954); and Donis Dondis, *A Primer of Visual Literacy* (Cambridge, MA: MIT Press, 1973).

Fig. 2) Otto Neurath on December 21, 1945.

3) See Eckhart Gillen, "Von der Symbolischen Repräsentation zur Rekonstruktion der Wirklichkeit. Das Verhaltnis von Bildstatistik bei Gerd Arntz," in *Politische Konstructivisten: Die "Gruppe Progressive Kunstler" Köln* (Berlin: Neue Gesellschaft für Bildende Kunst, 1975).

4) The Otto and Marie Neurath Collection, consisting of Isotype documents and publications, was deposited in the Reading University Library, Reading, England, in 1971. *Graphic Communication through ISOTYPE* (Reading, 1975) is an exhibition catalog that includes an extensive bibliography, and an essay, "The Significance of Isotype," by Michael Twyman, 7-17; the essay was also published in *Icographic*, 10 (1976): 3-10. Otto Neurath's *International Picture Language/Internationale Bildersprache* is available in a facsimile reprint of the 1936 English edition, with a German translation by Marie Neurath, ed. by Robin Kinross (Reading, 1980). Neurath's writings on Isotype, as well as essays on physics, economics, politics, sociology, and the philosophy of science, are collected in *Empiricism and Sociology*, Marie Neurath and Robert S. Cohen, eds., (Dordrecht, Holland: D. Reidel, 1973); this book also contains biographical and bibliographical material. Robin Kinross's "On the Influence of Isotype"

meaning. In this paper, a formal analysis of Isotype, *form* will be described not as self-evident sense data, but in terms of the cultural meaning and theoretical polemics attached to it.

Otto Neurath and logical positivism

Otto Neurath directed the Museum of War Economy in Leipzig (1918), the Museum of Town Planning in Vienna (1919-24), and the Social and Economic Museum, also in Vienna (1924-34). These innovative museums explained city policy to local citizens. In 1933, as political pressures forced Neurath to plan his departure from Austria, he established the International Foundation for Visual Education, at the Hague. The following year Neurath and his staff moved to Holland, where they worked until pressed to emigrate again in 1940. The Isotype Institute, directed by Otto and his wife, Marie (Reidemeister) Neurath, was established in London in 1942. The offices of the various Isotype organizations were staffed with researchers who gathered statistics and other information; with symbol designers who developed the Isotype vocabulary (chiefly Gerd Arntz); and with "transformers," who converted information into Isotype graphics.[3] Otto Neurath died in 1945, but the Isotype Institute continued to operate until Marie Neurath's retirement in 1972.[4]

In addition to developing Isotype, Otto Neurath helped found logical positivism, a philosophical theory formulated in the 1920s and 1930s by the "Vienna Circle," a group of philosophers that included Rudolf Carnap, Herbert Feigl, Hans Hahn, Viktor Kraft, and Friedrich Waismann, and was directed by Moritz Schlick.[5] Logical positivism brought together two philosophical attitudes that had previously been contradictory: rationalism, which studies reality through logic, geometry, and mathematics, rather than observation; and empiricism (or positivism), which claims that the only access to knowledge is through direct human observation. Vision is the classic source of empirical knowledge. Modern science had already combined rationalism and empiricism by transforming mathematics from metaphysics to method, from an autonomous system reflecting divine law or the inherent order of the mind to a tool for quantifying observable phenomena. Philosophy, however, continued to maintain an opposition between rationalist and empiricist theories of knowledge.[6]

The Vienna Circle extended the scientific method to philosophy by using logic, a traditional technique of rationalism, to analyze language. Symbolic logic, developed in the late nineteenth century by Giuseppe Peano and then Gottlob Frege, consists of a set of basic relationships, similar to the operations in arithmetic ($+$, $-$, \times, $=$). These terms are each given precise definitions and form a set of simple propositions from which complex statements can be built. The truth of any statement is referred back to the definitions which constitute the system, rather than to relationships and

ELLEN LUPTON

(Information Design Journal, 1981, II/2, 122-130) discusses the reception of Isotype. "The Eclipse of a Universal Man: Otto Neurath" is a short essay on Neurath and the context in which he worked, by William M. Johnston, in *The Austrian Mind: An Intellectual and Social History, 1848-1938* (Berkeley: University of California Press, 1972), 192-195.

5) Peter Halfpenny, *Positivism and Sociology: Explaining Social Life* (London: George Allen and Unwin, 1982), 46.

6) Charles Morris, "Scientific Empiricism," in Otto Neurath, et al., eds., *Encyclopedia of Unified Science* (Chicago: University of Chicago Press, 1938), 64.

7) Halfpenny, *Positivism and Sociology*, 48-49.

8) Rudolf Carnap, "Logical Foundations of the Unified Science," in *Encyclopedia of Unified Science*, 50.

9) Neurath, "Empirical Sociology: The Scientific Content of History and Political Economy," in *Empiricism and Sociology*, 326. In this essay Neurath discusses his theory of "physicalism," which states that all sciences, including social sciences, are reducible to the vocabulary of physics.

10) Richard Rorty's critique of logical positivism centers on the notion of philosophy as "mirror of nature." Rather than construct universalizing systems, philosophy should act as a mediating discipline among intellectual dialects, it should embrace interpretation rather than scientific description. See Richard Rorty, *Philosophy and the Mirror of Nature* (Princeton: Princeton University Press, 1979).

11) Ferdinand de Saussure, in Charles Bally, Albert Sechehaye, and Albert Riedlinger, eds., *Course in General Linguistics*, trans. Wade Baskin (New York: McGraw-Hill, 1959).

12) For a discussion of Saussurian linguistics and avant-garde poetics and typography, see Annette Michelson, "De Stijl, Its Other Face, Abstraction and Cacophony, or What Was the Matter with Hegel?," *October* 21 (Summer, 1982), 6-26.

objects in the physical world. The formulation "2 + 2 = 4" is *analytically* true, regardless of the objects being added, whether apples or angels. This analytical truth makes no claim to either physical or metaphysical reality, refering instead to relationships among abstract symbols.[7]

The Vienna Circle used symbolic logic to analyze language into a minimal set of direct experiences, represented algebraically. Logical positivism states that the terms of all languages – from physics to biology to the language of daily description – are reducible to a core of physical observations, such as "big," "small," "red," or "blue."[8] The aim of logical positivism was to identify basic observational terms underlying all languages. As Neurath wrote: "[E]ach statement that does not fit without contradiction into the total structure of laws must disappear; each statement that does not rely on formulations that relate to 'data' is empty, it is metaphysics all statements lie on one single plane and can be combined, like all parts from a workshop that supplies machine parts."[9] Logical positivism correlated the terms of a purely abstract system with units of direct experience, attempting to analyze language into a consistent and logical mirror of nature.[10]

The logical positivists' "mirror of nature" contrasts with the linguistic theory developed by Ferdinand de Saussure in the late nineteenth century, which describes the structure of language as fundamentally independent of any structure of nature. Saussure taught that the significance of any sign is produced solely by its relations with other signs, and not by its correspondence with material objects: the sign, taken by itself, is empty. Both the level of meaning (the ideas and objects which language represents), and the level of form (the visible or audible material of language), are systems of differences. The meanings of the pronoun "I" include *not-you, not-she, not-he*, and also *not-me* and *not-my*. In Saussure's proposed science of semiology, verbal language was the embracing model for all other modes of communication, including iconic signs, which resemble the objects they represent.[11] Whereas Saussurian linguistics influenced some branches of the artistic avant-garde,[12] the positivist tradition has powerfully influenced the modern design disciplines.

The language picture

Isotype is a popular version of logical positivism. An Isotype character is *positive* because, as a picture, it claims a base in observation; it is *logical* because it concentrates experienced detail into a schematic, repeatable sign. Neurath likened Isotype to a scientific theory: "The analysis of snapshot materials – photographs, films, models, stuffed or living animals, engines – suggests the creation of more and more observation statements with all their multiplicity, full of whimsicalities which may be unimportant today but important tomorrow. From these observation statements the

13) Neurath, "From *Vienna Method* to *ISOTYPE*," in *Empiricism and Sociology*, 240.

14) Neurath, "From *Vienna Method* to *ISOTYPE*," 217

Fig. 3)

15) Neurath, "From *Vienna Method* to *ISOTYPE*," 224.

16) See El Lissitzky's 1922 essay "New Russian Art," which discusses the universality of geometric signs and defines abstract art as a catalyst for the production of useful objects: "new form . . . gives birth to other forms which are totally functional." In Sophie Lissitzky-Kuppers, *El Lissitzky: Life, Letters, Texts* (London: Thames and Hudson, 1968). Not all avant-garde artists heralded the scientific worldview. For a reading of surrealism as a critique of modernist design, see "Design in the Environment," in Jean Baudrillard, *For a Critique of the Political Economy of the Sign* (St. Louis: Telos Press, 1981). According to Baudrillard, Bauhaus design tried to achieve for domestic production what positivism had tried to achieve for language, namely, a closed system of objects correlated with a closed system of functions.

scientist reaches his theories correlated with observation statements but distinguishable from them. Isotype aids are comparable with scientifically formulated statements."[13]

An Isotype character is similar to a scientific formula; it is a reduced and conventionalized scheme of direct experience. The picture, for Neurath, was an intrinsically neutral mode of expression: "Just through its neutrality, and its independence of separate languages, visual education is superior to word education."[14] The photograph, a mechanical record of optical data, would be the most neutral expression of all. An Isotype character formulates the undifferentiated, nonhierarchical detail of the photograph (figure 2) into a concise, repeatable, generalized scheme (figure 3). With Isotype, Neurath tried to combine the mechanical empiricism of photography with the abstract logic of diagrams.

Neurath felt that Isotype opened onto a realm of immediate experience, the autonomous realm of the visual: "a new world, comparable to our book and word world."[15] This new world was comparable to, but separate from, language. Isotype proposed a bridge between the arbitrary, constructed, and constantly changing world of verbal languages, and the natural, physical, transcultural ground of visual experience. The concept of vision as an autonomous and universal faculty of perception is central to Neurath's design and philosophy; it remains one of the deepest principles of modern design theory.

Neurath believed that a more egalitarian culture would arise out of an international program of visual education. By its universality, pictorial information would dissolve cultural differences. Despite the devastating effects of technology in World War I, Neurath had considerable faith in science to improve the material and intellectual life of humans. The new scientific order would be disseminated through the transparent medium of orderly icons, industrially produced for a mass audience. Neurath thus shared the convictions of many designers, artists, and architects who worked between the two World Wars. To the theorists of constructivism, de Stijl, and the Bauhaus, geometry held the promise of synthesizing art and technology, and offered a visual "language" that would exist independently of particular cultures. For example, Soviet constructivists saw angular abstraction as an international and revolutionary language; its potential to communicate across language barriers would have been particularly salient in the Soviet Union. Constructivist graphics often paired geometric and photographic imagery, both of which were considered universal and objective.[16]

Isotype exemplifies a project common to much modern art and design – the attempt to eclipse interpretation with perception, to replace reading with seeing. Interpretation involves intellectual confrontation with language and other cultural products. In the spirit of interpretation, meaning is not an innate quality of forms

ELLEN LUPTON

or an automatic reaction of the brain; it is discovered by relating signs to one's own personal and cultural experience, and to other signs. Images take meaning from stylistic and iconic conventions, from other images, and from words, as well as from natural objects. To interpret is to recognize that signs are not absolute, neutral, and fixed, but are, rather, in historical flux.

Perception, on the other hand, describes experience in terms of conditioned reactions of the body and brain. Esthetics based on Gestalt psychology constitute the most influential and primary modern design theory. This theory implies a universal ground for artistic judgment, based on unchanging structures of the mind and brain. Gestalt esthetics makes of abstract "elemental" form a transhistorical foundation which unites man in spite of changing cultural references.[17] As people concerned with the visual, artists and designers tend to focus on perception at the expense of interpretation.

International pictures demand interpretation; they must be read. A pictogram functions by connecting with the culturally bound expectations of the people using it. It does not have an automatic, natural link to its object, but rather uses a figurative image as the starting point in a chain of associations. The signs in figure 4 all come from different tourist information signage systems. These drawings of gloves, handbags, and umbrellas are not pictures of particular objects, but rather stand for general classes of objects. Their generic status is signaled by their style, which also makes them read as public information rather than advertisements or decorations. Next, these signs, because they represent typical items that are lost, together become a sign for lost objects in general. Finally, the concept of lost objects stands for the office in an institution where such items can be retrieved. As with other cryptic messages, once the rationale behind a sign has been unlocked, it becomes memorable. The act of deciphering, the act of interpreting, is a pleasurable, memory-enforcing process.[18]

Pictorial statistics

As Robin Kinross has noted, the influence of Isotype can be broken loosely into two areas. The first is the deployment of Isotype characters in charts, which are primarily statistical; the second is the design of the symbols themselves.[19] Neurath called his central method of information design *pictorial statistics*: "only quantitative facts are socially significant, but most people are afraid of rows of figures So we see men and women, wage earners and employees, marching over the page in simple, clear, colored, contrasted symbols."[20] In a given chart, one sign stands for a fixed quantity. These groupings allow instant, visual comparison, remembered as an overall configuration. The charts usually have several variables. For example, figure 5 shows a similarity in the development over time, as France and Germany begin with a rela-

Fig. 4)

17) See Arnheim, Kepes, and Dondis (cited in note 2).

18) This "chain" of associations has been ideally analyzed into a narrative here; the actual use of a sign would never involve such an articulated sequence. This technique of describing the function of signs comes from Roland Barthes, who described signification as a chain of substitution in which a first sign, often an image, becomes the material vehicle for a second sign, which in turn becomes the vehicle of yet another sign. See "Myth Today," in Roland Barthes, *Mythologies*, trans. Annette Lavers (New York: Hill and Wang, 1957, 1972). A similar chain of substitutions is described in Peirce's theory of semiotic, in which a sign always refers to yet another sign, ad infinitum, and never to the object "in itself." See Charles Peirce, *Collected Papers*, Vol. II (Cambridge: Belknap Press of Harvard University, 1941, 1960).
19) Kinross, "On the Influence of Isotype."
20) Neurath, "From *Vienna Method* to *ISOTYPE*," 222.

Telephones and Automobiles per 200 Population

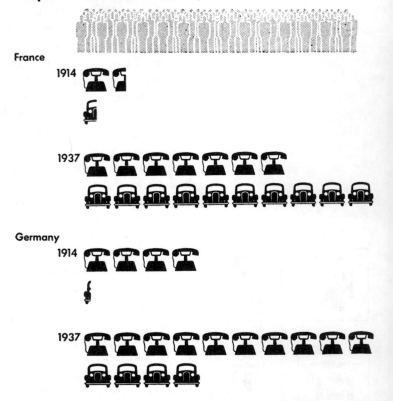

France
1914

1937

Germany
1914

1937

Fig. 5)

tively small quantity of telephones and automobiles; a geographic comparison shows a difference in the products' distribution. An Isotype chart substitutes literal figures for abstract numbers, exchanging exactitude for a memorable image. Isotype brings numbers to life by replacing them with pictures, and each picture is insured an objective, scientific status because it stands for a number.[21]

In the terminology of semiotics, Isotype figures are both icons and indexes.[22] An *icon* is a sign whose form is analogous to the object it represents, such as a perspective drawing or a map. An *index* is a sign linked to its object by virtue of proximity or direct physical contact. Some examples of indexes are a footprint, an image in a mirror, or a photograph. A statistical tabulation is an index of empirical observations; a population curve, for example, is a shape produced by the information it describes, not an invented image. An Isotype character is thus doubly bound to empirical reality. As an icon, it is purportedly grounded by physical resemblance rather than cultural convention. As an index, it is generated by numerical data.

Neurath saw statistics as "positive" and value-free. He wrote that sociology must limit its study to objectively measurable behavior: "Sociology on a materialist basis . . . knows only of such behavior of men that one can observe and 'photograph' scientifically."[23] Statistics were for Neurath such a photographic

21) Although "pictorial statistics" is the most systematic application of Isotype, Neurath used it in other ways as well. For example, Neurath's public information campaign for the National Tuberculosis Association uses Isotype characters to diagram the exchange of disease (New York, 1939). *Basic by Isotype* uses Isotype to identify vocabulary words in C. K. Ogden's "Basic English," a simplified grammar for international use. See Otto Neurath, *Basic by Isotype* (London: Kegan Paul, 1936). Neurath's *International Picture Language* advocates Isotype travel signage, which is perhaps its most popular use today. See Otto Neurath, *International Picture Language* (Reading, 1980).

22) The American philosopher Charles Morris, who worked with the Vienna Circle, promoted a theory of semiotic, based on the work of C. S. Peirce, which develops the categories of icon, index, and symbol. See Charles Morris, *Foundations of the Theory of Signs*, part of the *International Encyclopedia of Unified Science*.

23) Neurath, "Empirical Sociology," 361.

ELLEN LUPTON

method; they were neutral indexes of social fact. Yet statistics are always gathered and used in a context of interpretation and argument. Since the development of statistical methods in the nineteenth century, both positivist and antipositivist sociologists have debated their objectivity and usefulness.[24] When transferred from the discourse of professional sociology to a popular text like Neurath's *Modern Man in the Making*, a history book written for a general audience, statistics block any shadow of empiricist doubt. When set in a textbook or a newspaper, statistics resist the skepticism on which empirical method is founded, and project an authoritative image of self-evident factuality. Advertising continually relies on the scientific authority of statistics ("four out of five doctors recommend . . ."); the numbers arranged by an information designer may be less blatantly persuasive, but nonetheless arise from a motivated context. In Marie Neurath's description of an Isotype campaign designed for the Soviet Union in the late 1920s, the Russians "were interested in the representation of statistics, as everybody is who is proud of progress."[25] Statistics promote the objectivity of numbers while suppressing an interest in explanation.

The visual "Gestalt" configuration of an Isotype chart represents masses of data that have a supposedly objective, self-evident relationship to each other. A meaningful interpretation of the data is supposed to stem automatically from the numbers themselves. Like figure 5, the example in figure 6 is from Neurath's *Modern Man in the Making*. The juxtaposition of data implies a causal link between the two visually similar profiles, although the accompanying text is intentionally vague, in that it merely enumerates the social developments indexed by the charts, drawing few interpretive conclusions. Because the charts stand for numbers, Neurath believed they would inspire purely objective, rational readings, as if the figures offered up nature itself: his "picture/text style . . . should enable anybody to walk through the modern world . . . and see it as he may see a landscape with its hills and plains, woods and meadows."[26]

Pictorial signs

Isotype charts are built with Isotype characters. Neurath's writing suggests two central rules for generating the vocabulary of international pictures: *reduction*, for determining the style of individual signs; and *consistency*, for giving a group of signs the appearance of a coherent system. These rules have both explicit, practical functions and implicit, rhetorical functions. These constructive rules project an image of empirical, scientific objectivity; they also reinforce the "language quality" of picture signs, making individual signs look more like letters, and groups of signs look more like complete, self-sufficient languages.

Reduction means finding the simplest expression of an object.

24) See Halfpenny, Chapter 2, for a brief history of sociological statistics. For a description of sociology that demands the integration of empirical statistics into larger theoretical interpretations, see the Frankfurt Institute for Social Research, *Aspects of Sociology*, preface by Max Horkheimer and Theodor Adorno, trans. John Viertel (Boston: Beacon Press, 1956, 1972).

25) Marie Neurath, "Memories of Otto Neurath," in *Empiricism and Sociology*, 61.

Literates per 25 population

Fig. 6)

26) Otto Neurath, *Modern Man in the Making* (New York: Alfred A. Knopf, 1939), 7.

Fig. 7)

Fig. 8)

27) The sign as geometric shadow of reality is both a rhetorical connotation and a practical technique for many symbol designers. Martin Krampen suggested "simplified realism;" he urged designers to "start from silhouette photographs of objects . . . and then by subtraction . . . obtain silhouette pictographs." See Martin Krampen, "Signs and Symbols in Graphic Communication," *Design Quarterly* 62 (1965), 17. Statistics were used to select postures for the Munich Olympic Games signage: "The most significant action stages of the particular disciplines were found empirically by researching sports photo archives: the most significant stages were the ones most often shown." From Heiner Jacob and Masaru Katzumie, "Sign Systems for International Events," *Print*, (November/December 1969): 40.

Fig. 9) Examples of Isotype graphics which use isometry to indicate depth.

28) Neurath, "From *Vienna Method* to *ISOTYPE*," 237.

Fig. 10)

It is not meant to stylize the retinal image, but implies the operation of logical, mechanical principles. The international picture appears to be the necessary result of mechanized production and scientific method. Reduction does not actually strengthen the relationship between the picture and object it represents; it can even weaken that relationship by making pictures that are too geometric to be easily read. The implicit, *rhetorical* function of reduction is to suggest that the image has a natural, scientific relationship to its object, as if it were a natural, necessary essence rather than a culturally learned sign.

The silhouette is a central technique of reduction (figure 7). Silhouette drawing is a kind of pre-chemical photography that emulates the shadow, which is an indexical image made without human intervention, a natural cast rather than a cultural interpretation. International pictures suggest a rationalized theater of shadows, in which signs are necessary geometric formulae cast by material things – Plato's cave renovated into an empiricist laboratory.[27]

Flatness suggests a factual honesty, as opposed to the illusionism of perspective drawing. Isotype characters pull the shape of an object onto the ideal flat plane of a draftsman's drawing: They are blueprints of language (figure 8). The sign is simultaneously present to the eye, without imitative distortion.

When depth is expressed in Isotype graphics, isometry is used instead of linear perspective. In isometric drawing, parallel lines do not converge; dimension is fixed from foreground to background (figure 9). Isotype rationalizes the retinal by translating distorted sense material into a logical scheme. An isometric drawing describes what we "know" to be true, based on observation. Neurath was impressed by children's drawings, believing them to express naive, natural, and thus universal perception. Children, he wrote, do not use perspective. They are able to draw an object from all sides at once, and represent an entire forest with a single tree: "Isotype is an elaborate application of the main features of these drawings."[28]

The elimination of both perspective and interior detail heightens the alphabetic quality of international pictures. As in writing, the size, scale, or position of a given sign relative to other signs is not meant to be interpreted spatially, as a view of physical objects in a related scale. The image in figure 10 does not represent gigantic telephones or tiny cars; the size similarity is arbitrary and does not depict literal physical relationships. The signs are unified in terms of other signs, like letters in a typeface, rather than in terms of the objects they picture.

Reduction was also a principle for many other designers who were contemporaries of Neurath. From household objects to alphabets, formal reduction was linked with mass production. The sans serif typeface Futura was designed by Paul Renner

ELLEN LUPTON

ABCDEFGHI
WXYZ 1234
abcdefghijk

Fig. 11)

29) Twyman, "The Significance of Isotype," 13.
30) See Gillian Naylor, *The Bauhaus Reassessed: Sources and Design Theory* (New York: E. P. Dutton, 1985), 125.

Fig. 12)

31) Neurath, "From *Vienna Method* to *ISOTYPE*," 246.

around 1926-27 (figure 11), and Neurath adopted it for all Isotype graphics.[29] In the twentieth century, sans serif typefaces have expressed the machine age: Traditional references to handicraft are stripped from the essential, geometric core of the alphabet. At the Bauhaus in Dessau, Walter Gropius encouraged the design of essential "types" for domestic objects, based on the demands of industrial production and laws of abstract form.[30] "Machine esthetics" conceived of technology as clean, logical, transparent, free of redundancy, similar to the overall model of language built by the logical positivists – language as a machine for living in.

By eliminating the details, reduction gives an image a generic status. A pictogram stands for no object in particular. An Isotype character has features common to a varied class of objects. Its particular referent shifts with its use in a given instance, like the referent of an indexical sign. Its alphabetic look enforces its generality. As a flat, simple silhouette, a pictogram reads as a sign rather than a literal depiction. It is recognized as a temporary, reusable substitute for an actual object. Neurath tied the generic tone of Isotype to political internationalism and scientific progress. Isotype graphics represented the subordination of individual and national interests to the needs of an international community.

Few people today read Neurath's original intentions in international picture signs. Like many genres of modern design, the signs have been thoroughly integrated into corporate and bureaucratic identity programs. Retained in their style, however, is the look of factuality, nonconventionality, self-evidence. We now recognize that international pictures affirm the naturalness of public and quasi-public institutions, from government offices to tourist bureaus to corporations.

Consistency refers to the stylistic uniformity of a set of signs and to the standardized use of signs, allowing them to become conventional in a particular community of people. Isotype is based on a concept of universal legibility; at the same time, Neurath knew that unless Isotype was instituted as an official international standard, numerous other picture languages would enter the environment, as indeed they have: "There is no advantage to having more than one visual language; change in language does not increase the richness of the visual store Isotype experience teaches us that consistency of visual education is possible, that the same techniques of visualization can be used at all levels . . . and in all departments of scientific arguing."[31] Isotype itself, though, is not consistent (figure 12), having been developed over a period of 25 years in an environment of design collaboration as well as political and economic chaos. Neurath often had a large staff, its size peaking at around 25 in the late 1920s and early 1930s, in Vienna. Wartime political pressures forced him to relocate several times, the result being changes in staff and loss of documents. His *Symbol Dictionary*, which contains hundreds of pages and

32) The Isotype Symbol Dictionary is part of the Otto and Marie Neurath Collection at the University of Reading in Reading, England.

33) Neurath, "From *Vienna Method* to *ISOTYPE*," 217.

34) See Alan Windsor, *Peter Behrens, Architect and Designer* (New York: Whitney Library of Design, 1981).

thousands of symbols, was compiled between 1928 and 1940.[32] Isotype itself, in fact, could not have been consistent, because it was a huge sprawling experiment. Yet it pioneered consistency, through example and through Neurath's theoretical writings.

Neurath extended the principle of consistency to include the design of the architecture and graphics surrounding Isotype: "Even the furniture of the exhibition is to serve the Museum's purpose only and not to detract by sentimental or monumental effects By subdivisions and additions, a number of basic sizes of charts were found which can always be fitted together . . . all lettering is of the same printed type."[33] Thus Neurath suggested that a single visual system be extended to the environment at large. This is the central principle of "identity design," pioneered by Peter Behrens in the early twentieth century, at the AEG in Berlin.[34] The identity program became a major design service after World War II; it often centers around a logo mark, either abstract or pictorial. A corporate identity program is the visual "language" of a corporation, a consistent grammar and a vocabulary controlling the deployment of type and symbols, from invoices to architecture. An identity program projects the image of the corporation as a vast, coordinated machine with its own logical and natural mechanisms.

Practically, stylistic consistency unites a group of signs dispersed throughout an environment. Establishing a consistent way of grouping signs in a series of charts, or in a park or airport, allows users to learn to read them and to deduce from context what is not immediately understood. When consistent rules have been set, their occasional violation is then understood as meaningful. Consistency also simplifies the design process.

And rhetorically, stylistic consistency gives the effect of an ordered, self-sufficient "language." The repetition of line weights, shapes, boldness, and detail suggests the presence of a logically developed system, a uniform language of visual forms. This "language" is a stylistic matrix laid over a group of icons. This code does not control the basic semantic or syntactic workings of picture signs; that is, it does not control the ability of picture signs to enter one's broader linguistic repertoire. The semantic value of a picture sign is tied to its being a picture, not to its style. The same object could be represented by a photograph or a painting or an elaborate style. Stylistic consistency works semantically at the level of connotation, not denotation (projecting an image of grammatical coherence rather than functioning as a logical, linguistic rule). Consistency helps a set of pictures read as signs, as information markers rather than ornaments.

Fig. 13) Munich, 1972

Fig. 14) Tokyo, 1964

The sign system for the Munich Olympics of 1972 exemplifies the principle of consistency (figure 13). As in the Tokyo system of 1964 (figure 14), each sport is represented by a figure drawing. But whereas the Tokyo figures are drawn to order, the Munich signs

154 ELLEN LUPTON

Fig. 15)

are generated by a consistent "body alphabet" (figure 15). This matrix, though visually systematic, does not constitute an actual grammatical rule. One could put together a motley but legible set of symbols from a variety of picture alphabets. The legibility of the Munich pictures does not absolutely depend on the consistency of the body alphabet, as consistency is a rhetorical, stylistic device, rather than a necessary and independent syntax. The sign system prepared for the U. S. Department of Transportation by the American Institute of Graphic Arts is another exemplar of stylistic consistency (figure 16).

Fig. 16) Fig. 17)

When compound signs are built out of simple signs, the connection is compositional, rather than actually grammatical. Pictures are associated by simple virtue of proximity. In the tourist information signs shown in figure 17, all taken from different picture sets, the position of the telephone is inconsequential, circling the hotel like a moon. Just as size relationships between signs are not meant to be read literally, neither are most compositional groupings in international picture languages.

In the twentieth century there have been several efforts to design logically articulated picture languages from which sentences can be built, including semantography (or "Blissymbolics"), promoted by Charles Bliss from the 1940s through the 1970s (figure 18). Semantography is a collection of 100 symbols, each consisting of a "few schematized lines which faintly indicate the outline of things."[35] Hundreds of compound signs are built from this core, and syntactic markers allow each icon to function in three modes: thing, action, or human evaluation. Bliss wrote that semantography can translate any interpretive or metaphoric statement into quantifying, physical terms.[36] He called semantography a microscope and telescope for thinking. The person literate in semantography is no longer a reader, but an observer; Bliss's language is an instrument for examining empirical reality. Although semantography aimed for universality, it is a highly abstract code whose pictorial element is almost gratuitous.

eye to see visual

seem look out! picture

awake asleep clear
(open) (closed) (see
 through)

Fig. 18)

35) Charles Bliss, *Semantography/Blissymbolics* (Coogee, Australia: Semantography Publications, 1949, 1965).
36) Bliss, 265.

Conclusion

Otto Neurath understood that Isotype was not an autonomous, articulated language, yet he believed that visual communication could become a medium for unifying international social life. Pic-

torial signs offered the possibility of grounding language in a universal base of experience, appealing to the supposedly objective faculty of vision rather than to culturally bound interpretation. Neurath's philosophical project as a logical positivist was to create a scientific language whose system would mirror the structure of nature. At the popular level, he aimed to design a universal pictography for charting social facts, grounded in the apparent objectivity of perception. Neurath intended his visual language, like the proposed scientific language of the logical positivists, to become a set of signs free of the redundancy and potential ambiguities of an historically evolved verbal language.

Since the initiation of Isotype, a number of designers and writers have begun to question its purported objectivity and to formulate models of communication which stress the cultural relativity of images, and the openness of the categories "visual" and "verbal." Roland Barthes, writing in the 1950s and 1960s, analyzed images and objects as linguistic signs having historically determined, ideological functions.[37] In 1965 Gui Bonsiepe proposed a "visual/verbal rhetoric" for graphic design, one which would describe images in terms traditionally applied to verbal discourse.[38] Hanno Ehses, currently working at the Nova Scotia College of Art and Design, teaches designers to use patterns from classical rhetoric to generate ideas.[39] Francis Butler has written on the need for graphic designers to create images that are more culturally specific,[40] and the artist Victor Burgin has combined photography and text in projects which study sexual, political, and art historical issues.[41] Gregory Ulmer, a literary theorist, has proposed a visual/verbal practice based on the philosophy of Jacques Derrida, whose work attempts to dissolve the traditional distinctions between perception and interpretation, between objectivity and subjectivity. Ulmer's projected new discipline combines teaching, writing, and art: it could be a non-positivist revision of Neurath's role as educator, scientist, and designer.[42]

Many modern art schools have built a visual ghetto for the graphic designer. Though Otto Neurath helped to layer that theoretical wall, his work could also serve as a model for the graphic designer of the twenty-first century, the philosophical generalist, or the language worker who uses design as a tool for developing and promoting his or her own ideas.

For Otto Neurath, problem-solving involved designing the problem itself, that is, it involved defining the theoretical framework that allows particular questions to be asked. By extending a philosophical theory into a public context, Neurath initiated an original genre of communication, whose progeny have since been integrated into the public spaces of the industrial world. Now, in a changed technological and philosophical environment, designers and design educators must frame new questions about visual and verbal writing.

37) Roland Barthes, *Mythologies*; and Roland Barthes, "The Rhetoric of the Image," in Roland Barthes, *Image/Music/Text*, trans. Stephen Heath (New York: Hill and Wang, 1977).

38) Gui Bonsiepe, "Visual/Verbal Rhetoric," *Ulm* 14-16, 1965: 23-40.

39) Hanno Ehses, "Representing Macbeth," *Design Issues* I/l (Spring, 1984): 53-63.

40) Francis Butler, "Eating the Image: The Graphic Designer and the Starving Audience," *Design Issues* I/l (Spring, 1984): 27-40.

41) Victor Burgin, *Victor Burgin* (Eindhoven, Holland: Stedelijk van Abbemuseum, 1977), and Victor Burgin, *Between* (Oxford: Basil Blackwell, 1986).

42) Gregory Ulmer, *Applied Grammatology: Post(e)-Pedagogy from Jacques Derrida to Joseph Beuys* (Baltimore: Johns Hopkins University Press, 1985).

Picture credits: Figures 1 and 2, from *Empiricism and Sociology*, copyright © 1973 by D. Reidel Publishing Company, Dordrecht, Holland. Figures 4 and 16, from the symbol set designed by the American Institute of Graphic Arts for the U.S. Department of Transportation, 1974. Figures 6, 7, and 8 from *Modern Man in the Making*. Figures 3, 8, 9, 10, and 13, from the *Isotype Symbol Dictionary*, Otto and Marie Neurath Collection, University of Reading, England. Figures 14 and 15 from Henry Dreyfuss, *Symbol Source Book*. Figure 18 from Charles Bliss, *Blissymbolics*.

ELLEN LUPTON

Frances C. Butler

Eating the Image:
The Graphic Designer and
the Starving Audience

Printed text and images are still the central artifacts for housing of memory in literate culture. Although storage and retrieval of information is rapidly being transferred to computer memory banks, daily transactions in information, whether statistics, persuasion, or sentiment, are still made on paper. Some printed information is for reference, some is persuasive, and almost all of it is processed into a format determined by technology; for example, the typewriter determines the sizes of paper and envelopes.

In many countries, graphic design is still largely in the hands of printers, and even in countries with many active graphic designers, much of the printed material in daily life is designed by traditional format or with the new software from phototype and digital type companies. With this competition, designers present themselves as having achieved the unique ability to analyze and project images that constitute the symbolic meaning in the public message of their clients. Designers have accomplished this through long and specialized training in a highly theoretical body of knowledge and sophisticated technique, bolstered by a service orientation and a self-regulated social code, that is to say, by the definitions of their profession.

The mantle of skill is evaluated by the paying clients, who focus on economic results either in terms of products sold or interest engaged, or by the graphic designers themselves, who focus on novelty within a changing but restricted range of established conventions. Designers have had to be self-referential inasmuch as the other group concerned with visual images — the coalition of museums, art marketers, painters, and sculptors — contend that they alone generate images worthy of symbolic belief and use their publicity systems to exclude the replicated image of mass culture from public and scholarly attention or assessment.

However, designers' claims to communicative skill necessitate greater understanding of the nature of the real and the posited audiences and of the elements of image with which designers work, than has so far been demonstrated in designer critiques.

Far from understanding the nature of the tools of visual communication, designers tend to elaborate formulae that are evolved

by one or a few designers — Emil Ruder or Armin Hofmann, for example, and to justify the repeated use of these formulae by some verbal persiflage attesting to their legibility. Current fashions among designers, not the study of human communications, have continued to determine graphic design practice. Not only are there no tools for audience evaluation or participation in graphic design, but also designers decry the invasion of academic carpetbaggers who are likely to interest themselves in audience assessment. In so doing, designers are echoing the pain and outrage of older occupational groups that have managed to take onto themselves the somewhat fictive definitions of a profession, and who then claim that *only* the profession has the recognized right to declare "outside evaluation illegitimate and intolerable."[1] However, in cutting off audience evaluation, designers cut themselves off from understanding the extent to which their work is accepted and used or seen and ignored.

The graphic design trade today responds to overlapping phases of the continuum of audience reaction to print culture. Some of the products of graphic design address the expectations of the remnants of an oral culture; other formats are typical of literate culture. Oral culture, depending only on memory to retain the information considered necessary for social intercourse, tends to remember the typical, to cast into mnemonic forms that which is perceptible in the natural world and to cast out the purely eccentric as not being useful. For example, the genre scenes in advertising are normative, reinforcing stereotypes, although in the past twenty years some groups have managed to break out of their isolated stereotypes and join the general ones. Literate culture on the other hand tends to the abstraction of both verbal information and visual images. It also strives for novelty, if not originality, inasmuch as the maintenance of public memory is assured by the printed text. Thus the printed housing of general social norms is also the vehicle of innovative text and images for an audience that demands and supports novelty. Graphic designers themselves are confused about addressing different audiences, or more accurately, different expectations within the same audience, and to deal with the difference, attempt to divide the trade into two professional groups: graphic design and advertising. However, there does not seem to be any understanding that designers themselves operate on value judgements about the products that are made to engage the attention of the two-part audience.

Walter Ong notes the continuation of aspects of an orally based culture in our primarily literate culture in *Orality and Literacy, The Technologizing of the Word.* He has made some general comments about the way persons in an oral culture respond to their world, and that these responses have some relevance to the products of graphic design or the secondarily oral culture of electronic media. Among these notes are considerations of the ephemerality of sound as a record, which necessitates an elaborate procedure to memorize

1) E. Friedson, *Profession of Medicine* (New York: Dodd Mead, 1970), 71–72.

FRANCES C. BUTLER

2) Walter Ong, *Orality and Literacy: The Technologizing of the Word* (London and New York: Methuen, 1982).

information. Obviously, the nature of information itself is affected by the need to retain it through memory.[2]

The way things are done in an oral culture is learned by demonstration. The models for house building, marriage rites, or farming are visible before one to be copied, not abstracted as an image in an instructional manual. Story-telling performances require the gathering of the audience into one place, but because sound disappears so quickly, the characters and visual aids used in telling stories are *heavy* with symbolic traits and distinctive outlines. The stories, although complexly interwoven, are about action that involves exaggerated simple presence, absence, or battle. Agonism, or general verbal and physical quarrelsomeness, is typical of most oral stories, and opposition and its subsequent resolution is the basic format of almost all social symbolism.

We still carry with us, if not the intellectual configurations of oral culture, at least the nostalgic yearning for its reputed social concomitants — warmth, support, and community. We have been rendered ashamed of these yearnings by the emphasis placed on abstraction and objectivity by virtually every ideology in our culture — the word for religion, logocentris for philosophy, and rationality rather than emotionality as the sign of education. Nevertheless, one of the two rewards offered possible consumers of advertised goods is the fulfillment of these longings with the reward of loving encompassment of our body into one (or more) social bodies. For example, ads for White Horse whiskey promise consumers membership in a prestigious community of discerning drinkers. Conversely, the other reward promised by consumer society is power over the community.

Literate culture on the other hand requires both silence and vision, which when focused, is very narrow in scope. Reading requires separation and mental concentration and, thus, creates isolation both from the social group and from the physical world as well. The separation of knower from the known tends to turn the reader back on himself. Reading is thus profoundly dissective or analytical.

Writing creates an automatic memory, which encourages first linear and then subordinate phrasing of sentences and plots. As nothing is lost, redundancy is no longer considered useful. In fact, ever greater precision of dissection of experience and ever greater ingenuity in definition and naming becomes the supreme value of literate culture. Conceptual images, using E. H. Gombrich's term for simple outline images that picture all known functions on their edge regardless of their point of view,[3] (similar to a child's drawing of a boat or an Egyptian bas-relief figure that moves from front to side view to capture the most distinctive outline for each part of the body) are no longer necessary as mnemonic images. Instead, there is the gradual, erratically recurrent tendency for imagery to become illusionistic. The illusionistic image, to use another term defined by

3) E. H. Gombrich, *Art and Illusion* (Princeton: Princeton University Press, 1960), 87, 293–96.

Fig. 1) Conceptual Image by a 10 year old child.

Gombrich, is one in which the viewers must do the work and make the fuzzy blotch of paint and the edge become, as the nineteenth century art critic Heinrich Wölfflin phrased it, a boat or a lace collar through their own perceptual synthesis.

There is also among the literati the tendency to find abstract equivalents for visual images and, above all, to arrange these abstract marks in a spatial structure that will parallel their meaning. Both Ong and Frances Yates, for example, have written about the historic development of the shapes of text in space as aid for memory and rapid access.[4]

The nineteenth century writers about image were preoccupied with the exact relationship of form to the eye. Earlier, Plato had deliberately excluded poets from his *Republic* because they still celebrated the warm and blurry contact of the world with man, an approach that is typical of oral culture. He did not want the new abstract precision of his ideas, the forms based on the abstraction of number and geometry, besmirched by any unseemly, paratactic body-based clutter. Kant and Hegel separated the final reference for vision from the physical world and housed it in the Mind. Hegelian esthetics continued to influence later philosophers of art, such as Heinrich Wölfflin, who was in turn very influential in England and America, where indeed traces of his formalist psychology still color design criticism.[5] Wölfflin built his entire psychological esthetic on the expressive meaning of form. He spiritualized visual perception, separating it from iconography and generally from workmanship. His predilections were provided with physiological reality by the late nineteenth century perceptual psychiatrists who developed the theory of genetic compositional preferences called Gestalt psychology. Russian Constructivist graphic designers, of the 1920s and 1930s, who pursued the simple conceptual image in design as a political statement, a testimony to revulsion for the class-ridden historicism of the art of the bourgeoisie, rejoiced in the findings of Gestalt psychology because it by-passed class in assigning esthetic discernment (even the poor have genes). To win the Kulak to the Revolution, they designed a series of propaganda posters that celebrated the demonstration of closure and necessary proportions in Gestalt psychology. El Lissitzky's "Beat the Whites with the Red Wedge" is a good example. Now the Russian Kulak, as recorded by

4) Walter Ong, *Ramus: Method and the Decay of Dialogue* (Cambridge: Harvard University Press, 1958), and Francis A. Yates, *The Art of Memory* (Chicago: University of Chicago Press, 1966).

5) Heinrich Wölfflin, *Principles of Art History: The Problem of the Development of Style in Later Art* (1915; reprint, New York: Dover Publications, 194).

FRANCES C. BUTLER

6) A. R. Luria, *Cognitive Development: Its Cultural and Social Foundations* (Cambridge: Harvard University Press, 1976), 149.

A. R. Luria in the early 1930s, essentially inhabited an oral landscape.[6]

Self-reflection was transferred to material and social realms. One illiterate worker, when asked if he had any shortcomings, replied, "I have many shortcomings: food, clothing, everything." Self-evaluation was transferred to the group. To the question, "What sort of person are you?" another young man answered, "What can I say about my own heart? How can I talk about my character? Ask others, they can tell you about me." In this oral culture based on primary sensory perception, not abstraction, communication of social idealism through a visual demonstration of the operations of the faculties of perception was ridiculous, and eventually, divorced of its revolutionary intent, the mode of image found a more fitting home in the epitome of bureaucraticized labor, Western corporate business. Graphic designers have continued to trust these Gestalt theses, and the late twentieth century finds them believing that in Rudolf Arnheim's *Visual Thinking*[7] and *Entropy and Art*[8] or Donis A. Dondis's *A Primer of Visual Literacy*,[9] they have found models for composition that will infallibly align with man's genetic cognitive map. Thus, graphic designers have spent much time elaborating a series of abstract linear structures with which they seek to assure the transmission of their intended message to the perception of the audience.

7) Rudolf Arnheim, *Visual Thinking* (London: Faber and Faber, 1969).
8) Rudolf Arnheim, *Entropy and Art* (Berkeley: University of California Press, 1971).
9) Donis A. Dondis, *A Primer of Visual Literacy* (Cambridge: M.I.T. Press, 1973).

First the structure of the page was reorganized. The medieval manuscript had developed an *incipit* (beginning) in a style called *Diminuendo*, in which the letters of the words at the top of the page were very large and diminished as one moved down the page. After the development of the title page, which followed shortly upon the invention of printing, this *Diminuendo* structure was often transferred to chapter beginnings within the body of the book. The graphic designer in the mid-twentieth century transferred the *Diminuendo* structure to each paragraph, which was then placed at the intersections of variously devised grids, and together they were lined up like a string of beads that could be quickly told through. This linear index of separate entries allowed rapid access to information and assumed a much different relationship to and use of the page as an archive of memory than the traditional dense and relatively undifferentiated page structure.

Fig. 2) El Lissitzky, "Tatlin at Work on the Monument to the Third International," 1922.

Then designers continued to emphasize the center of the frame, which had emerged gradually as early Renaissance painters had supplemented the medieval vertical hierarchy with pictures of the human being centered in the visual field, often in a perspectival box of buildings or other man-made structures. The continuing symbolic use of the framed cental figure is often amusingly literal. From the nineteenth century to the 1930s, a filigreed picture frame was often used to convert advertising genre scenes to High Art, but even in the 1970s, a Winston cigarette advertisement enclosed two smokers bounding down a beach in a gold leaf picture frame labeled "Run-

ning Free."

Nonlinear reading amalgamates these discrete structural formats for legibility emphasizing top, line, center, and frame, with page formats organized to encourage multidirectional pursuit of understanding. This reader-syntaxed page had myriad precedents in the naive or preperspectival art of East and West, but was specifically recalled to the attention of designers through the rediscoveries of Sergei Eisenstein and other early twentieth-century movie makers. Unschooled drawings, and the popular prints available worldwide after about 1500, not yet being preoccupied with the existence of man in space, had assumed that every point on a page was of equal value and arranged the elements of instruction or narrative arbitrarily, determined by the fit of their conceptually defined outlines. This material was then organized by the readers, not much differently than audiences skilled in aural perception pick bits of plot line from the din of repetition, music, and whining babies at a public storytelling, fits these together into a story, and even appreciates details of delivery and the sly interjection of local gossip.

Early movie makers such as Eisenstein found that the audience could make the same connections, picking out a sequence through the showing of conflict within a frame, actions connected at the edge of successive frames, transparency, collage, scale change, direction change, and time change. Graphic designers such as El Lissitzky, Alexander Rodchenko, Piet Zwart, and Ladislav Sutnar incorporated this understanding of the possible feats of human memory into print graphics, trying as far as possible to make the page sequence "unroll like a film," as El Lissitzky said of his book *Of Two Squares*.

Another area of visual convention is the shape of type. The history of the structure of reading material and the history of type design have long been the locus of essentially political controversy. Type design has often been aligned with power, either directly as when Grandjean designed the *romain du roi* for Louis XIV's exclusive use, or indirectly through a long history of utopian philosophers who devised new or modified letter forms to correlate their ideas of truth of language to truth of perception through "real" writing.[10] The tradition of seeking an appropriate letterform for the posited *zeitgeist*, or spirit of the age, continues to the present day and formed the basis of the attempts of Herbert Bayer or later Paul Renner to devise a "more legible" sans serif type face, or the Bauhaus policy of only using lower case letters for its Bauhaus Bücher.

Moving to a smaller scale range of formal components, type usage is the most obvious area where conceptions of placement and the texture of the interplay of mark and support are subject to changing fashions in legibility.[11] The amount of paper visible between letters and whether those letters are static and self-contained (Bodoni or Helvetica) or are open and allow a lot of interaction with the paper (Centaur or Syntax) is not just an isolated phenomenon. When the

10) James Knowlson, *Universal Language Schemes in England and France, 1600-1800* (Toronto: University of Toronto Press, 1975).

11) The mark is determined by both medium and style. Support receives the mark differently, depending on its material nature, for example, paper, canvas, or ceramic.

FRANCES C. BUTLER

range of visual information is reduced to edge-dominated conceptual imagery, as was certainly the case in the 1960s when geometric abstraction was paramount in graphic design, closed letters that reduce the interaction of paper and type, and tight spacing that emphasizes the glitter of white paper, were also popular. When the hard-edged conceptual image begins to give way to the illusionary or impressionistic image, the tension between the paper and the type is also reduced and the decline of the glittering edge can be seen in the increasing popularity of the impressionistic stroke in illustration (see the work of Vivienne Fletcher or Fred Chalmers for example), in the wider letter spacing in type, and in nongloss papers, all of which are current.

fasten fasten
fasten fasten
fasten fasten

DYNAMIC STATIC

Fig. 3) Static and dynamic type faces.

The association of the shape and spacing of type with speed or thoroughness of comprehension is generally unfounded in perceptual research, but the assignment of moral value to style of mark is by no means restricted to persons calling themselves functionalists. William Blake was equally condemnatory about the moral qualities of some marks when he divided them into "the hard and wiry line of rectitude or broken lines, broken masses, and broken colors." Conversely, some mid-century photographers and graphic designers believed that the richly broken values of the photograph were both more truthful to reality and more appropriate to a machine age than the hand-drawn line. The scale of marks used, the scale of contrast in value, indeed the scale of compositional elements are all conventions that have changed through time. Nineteenth century graphic imagery had a full range of visual texture available for the audience, from the visible dots of chromo-lithographic printing through many middle-sized elements to large general compositions. By the mid-twentieth century, the range of the scale of information had contracted. Constructivism and, later, the corporate design style presented very large scale elements of plane or edge, with imagery often reduced to the conceptual outline. These examples were interesting primarily in their relationships to each other, not for their narrative content or their techniques of illusion, after which there was not much to contemplate until one came to the very small type and the details of ink or paper surface. The

material components, the ink and the processing of the paper through glazing, embossing, foil stamping, laminating, and coating for a gloss or a matt surface have been of great interest to designers and have led to an amazing elaboration of graphic arts technology in the past fifty years. Interest has shifted from high gloss to matte finish and from thin ink to thicker coverings. The changing material quality of ink has gone hand in hand with changing fashions in hue and value contrast and chromatic saturation, all of which have affected the way the intention of the image is perceived. This change of the pictured color of reality has had a strong influence on the color of other consumer goods, fabric, clothing, and paint.

The preoccupation with formal and material elements of the image continues to typify graphic design, even in periods like the present one where there is much apparent change in composition and style of mark. Essentially, the recent shift has been from vertical or horizontal geometric structure with clearly marked rhythmic intervals of space to a reader-syntaxed centrifugal structure. However, the balance of the elements is essentially the same, now being merely shifted away from the upright to the diagonal, so that the block of type slanting up the page from bottom left to upper right has become a cliché. The components are also the same, very large and very small type and many images about how we see or record vision, such as a photograph of a hand holding a photograph. Recent designs for posters or pamphlets, however, have shown many more items at a middle scale, with both less space and less tension between the elements, so that the overall effect is more like an ornamental fabric than the tense balance that typified graphic composition for fifty years. In this use of the repeat ornamental pattern, graphic designers parallel other composers of sensory stimulation — painters, authors, filmmakers, and musicians — all of whom have experimented with the return to unfigured or minimally ploted structure in composition. This mesh of marks style, whether rigidly gridded or freely distributed on the surface, is closely associ-

Fig. 4) Frances Butler, "Ornamental OK," 1979.

Frances C. Butler

ated with expressionism, which uses the convention of the gestural mark to suggest the presence and the energy of the artist in the artwork. This convention of gestural mark was closely associated with Abstract Expressionist painting of the 1950s and both then and now is a highly self-conscious abstract symbol for primal unstructured matter.

Constant stress on originality and change in literate culture has resulted in a new version of a real writing that will express the *zeitgeist,* this time, however, as a concrete manifestation of primal-experiential matter.

One further notes a tendency toward closure of thought patterns in a print culture, for example, the convergence of such fields as philosophy, religion, perception, and visual style, all parts of the contemporary world view. Therefore, it may be consoling to think that the closure of the fragmentary model can even be seen in the currently fashionable schemata for the operation of perception and cognition, which posits a constant dissection and qualification of sensory stimulation. Karl Popper[12] and J. J. Gibson, as outlined by Gombrich in *The Sense of Order*[13] and *The Image and the Eye,*[14] have provided the philosophy and the laboratory testing for the idea that humans perceive by noting differences, are intrigued by novelty and learn from it, and eventually ignore redundancy. Thus, the process of perception and cognitive pattern making is one of constant interaction of experimental stimuli filtered through shifting mental schemata. The model stresses all levels of sensory perception, but graphic designers tend to elevate visual stimulation to primacy. He continues the tradition of valuing abstraction above pictured realism by elevating the abstract symbol or the logo, especially those that have been smoothed off for efficient reading. This is done despite demonstrations that it is the precise, unusual, and personally engaging phrase and image that is remembered, whereas the abstract is either paraphrased or forgotten.[15] One San Francisco designer aptly demonstrated continued designer belief in the reductivist symbol by presenting an undifferentiated silhouette of a head with a rainbow colored seismic zig-zag lurching across its brain-pan as an appropriate symbol for an educational institution.

While designers devise abstract logos, patterned surfaces, and abstruse gestural symbolism and play about with variations on the geometries of the grid or indulge in quasi-sadomasochistic punk complete with flying pieces of cooked meat and chained women, the graphic design audience looks to this, which is, in both its print and its video forms, its only really public imagery, for information on the components of personal identity and social life in the late twentieth century.

There is a long social tradition of defining one's life through images. In the Middle Ages there were already stages-of-life prints, and this type of image is still being produced. The simplification of the print is now considered humorous, but the recent success of the

12) Karl Popper, *Objective Knowledge: An Evolutionary Approach* (Oxford: Clarendon Press, 1979).

13) E. H. Gombrich, *The Sense of Order* (Ithaca: Cornell University Press, 1979), introduction and passim.

14) E. H. Gombrich, *The Image and the Eye* (Ithaca: Cornell University Press, 1982), 162-71.

15) Janice Keenan, Brian MacWhinney, and Deborah Mayhew, "Pragmatics of Memory: A Study of Natural Conversation," in Ulric Neisser, editor, *Memory Observed: Remembering in Natural Contexts* (San Francisco: W. H. Freeman & Co., 1982), 315-24.

book *Passages* attests to the continued yearning for such social patterns. There were also many prints, books, and funerary displays to explain *L'Ars Moriendi*, how to die so as to be saved. In the fifteenth and sixteenth centuries, there began to be produced texts and popular prints that defined humans being gradually separated from God, with many images of the boundaries of the body, including images of the body as permeable, especially decaying in death. There were also many images of the body in life, its stance, its relationship to objects and to space, how to expand its presence with dress or movement. There were also images of instruction on social role, but the nineteenth century saw the height of the flood of images of how to be a useful member of society. Images of children began to emphasize helpful interactions, usually with the female child serving the male child, but sometimes just emphasizing team play. The definition of social role through popular imagery has certainly continued and defines how one behaves, that is, whether as a servant or as someone with power, how one looks if male or female. Men have generally been so ill served as to have a very narrow repertoire of faces or stances allowed them, although they are allowed wrinkles, and to be largely defined by props: hats, glasses, chairs, or other bits of space-defining structure. They are usually shown grasping objects firmly, sitting in chairs with their bodies arranged in positions of alert attention, not contorted for show, that is, physically present. Women have been generally shown with more attention to line than to their possibilities for action: head tilted, body twisted into chairs, hands curved and flapping, never grasping, and like most subjects about which there is acute unease, with frequent laughter (you've come a long way, baby).

These scenarios are pale reflections of some of the visual icons used for oral storytelling. The characters and the scenes of advertisements are similarly made into icons, with a lot of exaggerated peculiarity to distinguish them as types. Seductive women, for example, are very thin, with elongated fingers and, at present, padded shoulders and hips.

TV culture continues the agonistic behavior that was used to describe life in oral cultures, now with a profusion and perfection born of a rich repertory of high-tech special effects for showing dismemberment and death. Designed print graphics, as opposed to newspapers or television, remove all trace of antagonism and violence between individuals and transfer the locus of warfare to that between individuals and objects. This is not surprising as most print graphics are financed by mass production seeking mass consumption.

Rosalind Williams in her recent book *Dream Worlds, Mass Consumption in Late Nineteenth Century France* (unfortunately ignoring the continued use of consumption as an instrument of intimidation and power, which has prevailed from the Egyptians onward) outlines contemporary consumerism and its social and per-

Fig. 5) Tomb of Rene of Chalons, 1544. "And though after my skin, worms destroy this body, yet in my flesh I shall see God." Inscription.

FRANCES C. BUTLER

6) Rosalind Williams, *Dream Worlds: Mass Consumption in Late 19th Century France* (Berkeley: University of California Press, 1982).

sonal impact effectively.[16] She places the genesis of the twentieth century ideology of consumerism in Louis XIV's use of consumption to define power and to ensnare his nobles in an endlessly escalating warfare of frustrated elitism in which goods and their appreciation were the weapons. Eventually, mass production allowed many persons at least the imitation of luxury. However, along with this "democracy of luxury" came the continued quest for originality typical of print culture, which does not need repetition as an aid to memory and turns toward constant discovery as its model of intelligence. Thus, the bourgeoisie too were sucked into a continual striving for the authentic, or the rare, or that which had a high labor value, the unique, handmade object. Authentication became a profitable career for art historians, and the entire drive of art making and art marketing since the mid-nineteenth century has turned on hand work, rarity, and authentication. The association of the replicated product with lack of authenticity has continually plagued graphic design, which of course does not exist except as a mechanical, until it has been reproduced. Popular economic myth cannot assess the labor value of an object if it is the product of a team of workers. It thus cannot assess the pin or the medical center, the information system, or graphic design.

The ideology of consumer warfare dictates that those who amass money and wish to authenticate themselves must know how to use, hold, and stand next to their consumer goods, so that they will present the image of power, this being the second major reward promised. Most consumers check the mirror of print graphics, whether looking for the imagery of the dandy collector Huysmans, in *Architectural Digest* or the correct body shape for tennis in *Sports Illustrated*, because each nuance of the object becomes a critical demarcation of the Principle of Consumer Originality (being exactly like everyone else while being completely original). The corollary to this ideology already discovered by its first practitioners, the Roman emperor Hadrian or Louis XIV himself, is that the use of the object for self-definition and power soon reduces the options for behavior to a catalog of correct responses, leading to *ennui*, a profound and futile boredom.

So far there have not been any significant alternatives to mass production/mass consumption, and in the service of various aspects of consumer society, graphic designers have responded with either the pride of the literati, producing the abstracted logos and grids and pictures about picture making, which have received the approval of the lettered since Plato's *Republic*, or they have with embarassment masked by the constant humor that characterizes American advertising, produced designs that glorify the consumption of the image.

Rousseau once tricked his adored Maman into putting down a piece of meat she was chewing, whereupon he snatched it up and ate it, gaining, he tells us, a real sense of unification with his beloved.

As graphic designers have understood that human mimicking abilities allowed the interpretation of images in terms of real experience, they have depicted the consumption of the image quite literally. Open mouthed actors selling deodorants, refrigerators, stereophonic recorders, or automobiles are joined by large tooth-marked chocolate covered transparent jellies to efface the boundary between the object and the viewer entirely.

The emphasis on the consumption of image is perhaps an effective way to activate the memory of past experience. Certainly Marcel Proust thought taste was the most accurate mnemonic, and the closest graphic design can come is to show the image of the circumstances of taste. Although the body mechanics of stimulus and response are obviously different, the activation of individual memory by an image is parallel to the process of the retrieval of experience through a proverb or folk metaphor. The index through which the individual rummages to assign meaning to a situation and to encapsulate that meaning is the context of his personal past action. Personal experience makes the proverb or the image an effective mnemonic. When the image is too general, it cannot activate memory because it cannot be assimilated into any personal experience, and thus can only substitute itself for any past memory. Then it is like the proverb learned from a book rather than from life. It can indeed be quoted, though not as a primary definition of life experience but as an illustration to a definition that has no doubt been tried in other and stumbling phrases first and then wrapped up with the phrase "as the old proverb says"[17]

Linguists and rhetoricians have spent the past fifty or sixty years describing the relativistic nature of language, the definition of each word in terms of another, and the trail of punning sleight-of-hand partial substitutions through which metaphor is used to define the world. Graphic designers, too, find they are trapped in an ever-returning *Prison House of Language,* as Fredric Jameson terms it, with no final definitions.[18] Images can demonstrate visibly and triumphantly that the abstract combinations of metaphor can exist (there *are pictures* of winged elephants) when suddenly a painted leaf will turn into the leg of a faun or the pictured gesture that meant one thing to one person means something entirely different to a neighbor and the image itself cannot mediate between its multiple interpretations. One can perhaps pin down the image by internalizing it and eating it; perhaps the obsessive adolescents who gobble up the electric images of Pac Man® will eventually gain some of the sense of authenticity that Rousseau gained when he gobbled his Maman's partially chewed food. But most attempts at definition simply try to fill the empty center of the verbal or visual metaphor by turning the figure of speech pictorially upon itself to show its origins in consumption, as in a recent whiskey advertisement that shows the modern composer Philip Glass holding a clump of large music notes in one hand and a glass of the client's beverage in the

17) Amin Sweeny, *Authors and Audiences in Traditional Malay Literature* (Berkeley: Center for South and Southeast Asian Studies, 1980).

18) Fred Jameson, *The Prison House of Language* (Princeton: Princeton University Press, 1972).

FRANCES C. BUTLER

other, implying apparently two liquid transfers of musical ability, one to Mr. Glass and one to the random reader. A few print designers approach the problem by attempting to fill the void with a tangible object, as does a religious huckster from Fresno, California who unites the Biblical phrase "There is peace in the shadow of his wings" with an actual orange feather that can be pressed to the forehead while praying. A more symbolic level of consummation is involved in the old folk practice of decorating the car of a newly wedded couple with tin cans and old shoes to celebrate the first sexual union of the bride and groom through the ancient symbol of the shoe into which the foot fits. A recent printed version of this scenario did not even picture any shoes. Here the variation was probably introduced because the client was making explicit the operation of folk symbols, which are deliberately not understood by their users as they are the only release available from the anxiety or embarrassment of speaking of taboo subjects.

But the removal of the specifics of symbolism undercuts the remnants of shared symbolic action, typical of oral culture, which can sometimes still exist and which provides a social memory. The anthropologist Mary Douglas calls it *implicit meaning*.[19] The diffuse nature of implicit meanings, the fact that a social symbolic act, such as not eating meat on Friday, can have significance ranging from the simple maintenance of a family tradition to a full spiritual understanding of the transubstantiation of the body of Christ, allows the perpetuation of a comforting web of assumptions that is free in that it need not be closely questioned, but which allows the members of a community to move with some assurance.

Graphic design is about sight, but it is also the principal compendium of public imagery and, as such, could attempt to show the visible traces of heightened sensory awareness, with attention and validity given to the real body, real social space, real touch, gesture, and to group specific symbolic acts. Imagery to evoke full sensory awareness is perhaps a contradiction in terms, but more attention to visual realism and perceptual acuity could at least remind viewers of the social configurations of a life wherein the individual is not so physically and intellectually isolated by the abstractions and conceits of the graphic designers' imaginations. The language of most graphic design is either abstraction or pun, wherein what is visible is not what is real. That aspect of culture that could be called oral culture longs to make a connection with imagery wherein what is seen is what is real, or as Touchstone put it in Shakespeare's *As You Like It:* "Then learn this of me: to have is to have, for it is a figure in rhetoric that drink, being poured out of a cup into a glass, by filling one doth empty the other. . . ."[20] The pun, either in words, image, or both is a form of verbal usury, where the reality presented by the pun borrows from its component parts to present an inflated and intangible spectacle of presumed meaning. But the interest rate on the loan is usurious, and when the audience comes to claim the sub-

19) See Mary Douglas, *Implicit Meanings* (London: Routledge and Kegan Paul, 1975), and *Natural Symbols* (New York: Random House, 1973), chapters 9 and 10.

20) Craig Hardin, editor, *The Complete Works of Shakespeare* (Chicago: Scott, Foresman, 1951), 611.

stance of the pun, which is the metaphor, they find only the figure of rhetoric, the empty cup.

When demands are made on the abstracted image, either logo or the typographic gymnastics of original Swiss style or the Swiss Style Nouveau of Wolfgang Weingart, there is the same return, a figural repast. As yet, graphic designers do not understand that the ever-increasing originality of abstract symbols is not the only diet needed by the audience. In the face of a growing demand by the American public for some other sustenance than the consumed object, perhaps some designers will turn their attention to providing a more attentive and more respectful visual picture of both the body and the social symbol. The most recent imagery stressing body awareness and its place in vision and spatial perception has been pornography. The principal example of social symbolic action seems to be the lighting of cigarettes. Even the ethnically and culturally stereotyped and sentimentalized social symbolism of Norman Rockwell has been replaced, not by more attention to the specific details of the daily life of a wide range of the multiple ethnic groups in the United States, but by computer imagery of fast space travel or dance movements. But the respectful and interesting scenario or the social symbol that invokes memory can be reactivated if more attention is given both to understanding the value judgements that graphic designers assign to various image styles and to the ways in which symbolic imagery is used by those groups who have managed to maintain their own visual iconography.

Graphic designers should try to understand that their visual ideologies are determined by a very limited range of experience, training, and values, and the abstracted image is no more valuable than that which shows the details of belief. The literalization of the metaphor, which Alan Dundes cites as typical of much folk symbolism,[21] is not laughable when it is used by the artist for the Jehovah's Witnesses magazine *Awake,* who shows a very carefully rendered pointillist seven-headed Monster. It is laughable when Christian Piper or Antonio Lopez draws a snarling tiger-headed woman. The critical difference is that the Jehovah's Witness images are specific in form and symbol to their audience and they engender belief, whereas graphic designers seek to symbolize human psychology with shop-worn reruns of surrealist imagery that are not specific to any audience and thus do not elicit anyone's belief. Now this is all very good and well if the designers present themselves as unconscious generators of images for a small trade group, but certainly does not justify them calling themselves professionals in communication. Designers need a much wider training than that given by the commercial art schools. They need to look at something besides each other so that they can begin to note and present the precise detail of human life that will charge the focus of body, eye, and mind called attention and which has been cited as the point and pleasure of life from Michel de Montaigne to William James.

21) Alan Dundes, lecture, University of California, Berkeley, Fall, 1983.

Fig. 6) *Awake* magazine, "The Scarlet colored Wild Beast," c. 1965.

FRANCES C. BUTLER

Jack H. Williamson

The Grid:
History, Use, and Meaning

This article grew out of the author's lecture at the Second Symposium on the History of Graphic Design (Rochester Institute of Technology, April 1985), entitled "The Iconology of the Grid: Past and Present Uses and Meanings." The author would also like to thank the editorial staff for many useful suggestions.

1) Here defined as a proportional system of coordinates intersected by vertical and horizontal axes.

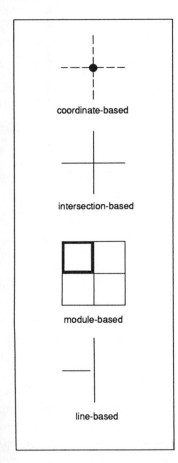

coordinate-based

intersection-based

module-based

line-based

Fig. 1) Typology of the Grid: the four subforms.

The grid[1] has played a central role in the development and consolidation of the modern movement in twentieth-century graphic design. Due to its ostensible use during this period as a compositional design matrix for controlling the placement of typography and imagery, the modernist grid was not visibly present in the finished design. Consequently, its symbolic aspect is not generally recognized or even suspected. Though equally obscure in significance, the contrasting decorative role of the grid as a prominent piece of visual iconography in postmodernist graphic design more readily admits to a possible symbolic function.

To understand these symbolic functions it will be necessary to first examine some key junctures in the pre-twentieth-century development of both the grid and, in some cases, its individual elements: the point (or coordinate), the axial line, and their mode of interaction. In terms of the impact the changing values of the grid's constructive elements have on the meaning of the grid itself, a structural typology of the grid reveals four basic grid subforms: coordinate-based, intersection-based, module-based, and line-based (figure 1). Although identical in appearance, the specific valuation of each element distinguishes in turn each of these subforms and is directly related to its symbolic content. Historically, these subforms are found to function in pairs and thus jointly to constitute two major forms. The first major form will be referred to as *point-based* and includes the coordinate- and intersection-based subforms. The second major form will be referred to as *field-based* and includes the module- and line-based subforms.

The late medieval grid

The point-based grid best characterizes the late medieval Christian world. Point-based grids were used to emphasize the focusing potential of the coordinate, either in and of itself or as the conjunction of two axes. This constructive logic supported the late medieval grid's symbolic status as a set of qualitative *vertical relations* between the superphysical above and material reality below, which were divinely generated by means of point coordinates conceived as "thresholds." Other grid forms were nonetheless present as well. For example, a simple, line-based grid is visible in Guten-

171

berg's 42-line Bible of 1455, in the form of lines used to position the double columns of text, the folios and headings, and the margins. These lines were derived from the guidelines that served a similar function in inscribed Gothic manuscripts.[2] In addition to vertical guidelines that helped establish the placement and width of columns and margins, illuminated Gothic manuscripts featured horizontal rules to guide the hand of the scribe who wrote the text. In some instances, these vertical and horizontal lines have been found to control both the placement and the pictorial composition of the painted miniatures. This function is evident in the diagram of an illuminated page (figure 2) from an early fifteenth-century *Book of Hours*, in which the left edge of the lectern from which St.

2) Allen Hurlburt, *Grid: A Modular System for the Production of Newspapers, Magazines, and Books* (New York: Van Nostrand Reinhold Co., 1978).

Fig. 2) Diagram showing the relationship between the page rulings and the pictorial composition of the painted miniature in a manuscript page from an early fifteenth-century *Book of Hours*.

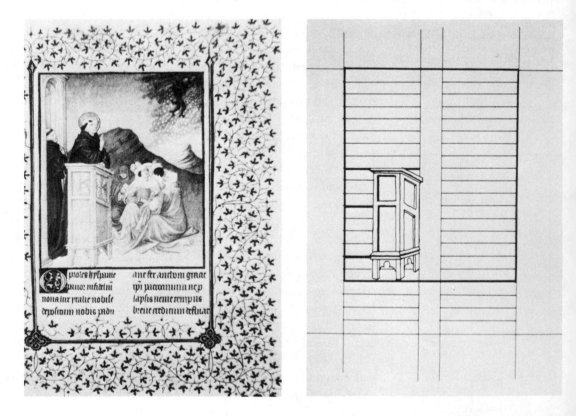

Anthony preaches coincides with the inner-columnar margin for the text. This integration of text and image strongly suggests that both the layout of the page and the pictorial composition were planned and executed by the miniaturist himself. Such use of vertical and horizontal lines to position text and image does not greatly differ in principle from the twentieth-century modernist grid that acts as an understructure to control the layout of the page. However, the shared identity of the designer and painter, coupled with the fact that guidelines also regulated pictorial composition, opens up the possibility that grid-lines may have also been used for representational or symbolic ends.[3]

Such is the case with the illuminated manuscript page of the fif-

3) Donald Byrne, "Manuscript Ruling and Pictorial Design in the Work of the Limbourgs, the Bedford Master, and the Boucicault Master," *Art Bulletin* LXVI, No. 1 (March 1984): 118-36. Byrne's proposal that the designer and miniaturist were the same person was even more strongly supported in one instance by the presence of prick marks at page top and bottom to vertically establish the placement not only of text and margins, but of the painted illumination as well.

JACK H. WILLIAMSON

a

b

d

Fig. 3) *Birth of John the Baptist* manuscript page from the *Tres Belles Heures de Notre Dame*, Turin-Milan *Book of Hours*, fifteenth century.

teenth-century *Tres Belles Heures de Notre Dame*, which depicts the birth of John the Baptist above and John's baptism of Christ below (figures 3a & 3b). Not only are rule lines visible beneath the lines of the page's text, but the exact spacing of those lines continues the length of the page and corresponds either to the edges of represented objects or to the placement of key symbolic objects in the pictorial program. Vertical spacings of the same width also correspond to a like positioning of edges and objects, resulting in a grid of uniform spacing based on the ruled line of text, which underlies and regulates the entire page composition. Visual analysis of the pictorial composition reveals that these lines have a representational and symbolic purpose superseding alignment for mere esthetic effect. For example, the newborn baby John in the scene of an interior above is in perfect vertical alignment with the adult John the Baptist in the landscape below (figure 3c). Also, the tight, round form of Christ and John at the river bank is perfectly echoed on their right by a large boulder, itself sited on a vertical grid-line shared with a sashwork cross in the window of the room above (figure 3d). These two vertical grid-lines thus serve to reveal a unique correspondence between the two scenes: The birth of John above is linked to the baptismal birth of Christ below and follows a downward motion echoed by the descent of the baptismal dove sent by God, who is seated in a zone between (and quite separate from) the temporal realities of two pictures. This

descending motion is also emphasized by the **V** of the hills seen above the Baptizer's head. Conversely, if we follow the peak of the hill to the right, the right grid-line leads the eye back up from the rock to the cross and symbolizes the death and resurrection of Christ after the rock was removed from His tomb. Taken together, the two grid-lines become part of a dynamic, counterclockwise schema of incarnation, death, and rebirth. The grid establishes a visual relationship between depicted objects and events, removed from one another in space and time but spiritu-

4) In designing this page, the artist innovated a visual counterpart to the practice of scriptural exegesis, a method of critically reading and comparing Biblical passages to discover hidden patterns of correspondence planted there by God. The discovery of these patterns could be accompanied by various forms of spiritual illumination, as was consistent with the anagogical principle holding that certain physical events or objects (in addition to scripture) contained the impress of the divine. When properly understood through contemplation, one's consciousness would be led from the object to its transcendent source in God.

5) The use of the point as a focus for contemplative consciousness, or the concept that it could be a threshold between physical and spiritual realities, was a standard feature of spiritual education in the Middle Ages. For example, in the twelfth-century treatise on Noah's mystical ark by Hugh of St. Victor, a mandala-like diagram guides the Christian meditator in the construction of a sequence of mental images until, arriving at the centerpoint of the figure, a concentration and transformation of consciousness occurs with an attendant passing into the Godhead (see Grover A. Zinn, Jr., "Mandala Symbolism and Use in the Mysticism of Hugh of St. Victor," *History of Religions*, May 1973). The allusion to Noah's ark in the title of the treatise may help to explain the unique psychotechnics of this meditation. On a metaphorical level, the Biblical account of the flood represents a plant-like process of world death and rebirth: the contraction of life to a seed-point (into the ark), the passage and survival of that point through the obliteration of the surrounding senseworld (the flood), and the subsequent re-expansion or blossoming of that point on the "other" side.

6) Robert Campin's triptych, *The Merode Altarpiece* (c.1426), which is contemporary with the birth of St. John, uses the same devices to the same ends. The altarpiece is based on an underlying grid with key symbols and dramatic points of action sited at strategic coordinates and intersections, and a sashwork cross in a window represents the only place in the pictorial program where the grid is revealed to the viewer (see the author's master's thesis, *The Meaning of the Merode Altarpiece*, Ann Arbor: University Microfilms, 1982, 350pp).

ally linked by God, who acts behind outer historical events to bring about world redemption through Christ's incarnation, death, and resurrection.[4]

The grid in the *Tres Belles Heures* manuscript page is therefore much more than a mere compositional device. It symbolizes God's design plan for the redemption of world and man because the coordinates – the junctures where special symbols and events are sited (birth of John, baptism of Christ, rock and cross) – signify those points where God's plan or will has asserted itself upon physical reality and historical time. These coordinates thus represent crossing points, or thresholds between the qualitatively distinct levels of spiritual and physical reality. Furthermore, these coordinate points lead both ways, from God's will into the physical world, or, for the prepared reader, anagogically to God. This movement between qualitatively different worlds is fundamental to the Christian drama and demonstrates that the grid is point-based. Axis lines play a secondary role.[5]

By extension, this concept of the point is also present in the emphasis given to a certain intersection of the horizontal and vertical axes in the same manuscript illumination. These grid axes correspond to the beams of the window's sashwork cross, which is the only place in the composition where the underlying grid is visually revealed.[6] Likewise it was in the cross itself, symbol of Christ's death and resurrection, that God's design plan for world redemption became outwardly revealed. The true basis of the grid (and of God's design plan which it symbolizes) is in fact the cross itself. This conclusion is fully consistent with the standard medieval interpretation of the cross in which the horizontal and vertical beams are seen to represent – as is Christ Himself – the conjunction of heaven and earth respectively.[7] It is the *point* of heavenly and earthly conjunction that is of fundamental importance here (i.e., of God becoming flesh), rather than the perpendicular bypass of two axes. The combined emphasis on coordinate and intersection was thus indissolubly linked in the symbolism of the point-based grid of the later Middle Ages.

Renaissance and Cartesian grids

Beginning with the Renaissance, however, there occurs a transition from a sacred to an increasingly secular world conception. This is accompanied by a corresponding shift from a grid based on value-loaded coordinates and intersections to one conceived of as a *field* comprised of points and axes possessing either neutral or numerical (quantitative) value.[8] Field-based grids were used to emphasize the expansive potential of the repeated module or individual axis-line in continuous or near continuous extension. These elements in turn defined a set of *horizontal relations* occurring on a physical plane. (It will be noted that this definition is in essential accordance with the previously cited Gutenberg Bible page grid.)[9]

JACK H. WILLIAMSON

7) The cross was but one of a host of symbols that represented Christ as the conjunction of the heaven and earth. Another such symbol, also popular in Christian religious art, was the almond-shaped *mandorla* in which was placed the seated or standing figure of Christ. The shape was formed by overlapping two circles that represented the spheres of heaven and earth. As the link between both, Christ occupies the area of their conjunction.

8) The coordinate's shift from a spiritual to a physical meaning is well exemplified in the radical alteration of environmental space which occurred in Lyon, France, when the city passed from Catholic to Protestant rule in the sixteenth century. The widespread iconoclasm which accompanied the takeover eliminated numerous sacred grottoes, churches, and similar spiritual "hotspots" through which the divine was felt to vertically penetrate the space of the mundane world from above. Once destroyed, a more horizontally-oriented environmental network of secular and commercial activities took its place. A homogeneous cityscape thus displaced one that was qualitatively differentiated. Natalie Zemon Davis, "The Sacred and the Political in Sixteenth Century Lyon," *Past and Present* 90 (February 1981): 40-70.

The gain in priority status of axes and horizontal relations which characterizes the *field-based grid* is accompanied, in the same century, by history's greatest expansion of global exploration and discovery. To aid this process, the Flemish mathematician and cartographer Gerardus Mercator revolutionized navigation by developing a grid with mathematically determined coordinates and straight axes of longitude and latitude to accurately represent relative physical distances on the spherical plane of the globe.[10] This grid's individual squares (like the axes) conveniently framed specific places. As a result, the grid functioned equally well as a field of either modules or axes. The infatuation with the world of nature and sense experience that characterized this age of physical discovery was perhaps best expressed in the rise of mathematical pictorial perspective in the fifteenth century, and its subsequent immense popularity in sixteenth- and seventeenth-century painting. Like Mercator's cartographic grid, mathematical perspective construction employed a field-based grid either to simulate or to document spatial relationships between physical points on a plane. This particular form of grid was tilted to create the illusion of spatial recession in three dimensions through the implied convergence of parallel lines. Unlike the late medieval grid, the intention was not normally to lead the viewer of perspective from the material world into the sphere of the superphysical. Rather, the depicted space was conceived of as an extension of the viewer's own space. Leon Battista Alberti, a painter and early propagator of the technique of perspective construction, wrote that the intended effect was similar to the experience of looking through a window.

Fig. 4) Albrecht Dürer, woodcut, 1538.

The instructional woodcut by the sixteenth-century graphic artist Albrecht Dürer (figure 4) demonstrates the use of a grid for a similar recording of visual reality. In this instance, the grid visually breaks down the three-dimensional image into a set of modules for the purpose of transferring and reconstructing it on another surface with a corresponding grid.[11] Also in this example, three paradigmatic themes of this period, each of which finds

9) In major respects, the page grid under-
goes few significant alterations in its
development during the five-hundred-
year period between Gutenberg and
modernist graphic design. As with
Gutenberg, the modernist grid is a field
defined by either large zones created by
perpendicular axes and/or by small zones
in the form of individual typographic
modules. In the interest of historical
accuracy, it must be conceded that it is
perhaps unlikely that the character-based
typographic grid which typifies high-
modernist graphics was consciously cor-
related by Gutenberg with his simple
guidelines grid. Nonetheless, Guten-
berg's grid *was* based on the rule which,
like the entire printed field of the page
itself, was undoubtedly conceived in
terms of the individual typographic unit.
That these two field conceptions of the
page may not have overlapped in Guten-
berg's mind did not, however, prevent
the fact of their being grasped and uti-
lized by his successors.

10) Earlier world maps treating spiritual in
addition to physical geography often fea-
tured Jerusalem at the center. Operating
as the *axis mundi*, a concept derived from
earlier "world tree" mythologies that
posited a spiritual connection (trunk)
between heaven (branches) and earth
(roots), Jerusalem was highest in qualita-
tive status, other geographical locations
being measured in value by their proxim-
ity to it. Considered alternately as a
"world navel," a similar umbilical-like
connection between earth and heaven
was implied.

11) The use of the grid as a device for trans-
ferring drawings from one surface to
another, and from one scale to another,
dates back to ancient Egypt and seems to
have been in fairly continuous use by art-
ists ever since (see James W. Davis,
"Unified Drawing Through the Use of
Hybrid Pictorial Elements and Grids,"
Leonardo 5 (1972): 1-9, especially the
section on "Grid Structures in Western
Art").

12) That this combination was both unique
and representative of a new concern
entering Western culture at that time is
suggested, using the example of perspec-
tive painting, by the many artists using
perspective to achieve a novel effect ver-
sus the few who used it chiefly as a
method not of representation, but of
investigation.

expression in the grid, may be observed. First, there is the intense fascination with surface appearance and its description. This is coupled, in leading individuals, with the quite different interest in the invisible laws and structural principles that underlie external appearance.[12] And third, there is the increased status of the rational mind itself, seeking to discover structure through critical observation.

As one moves from the Renaissance toward the twentieth century, there is a gradual shift in emphasis from appearance to structure accompanying the ever rapid growth of natural science (called natural philosophy).[13] With the writings of the seventeenth-century French philosopher and mathematician René Descartes, underlying structure and rationality achieve their most powerful expression. Descartes's *Discourse on Method* (1637) was to serve as a principle stimulus informing not only the use and meaning of the grid in this period, but also problem solving in later twentieth-century design.[14] With Descartes, knowledge is achieved by action of human reason, not divine revelation. Furthermore, the goal of knowledge is the physical world and its laws, not God and the supersensible world, as had earlier been the case. The grid's identification with material reality and laws is evident in his treatise *Geometry*, also of 1637. There, Descartes lays the foundation for an analytical geometry which defines the position of coordinates and axes – conceived as numerical quantities – on a plane in space. Yet with Descartes's stress on abstraction, the grid's association with the world of outer appearances loosens. As the rules elaborated in the *Discourse* made clear, appearances are suspect, and a problem (or, in visual terms, a field) is to be divided into its smallest component parts. This geometric, reductive operation is, of course, a mental process. The grid thus comes to represent not only the structural laws and principles behind physical appearance, but the *process* of rational thinking itself. So timely is this conception that, by the late seventeenth and early eighteenth century, the concepts of Nature and Reason achieved the status of leading ideas and came to be used interchangeably.[15] Signs of this reciprocity are evident, for example, in the application of the Cartesian grid to the exterior landscape, as in the case of the great French geometrical gardens.

Yet it is at the end of the eighteenth century that we find one of the best examples of the Cartesian grid bearing such symbolism. The intellectual climate at this time was characterized by deism, a movement which was a well-established by-product of rationalism. The latter is a theory that rejected formal religion and the concept of supernatural revelation but argued that the logic of nature demonstrated God's existence. Conceived as the Great Clockmaker, God had designed the world as a machine run by natural laws and then had abandoned it to run by itself. This mechanistic determinism informed the use of the grid by the

JACK H. WILLIAMSON

13) Early examples include, at the turn of the seventeenth century, Leonardo da Vinci's dissection of cadavers in order to understand the nature of bone, muscle, and tissue and the effect of these on external bodily form and movement. Also, at century's end, the first compound microscope was developed, thus opening a window onto material phenomena lying below the threshold of the unaided physical senses.

14) In the *Discourse*, Descartes presents four rules for acquiring knowledge, which may be paraphrased as follows: (1) doubt all that is not clearly evident to be true and do not accept surface appearance, (2) always begin by dividing each problem into its smallest component parts, (3) always conduct thoughts in logical order proceeding from that which is most simple to that which is most complex, and (4) reason rigorously and geometrically and never skip a logical step. Robert Nisbet, *The History of the Idea of Progress* (New York: Basic Books, 1980), 116.

15) John Herman Randall, Jr., *The Making of the Modern Mind* (New York: Columbia University Press, 1926/1976), 255.

16) Jean Clay, *Romanticism* (New Jersey: Chartwell Books, Inc., 1981), 35.

Fig. 5) Jacques Louis David, charcoal study for the painting *The Death of Socrates*, 1787.

French neoclassicist painter Jacques Louis David in his painting *The Death of Socrates* of 1787. In the charcoal study of this painting (figure 5), David used the grid not merely as an illusionistic tool for transferring the drawn figure of Socrates from paper to canvas; rather, the rigid network of horizontals and verticals, evident in the wall behind Socrates, is represented in the finished painting as well.[16] The grid, which invades and integrates itself into the figure's very gestures, signifies the rational, impersonal, and inevitable character of natural law, which deterministically controls the structure of the material world and of events within that world. Indeed, the main theme of David's painting is the syllogistic inevitability of Socrates's death by his own hand as a consequence of his rigid adherence to the laws of rational thought and logically determined behavior.

The modern grid

By the second decade of the twentieth century, the full development of the Cartesian grid was realized. The dual emphasis on appearance and structure that had characterized the symbolism of the grid during the Renaissance, scientific revolution, and Enlightenment now moved strongly toward structure and away from appearance and the illusionistic depiction of external phenomena. The architectonic and constructive values so central to the early twentieth-century modernist canon were inherited from the preceding century. Viollet-le-Duc's or Joseph Paxton's promotion of exposed iron structure in buildings, Christopher Dresser's functional Arts and Crafts design of teapot handles based on bird and fish skeletons, or art nouveau's rejection of the applied surface decoration of Victorian design were all nineteenth-century expressions of this exodus from a belief in surface appearance as an esthetic end in itself.

The Cartesian tradition in France continued to act as the major stimulus for the grid as it assumed its modernist embodiment. For practical purposes, the process may be said to begin with Paul Cézanne's initial move away from Renaissance illusionism toward the abstraction and geometricization of nature and an emphasis on the flat field of the picture plane. This impulse continues through the faceting of the picture plane by synthetic cubism to produce an overall effect, and it peaks when Piet Mondrian takes up the pictorial grid of synthetic cubism to explore and purify it in virtual isolation from other pictorial elements. Under cubism's influence, Mondrian's naturalistic subject matter became progressively abstracted until, in 1915, he could paint a circular field of short horizontal and vertical bars and title it *Pier and Ocean*. His paintings in the years immediately following continued to employ vertical and horizontal bars, sometimes colored and usually not touching, on a white field. Often these bars appear to continue off the edge of the canvas, suggesting that the field extends infinitely

Fig. 6) Piet Mondrian, *Composition with Red, Yellow and Blue*, 1920.

Fig. 7) Dynamic spatial projection of the axes of Gerrit Rietveld's *Red and Blue Chair* of 1917.

17) In his influential "Special Theory of Relativity" of 1905, Einstein had defined the infinite as merely the finite in extension. The medieval concept of a qualitatively differentiated, two-tiered universe consisting of physical and superphysical dimensions was thus collapsed into a nonhierarchic, physical universe conceived of as being in continuous extension. In terms of Mondrian's work, the reference to the sea in his early use of the grid in *Pier and Ocean* (1915) suggests that the continuum paradigm was established well before his mature works of the 1920s.

in all directions although the viewer sees only that portion visible within the "window" of the canvas. By 1920, Mondrian's pictorial vocabulary is established and consists of a white field through which travel continuous black horizontal and vertical bars that bound intermittently occurring rectangular zones of primary color (figure 6). The composition still implicitly extends beyond the borders of the canvas, and (according to Mondrian) the bars cross one another and overlap, but do not actually intersect. The resulting grid is of the *line-based* type and is thoroughly Cartesian in its presentation of an unchanging regular and isotropic universal field, ruled by logic and by the mathematical law that underlies the world of external appearance. The same conception is expressed in three dimensions in the *Red and Blue Chair* of 1917 by Gerrit Rietveld, who, like Mondrian, was associated with the Dutch de Stijl movement. Each axial structural member of the chair bypassed rather than abutted its neighbor and was painted black, with the exception of the exposed yellow end which signified it as an arbitrary terminus for an otherwise infinitely extending axis (figure 7).

This concept of an axially-defined field in infinite extension brings the symbolism of the Cartesian grid to its highest stage of development by linking it with the concept of a universal continuum drawn from contemporary physics.[17] The de Stijl grid visualized this physical spatial continuum not so much in material terms, but rather in terms of the mathematical laws that rule matter, space, and time. Mondrian's two-dimensional composition and Rietveld's chair were thus subsets of a larger universal field described by the grid. Also, because the modern grid was synonymous with the continuum itself, it may be defined equally well as a set of continuous axes or as a never-ending series of modules. The modern grid thus continued to be a field-based matrix predicated on the line and module.

The modernist principle of continuousness was applied as much to space as to material. The exploded form of Rietveld's chair partially dematerialized the object by dispersing it into the spatial field; space was thus allowed to circulate uninterrupted through the chair. This field-centered approach, which sought to oppose the object- or possession-centered ideals of the Victorian bourgeoisie (as expressed in their dark, massive, and closed furniture forms) was also to become the ideal of modernist interior space. Examples of this are the flowing spaciousness of Mies van der Rohe's interiors and the "free plan" of Le Corbusier, as are the reductive furniture forms they developed based on skeletal line and supporting plane, which subordinated the piece of furniture to the greater realities of streaming space and light.

But although the concept of the modern grid as a representation of the ubiquitous and invisible field of universal physical law was not too different in general meaning from that of the Cartesian

Jack H. Williamson

grid of the eighteenth century, its specific meanings were closely tied to early twentieth-century events and ideas which informed the modern grid and, later on, the postmodern grid. A basic characteristic of twentieth-century conceptions of the field is the de-emphasis of the point coordinate or individual unit (not unlike the de-valuation of the point which occurred in the shift from the late medieval to the Renaissance grid). This de-emphasis was an implicit feature, for example, of the homogeneous continuum of Einstein or of the anti-object paradigm of the Rietveld chair's exploded form. The pro-field, anti- or neutralized-point paradigm also characterized leading conceptions of the *person-environment relationship* during this period. For example, in the fields of sociology and psychology, Durkheim, Freud, and Watson described human behavior as environmentally or statistically determined. In the sociopolitical realm, socialist, communist, and collectivist writings and experiments placed great emphasis on groups and on relationships between groups, thereby de-emphasizing the importance of the autonomous individual. And in the sphere of design, the artists and designers affiliated with de Stijl and the Bauhaus felt that the passionate individualism at the root of the competing nationalisms which had caused World War I must be countered by an international impulse in architecture and design that would transcend national styles and differences.[18]

It is therefore not surprising that an anti-individualist vision expressed itself in the entire spectrum of innovations which accompanied the use of the Cartesian grid in European graphic design in the late 1920s. The underlying, invisible matrix of the grid guided the placement not of manually produced letterforms or expressive gestures, but of clean and geometric sans serif typography. Horizontal and vertical bars and rules were also used to subdivide the page space and corresponded to certain axes of the underlying grid. The leading innovators to employ this family of elements included El Lissitzky (*The Isms of Art*, 1925), Herbert Bayer, and László Moholy-Nagy (Bauhaus publications), culminating in the formulaic expression of the philosophy and method of this approach by Jan Tschichold in his 1928 book, *The New Typography* (figure 8). The field axiom behind this form of graphic communication was also evident in factors beyond the use of the grid and of copy that was factual and impersonal. For example, the asymmetric distribution of typographic elements on the page created an overall visual tension that converted the negative white space from a passive to an active value. The entire visual field was thus dynamically brought into play. The tension of this field was due as well to the use of sans serif typography, which *decreased* visual interaction between different letterforms and between letters and white space.[19] This lack of interaction between the individual letter and its neighbors was another example of the element of the impersonal. In addition, the preference

18) The most representative design example of this is the Weissenhof Housing Project, done for the Deutscher Werkbund exhibition of 1927 and directed by Mies van der Rohe, and generally regarded as the first official expression of the International Style in European architecture. The project sought, through the rational standardization of building forms and materials, to achieve a uniformity of vision and expression.

Fig. 8) Jan Tschichold, Prospectus for *Die Neue Typographie*, 1928.

19) Frances Butler, "Modern Typography," *Design Book Review* no.3, 96. The organic letterforms of art nouveau, on the other hand, carried on an intimate

visual conversation with the surrounding white space. Open, sinuous, or seemingly undulating art nouveau letters often sent the surrounding space swirling in eddies in and around themselves and one another. This expressive relationship between letter and page was a carryover from art nouveau's sculptural treatment of wall or surface planes in the design of interiors and domestic artifacts. In such instances the surface was conceived of as a mobile, living membrane with an inner being out of which expressive forms would manifest themselves in low sculptural relief. Thus, in the case of extremely organic art nouveau letterforms (e.g., Henri Van de Velde's initials for *Van Nu en Straks* of 1893, or Otto Eckmann's *Fette Eckmann* typeface of c.1902), the white of the page was seen as a generative surface out of which grew (as with the surface of nature upon which this surface was modeled) living forms. Naturally, these living forms were closely tied to the *environmental field* of nature from which they sprang. The geometric and thus inorganic sans serif letterform understandably lacked this living relationship to its environmental context: the empty white space of the Cartesian plane. More precisely, the white space of the Cartesian field signified the deserted spatial field of the deists made final in the continuum of Einstein. The estrangement of the sans serif letterform from its field was in truth a symptomatic expression of the increasing alienation of modern rational man from the world (as reflected in the pro-field, anti-individual paradigm already discussed). It was therefore not coincidental that, during the decade of the 1920s in which this visual language of modernist graphics was being articulated, the same message was being verbally expressed in the existentialism of the German philosopher Martin Heidegger, (professor at Marburg 1923-28, Berlin 1928-33) in his 1927 book, *Being and Nothingness*.

20) Leading examples of this include Bayer's "universal" lowercase alphabet of 1925 and Tschichold's "single case" alphabet of 1929.

for principally lowercase letters – even to the point of occasionally refusing to use uppercase initials for proper names or sentence beginnings[20] – reveals an antihierarchic disposition that disdained the elevation in status of the individual (be it a person's name or other proper noun) above an otherwise *homogeneous* field.

The subsequent generation of Swiss graphic designers expanded the applications of the mathematically drawn grid and brought it to a level of perfection and elegance, without, however, altering its basic use as a tool for rationally structuring and delivering factual information. Representative designers of the Swiss school included Theo Ballmer, Emil Ruder, and Joseph Müller-Brockmann, who acted as the movement's chief theorist and spokesman. The movement proved to have much international influence in the 1950s and 1960s, although the grid itself retained the same meaning it had in the 1920s; that is, as the continuous field of rational law which underlay the physical universe much the way the grid itself remained invisible "beneath" the final design composition. As Müller-Brockmann's own book, *Grid Systems*, made clear, the modern Swiss grid retained all the Cartesian symbolism it had possessed during the early modernist era and remained a rational, universally valid, objective, and future-oriented design tool.[21]

The postmodern grid

The modern Swiss grid enjoyed its heyday during the decade of the 1960s. But during the 1970s a number of graphic designers began to overthrow the conventions of modernist graphics and use the grid to new ends. The representative work of Yale graphics instructor Dan Friedman (figure 9), or that of former Emil Ruder student and Basel School of Art graphic design professor Wolfgang Weingart (figure 10, 11), illustrate the changed use and features of the grid within postmodernist graphic design. The postmodernist grid no longer acted as the invisible logic "behind"

Fig. 9) Dan Friedman, change of address card, 1976.

JACK H. WILLIAMSON

21) In the chapter entitled "Grid and Design Philosophy," Müller-Brockmann states, "The use of the grid as an ordering system is the expression of a certain mental attitude inasmuch as it shows that the designer conceives his work in terms that are constructive and oriented to the future. This is the expression of a professional ethos: the designer's work should have the clearly intelligible, objective, functional, and esthetic quality of mathematical thinking. . . . Working with the grid system means submitting to laws of universal validity." And finally ". . . [The grid] fosters analytical thinking and gives the solution of the problem a logical and material basis." Josef Müller-Brockmann, *Grid Systems* (New York: Hastings House, 1981).

22) Weingart's cover designs for the 1974 spring and summer issues of the journal *Visible Language* offer extreme instances of over- and underexposed typography in which recognition of words and individual letters is often impossible.

the composition, but was often visually exposed and used as a subordinate decorative element. The grid was sometimes tilted and made to express antirationality and randomness. It was often coupled with other seemingly accidental marks or manually applied gestural (signature) elements, in stark contrast to the impersonal and overly rational compositions of Swiss modernism. Usually the grid was established and then violated (ignored) or fractured along with the surface plane it defined. Both grid and composition departed radically from modernism's functionalist ethic, sometimes to the point of sacrificing the clarity, legibility, and readability of the typographic message itself by disrupting the alignment of type or by in some way obscuring the individual words and letters.[22]

Like other manifestations of postmodern culture, the grid expresses the general theme, in opposition to modernism, of antirationality and even irrationality. The most common variations on this theme (many of which, when expressed visually as in architecture or graphic design, utilize a common iconography) include the

Fig. 10) Wolfgang Weingart, *State Art Aid* poster,

Fig. 11) Wolfgang Weingart, magazine cover combining rational clarity typical of Swiss graphic modernism with a contradictory use of rules which cut into the lines of type to produce various levels of illegibility, 1979.

celebration of irrational or violent phenomena, often depicted as occurring behind the veil of surface appearance, or the representation of surfaces or facades as blatantly false, sometimes with the suggestion of some unknown quantity or realm concealed behind them. In contrast to the modernist tendency to openly reveal structure and purpose via functional form, these surface planes are

perforated or fractured to suggest that they are thresholds at the border of a mysterious, often nonmaterial dimension. To understand the significance of the postmodern theme of arationality or irrationality as it is reflected in the recent iconography of popular culture and design (of which the grid is part), an examination of its sources is necessary. The first major source is the antirationalist undercurrent of twentieth-century modernism. The second, more immediate, source is the movement that begins in the 1960s and continues into the present as a conscious reaction to modernism.

In addition to the early twentieth-century concept of the field as a rational network of predictable mechanistic laws regulating physical reality (e.g., the *universal field* of de Stijl), there was a notion of the field as a far less determinate set of forces. The original notion of a "field" was put forth in the mid-nineteenth century by the English scientist Michael Faraday. Faraday explained how atoms and molecules, with so much space surrounding them, were held in spatial extension by an electrically charged, tentacle-like network that spread invisibly through the earth's matter and the space surrounding the earth (since identified as earth's electromagnetic field). The components of this network Faraday called "lines-of-force," and these helped explain why changes in one part of a field occurred at the same time as changes in far distant parts of the same field even though no connecting physical action between the two was evident.

Faraday's concept of electrical lines-of-force was later absorbed into the Italian futurists' revolutionary philosophy of dynamic speed and change. Drawing on the pictorial innovations of cubism, futurist painters used a similarly gridded picture plane to represent not only outer movement but the inner forces of electricity and will which interpenetrate and incite both muscular and mechanical action.[23] Impulsive, impassioned action, usually of a destructive kind, not cool calculation or rational passivity, was the hallmark of the futurist credo. The movement's manifesto, written in 1909 by Filippo Tommaso Marinetti, poet and founder of futurism, centers on an account of a reckless, high-speed auto race through the streets of Milan at night. The account is characterized by an intoxication with death and destruction and presents the reader with a theme common to most later futurist work: that volcanic forces beneath the calm surface of outer physical and social reality can erupt forth at any given moment.

A similar message was presented in 1927 by physicist Werner Heisenberg, the same year the Weissenhof Housing Project signaled a triumph for modern architecture's clean rational geometries and functional layouts. Heisenberg's discovery, known in physics as the "indeterminacy principle," revealed that beneath the predictable mechanistic laws that rule the visible world in which we live, another set of laws with no apparent order operated at the atomic level upon which, it was assumed, the world was

23) Representative examples of futurism's infatuation with electrical phenomena include Umberto Boccioni's painting *Forces of a Street* (1911), an early example of the "lines-of-force" theory (also associated with "atmospheric electricity" or lightning); his painting *Matter* (1912), in which material reality becomes transparent to reveal a ubiquitous field of powerful forces which overwhelm both the woman in the picture and the viewer (Boccioni wrote about some people's clairvoyant ability to visually penetrate the opacity of material bodies, in the manner of X rays); and the futuristic cities of the movement's architect, Sant' Elia, in which electrical generating complexes and powerhouses were the favored building type.

JACK H. WILLIAMSON

built. This interpretation of the world is the complete opposite of that symbolized by the Cartesian grid, which pictures the substructure of the world as rational, predictable, and deterministic.

The notion that reality may appear rational outside while being irrational inside had been persuasively argued even earlier by Sigmund Freud, who posited a libidinal reservoir of powerful drives and impulses operating beneath the level of a person's conscious awareness and behavior. With Freud, the contingent twentieth-century theme of the *freeing* of forces that are arational or irrational and that are located beneath the normal world of outer appearance and *bringing them up into* the outer world, finds dramatic expression. Freud's original use of hypnotism to release the repressed memories of traumatic episodes was superseded by his well-known technique of "free [word] association," which accomplished a similar end without hypnosis. This technique was appropriated (and renamed "psychic automatism") by the nihilistic Dadaist art movement which arose in response to the devastation and inhumanity of World War I. In both its methods and its products, Dadaism satirically celebrated the irrational in man. Surrealism, Dada's main descendant, likewise externalized psychic events occurring below the surface of consciousness in the form of hallucinogenic dreamscape paintings or other artforms designed to engage not the viewer's conscious self, but his or her subrational side.

The theme of releasing powerful "subphysical" forces (i.e., forces below the level of external physical reality) is again expressed in the year 1919. In the modernist calendar of key historical events that year marks the founding of the Weimar Bauhaus, the major force in the institutionalization of rationalist design theory and practice. For the history of irrationality, however, 1919 marks the date when the first atom was successfully smashed. The fruit of this event was the ability to tamper with atomic structure and so release huge amounts of explosive force and deadly radiation from the level of atomic events into the world of plants, animals, and human beings, as manifest by the dropping of two atomic bombs on Japan in 1945. The subject of the destructive release of irrational, subphysical forces onto the physical plane became a key theme in the iconography of postwar popular culture and came to inform postmodern architectural, graphic design, and advertising iconography as well. For example, the films of Japanese director Ishiro Honda (e.g., *Godzilla* 1954, *Rodin* 1956) featured a beast accidentally released from a state of subterranean hibernation by a careless atomic explosion. The beast, equipped with either radioactive breath or vision, would then proceed to destroy Japan's major urban centers.[24] Prior to 1960, therefore, antirationalist tendencies and traditions in twentieth-century art, scientific thought, and popular culture existed side by side with the stream of modernist rationality.

24) The sense of an unseen, hidden menace also characterized an important aspect of the 1950s in American society. The "red scare" of the cold war years, the profusion of 1950s science fiction monster films, and the post-Sputnik rash of backyard fallout shelters all expressed the anxious sense that an unseen menace lurked at the edges of the familiar world accessible to the rational mind.

It was out of the antirationalist stream which coalesced in the 1960s and early 1970s that postmodernism was to arise. During this period two concerns were expressed which played a central symbolic role in later postmodernist iconography in general and in that of the grid in particular. First, there was a conviction that surfaces were false and superficial. Second, there was an interest in and exploration of that which lay behind such surfaces. As the baby boom generation became disillusioned with the Vietnam war, big business, corrupt governmental leaders, and the capitalist value system in general, all *surface* phenomena (norms and conventions) were questioned, mocked, and satirized. Pop art satirized the hollow commercialized images of consumer advertising by adopting the techniques and presentational scale of magazine and billboard advertising imagery. Robert Venturi's 1966 postmodernist manifesto, *Learning from Las Vegas*, gloried in the falseness of the commercial facades of the Las Vegas strip and promoted the false surface as a model for a new movement in architecture. No longer did the outside have to be functionally related to the inside. Rather, superficial decoration was allowed, and the resulting contradiction or discontinuity between inside and out was itself a strong critique of the clean, rational exterior of modernist architecture.

This love of parodying the falseness of surface appearances in art and architecture had its counterpart in the structuralist movement in French linguistics. Strongly colored by Marxist determinism, structuralism exercised a major influence in American universities during the 1970s, accompanying the demoralization of America and the expansion of Soviet power. Unlike modernism, structuralism held that surface appearances were false and that rationality was itself a surface phenomenon under which lurked a subrational self unknown to us.[25] The structuralist attempt to demonstrate that rationality, the conscious self, and conscious speech were false fronts for irrationality was represented in postmodernist graphic design as well. For example, Weingart's fracturing of the gridded surface (figure 10) represented the destruction of the field of the rational mind.[26] The ubiquitous use of the tilted grid, evident in magazine ads, posters, television graphics, and other popular media over the last several years, also represents the arational or irrational, because the grid – as a symbol of the field of consciousness – has become disoriented in its detachment from the world, as indicated by its lack of gravitational orientation.[27] Furthermore, the defilement of the typographic message by Weingart (figure 11) and other postmodernist graphic designers was analogous to the structuralist's belief that language did not represent the conscious, rational self, but the "other," subrational self. April Greiman, a student of Weingart, took the destruction of the surface plane further by depicting planar fragments exploding forth in a field of deep illusionistic space.

25) Freudian and structuralist Jacques Lacan asserted that a person's speech, far from expressing the thoughts of the conscious self, was the medium through which the "Other" self expressed itself. This "Other" was a being prior to and more real than a person's conscious self. Lacan maintained that rationality, like the conscious self, was also surface illusion. Following Lacan, structuralist Michel Foucault extended the concept of the subrational "Other" still further in 1966 with his "end of man" doctrine. See Peter Caws, s.v. "Structuralism," *Dictionary of the History of Ideas* 4 (New York: Charles Scribner & Sons, 1973), 329.

26) The drug culture which arose to assist the flight from the unpleasant realities of this period likewise represented a quite forcible destruction of rational consciousness, and the substitution of a consciousness of or by some "other" self.

27) The tilted, floating grid represents free-floating or disembodied consciousness. Although it may signify human consciousness loosed from rational or "earthly" applications, the tilted grid has been most commonly used in association with computers and high-tech advertising. This is appropriate inasmuch as the computer is the ultimate externalization (disembodiment) of human rationality.

JACK H. WILLIAMSON

The theme of "otherness," of what lay behind the plane, was now becoming more important than the defilement of the plane itself. One common compositional feature of Greiman's work during the late 1970s and early 1980s was an empty exploding core, with planar shards moving toward the periphery of the layout (her *TV awards poster* of 1981 featured a trapezoidal black "window" of infinitely deep space near composition center, out of which exploded numerous objects).[28]

The representation of an exploded surface plane was a favored subject in television advertising during these years as well. A popular Shell Oil Company advertisement filled the television screen with a flat white field upon which was printed the Shell logo. Through this would burst a car, thus creating the illusion that it was entering the space of one's living room. The first Shell ad of this type was aired in 1964, and the company has continued to use this format, extending it to magazines in the 1980s (figure 12). Schlitz Malt Liquor's television commercials in the late 1970s similarly featured a bull bursting through the wall of a room in which beer drinkers sat. Beyond the specific subtextual meaning that alcohol could release the subrational, animal side of a person, this ad joined with the large number of similar commercials and cinematic images of powerful, often menacing entities bursting into the viewer's space[29] in indicating that the destruction of the plane of surface reality and the rational world of predictable events was due to the eruption of irrational forces from a world behind or below the plane of outer reality. The surface plane was thus not to be trusted and was in fact a threshold to a nonrational realm on the other side of normal reality. The modernist vision of a logically constructed physical reality underlaid by an equally logical set of predictable mechanistic laws was thus replaced by a postmodernist vision of outer reality as a sham underlaid by a more real but nonrational set of unpredictable forces.

Yet, side by side with the postmodern iconographical drama of subterranean forces exploding through the surface plane into the viewer's space was the reverse scenario of diving into and through the surface plane from the physical into a subphysical, nonmaterial realm. Simulating a microscope with a zoom lens, the opening credits of the 1980 computer-animated film *Tron* carried the viewer into a letter of the word "Tron," down through a microgrid composing the larger letter, and through that grid into a nonmaterial world of micro-electrical phenomena. The same "transfer" was repeated in the story itself when the main character was "digitized" as he sat before a computer terminal. He was then absorbed through the computer screen and reconstituted "below" in a nonmaterial realm defined by electronic grids and menacing, computer-generated beings.[30] A similar "descent" was the subject of a 1984 television commercial in which the viewer accompanied a Camaro driving through a car-sized black Chevrolet logo that

28) The result of this collection of fragmented planes was that the "picture space" abounded with a profusion of edges. The same abundance of edges characterizes much of postmodern architecture as well. Take, for example, Charles Moore's *Piazza d' Italia* of 1975-79, in which layers upon layers of false facades stand on the periphery of an open circle of space. The theme of the vacated center, of attention focused on the periphery and on the edges of things, is typical of postmodernism in general. Architecture, graphics, furniture, and interiors abound with color-differentiated planes continually "popping away" from another. Postmodernist scholarship is characterized by a dilettantish love of peripheral or fringe topics rather than mainstream issues, a looking at phenomena from odd angles, and the rejection of sustained and centered treatment of material in favor of eccentric digressions. This search for "otherness" in the freakish and bizarre within postmodernist writings is criticized in Robert Darnton, "Pop Foucaultism," *The New York Review of Books* (October 9, 1986): 15ff. In popular culture, the Steve Martin and "Nerd" films about social misfits are similar expressions of postmodernism's "off-center" interest. This off-center theme of the late twentieth century was prophesied by W.B. Yeats in his poem *The Second Coming*: ". . . Things fall apart; the centre cannot hold;/Mere anarchy is loosed upon the world. . . ." The poem was composed in 1919, the first year the atom was smashed.

29) The 1975 movie *Jaws*, which spawned a rash of similar movies, featured a mammoth killer shark which lurked beneath the placid water surfaces of swimming beaches, etc., only to burst upward and pull someone back down at unexpected moments.

30) Michael Bonifer, *The Art of Tron* (New York: Simon and Schuster, 1982).

Fig. 12) Magazine advertisement for Shell Oil. The ambiguous juxtaposition of dark road and gridded surface plane suggests that the gas pump is exploding upward through a deep fissure in the grid.

31) A series of books were written in the late nineteenth century that dealt with descending to the center of the earth, such as *Alice's Adventures Underground* (later titled *Alice in Wonderland*), *Journey to the Center of the Earth*, and *20,000 Leagues Under the Sea*, many of which were turned into American movies in the 1950s. French filmmaker Jean Cocteau's films *Blood of a Poet* (1930) and *Orpheus* (1950) represented similar descents – now into the irrational underworld of the self – by having the main character pass through the threshold of a mirror.

32) This is well exemplified in the anthropomorphic symbolism which abounds in the bureaus, shelving units, and lamps of the Italian Memphis group. The staccato angularity of these figures refers to electrical phenomena (see, for example, Ettore Sottsass's *Ashoka Table Lamp*, figure 6, page 13, *Design Issues* II/1 (Spring 1985), and may draw from the earlier Italian futurist conception of the human being based on subphysical electrical forces.

stood on a test track, which in turn led to a red, subterranean landscape wherein dwelt a large, reptilian monster. The threshold to the superphysical of the late medieval grid has thus been completely reversed in postmodernism. In postmodernism, the fractured surface plane acts instead as a threshold to the subphysical and subrational.

The descent of rational consciousness beneath the surface of matter has always been a central activity of modern science in its study of material phenomenon. Because of this, the descent of consciousness into and "beneath" matter became a common theme in popular art and literature from the late nineteenth century to the present.[31] For example, in the 1967 Charles and Ray Eames film for IBM, entitled *Powers of Ten*, the Einsteinian concept of the infinite as the finite in extension was given physical expression as the camera first zoomed into the universe and then returned to microscopically descend – through a man's hand – to the molecular, atomic, and then subatomic level. Modernist rationality inevitably led, as Heisenberg experienced, from a fixation on the surface of material phenomena to its subsequent penetration and the arrival of rational consciousness to an alien, nonrational sphere. Because modern science had rejected the concept of a nonmaterial, superphysical dimension, it was inevitable that the probe of rational consciousness must confine itself to material reality and to the nonmaterial, subsensible reality beneath it.

Despite the positive accomplishments of postmodernism – a throwing off of a severe rationalism which denied more intuitive faculties, an exploration of symbolic and decorative values, and a recognition and utilization of the past – the movement is at base limited by an insufficient image of the human being, an interpretation that generally admits of only rational and subrational faculties.[32] Postmodernism may thus be considered a form of *late modernism*, inasmuch as it reveals rather than surpasses the key limitations of modernism's conception of the human being.

The foregoing survey has tried to show that, with few apparent alterations to the basic form itself, the grid has shifted in its meaning from a threshold between physical and superphysical worlds, to a representation of the surface of the physical world and the rational cognition which beholds it, to a threshold to the submaterial world and irrationality. In each period, the grid has thus expressed a leading conception of man and world prevalent at that time.

JACK H. WILLIAMSON

Hanno H. J. Ehses

Representing Macbeth:
A Case Study in Visual Rhetoric

Introduction

The creative process of finding appropriate design solutions to visual problems would become more accessible and more probable, and could be enriched if designers were more conscious of the underlying system of concept formation. Instead, they seem to use it intuitively. In adapting contemporary semiotic and rhetoric theory, the following study of Macbeth posters endeavours to present an operational model of concept formation that is often identified with the creative process. Semiotics, the doctrine of signs, explains the principles that underlie the structure of signs and their utilization within messages, and rhetoric, the art of persuasion, suggests ways to construct appropriate messages.

Speaking out on concept formation and the problems involved in designing a poster for a theater play, J. Shadbolt, the designer, remarked: "The psychological problem was what slowed down the process. I would read the actual play, consider carefully its overall impact, and then try to convey with the totality of my design something of that precise import. It's easy to make an elegant decoration, but quite another thing to evoke exact implication."[1]

Shadbolt's remark addresses some fundamental problems in the design activity, and directs special attention to the following questions: How is meaning created visually in design? What is the routing that leads from the text of a play (or any other statement) to a concept and its visualization in a poster (or a book cover or trademark)? What is the nature of the relationship between the figurative image and the text? These questions are all related to the process of signification, that is, the coding dimension that precedes all message transfer and communicative interaction.

To find answers to these questions and to illuminate the process of arriving at a design solution, this article will examine the relevance of rhetoric to design and explore some of its basic principles. The semiotic structure of coding and the rhetorical characteristic that governs the visual appearance of a poster will also be discussed. In addition, the operational potential of rhetorical procedure for design in conjunction with the outcome of a recent case study is demonstrated.

[1] Quoted in R. Stacey, The Canadian Poster Book (Toronto: Methuen, 1979), 58.

Design and rhetorical principles

Rhetoric, generally speaking, is concerned with the functional organization of verbal discourse or messages. It operates on the basis of logical and esthetic modes to affect interaction in both a rational and emotional way. According to Aristotle, rhetoric is concerned with "discovering all the available means of persuasion in any given situation" either to instruct an audience (rational appeal), to please an audience and win it over (ethical appeal), or to move it (emotional appeal). The object of rhetoric is eloquence, which is defined as effective speech that makes it possible to determine the attitude of people in order to influence their actions. The possibility of influencing and being influenced presupposes the possibility of choice. Choice is a key term in rhetoric as well as design, as both pertain to making appropriate selections of means to achieve a desired end. Design, as a communication-oriented discipline, is governed by and must pay attention to pragmatic motivations and functional considerations. Inasmuch as the spirit of rhetoric is also pragmatic, this situation gives design a rhetorical dimension.

Despite all the negative connotations, persuasion is not necessarily an underhanded device, but rather a socially acceptable form of reasoning. During the past few decades, I. A. Richards and C. Perelman in particular have been influential in freeing rhetoric from articulated prejudices.[2]

At present, the exponents of the "new rhetoric" contend that even the simplest utterances are pragmatic, that is, functionally determined and, therefore, persuasive. According to this school of thought, "Almost all human reasoning about facts, decisions, opinions, beliefs, and values is no longer considered to be based on the authority of Absolute Reason but instead intertwined with emotional elements, historical evaluations, and pragmatic motivations. In this sense, the new rhetoric considers the persuasive discourse not as a subtle fraudulent procedure but a technique of 'reasonable' human interaction controlled by doubt and explicitly subject to many extralogical conditions."[3]

Because all human communication is, in one way or another, infiltrated rhetorically, design for visual or verbal communication cannot be exempt from that fact.

Although rhetoric has developed as a method that deals fundamentally with speaking and writing, rhetorical principles have been transferred into various other media, as well. This has been indicated by E. R. Curtius[4] and R. Lee,[5] both of whom refer to rhetoric and its relationship to painting, architecture, and music. The potential value of the rhetorical system within a semiotic framework was also realized by G. Bonsiepe, who published the article "Visual/Verbal Rhetoric" in 1965.[6] Essentially concerned with analyzing advertisements, Bonsiepe demonstrated that visual rhetoric is possible on the basis of verbal rhetoric. In 1968, M. Krampen remarked that "a careful study of classical rhetoric could

2) Edward P. J. Corbett, *Classical Rhetoric for the Modern Student*, 2nd ed. (New York: Oxford University Press, 1971), 625-30.

3) Umberto Eco, *A Theory of Semiotics* (Bloomington: Indiana University Press, 1976), 277-78.

4) E. R. Curtius, *European Literature and the Latin Middle Ages* (Princeton: Princeton University Press, 1953), 77-78.

5) Rensselaer Wright Lee, *Ut Pictura Poesis: The Humanistic Theory of Painting* (New York: W. W. Norton, 1967).

6) G. Bonsiepe, "Visual/Verbal Rhetoric," *Ulm* 14/15/16 (1965).

HANNO H. J. EHSES

7) Martin Krampen, "Signs and Symbols in Graphic Communication," *Design Quarterly* 62 (1968): 18.

lead to a catalog of rhetorical devices that are capable of visual duplication."[7] In light of these suggestions, ten figures of speech were selected for this case study. The ten that were chosen suggest an obvious potential for visual duplication. What precisely constitutes such a rhetorical figure, and what is its position within the rhetorical system?

The system of classical rhetoric formulates precepts for the production of a message and traditionally is divided into five phases (see Fig. 1).

I **Inventio: Discovery of ideas/arguments**
Concerned with finding and selecting material in support of the subject matter and relevant to the situation.

II **Dispositio: Arrangement of ideas/arguments**
Concerned with organizing the selected material into an effective whole (statement of intent).

III **Elocutio: Form of expressing ideas/arguments**
Stylistic treatment or detailed shaping of the organized material in consideration of the following criteria:
■ Aptum: appropriateness with reference to subject matter and context
■ Puritas: correctness of expression
■ Perspicuitas: comprehensibility of expression
■ Ornatus: deliberate adornment of expression

IV **Memoria: Memorization of speech**

V **Pronunciatio: Delivery of speech**
Concerned with voice and gestures, but also with appropriate setting.

Fig. 1)

The third phase is of particular interest, as it covers the stylistic features that have already been referred to as figures of speech. According to Quintilian, rhetorical figures generate rules that can be looked upon as means of "lending credibility to our arguments" and "exciting the emotions." He also considered the use of these figures as "the art of saying something in a new form" to give a message greater vitality and impact. The essence of a rhetorical figure is an artful departure from the ordinary and simple method of speaking. It should be added that these figures do not refer to ready-made expressions; rather, they should be viewed as abstract operational terms that can be filled out.

The notion that stylistic devices are simply the "dress of thought" needs to be erased. According to E. Corbett, "Style does provide a vehicle for thought, and style can be ornamental; but style is something more than that. It is another of the available means of per-

suasion, another of the means of arousing the appropriate emotional response in the audience, and another of the means of establishing the proper ethical image. If the student adopts this functional notion of style ... he will begin to regard style in the way Stendhal conceived of it: 'Style is this: to add to a given thought all the circumstances fitted to produce the whole effect that the thought is intended to produce.'"[8]

8) Corbett, *Classical Rhetoric*, 415

Rhetorical figures are usually divided into two groups, schemes and tropes. Whereas the former are defined as departures from the ordinary positioning of words in a sentence ("Uncomplicated are young people, sometimes," as opposed to "Young people are sometimes uncomplicated"), the latter are defined as departures from the ordinary signification of words or idioms ("The ground thirsts for rain," as opposed to "The ground is very dry and needs rain").

To delineate building blocks of concept formation, this article must concentrate on the tropes. The nature of the trope can be explained by the following example. In "He was a lion in battle," the term lion is the departed substitute referring to the substituted expression "undaunted unconquerable fighter." The person is not a lion in actuality, but only in some transferred sense. Although the substitute word appears only rarely or occasionally, the substituted words represent the ordinary or habitual mode of expression. The occasional departure involves a change in meaning because it results in effects that are different from the ordinary mode of expression.

Different classifications of figures of speech have been adopted by various writers in the past. In adopting a classification for this study, DeMille's *Elements of Rhetoric*[9] and Corbett's *Classical Rhetoric for the Modern Student* served as guides. The classification is as follows:

9) J. DeMille, *The Elements of Rhetoric* (New York: Harper and Brothers, 1878).

Figures of contrast

■ *Antithesis:* the juxtaposition of contrasting ideas, for example, "By the time the wallet is *empty*, life will be *full*."

■ *Irony:* an expression that conveys a meaning opposite to its literal meaning, for example, "Robbing a widow of her life savings was certainly a *noble act*."

Figures of resemblance

■ *Metaphor:* an implied comparison between two things of unlike nature, for example, "The colorful display was a *magnet* for anybody in the room."

■ *Personification:* a comparison whereby human qualities are assigned to inanimate objects, for example, "The thatch-roofed cottages in the valley *seemed to be asleep*."

Figures of contiguity

■ *Metonymy:* the substitution of terms suggesting an actual relationship that can be of causal, spatial, or chronological nature

HANNO H. J. EHSES

(cause instead of effect, instrument for agent, author for work, container for contained, and produce for producer), for example, *"The White House* (President of the United States) reduced her troops in Europe," or "He had always been a great lover of *gold* (money)."

- *Synecdoche:* the substitution of a more inclusive term for one that is less inclusive or vice versa, the nature of which is quantitative, for example, *"Canada* (Canadian team) won the competition" or "He lived for a week *under my roof* (house)."
- *Periphrasis:* circumlocution, the indirect reference by means of well-known attributes or characteristics, for example, *"to go to a better world"* instead of "to die."
- *Puns:* a play on words, using words that sound alike but have different meanings, for example, "Check in here for the *rest* of your life (Wandlyn Motel)."

Figures of gradation
- *Amplification:* the expansion of a topic through the assemblage of relevant particulars, for example, "He used all the means at his disposal: *radio, TV, brochures, posters, advertisements, and so forth."*
- *Hyperbole:* the exaggeration of an object beyond its natural and proper dimensions, for example, "Jan's friends tracked a *ton of mud* through the hallway."

Any departure from the ordinary way of expression endows the expression with a strong dynamic tension directed either toward the ordinary (making the hallway terribly dirty) or away from it (tracked a ton of mud through the hallway). The less known the trope, the longer the tension span.

It is a necessary condition for all figures of speech that they presuppose a basic understanding of grammatical forms and lexical content from which departure is possible. Figurative variations cannot ignore the grammar of the language inasmuch as any change for a greater effect must respect grammatical possibilities. Because the basic understanding is determined by the grammar and rhetoric is built upon its fundamentals, rhetorical procedure is also referred to as constituting a secondary grammar.

Furthermore, both grammars participate in successive generations of order. However, in using the aforementioned rhetorical figures, a lower literal order is transformed into a higher rhetorical order, giving the expression more vitality. The difference is characterized by the word *money* depicting an image of coins and bills (literal order) as opposed to *money* being illustrated metonomically by the trademarks of several major Canadian banks (rhetorical order). Thus, the effectiveness of a rhetorical figure always depends on the audience's ability to perceive the difference between the substitute and the substituted way of expression.

Whether the literal or rhetorical order is used depends on the number of structured relationships that have materialized, which also implies reference to pre-existing cultural knowledge that predates a design. The connection between both orders is one of balancing two oppositional forces, the obvious and the new. Whereas the obvious tends toward satisfying expectations by responding to existing standards, the new moves toward upsetting those standards by way of a novel and atypical approach with lesser relation to existing expectations. This situation may be described as a state of mutual equilibrium between both preservative and changeable forces. In responding to existing expectations and supplying something unexpected at the same time, a design produces a challenge (a pleasant or unpleasant surprise) in addition to a renewed and extended perspective.

From concept formation to visual form

Visual communication takes place on the basis of more or less conventionalized signs belonging to many kinds of codes of disparate languages. A theater poster is seen as a message representing a complex of signs built on the basis of codes, conveying certain meanings that are interpretable on the basis of either those same codes or different ones. Concept formation coincides with the process of coding insofar as the designer assumes and activates codes by correlating selected graphic devices with selected culturally sanctioned meanings, thus binding something present with something absent. The process of coupling these two opposed units is called *signification*, an act whose product is a sign. A sign according to C. S. Peirce is "something that stands to somebody for something [else] in some respect or capacity."[10] Thus, the possession of codes allows readers to draw relationships, for example, between a poster titled "Macbeth" and an actual play by Shakespeare. Codes can stimulate a variety of interpretations by allowing the designer to draw relationships between the play *Macbeth* itself and concepts such as "crowned beast," "sinister king," "curse of evil actions," "scene from an actual theatre production," and many more.

Signification operates on the basis of denotative as well as connotative codes, both of which draw upon different experiences. Anything derived from the visual perception of a literal reading of a theater poster is denotative, while anything derived from additional experiences and associations or symbolic readings is connotative. Whereas denotation is referential and direct and tends toward monofunctionality (a theater poster as a vehicle whose sole function is to announce the play), connotation is suggestive and indirect and tends toward polyfunctionality (a theater poster suggests a whole host of shared assumptions and possible functions).

Thus, while the posters shown at the end of this article refer to the play *Macbeth* and are denotatively interchangeable in announcing the play, they are connotatively quite different. It follows, then,

10) Quoted in Eco, *Theory of Semiotics*, 15.

Hanno H. J. Ehses

that any act of signification — in addition to conventionalized denotations — must consciously take into account the breadth and complexity of connotations.

An inquiry into concept formation and rhetorical coding must proceed backward from the result toward a hypothetical model that explains the process. To this end, a theater poster is the result of the interplay of two sign systems — title of play and graphic image — that elucidate and complement each other. This is possible in theater posters because the signification of the image is assumed to be intentional; the signifieds of the message correspond to certain attributes or associations of the play that are graphically transmitted in the clearest way. Therefore, the graphic image is seen as a series of signs replacing a statement about the play or about a specific theatrical interpretation of the play. It represents a concept analogous to a written précis.

Having a more focused object of study, the next step involves outlining the elementary conditions of graphic signification, which also includes a wider application than that of the design of theater posters. A visual system such as that of theater posters is the result of two coordinated sets: the set of possible graphic forms and the set of plays to be announced (see Fig. 2). According to a scheme proposed by L. Hjelmslev,[11] all graphic forms correspond to level of expression; all plays to level of content. On both levels, a form

) See Eco, *Theory of Semiotics*, 51-57.

Fig. 2)

(play/graphic representation or discourse) is distinguished from a substance (text characteristics/graphic means). The coupling of the two oppositionally structured sets of forms determines the semiotic structure of the visual system. The structure itself becomes semiotic, since each of the two forms involved contains information over and above that pertaining to its own set. The additional charge of information is obtained through the correlation of the signified play and signifying graphic image, thus determining the deliberately fixed signification of a poster.

The next step of analysis must be to identify the plot or chosen visual concept that is equivalent to the meaning nucleus of a given

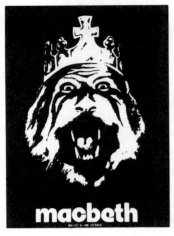

Fig. 3)

graphic image. In decoding the meaning of the Macbeth poster in terms of ideas conveyed or suggested, feelings expressed and connoted, a summarizing statement could read "King Macbeth, a human beast" (see Fig. 3). This graphically encoded statement should be seen as the designer's chosen visual concept that was skillfully and clearly encoded. It should be pointed out that the identified visual concept is not only the result of a literal reading of the perceptible units (crown, face, fangs), but also the result of denotative and connotative reading which, in turn, is influenced by a familiarity with this particular play and by a certain visual literacy.

The remaining question concerns the designer's method of arriving at such a concept. The text of the play itself contains a large stock of suitable material for conceptualization, such as references to certain locations and events, key objects and scenes, main characters, cause-effect relations, and so forth. However, in the text

Fig. 4)

		Graphic encoding			Concept formation		
	= result of	Content	King Macbeth as human beast	= result of	Content	Play Macbeth	Rhetorical pattern: Metaphor
		Expression? (graphic image)			Expression? (King Macbeth as human beast)		

of the play, there is no direct reference to King Macbeth as a human beast. But there are enough indications to constitute an image of Macbeth as a despot. In the example, the designer went one step further in reaching a solution that clearly mirrors the dialectic of comprehensibility and attractiveness to stimulate interest and to represent a high degree of information, the full extent of which can only be discerned by the attentive reader. Referring back to the process that led to the concept, the initial interpretation of Macbeth as a despot has been replaced and dramatized by a visual concept that displays King Macbeth as a human beast.

The relation of the form of expression to the form of content is regulated by specific figures of speech. To reveal the rhetorical figure that governs the concept formation, it is necessary to look at the relationship "title of play = Macbeth" and the concept "King Macbeth, a human beast." In this particular poster, the relation follows a metaphorical structure. A metaphor is defined as an implied comparison between two things of unlike nature, which in this case is Macbeth being implicitly compared to a beast.

Fig. 4 indicates that the signification process in visual design involves two major operations: formation of the visual concept, as well as its graphic encoding. Although in the former, the central problem of design involves finding an idea that expresses the play in some respect or capacity, the concern of the latter is in the visual

194

translation of this concept. Both operations are equally important.

Although graphic encoding is beyond this study, it is likewise governed by rhetorical figures. This point can be illustrated by looking at the visual treatment of the poster previously discussed. To express the concept of the human beast graphically, the designer omitted certain features of a human face and replaced them with features of a particular predatory animal. This graphic manipulation, the departure from a common face—human or animal—adds considerably to the graphic interpretation of beastness. The underlying rhetorical figure at work here is called oxymoron, defined as the yoking of two terms that are ordinarily contradictory. Transferred to this example, it is the yoking of the facial features of a human being with those of an animal. By combining contradictory elements, the designer produced a startling effect, especially as the figure is used in such an obviously fresh and apt way. Finally, in addition to a clear expression of the concept, the designer's command of different media and techniques of visual treatment also allows for modification of the degree of human beastness, which is similar to the use of adjectives to modify nouns or adverbs to modify verbs in a sentence.

Visual duplication of rhetorical figures

From a design viewpoint, rhetoric has classified numerous patterns of signification. However, rhetoric does not say metonymy exists when a king is represented by a crown. Instead, it formulates a kind of equation by saying that metonymy is a substitution for one another of terms suggesting an actual relationship that can be of causal, spatial, or chronological nature.

A common criticism that arises when dealing with rhetorical figures is that discourse manifests itself as concrete, particular, and individual, whereas these terms are abstract, general, and universal. How then can they be useful for the study of design? Their usefulness, according to K. Burke, resides in the fact that they can be re-individuated into different subject matter, that is, a particular figure can be filled out with a completely different subject. As Burke explains it: "A *metaphor* is a concept, an abstraction, but a specific metaphor, exemplified by specific images, is an *individuation*. Its appeal as form resides in the fact that its particular subject matter enables the mind to follow a metaphor-process."[12]

Thus, from a pragmatic viewpoint, rhetorical figures manifest themselves in vividly concrete ways, for example, Macbeth as a human beast. From a logical viewpoint, however, they represent only different abstract terms, for example, a metaphor that can be revitalized in numerous ways. Rhetorical figures should be viewed as construction principles that can assist designers in their search for visual concepts.

To conduct the case study, second-year graphic design students at the Nova Scotia College of Art and Design were introduced to

Kenneth Burke, *Counter-Statement* (Los Altos, CA: Hermes Publications, 1953), 143.

rhetorical methodology. They were encouraged to adopt and test rhetorical figures in conjunction with the designing of a Macbeth poster for the local theater company. It was anticipated that this approach would help to shed more light on the process of concept formation, sparking a greater diversity of interpretations, and, therefore, a greater range of original poster designs. They read the play, viewed the movie *Macbeth* directed by Roman Polanski, and formed study groups around ten listed rhetorical figures. With the construction principle of a specific rhetorical figure as a guideline, each group looked for potential themes that fit the term and had visual potential. Finally, a theme was selected and visually executed; the results then were compared. The feedback from the students was enthusiastic; several mentioned that, for the first time, they felt as if they had produced something that deserved to be labeled "creative." The posters show the visual duplication of one specific rhetorical figure together with the concept statement (see Figs. 5-14).

Rhetorical figures do not by any means represent specific recipes. They are exploration tools that can spur lateral thinking, giving designers the awareness of possibilities to make the best choice. However, the creative process will not become mechanized, because each concrete task requires a different solution. The real problem continues to be that of bringing together the abstract construction principles with original ideas within the confines of a specific task. Concerning design curricula, it would be worthwhile to consider consciously once again the surprising adaptability of rhetoric, especially in light of the new rhetoric movement and in the context of contemporary society, for this society is informed by visual discourse through a wide variety of media to a degree incomparable with any other time.

Fig. 5) Antithesis:
Juxtaposition of Macbeth, the loyal general, with Macbeth, the visciously evil king (Joseph McDonald).
Fib. 6) Irony:
The amiable couple, Her Highness Lady Macbeth and His Highness King Macbeth (Marilyn Dyke).

HANNO H. J. EHSES

Fig. 7) Metaphor:
Comparison between events in the play
Macbeth and contemporary events of a
similar nature portrayed as we would
learn of them today, for example, in a
newspaper (Nat Connacher).

Fig. 8) Personification:
Human qualities are assigned to ani-
mate and inanimate objects bearing
historical significance, bleeding armour
(Ian Mason).

Fig. 9) Metonymy:
The crown and the blood suggest an
actual relationship with the tragic
theme of the play (Julien LeBlanc).

Fig. 10) Synecdoche:
Substitution of a part for the whole, a
portrayal of Macbeth's sinister char-
acter through concentration on the eyes
(Cynthia Henry).

Fig. 11) Periphrases:
Macbeth's fatal strategy to attain power
and crown is indirectly referred to by a
"baited trap" (Siuw Ying Soo).

Fig. 12) Pun:
A play on the three witches, who
spur Macbeth's ambition to attain the
crown, and the crown itself (Steve
Durning).

Fig. 13) Amplification:
Selection of key elements of the play to
enhance its nature (Dave Roe).

Fig. 14) Hyperbole:
Exaggeration of the crown, which turns
out to be an unbearable burden for
Macbeth (John Murphy).

Clive Ashwin

Drawing, Design and Semiotics

Few design practitioners, theorists or educators would challenge the central importance drawing has in their professional discipline; equally few would deny that at the same time drawing is extraordinarily difficult to talk about. Of course, a great deal can be said that is true and relevant about the nature and practice of drawing including providing facts about its materials, history and usage; but most of the concepts and issues that are central and seminal to the essential nature of drawing remain strangely elusive and inexpressible in terms other than those of drawing itself.

A partial explanation of this problem is that it is precisely this inexpressible element that makes drawing valuable and irreplaceable: if everything could be converted into other forms of expression there would be no point in drawing. However, there are historical and cultural reasons why verbal discourse about drawing has remained in an unnecessarily primitive and undeveloped state compared with other fields such as law or medicine. In Britain, as in many other countries, art and design continue to occupy a relatively marginal place in advanced education. They are rarely represented in the universities except as history of art (not, usually, history of design) and one or two cognate areas such as architecture. We continue to suffer from the cultural legacy of the Romantic Movement which often represented the plastic arts, including drawing, as a matter of intuition and inspiration somehow above and beyond the access of rational inquiry and understanding.

This state of affairs has, in my view, seriously impeded the development of drawing. The most rudimentary concepts surrounding issues such as style, content, meaning and expression defy articulation to such an extent that terms and concepts have been devised or borrowed from other disciplines in order to forge a means of appropriately discussing a theory of drawing.

This article reviews *semiotics*, the science of signs, as a possible intellectual groundwork for developing a theory of drawing. Drawing as a system of signs has important cultural origins that are reflected in etymology. The German *Zeichen*, meaning *sign*, gives us *zeichnen* for the verb *to draw*, that is *to make signs*. Similar connections can be seen in the Italian *segno* (sign), *disegno* (drawing, design) and *disegnatore* (designer). The English *draw-*

ing takes its form from the action of pulling, which is characteristic of so much drawing activity, but a similar etymological link can be seen in the words *sign* and *design*.

Many of the central issues of semiotics are highly controversial, and, therefore, readers with a background in semiotics or communications theory may take issue with positions adopted in this article. However, because of the need for a forum for continuing debate about pertinent areas of design theory, this article was written intentionally as an introduction to concepts of semiotics that are under discussion. As such, much of what is said in this article is derived from other sources; some of it, and its synthesis, is original.

Semiotics emerged as an area of theoretical inquiry in the years immediately preceding World War I. Its principal protagonists were Ferdinand de Saussure (1875-1913), the Swiss linguistic theorist and Charles Sanders Peirce (1839-1914), the American pragmatic philosopher. Much of Saussure's most important work was actually assembled from notes made by his students at the University of Geneva. This is true of his influential *Course in General Linguistics* in which he argued, *"A science that studies the life of signs within society is conceivable; it would be a part of social psychology and consequently of general psychology; I shall call it semiology (from the Greek semeion 'sign').* Semiology would show what constitutes signs, what laws govern them."[1]

1) Ferdinand deSaussure, *Course In General Linguistics* (McGraw Hill Book Co., New York, 1966), 16.

2) Charles Sanders Peirce, *Philosophical Writings of Peirce*, Vol. II, 227.

3) Terrence Hawkes, *Structuralism and Semiotics* (University of California Press, 1977), 127.

At about the same time Peirce wrote, "Logic, in its general sense, is, as I believe I have shown, only another name for *semiotic* the quasinecessary, or formal doctrine of signs."[2]

The terms *semiotics* and *semiology* are more or less synonymous, the former being derived from the French *semiologie* and the latter an English variant.[3] It is possible to dispute the truth of this view, and argue that the two terms now denote different areas of theoretical inquiry. In the decades since the pioneer work of Saussure and Peirce, semiotics has broadened into an international area of theoretical inquiry impinging on linguistics, social theory, film theory, cultural history and communications. It has its own international journal *Semiotica* and has attracted leading intellects such as the Italian Umberto Eco, the French Roland Barthes, and the American Thomas Sebeok.

A sign may be construed as composed of two ingredients, a *signifier* and a *signified*. The function of the sign is to communicate a *message*, and in purposive communication, the process requires two participants, an *emitter* and a *receiver*. The message is embedded in a *medium* and subsists in a set of conventions or *code*. The sign is *encoded* by the emitter and *decoded* by the receiver or interpretant.

Following Peirce's lead, signs have traditionally been classified into three groups, each with numerous possible subdivisions. The *index* is a sign that arises as a result of, or in contiguity with, the thing that it signifies. Classic examples are the footprint as a sign

CLIVE ASHWIN

of an earlier presence at a given spot or smoke as a sign of fire. The *icon* (from the Greek word for image) is a sign that bears a similarity or resemblance to the thing it signifies. Road signs that present a schematic image of, for example, animals or vehicles fall into this category, as do more elaborate depictive drawings. Finally, the *symbol* is a sign which bears no apparent resemblance to its related signified, but operates within an agreed set of conventions. For example, the word *tree* has no obvious similarity to the object it denotes, and totally different signifiers are perfectly adequate in other languages (*arbre, Baum, albero*).[4] Other typical examples of symbolic systems are the Morse code and flag semaphore. Because they manifest a deliberate desire for resemblance or similarity, icons are sometimes described as *motivated* signs, whereas symbols are regarded as *arbitrary* or *conventional*.

4) Charles Sanders Peirce, *Philosophical Writings of Peirce*, Vol. II, 227.

If this simple three-fold division or trichotomy is applied to drawing, the importance of the concept of *iconicity* is immediately obvious. Much drawing in relation to design is dedicated to the recording and transmission of resemblances. This process arises as the result of an attempt at *representation*, the recording of a phenomenon already present to the senses, or *presentation*, the process of making material an otherwise immaterial form or idea that existed only as an idea or concept in the designer's mind until its commitment to paper. The iconic (image-like) nature of such drawing is interestingly reflected in the etymological link between *image* and *imagine*.

However, further investigation reveals that iconicity does not provide a comprehensive account of drawing in relation to design. Drawing for design is also deeply involved with the creation and interpretation of signs as symbols. For example the designs of logograms for corporate identity are often symbolic in two senses: they employ alphabetic motifs such as company initials; and they attempt to symbolize the company's supposed character by means of appropriately devised forms, be they "robust," "refined," or "sophisticated."

Practices such as engineering design, architectural design and interior design have generated similarly hybrid sign systems. Although they normally make extensive use of iconic systems based on resemblance, employing such techniques as representational scale, perspective, tone, and texture, they often introduce purely conventional symbolic systems such as codes for the representation of cross sections, interruptions of form, or the depiction of materials, colors, and textures in black and white. This point can be argued further: that even the most unproblematic drawing from observation may contain conventional signs not explicable in terms of resemblance, such as a linear profile representing the boundary of a plastic form in space. A central task of the teacher of drawing is to alert the student to the distinction between the recording of empirical experience through the creation of resemblant equivalents and deploying of purely symbolic

codes. (Whether such a clear distinction can be made is one of the central problems of semiotic theory.)

An underlying *indexical* quality can also be detected in drawing. Certainly, studying the drawing procedures of young children and animals shows that deliberate attempts to form icons and symbols is only a partial explanation of the process. Young children may continue to draw without either precise knowledge of *what* they are drawing or self-conscious control over the process of image-making. The psychomotor activity of swinging a crayon in space may be enough, and the drawing child may engage a friend in conversation and attend to something completely removed from the field of the drawing while the hand continues to move fluently and energetically. The hierarchy of signs, from the footprint on the beach to the idle tracings of a finger in wet sand to doodling on a telephone pad to more deliberate drawings and to the most sophisticated and conscious processes of image-making is not easily broken into a series of discrete rungs. It may well be that in the·most deliberate and controlled drawings there subsists an indexical element that cannot be explained in iconic or symbolic terms.

Having introduced the tripartite division of signs into indexes, icons, and symbols, the *functions* of communication via sign systems can be discussed with special reference to their relevance to drawing for design. It has been claimed that sign systems serve at least six principal functions. A message (drawing) may be *referential* in that it attempts to describe or communicate a form or idea in as objective and dispassionate a manner as possible. It may be *emotive* in that it attempts to communicate certain subjective responses of the emitter in terms of, for example, excitement, attraction or repulsion for the thing depicted. It may be *conative*

Fig. 1) Sectional drawing of a pulley assembly. Middlesex Polytechnic. The conventions of engineering drawing involve complex interrelationships of iconic and symbolic codes, such as the use of hatching to present cross-sections and wavy lines to indicate continuations of form. They are stictly monosemic in intention, that is capable of a finite set of correct interpretations.

CLIVE ASHWIN

(or *injunctive*) in that it persuades or exhorts the receiver to respond and behave in a certain way. It may be *poetic* in that the principal intention is not to communicate facts or influence behavior, but to create an intrinsically admirable (or beautiful) self-justifying form. A *phatic* communication is one that does not attempt to record or communicate facts, views, or information, but serves as a means of initiating, maintaining, or concluding communication between the emitter and the receiver. (Expressions such as "Hullo, can you hear me?" are not so much requests for information as ways of maintaining discourse.) Communication may also be *metalinguistic*, created for the express purpose of clarifying other signs, which may be in the same or another medium. A good example is the key provided on a map.

Before looking at these six communication modes in more detail a useful tool that illuminates their individual character and their interrelation should be introduced. Signs may be characterized as having three possible levels of specificity. *Monosemic* systems offer only one correct interpretation; other interpretations are not viable alternatives: they are considered mistaken and wrong. Hence, cartographical signs and engineering drawings are predominantly monosemic. *Polysemic* systems offer more than one legitimate interpretation. Hence a figurative drawing of a car for an advertisement might evoke a variety of acceptable responses from interpreters, such as speed, power, reliability, and so forth. However, although the range of permissible responses might be wide, it is not infinite, and many would be rejected by the emitter (draughtsman) as wrong or unintended. *Pansemic* systems offer apparently unlimited possiblities of interpretation, a good example being much nonfigurative drawing and painting. It is impossible in this case to reject any reading of the communication as unequivocally wrong or unacceptable. (Many abstract artists would repudiate this assertion and claim that even totally abstract imagery can possess a high level of specificity in regard to the ideas and emotions it is intended to convey.) The designer-draughtsman operates predominantly within the range of monosemic and polysemic systems, as there is invariably a striving for a degree of specificity, ranging from the mechanical precision of engineering drawing to the more allusive use of drawing for book illustration and the promotion of consumer goods.

The six functions of communication are as follows:
- *1. The referential function* Much drawing for design is essentially referential and monosemic. Production drawings for industry, city plans and architectural drawings are guided by the constant imperative to inform the receiver or interpretant (client, artisan, colleague) in a precise and unequivocal manner. Every effort is made to eradicate alternative readings and ambiguities in the encoded message. This perhaps explains why there is such a pronounced tendency to conventional sym-

bolism, even in what are basically iconic drawings. Drawing codes used for engineering, for example, orthographic, axonometric, or oblique projections, bear a rudimentary resemblance to the object of visual perception in terms of scale, perspective, and perhaps even light and shade; but they are at the same time subject to clearly stated codes and conventions of representation. These may prescribe such factors as the thickness of lines employed, angles of projection, interrelation of different views, and even a code for colors.

Drawings that are predominantly referential in function at the same time may import emotive or conative elements. For example, architectural drawings often depict incidentals such as trees, lawns, or figures. The plant life, although rendered schematically, is invariably healthy and well-tended and the lawns are carefully trimmed. The figures are selected as stereotypes appropriate to the setting, for example, brisk young executives emerging from a proposed office block. The fact that most executives are neither brisk nor young or that office blocks are visited or surrounded by general pedestrians, policemen or down-and-outs is not likely to register in the architect's speculative drawing. It is, therefore, an *idealized* image appeal-

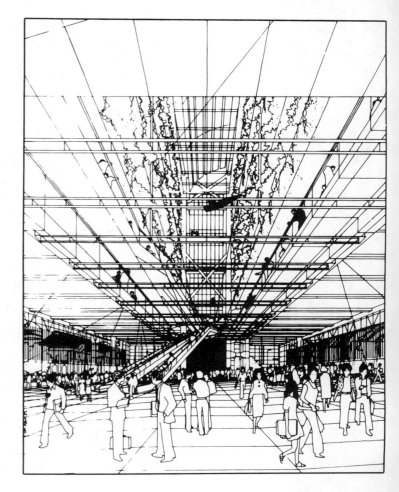

Fig. 2) Architect's visualisation: Hong Kong and Shanghai Banking Corporation Headquarters, Public Concourse and Banking Hall. Draughtsman: Birkin Haward. Permission Foster Associates, London. Although putatively referential in function, architect's presentation drawings invariably entail a degree of idealisation designed to arouse a favourable emotional response in the viewer.

CLIVE ASHWIN

ing as much to the interpretant's sense of order and propriety as to the demand for a true visual account of how the completed building is likely to appear. In similar fashion, a street plan for a city such as New York will provide much useful factual information, but it is unlikely to give an indication of the local condition of streets, problems of traffic congestion or potentially dangerous areas, however valuable this information might be to the plan's user. Again, we see how the striving for monosemic precision is consistent with a tendency towards idealism.

■ *2. The emotive function* Much drawing for design has an intentionally emotive function. Especially in the advertising of consumer products, graphic artists are not only expected to communicate a resemblance of the commodity being promoted, perhaps clearly enough to enable the receiver to identify it in a store window, but to present the commodity in a value-favorable light by means of the content, style and detail of the drawing. In a drawing of a shoe, for example, unique design features such as surface decoration and patterns are emphasized, whereas other equally important or visible characteristics, such as the creasing of the leather, may be suppressed or ignored.

Drawing for fashion design is often emotively biased to conform to a current notion of preferred physical type or body language. In much contemporary fashion drawing, the head is sharply reduced in scale relative to the body to suggest physical elegance, and shoulders may be broadened and legs lengthened. Potentially distracting features such as the nose or mouth may be omitted. Fashion drawing is also characterized by a high incidence of escapements: breaks in the profile of a form which generate a sense of fluidity and movement. The striking difference between contemporary and Victorian fashion drawing shows a great deal about the values of the cultures that created them. The code of Victorian fashion plates was highly referential and monosemic. The emitter wished to convey, and the interpretant to receive, precise information about the form and construction of the garment depicted, its decorative detail, and so forth. If Victorian fashion drawings have an emotive axis, it is articulated by means of preferred physical types (young, beautiful, wasp-waisted) and locations (women in parks and boudoirs, men in clubs and hunting scenes). This illustrative example shows that the function of the drawing as referential or emotive is determined not only by the nature of the content, but also by the stylistic rendering.

■ *3. The conative (or injunctive) function* In contrast to drawing in the context of fine art activity, drawing for design is frequently conative in function; its purpose is to persuade the interpreter of some desired course of action, for example, to

Fig. 3) Robert Mason. Illustration for *The Sunday Times* on the theme of changing roles in the family. Fiction and magazine illustration normally has a referential function in that it alludes to the related text, but may be more importantly emotive, conative or poetic. While engineering drawings set out to provide complete information and eliminate alternative readings, this drawing is intended to arouse the curiousty of the viewer.

buy a certain product in preference to others. Designers of buildings and interiors are simultaneously engaged in communicating the specific facts of a scheme and persuading clients and colleagues of the quality and attractiveness of their proposals, thereby creating a response favorable to acceptance. This is even more acutely true of drawing for advertising design, where the whole purpose of a drawing is to persuade the interpretant to behave in a certain way, to buy the product, or at least to admire it and possibly recommend it to friends. In a nutshell, drawing for advertising is implicitly or explicitly persuasive (conative).

It is more important to note that although the conative force of a drawing may be intended to be emotive with respect to the interpreter, known in advertising parlance as the prospect, it may well not be genuinely emotive with respect to the draughtsman. Draughtsmen might be required to serve as advocates in causes for which they have no particular feelings, or even which they feel real repugnance. They may be required to invent graphic arguments in favor of products they regard as socially destructive and pernicious, just as lawyers might be required to defend clients they regard as complete villains.

This analogy illustrates an important distinction between drawing for design and drawing in relation to fine art activity. The conative function must always harmonize with an artist's emotive aspirations: a fine artist who draws in a certain way not because it made his work saleable rather than because it reflected his emotional condition thereby moves into an area of activity more akin to advertising design than fine art. The interplay between the referential, the emotive, and conative functions of all graphic imagery, including drawing, with its potential for willful deception and misrepresentation, has led to the creation of legal and professional codes of practice to govern the use of such imagery.

■ *4. The poetic or esthetic function* It could be argued that the designer *qua* designer never creates a drawing for purely poetic

CLIVE ASHWIN

or esthetic reasons. In such cases where designers work with the sole motive of self-expression or a concentration on the intrinsic beauty or quality of images, the results are likely to be fine art. Drawing for design always has an *instrumental* purpose. Its ultimate justification is not pleasurable contemplation by the executant or the spectator, but the communication of some important piece of information or value that will influence attitudes and future action. This action may range from the precise manufacture of a machine part to the purchase of a commodity. Designers' work may, of course, be pleasurably contemplated by interpreters, but that is not its *raison d'être* or criterion of success.

The status of designers' drawing may change with the passage of time and change of circumstances. Toulouse Lautrec's drawn advertisements for the cabarets and artistes of the 1890s no longer serve an instrumental function, because the cabarets and artistes they depicted no longer exist. If such drawings have any continuing value it is for their poetic or aesthetic function. This is admittedly a problematic issue. It is impossible to separate the poetic function of a drawing from its other possible functions. Even the most objective and dispassionate drawing of engineering design, intended as totally referential in function, can nevertheless generate a sense of delight in the spectator and serve as a quasi-poetic communication. Similarly, many drawings by fine artists have an unmistakeable conative or injunctive function. Käthe Kollwitz's drawings of the German working class are intended to persuade the interpreters of certain social and political truths and move them in the direction of certain kinds of behavior, as well as being fine pieces of poetic drawing.

- *5. The phatic function* Phatic communications are easy enough to find in speech. Expressions such as "Ah, well" and interjections such as "sort of" or "of course" serve principally as signals to maintain discourse or dialogue and have little or no intrinsic meaning. Much more complex statements might nevertheless be essentially phatic in function. Opening a public speech with "Unaccustomed as I am to public speaking" or closing a travelog with "and so we say farewell to" are examples of phatic utterances masquerading as referential communications. Although phatic utterances easily degenerate to cliches and can become a source of humor and an object of ridicule, they do serve an important purpose in initiating, maintaining, redirecting, concluding communication. Anyone who has ever tried to eliminate everything redundant from his speech will appreciate what a strain it places on the speaker and what curious language it can produce.

Phatic communications play an important role in many areas of drawing for design. The presence (or absence) of framing devices such as lines and rules and the deployment of graphic

Fig. 4) David Penny. Line drawing of a grasshopper escapement. Courtesy Mr. A. King. Even the most objective and dispassionate drawing of a piece of engineering design can nevertheless generate a sense of delight in the spectator and serve as a quasi-poetic communication.

motifs such as arrows are extensively used to capture and direct the attention of spectators. Drawing for comic papers has generated an immensely complicated semiotic code rich in phatic devices and signs. These signs include special ways of framing drawings to indicate the relation between separate frames, and devices such as lines, arrows, and escapements are used to maintain movement, change location, shift focus, and direct the narrative. From a purely semiotic point of view, comic papers constitute one of the most complex and sophisticated areas of drawn communication.

■ 6. *The metalinguistic function* The purpose of metalinguistic communication is to comment upon, explain, clarify, or qualify other communications. Quotation marks or commas around a word indicate that it has a special meaning in the context in which it is used, just as a frame signals the special kind of relationship a painting has with its environment. Metalinguistic communication has a prominent role in areas of drawing (common examples include maps, plans, statistical displays and technical illustrations) that depend heavily upon conventionalized codes. To achieve a high level of specifity, the code must establish a close and unequivocal correspondence between signifier and signified, with the elimination of ambiguities. Sometimes the code may be represented as a metalinguistic display in the field of the actual drawing, as may be the case with the key of a map or the explanatory key of a statistical display. In other cases, whole areas of drawing practice may be governed by well-known codes of representation that are not included with every example but are published separately and assumed to be known to everyone practicing in the area. An example is the phamphlet entitled *"Engineering Drawing and Practice"*, published by the British Standards Institution and recognized as the professional code of practice by engineering draughtsmen in Great Britain.

Running right through the range of communicative modes are the semiotic concepts of *denotation* and *connotation*. The denotation of a sign is its commonsense meaning, what it might be taken to represent in its most fundamental and obvious interpretation. Its connotations are the association and ideas that it may evoke in individual interpretants. The denotation of a road sign showing a horse is the animal and the likelihood that a horse might be encountered on the stretch of road ahead. Its connotations, however, will be different for different travellers. One might welcome it as evidence of the great outdoors; another may see it as an unwelcome source of hazard; yet another might be reminded of a childhood spent on a ranch. The distinction between denotation and connotation is not always easy to make. One may question whether there is ever a straightforward unequivocal "common

CLIVE ASHWIN

sense" reading of a graphic sign that is the same for all spectators. Conversely, some connotations are so universal that they constitute invariate associations of the sign, and therefore, are akin to denotation.

As mentioned previously, semiotics grew out of linguistic theory and philosophy, and its content and procedures have been much influenced by its origins. Many characteristics of verbal language are not easily transferable to pictorial or other systems of communication. In verbal language, individual signs (words) are combined in a linear sequence that permits analysis in terms of both the meaning of each sign and its position within the syntax of the sequence. For this reason, verbal communication has been described as a *discursive* system. Pictorial communication usually presents interpreters with manifold ensembles of signs rather than sequences, and the interpreters must make their own order of the presentation, perhaps attending first to the whole and then its parts, or vice versa. For this reason pictorial systems have been described as *presentational*, as opposed to discursive, systems.

The syntax of verbal language provides its rules of combination and sequence, governing such issues as the position of verbs and the order of clauses within a sentence. The concept of syntactical relations can be easily transferred to other areas of representation. For example, clothing is governed by syntactical rules of combination, that is, inclusion and exclusion, which are dictated by social practices and expectations. Attire that departs from these syntactical rules may be regarded as bizarre, outlandish or even indecent. The eating habits of a culture are similarly governed by a syntax that dictates what may be eaten (inclusion and exclusion), the number and sequence of dishes, and rules of substitution. These rules may be codified in the form of a restaurant menu. Although applying the concept of syntax to pictorial imagery may be difficult, it makes a useful analytical tool for the study of drawings, and this is true of the whole area of semiotic theory.

Bibliography

Ashwin, Clive, "The ingredients of style in contemporary illustration: a case study" *Information Design Journal*. Vol. 1, No. 1., 1979, pp. 51-67.

Barthes, Roland, *Elements of Semiology*, Hill and Wang, New York, 1977.

Barthes, Roland, *Mythologies*, Hill and Wang, New York, 1972.

Barthes, Roland, *Image, Music, Text*, Hill and Wang, New York, 1978.

Eco, Umberto, *A Theory of Semiotics*, Indiana University, Bloomington, 1979.

Guiraud, Pierre, *Semiology*, Routledge, London, 1975.

Hawkes, Terrence, *Structuralism and Semiotics*, University of California, 1977.

Peirce, Charles Sanders, *Philosophical Writings of Peirce*, Dover, New York, 1940.

Peters , J.M., *Pictorial Communication*, David Philip, Cape Town, 1977.

deSaussure, Ferdinand, *Course in General Linguistics*, McGraw Hill, New York, 1966.

Williamson, Judith, *Decoding Advertisements*, Merrimack, Bridgeport, 1978.

Wollen, Peter, *Signs and Meaning in the Cinema*, Indiana University Press, Bloomington, 1973.

Writing Design History

Clive Dilnot

The State of Design History
PART I: MAPPING THE FIELD

Introduction

The history of design as one aspect of a more general rise in the study and practice of design is an important and rapidly developing area of design studies. In Britain, it has a firm institutional base in the highly developed system of degree and subdegree design education. In the United States, acknowledgement of the important pedagogic role of design history and the enthusiam of some studio design instructors is leading to similar developments, despite some initial recognition problems from bodies such as the College Art Association.

There is also considerable professional awareness in the United States of the need for histories of the various design professions. In East and West Germany and Italy, design history is emerging more as a cultural-historical critique of design's role within industrial culture than as a pedagogic tool or as a provider of historical perspectives on the growing maturation of the design professions.

These developments coincide with a general rise of interest in design issues in the major industrial nations. Business is now acknowledging design as a significant agent in corporate development, governments increasingly see design as a resource to aid industrial regeneration, and the academic world is reluctantly beginning to consider design and its issues as a significant area of study.

Design history has developed substantially during the past few decades, and its awareness permeates discussion on design matters. In current design debates, most positions are informed by notions of history.[1] There is thus some value in giving a topography of the "methodological, political, social, and design theoretical positions"[2] that underlie current design historical work.

The most obvious example of history's relation to practice is in architecture. The confusion surrounding the demise of Modernism and the rise of varieties of Post-Modernism have all been accompanied by feverish historical writing. Special issues of *Architectural Design* illustrate the current use of history. Letter from Victor Margolin to the author setting out the brief for this article, July 1983.

Such a survey and critical assessment can facilitate design history's development as a discipline in its own right. They can achieve this goal by exploring the problems of method and definition that have recently come to the fore. Equally essential is the need to consider design history in the wider academic context: What is the relationship between design history and other areas of study and inquiry? To use the most obvious example, what is its

relationship to art history? Also, what is its relationship to history in general and to the specialist histories of technology, economy, and business that impinge on the subject? If there remain unresolved issues, one way of exploring them is through a survey of current work.

However, these questions are predicated on the overall relationship between the history of design, design history[3] as a specific academic subject, the wider field of design studies,[4] and design practice. In particular, the tripartite relationship between history, understanding, and practice is of central importance to design as a whole. Understanding such problems as the lack of a clear philosophical or methodological basis for design following the collapse of Modernism, design's social role,[5] or the role of esthetics in design cannot be adequately understood or solved in practice without historical study.[6]

This leads to another question: To what extent can history contribute to the understanding of what design is and what the designer does, and to what extent can history make that understanding public? Despite the evident (to designers) centrality of design in twentieth-century society, that importance is still not publicy understood. The paradoxical postion design finds itself in is neatly summed up in the introductory paragraph to Penny Sparke's recent study, *Consultant Design: The History and Practice of the Designer in Industry.* According to Sparke, "[if] the word *designer* has finally infiltrated the vocabulary of everyday life such that American commercials extol the virtues of *designer jeans,* Vidal Sassoon proudly refers to himself as a *hair designer,* and the French and Italians have absorbed the word directly into their own languages," a corollary of this situation is that neither *design* nor *designer* are well-understood concepts. "Attempts to define [a designer's] role are usually, however, vague, confused, and ill informed: Nobody seems to know what he does other than to imbue products with added desireability."[7]

This misconception might not be so worrisome if the level of concern were simply hair styles or designer jeans,[8] but it is not. We are becoming more and more a *designed* and a *designing* society. As Thomas Hughes, the American historian, has noted, "Whereas once technological systems, especially the largest, evolved, now more and more and larger and larger ones are designed, constructed, and managed by man."[9] Nor is this phenomenon only technological. It is also cultural. This is Arthur Pulos's argument in the very first paragraph of his recent book, *American Design Ethic: A History of Industrial Design.* "Design is the indispensible leavening of the American way of life. It emerged with the need of the colonists to transform the wilderness into a secure haven and expanded as a natural component of the industrial revolution in the New World. The United States was in all likelihood the first nation to be designed — to come into being as a deliberate consequence of

3) The history of design should not be confused with its present institutional and academic form, design history. The latter by no means encompasses all of what the former might eventually become.

4) As in the work of the British Design Research Society and its journal, *Design Studies.*

5) See Clive Dilnot, "Design as a Socially Significant Activity," *Design Studies* 3 (July 1982): 139-46.

6) For a critical assessment of this problem, see Tony Fry, "Design History: A Debate?" *Block* 5 (1981): 14-18. For an argument which states that history must relate to practice, see Joseph Rykwert, "Art as Things Seen," *Times Literary Supplement* (May 29, 1974). The article is addressed to art historians, but has considerable impact for design historians.

7) Penny Sparke, *Consultant Design: The History and Practice of the Designer in Industry* (London: Pembridge Press, 1983), 1.

8) This is not to say that these are irrelevant areas. See Dick Hebdige, *Subculture: The Meaning of Style* (London: Methuen, 1981).

9) Thomas Hughes, "The Order of the Technological World,: *History of Technology* 5 (1980): 1. Hughes's argument for a systems-organizational perspective on technological history is of considerable interest to design historians. (Suzette Worden brought this article to the author's attention.)

CLIVE DILNOT

) Arthur Pulos, *American Design Ethic: A History of Industrial Design* (Cambridge: M.I.T. Press, 1983), 1.

) See the review of the Pulos's book by John Heskett in *Design Issues*, vol. 1 no. 1 (Spring 1984): 79–82.

) More than anything else, this conundrum illustrates the significance of the concepts that are used. This is not to say that real problems in design practice or design understanding can be reduced to a question of terms. But in most cases, terms, and especially the assumed meanings given to them, are part of the problem. This observation also applies to problems in history.

) Judith Hook, *The Baroque Age in England* (London: Thames and Hudson, 1976), 7.

) The point comes from a fascinating essay by Stephen Yeo, "State and Anti-State: Reflections on Social Forms and Struggles from 1830," in *Capitalism, State Formation and Marxist Theory*, edited by Phillip Corrigan (London: Quartet Books, 1980), 111-14.

the actions of men who recognized a problem and resolved it with the greatest benefit to the whole. America did not just happen: It was designed."[10]

Pulos's somewhat purple prose and celebratory instinct (which are manifested to an even greater extent throughout the rest of the preface and, indeed, throughout the book as a whole)[11] should not be allowed to obscure the potential importance of this argument. If Hughes and Pulos are even partly right, then design has an importance that society in general and the academic world in particular have traditionally been loath to grant it.

Clearly then, both understanding of design and its public communication are not only necessary professional demands, but also urgent *social* needs. But the points that Pulos and Hughes make also implicitly call into question the context in which we should think about design. For example, the notion of a journal such as DESIGN ISSUES implies an arena of debate about design — its future, its history, its role. But what should the context for such debates be, the design world as we understand it, as it might be, or as it once was? Or, should the context be society as a whole? Context depends on definition, which in turn depends on context. The process is circular: The way one segment of the problem is defined determines the answer for the other.[12]

Discussion of future roles for design cannot take place either in an historical vacuum (where merely Utopian ideals are put forward rather than concretely realizable projects) or in a context where present practices dominate so that no other kinds of practice can ever be contemplated. However, attempts have always been made to evade history, to pretend it is of no significance, and to eradicate the idea of other possibilities. Historians, "notorious for their abilities to shirk fundamental issues,"[13] have participated in this as much as anyone. In the case of design, they have made repeated efforts to collapse historically different and precise forms of designing into a single system, usually one dominant at the time the history was written.[14]

However, it is precisely a careful study of history that can prevent this. History can keep open the *differences* involved. Most important, it can allow differentiation between *designing*, a verb denoting an activity, not necessarily professional, and *design*, a noun referring to a particular profession or a particular class of phenomena. Therefore, the first context for design understanding is the historical. Design thereby can be understood in toto by making the *varieties* of design historically credible. Paradoxically, defining and explaining design and what a designer does are dependent not only on immersion in design practice, but also on the ability to see this practice in both historical and social perspectives.[15]

There is another reason for carefully exploring the history of design. An exploration of the field demands that at least some account be given as to why a history of design has taken so long to form.

15) It is significant that the Open University's design discipline has used this approach to make design and technology issues comprehensible to students. See, for example, David Walker and Nigel Cross, *Design: The Man-Made Object*, Units 33 and 34 of course T100, The Man-Made World: A Foundation Course (London: The Open University Press, 1976), 53-63, and Nigel Cross, *Design and Technology*, Unit 9 of course T262, Man-Made Futures: Design and Technology (London: The Open University Press, 1975), 9-25.

16) One pertinent example will do. Raymond Williams, a highly respected English cultural critic, is the author of *Keywords: A Vocabulary of Culture and Society* (London: Fontana, 1976). Amongst the 110 or so terms discussed in the section "The Significant Binding Words in Certain Activities," page 13, *design* and *technology* are notable for their absence.

17) The difference between the two is important. Self-consciousness has been common in avant-garde designing since 1851. However, like this approach to design, theory and study have been largely subjective polemical activities, not at all substitutes for the more careful consideration of design that needs to take place. For an argument worth careful consideration, but whose conclusions the author cannot agree with, see Roger Scroton, *Aesthetics of Architecture* (London: Methuen, 1979), especially the introduction and chapter 1.

18) To what do we owe the origins of this division out of which first architecture and then design emerged as professions? It seems to me that understanding this development in the fullest sense is a precondition for comprehending the position of design today.

19) In relation to current design practice, see Clive Dilnot, "Thinking about Design," *Designer* (October 1983).

20) The situation in technology is now being redeemed. Serious historical work has been going on for more than twenty-five years, and there has been important and encouraging growth in technology policy and technology-society studies. A very significant critical strand to this work, whether from an ecological point of view as in the work of E. H. Schumacher, or from a more directly political viewpoint, has emerged. See, for example, Hillary Wainright and Dave Elliott, *The Lucas Struggle* (London: Allison and Busby, 1982); David Dickson, *Alternative Technology* (London: Fontana, 1974); Phil Slater, editor, *Outlines of a Critique of Technology* (London: Ink Links, 1980); and Mike Cooley, *Architect or Bee* (Slough: Langely Technical Services, 1979).

This process, in turn, uncovers the way design has been perceived within the Western industrial societies. The most striking feature is that the academic world has cared little for the study of design.[16] Consciousness of design, not in the sense of *self-consciousness*, but of developed conscious historical and theoretical understanding,[17] has played a negligible role in academic research or study and within design practice. The exception has been architecture.

Some explanations may be useful. The cultures of the major industrial societies are all characterized by a profound ambivalence over the role and value of technology, goods, and images in creating or forming their "civilizations." Two attitudes are characteristics. In Britain and Germany, some of the most powerful cultural criticism has been written *against* technology, materialism, and goods and consumption.

However, elsewhere in Europe, and in the United States, almost the converse attitude has emerged: an exaltation of technology's powers and its *objectivity* (the purity of technology untouched by human desires and wants) as well as its *autonomy* (technology as a material but not a social activity). The effect of hypostatizing technology has been to expel the "empire of things" from the world of culture and to maintain and strengthen the division between industry and culture, work and family, and technology and design that occurred in the nineteenth century.[18] For, as a further consequence of this historical development, thinking is freed from any need to concern itself with doing (hereon presumed to be a socially neutral technical activity) and doing is divorced from any concern with cultural matters.[19]

Discouraged from pursuing the kind of self-reflection characteristic of the humanities and sociohistorical sciences and of science itself, neither technology[20] nor design has pursued the historical, cultural, or philosophical-analytical study of itself. The near impossibility of analytically separating designing from making until at least the onset of the Industrial Revolution, along with the lack of a profession (until recently) rather than a craft of designing, and the total lack of an articulation of design as a practical, cognitive activity in its own right, have all contributed to ensuring a very low status for designing and design within the value systems of industrial societies.[21]

However, this status is being challenged in a number of ways. The greater professionalism of designers is one way. Another is the founding of journals such as DESIGN ISSUES, which also represents the recognition of design as a complex and important activity worthy of study and research. Yet, because history has recently become a main channel for the more academic exploration of design, questions of the formation of design's history and intellectual organization are important. This development must also be understood as a whole. For example, a history of design's relationship with the academic world would tell volumes about the nature of academic

CLIVE DILNOT

21) A significant measure of academic status is given by the almost complete lack of postgraduate education and study in the design field compared with almost any other subject or discipline studied at a degree level. In Britain there are social science, and engineering research councils, but no design research council and no research funds.

22) What is the different significance of history and study between architecture and design? A study that focused on this issue could provide a whole range of insights into what differentiates the practices of architecture and design in a conceptual sense.

23) In retrospect, it seems that design history's problem with art history was less the way the latter imposed its methodology on design history and more the fact that design history kept art history's methods but renounced its intellectual core, thus depriving itself of the means to give significance to the form of the things it dealt with. The histories of the decorative arts, with some exceptions, have already anticipated design history in this.

24) When historically does society begin to recognize consciously that things are *designed* rather than that they simply are? This seems to be a fundamental problem. It is the difference between design as a necessary but barely acknowledged moment of human praxis and "design" as the conscious aperception and acceptance of this fact. But when and why does the latter occur?

25) Nikolaus Pevsner, *Pioneers of Modern Design* (London: Faber and Faber, 1936).

26) Pevsner, *Pioneers*, 18.

priorities, how the design field has considered itself in the past, and the forms of interaction between how a practice pictures itself and the ways that it organizes as a profession or activity. The result would be to throw considerable light on the questions of how design operates in, is formed by, and is perceived by society.

A survey of what is now happening in design history ought at least to raise issues discussed here. Therefore, this article surveys design history today. Inasmuch as it is written from a British perspective, the emphasis is on events in Great Britain.

The emergence of design history

Before 1939, there were two or three areas of design historical activity, with the exception of architecture.[22] One area was the history of the decorative arts. Largely constituted as a branch of the history of monumental architecture, especially of great houses, it included the histories of interior or garden design and the contents and furnishings of rooms. It also included the provenance — creating histories of all those objects, that is, furniture, glassware, ceramics, silver, and so forth, collected in museums, preserved in the country houses, and, above all, sold through the antiques trade and the sales room. The histories of the decorative arts are intimately related to the history of art in this area.[23] Because the histories of the decorative arts are oriented to the needs of the sales rooms as the most vital and vigorous consumers of their work, they have accomplished important achievements in detailed research. But they lacked a concept and a comprehension of design.[24] As will be discussed, the act of *designing* is the missing thread throughout the histories of the decorative arts, almost without exception.

By contrast, the second embryonic form of design history, building on art and architectural history, elevated design to the highest principle. If design history has an academic antecedent, it is surely Nikolaus Pevsner's *Pioneers of Modern Design*, despite all later criticisms.[25] First published in 1936, it is animated by two powerfully linked ideas. First, design is of great importance and significance in the modern world. Second, precisely because of this, the *form* that designing takes in this emerging world is of social and ontological importance; so, too, is its history. History establishes a tradition and, therefore, a coherence to an activity. And, for Modernism ("the style of the Fagus Works and the Cologne model factory"),[26] which existed then only on the margins of English and American design and was already beset by what Pevsner called the Jazz style or *Moderne* designing, history or *tradition building* was in this sense a vital polemical component in winning the battle for the acceptance of a true modern design.

History also supported Pevsner's parallel fight for the recovery of a unified design principle and practice. For Pevsner, history elucidated, through the exploration of design, the relation of designed things and design attitudes to society. Scarcely formulated in

27) This is in sharp contrast to the poor caricature of Pevsner's work recently drawn in David Watkin, *Morality in Architecture* (London: Oxford University Press, 1978).

28) It certainly fires *Pioneers* and guides the series of biographical and critical articles Pevsner wrote in the late 1930s and 1940s. Many of these articles are usefully collected in Nikolaus Pevsner, *Studies in Art, Architecture, and Design*, vols. 1 and 2 (London: Thames and Hudson, 1976).

29) Stanley Morison, Daniel Berkeley Updike, and Beatrice Warde are among the most important members of this group. Anthony Coulson's *Bibliography of Design in Britain, 1881-1970* has a list of major works. See also the following journals: *Ars Typographica*, 1918-1934, *Fleuron*, 1923-1930, *Signature*, 1935-1940 and 1946-1954, and *Alphabet and Image*, 1946-1948.

30) Harmondsworth: Penguin, 1955. See also Lucien Febre and Henri-Jean Martin, *The Coming of the Book* (London: NLB, 1976).

31) The English tradition has continued with works by Michael Twyman, John Lewis, and Herbert Spencer, among others. See the work in the new typography journal *Typos*, published by the London College of Printing. But is the impulse comparable?

32) Giedion's influence on Modernism has been frequently commented on. Less discussed because more problematic is the influence of Giedion's *Mechanisation Takes Command* (London: Oxford University Press, 1948). In some ways, it would seem that this curious work has never been fully assimilated into design history.

his writings to any explicit theoretical extent, the conviction of the import and subtlety[27] of this relationship animates almost every sentence Pevsner wrote.[28]

History as polemic in the service of a design principle, or even history for use as functional to collecting, has lost much of its respectability or has taken on the new form of history as celebration. But the quasiscientific detachment to which historians now sometimes pretend, was, before 1939, ruled out of court, at least for "design history" (for what possible market could there have been for it?). Design history in relation to a purpose was the only possible history. Nor was or is it necessarily a bad thing. There is evidence of its benefits in one of the other areas of design history that existed before 1939. The revolutions in typographic practice initiated by William Morris's re-establishment of the Jensonian typefaces in the 1880s, the subsequent rise in America and Europe of the Private Press movement, and the work on scripts by Edward Johnston and Eric Gill, produced by the 1920s, an international typographic movement of great sensibility and a deep concern for typographic history. Stanley Morison in England, Daniel Berkeley Updike in the United States, and a host of others concerned themselves with typographic history.[29] It remained largely internal to the discipline, although out of it came books like the popular *500 Years of Printing*, by S.H. Steinberg.[30]

However, even in graphic design, the efforts and achievement of these typographers and historians are too little recognized,[31] indicating something about the nature of design history in relation to design practice. Design history arises, in the service of design, as a response to particular practical problems. It does not arise artificially, simply for the sake of itself. Once the problem is solved, through the assistance of history, interest in the subject tends to die down again. This tendency prompts the question, what is implied by the current simultaneous rise of a need for history on all design fronts? And, will the answer explain the otherwise puzzling absence of design history between 1936 and the late 1960s?

The reasons for this absence are many. Modernism's rampant success in colonizing both the British and American architectural establishments after 1945, undoubtedly helped by Pevsner and Siegfried Giedion,[32] was not perfectly repeated in design. When product design, in particular, took on the Modernist ethic, it did not need the historical and intellectual weight that was a necessary precondition for adaptation by architecture. The critical arguments such as those developed in Herbert Read's *Art and Industry* were of more impact.

The same remained generally true in graphic design. Except for specialist areas, notably typography[33] and illustration, history seemed to be irrelevant for a discipline in the process of forming itself and attempting to escape the historic limitations of arts-and-crafts attitudes and its commercial art background.

CLIVE DILNOT

3) The exceptions as it were prove the rule. The 1950s saw the Swiss school of typographers attempt to establish their scheme of rational design in part by reclaiming the functional heritage of the 1920s. See, for example, Karl Gerstner and Markus Kutter, *Die Neue Graphik (The New Graphic Art)* (Teufen: Arthur Niggli, 1959). But history was here wholly functional to the design enterprise.

4) There is, however, a useful account of these developments in Pauline Madge's review of John Heskett's "Industrial Design," Design Analysis and Design History," *Information Design Journal* 3/1 (1982): 23-29.

5) See, for example, the collected articles of Reyner Banham, *Design by Choice*, edited by Penny Sparke (London: Academy Editions, 1980).

Conditions were not propitious for the emergence of design history. A rampant anti-intellectualism, combined with a hierarchical dominance of the fine arts, the history of art, and the idea of "culture" in the art and design schools, served to make discussions of design in any historical sense more or less impossible. But if the emergence of the history of design remains to be studied,[34] there is little doubt that the present need to understand the historical coming to be of design and to acquire a broader historical perspective, has its roots in academic discussions and in the complex and often contradictory developments that occurred in both design and popular culture in the 1950s and 1960s. During this period, design came of age; it emerged into public consciousness in a way very different from that of the 1930s and 1940s. The consumer revolutions of the post-war period, the institutionalization of design, the expansion of art and design education, and the explosion of youth and pop cultures, all served in different ways to highlight design and styling skills and to emphasize the new significance of the look or style of things. Along with the explosion in the sheer quantity of images, especially photographic ones, that the average person was exposed to, these developments made goods and images a part of popular culture in a new way. The effects of advertising and design styling combined to make "things" less things in themselves and more totems, or images or fetishes of other things.[35] And the curious situation that has arisen now is that, amongst the values expressed or represented by the design of things, are those of "design" and "style" themselves. Design itself gradually became a fetish or a value.

This cultural identification with things also marked an acceptance of industrial culture. Beginning in 1952 with the exhibition of Victorian and Edwardian decorative arts at the Victoria and Albert Museum, a gradual revival of interest occurred in the objects and history of the nineteenth and twentieth centuries. The Victorian Society was founded in England in 1957, the Society for the History of Technology in America in 1958. The decade also brought the beginnings of industrial archeology and a general popular obsession with the previously despised Victorian Age.

Pevsner's *Pioneers of Modern Design* was revised and re-issued in 1960, and in the same year, Reyner Banham's *Theory and Design in the First Machine Age* was published. Banham's book marked the beginning of a period of intensive study of Modernism and its origins, which meant that the Pevsnerian program of study was at last taken seriously. In addition, the research that subsequently emerged departed somewhat from the Pevsnerian model. Although still architectural in character, the new writings on late nineteenth- and early twentieth-century design widened to include additional designers and explored design proper rather than architecture alone. The effect was to push the study of design away from the purity of progresssion that Pevsner had given it. However, the radical

approach of these writings should not be exaggerated. At this level, the emerging design history still fit easily into the traditional forms of art and architectural history writing. Pevsner's book treats painting seriously, and is written in terms of "great men." In fact, it is on individuals that the early design history was based.

This approach was not necessarily counter to the interest of the emerging design professions. The codification of professional design education in Britain in the early 1960s was accompanied by the enhanced status of designers and design. In that context, design histories that further developed the role of professional designers and design institutions were welcomed initially. However, this kind of history, severely limited from a design perspective, was still heavily oriented to architecture, fine art, and notions of what good design is. Thus, by the late 1960s and early 1970s, considerable pressure was coming from the design education field, particularly graphics and industrial design, to develop a design history that was not based as much on fine art and architecture. To what extent did this reflect the design profession's own awareness of problems in design? It was clear by the early 1970s that "good design" was not a magic talisman. Modernism began to lose its appeal, and problems of design organization, technology, and the relation of design to society and to the economy came to the fore. Also, the question of design's relationship to commerce, markets, and popular taste provoked both practitioners and embryonic historians to re-examine the tenets and assumptions of a Modernist design practice and a history of design that simply reproduced the modernist story or somewhat naively documented the emergence of good design and its institutions. This rethinking of approaches set the stage for the emergence of a new design history.

The forms and varieties of design history
In the absence of a real tradition of design history as previously discussed, what form could a new design history take? The form it did take was considerably influenced by the educational and professional context in which, in Britain at least, it emerged. However, the important point to note regarding the design history in this phase, approximately 1970 to 1980, is that mostly art historians entered the field.

The coherence of a design historical attitude was both slow in forming and not bound by any rigid framework or set of texts. (In that respect, even *Pioneers* has not dominantly imposed its values on present design history.) On the contrary, with the laudable aim of keeping the discipline open and relativistic, there was a notable reluctance to specify objects and subjects of study or to consider what the role of this history might be.

The major consequence of this almost accidental emergence of a history of design is that design history, in the sense of a single, organized discipline with defined aims and objects, *does not exist*.

It is thus bafflingly difficult to survey or define design history in its present state. At best, one can say that, without explicit definition or statement, the new design history is formed around four linked principles and four related absences. The principles are as follows:

- Design history is the study of the history of professional design activity.
- It is not the activity itself that forms the first layer of attention of historians, but the results of that activity: designed objects and images. (This emphasis is justified on a number of esthetic and archeological grounds, as well as on the premise that design is a practical activity that results in a new thing or image.)
- An equally natural orientation was added to design in the nineteenth and twentieth centuries.
- Design history emphasizes individual designers. Explicitly or implicitly, they are the focus of the majority of design history written and taught today.

The absences, by contrast, are less specific, but equally present in the way the discipline operates:

- There is little explicit consideration of aims, methods, or roles of design history in relation to its actual or potential audiences.
- There is little consideration of design history's origins, except in an educational and institutional sense.
- There is a general lack of historical, methodological, or critical self-reflection. Whereas self-reflection might at the very least engender clear statements of position or clarification of aims, the ad hoc nature of most design history means that is is very difficult to define social, theoretical, or methodolocial presuppositions. This not not to say they do not exist.

Differences of emphasis and orientation in design historical work certainly exist. These can be classified as four general traditions or approaches; however, it is important to note that these are only general attitudes or tendencies, not schools to which historians ally themselves, nor are they necessarily exclusive categories. Many historians of design cross some or all of these boundaries in the course of their work.

In addition, there are four areas of work in design history that can be set out as follows:

1. A continuation of the traditional histories of the decorative and minor arts as applied to the subject matter of design, decoration, and ephemera of the nineteenth and twentieth centuries. As the recent past has become of more concern to design historians, museum directors, collectors, and designers, there has also been a natural tendency to extend to the decorative arts of the nineteenth and twentieth centuries the kind of scholastic attention

that, prior to 1945, was confined almost exclusively to works of the eighteenth century and earlier. This has taken a number of forms. The most dominant at present is the encounter with the world of mass culture (the break is approximately 1925). There, the orientation of the studies has shifted to a whimsical conception of popular taste and to a concern with what might be called junk antiques. Typical products of the recent histories of this genre are the enthusiastic studies of early Art Deco products, histories of fashion, and popular books on ephemera, such as Bevis Hillier's *Austerity Binge*.

What links all of these works is the patent problem of attempting to discuss issues of twentieth-century decoration within the traditional terms of the "high" decorative arts. There is nothing on the taste of the industrial period to compare with Hugh Honour's marvelous book *Neo-Classicism* or Judith Hook's *The Baroque in England*. Nor is there anything on the decorative functions of things to match Michael Baxandall's *Limewood Sculptors of Southern Germany*. This is partly due to the seriousness with which the subject is approached. Decoration in the twentieth century is not considered to have the same weight or meaning as Mannerism in the sixteenth century.

This lacuna is also due to a shift in conditions in the industrial period, a shift that has not yet been adequately explored. The central issues in terms of the decorative (and one must ask whether that term can even apply to twentieth century phenomena) now are issues of style, taste, and fashion. Indeed, it is precisely works that deal centrally with these concepts that best support the attempt to write a serious history of the meaning of decorative style in the twentieth century.

The same facts probably explain why the more successful recent histories of nineteenth- and twentieth-century decorative arts have been written about those areas to which these strictures least apply. Histories of furniture, for example, can be written with relatively less break from the traditions and formats of decorative history, particularly if they concentrate on fashionable designer furniture by borrowing ideas and methods from mainstream history, or begin to explore company histories. This has its limits, of course. The most fascinating work on Wedgewood is undoubtedly that by Neil McKendrick, the economic historian.[36] However, the integration of McKendrick's work into a more complete design history of Wedgewood still awaits its author. This in turn poses the question noted earlier. If Wedgewood is considered solely under the rubric of the decorative, could such an integration of esthetic and economic histories take place? Is not the precondition for this integration the abandonment of the decorative as a term useful for comprehending decoration even in the twentieth century?

Yet the tradition of writing decorative history survives. Its ability to elucidate the precise provenance of an object is in considerable

36) See Neil McKendrick, editor, *The Birth of a Consumer Society* (London: Europa, 1982), 100-46.

demand by the sales rooms, the antiques trade, and the new museums that emphasize nineteenth- and twentieth-century collections. What this tradition can give in terms of developing an understanding of design and decoration in the twentieth century remains to be seen.

Considered from this point of view, does the history of the decorative have any role in design history or design understanding? Two developments suggest a tentative yes. The first is in the area of craft history. Opinions differ sharply as to the position of the crafts in relation to a concept such as design. However, during the next few years a history that takes a more serious view of the decorative, esthetic *function* of craft objects will emerge. At present, the history of the design crafts area is a problem for practitioners. There is a need to construct histories of design crafts that either avoid the excesses of recent decorative histories or assimilate them into an overall model of the development of industrial design.

The origins of such a history very likely lie in the recent work undertaken on William Morris, the Arts and Crafts Movement, and Art Nouveau. This work has been concerned with augmenting the lineage of Modernism that was first set out in Pevsner's *Pioneers*. The concerns of those who have labored to rediscover designers such as Christopher Dresser were similar. It is also noticeable that such histories are in many cases inspired as much by the decorative and visual qualities of the objects themselves as by the desire to explore the conditions that gave rise to these objects. Therefore, both works and histories can be considered as celebrations of a slightly different set of values, even if they are read as proto-Modernist.

Are these then decorative histories? Probably not. Although they arise in many cases from an esthetic or stylistic impulse or from a concern with the complex ethics of arts and crafts designing, their general development is toward an increasing examination of the social conditions in which this work was produced and its connection to theories of life and human relations.[37] There is also a move toward more detailed explorations of the design and craft processes involved. On both counts, this history sharply separates itself from much decorative history and identifies with the approaches described in the third and fourth categories.

See, for example, the shifts of focus from Gillian Naylor, *Arts and Crafts Movement* (London: Studio Vista, 1971), to Lionel Lambourne, *Utopian Craftsmen: The Arts and Crafts Movement from the Cotswolds to Chicago* (London: Astragal Books, 1980).

2. A focus on Modernism. The fascination with William Morris and Arts and Crafts values is almost a Pevsnerian trademark. Later studies of Modernism, beginning with Banham's 1960 revisions on architectural history in *Theory and Design in the First Machine Age*, have stressed the period after 1900, the less immediately central aspects of the European avant-garde (Italy, Expressionism, De Stijl), and technology (electricity and building services). Important, too, is the question of housing. In British design history, study of these areas and the attempted integration of architecture and design into a single history of Modernism has been greatly stimulated by

the work of Tim Benton. He and his Open University course team have developed what must be the single most important work of design history to have emerged in Britain; that is, the Open University's third-level course on the history of modern architecture and design from 1890 to 1939. It is a remarkable piece of work, consisting of twenty-four course units organized in sixteen course books and covering most aspects of Modernist history between Art Nouveau and the onset of World War II. Because the Open University teaches through radio and television, each course unit has accompanying radio-vision or television programs.[38] Considerable emphasis is placed on working from primary sources. The course is therefore much more than a rehash of existing theories and histories of Modernism.[39] In fact, it attempts a massive broadening of that history, although critics have not yet recognized this. In the process, the course raises extremely important questions vis-a-vis the relations of design to architectural history and the relation of the history of design to the history of Modernism.

The course originated in 1972 as a major effort of the History of Art Department and was planned from the beginning to cover architecture and design in roughly equal proportions. The selected topic, effectively the rise of modern architecture and design in the first half of the twentieth century, continued the strong interest already evidenced in architectural history, but also emphasized design as a necessary and, theoretically at least, equal element. However, as far as architecture was concerned, the course could form a critical re-assessment of Modernist history, but with respect to design, the date of the original preparatory work for the course (1972) alone indicates that in its new research it *preceded* the main rise in design history. In that case, it is hardly surprising that architecture supplies the thread; design is considered, almost by necessity, as an extension of architecture. For example, the major "heroes" of the course are architect-designers such as Henry Van de Velde, Mart Stam, and Gerrit Rietveld. In that sense and in its general concentration on the development of the work of individual designers across their careers and across a range of conditions, it follows and also modifies the Pevsnerian tradition. Pevsnerian also is the emphasis on stylistic analysis. However, the course departs from the straightjackets of Modernist histories. The introduction contains a design case study on Norman Bel Geddes, and the course includes units on British design and the electric home, the garden cities movement, and mechanical services. Organizing the course made evident at least two of the problems of doing design history. Although the primary research (for example, into the archives of Heals, the London furniture store) disclosed archives and materials from which a design history could be developed, this abundance of potential material also disclosed the lack of a conceptual framework within which to make sense of it all. Unlike design, architecture has well-developed schemes of interpretation. Much of the history of

38) One of the most interesting developments offered by the Open University courses is the use of video and television to illuminate architecture in particular. The possibilities of this in relation to design history ought to be a subject of investigation. What other subject could benefit from video more than design history?

39) Although, in Italy, the course was taken very seriously. It was exhibited as part of the 1976 Venice Biennale. Six of the programs were shown on main-channel Italian television, attracting an audience of approximately 300,000 and considerable critical debate. (Information provided by Tim Benton.)

architecture is concerned with the understanding of the building itself. By analyzing the building through plans, site photographs (often taken by the researcher himself) and building documentation, the wider import of the design solution is perceived. In design history, this is much more difficult to do. The kind of information (for example, detailed scale drawings) on which so much architectural history is based is often lacking in design. Where drawings do exist, the lack of systematic conventions for interpretation renders them much more difficult to use than conventionalized architectural drawings.[40]

From a conversation with Tim Benton, Summer 1983.

But there is a second problem. Information is relevant in terms of what things are. If nothing else, the *tradition* of architecture establishes a certain role for buildings and the built environment. What do designed objects or images stand for? Are they also cultural icons or indexes of a complex process of production and consumption of commodities? How are they to be understood if we cannot define what they are? For Pevsner this was not a problem. In *Pioneers*, a smooth and easy elision exists between artifacts and architecture. (The plethora of architect-designers in the twentieth century seems to bear out Pevsner's approach.) The incorporation of design into the course was not so easily achieved. Its adoption threatened to disrupt the coherence of the Modernist history. Tim Benton's opinion now is that much of what was separated from the main historical-Modernist stream, for example, the electric home unit, should have been more fully integrated into the main historical scheme, even though this would have made the "heroic" Modernist history much more complex and equivocal.[41] The problems of trying to integrate very diverse phenomena into a narrative history that until that point had established a wonderful simplicity prevented this from happening.

From a conversation with Tim Benton, Summer 1983.

This point implies that the history of Modernism, which had been primarily an architectural history, cannot remain unaltered by the incorporation of the history of design. This leads to the development of a more complex and rounded Modernist history. The ideological and esthetic or theoretical history as an avant-garde phenomenon is united with a broader history of social and industrial developments. In addition, the focus shifts from Modernism per se to the unraveling of its *meaning* and *function* in the present phase of capitalist development. This is accomplished by combining the self-conscious Modernist developments with the more anonymous developments in technique, industrial production, and consumerism.

In practice this has begun to happen, first, with the emerging interest in the period since 1945, but more notably in the attention being given to American design. A contradiction lurking in Pevsner's *Pioneers* was the advocacy of design for the machine and, hence, for mass design, combined with an abhorrence of the realities of mass designing in the modern world. As a counterpoint to

Pevsner's history and European work in general, Penny Sparke in Britain and Jeffrey Meikle and Arthur Pulos in the United States are asserting the validity of American design contributions, particularly the American system of manufactures and the development of professional design consultants in the 1930s.[42]

These histories constitute more than patriotic flag waving. They are highly relevant to the debate over Modernism, because they challenge the notion of what it is to be modern. For Pevsner this meant to have a self-conscious awareness of design's social role and its progression toward a rational universalism. Indeed, one was modern to the extent that one was aware of the significance of design *as an ideal*. For Americans, to be modern in the esthetic or design theoretical sense is acceptable, but of more import is to be modern in the economic and technological sense, to be in tune with the most progressive developments of American capitalism. Pevsner, on the other hand, would have the social possibilities of technology and rationalism freed from the limitations and distorting mechanisms of the market.

If the modern is to be defined in this new way, then the study of it requires a new orientation. The focus must shift away from Modernism in the European sense, as it does in the studies referred to above. Attention must turn to issues of design organization, and to the relation of design to the wider manufacturing and consuming process, as well as to economics for evidence that can account for these kinds of design developments. Once the designer is considered to be working in society at large rather than within the milieu of the avant-garde, then the arena of investigation must shift from institutional study to the question of the design profession itself. Questions of "its formation, its function, and the legal and structural limitations upon it" then become central.[43]

3. A focus on issues of design organization. The third area of work in recent history is design organization. "Proper" design history begins with such issues because no matter how diverse the subject, design organization deals with the changed situation of designing in the industrial world. If there is a clear thread at all discernible in the history of design in industrial societies, it is that design in the process of production has become separated from the act of making and, therefore, has increasingly become a process of conceiving rather than realizing form. Whereas it was once sufficient to link the precise evolution of a craft-designed object to a particular socio-technical complex (for example, the workshop and its context as described in George Sturt's autobiographical study *The Wheelwright's Shop*)[44] and then more precisely to the close interaction of material, process, hand-skill, and adaptable patterns and conventions that between them actually realized the object in industrial production, this is no longer possible. Simple coherence is "fragmented, and the complexity of conception and making is exposed by its subdivision

42) The works of Pulos and Sparke have already been mentioned. Meikle's work is *Twentieth Century Limited: Industrial Design in America, 1925-1939* (Philadelphia: Temple University Press, 1979). The subject is now a highly fashionable one for design historians. However, concentration on the most overt designers (Loewy and so forth) is likely to distort considerably the wider understanding of the commercial role of design in the United States in the 1930s and its relation to the U.S. economy and society.

43) Jonathan Woodham, *The Industrial Designer and the Public* (London: Pembridge Press, 1983).

44) George Sturt, *The Wheelwright's Shop* (Cambridge: Cambridge University Press, 1923).

CLIVE DILNOT

John Heskett, *Industrial Design* (London: Thames and Hudson, 1980), 7.

Penny Sparke, "Design History: Fad or Function? Some Afterthoughts," *Design History Society Newsletter* 3 (December 1978).

into a series of specialized activities. These processes are interlinked, but in relationships often remote and impersonal,"[45] having to do not only with design questions, but also increasingly with those of company corporate policy and political or legal matters. Hence history needs to explore this arena and Penny Sparke's argument arises: "If there is a nucleus at the center of the design history complex, then this approximates to it, providing essential material for any wider historical discussion of design."[46]

In practice, design organization is the core concern of works as chronologically and methodologically diverse as John Heskett's *Industrial Design*, Jonathan Woodham's *The Industrial Designer and the Public*, and Penny Sparke's *Consultant Design*. Justification exists for the argument that this is the core that provides essential material for other studies. Natural extensions of this relation lead either to technological and industrial histories, to institutional studies, or to studies of the consumer or the design purchasing and design-affected public. In specific cases, design organization is also a subject that social and economic historians have become interested in, unsurprisingly as it is quintessentially a socioeconomic relationship that is *relatively* unmediated by design esthetics or design theoretical issues.

The intervention of socioeconomic historians into design history should serve as a reminder that although Penny Sparke's argument contains an important truth, it also contains the possibility of distorting the relationships involved in designing. The conditions surrounding the emergence of a designed object or a particular kind of designing involve complex social relations. The fact that these relations are frequently described *only* in design terms obscures their social or socioeconomic aspects. To what extent, then, does the design organizational approach limit the explanations of designed phenomena to what can be explained from within design?

The problem was summed up by Jon Bird in an early paper for the Design History Society: "To separate the history, criticism, and evaluation of cultural objects from the total social, cultural, and economic conditions of the society that contains them is to isolate a set of factors present in the designed object — factors that can broadly be categorized as esthetic — while simultaneously ignoring the fact [that] the designer is a member of a social group and thus comes under specific social and economic conditions, shares certain values and beliefs, and, in the widest sense of the term, represents in his or her work an ideological position. No designer working today can, if he bothers to think about it, maintain a professional attitude that does not at some point become contiguous with one or more aspects of the economic and political basis of Western capitalism. Even the most extreme conceptualist deals in "commodities" that possess an exchange value. Thus, the products of the designer as either enforcing commodity fetishism, or, as in the case of people like Papanek, opposing capitalist production techniques with

47) Jon Bird, "Art and Design as a Sign System," in *Leisure in the Twentieth Century* (London: Design Council, 1978), 86-91.

methods superficially more sympathetic to specific cultural contexts, are all expressing an ideology that should be the critic's or historian's function to uncover, so far as it is possible, through analysis of the object as a cultural fact in a complex series of interrelated meanings and significations."[47]

Bird argues that the immediate context of design production or reception is not a wide enough perspective from which to understand design. Although emphasis on this context might disclose why a particular design rather than another came into being, concentrating on this issue alone prevents understanding of the wider context of meaning and production and of the role and functioning of design in Western capitalism. Furthermore, if objects and images as the forms of design and its practice are aspects of capitalism, then design loses its neutrality. Bird would argue that it is difficult to deal just with design and far more necessary to examine critically the ideological role that design and designers perform. However, the concepts and the practices of design cannot be accepted without criticism. The issue, then, is not beginning with "design" and working from there, but "bracketing out" major concepts. For example, rather than accepting design as a given, an attempt is made instead to understand how and why design has developed and whose interests it serves. Bird argues that only from this perspective can the complex functions of design be understood.

4. A focus on the social relations of various kinds of design. The fourth area of work has assumed Bird's essential points and is a natural outgrowth of the focus on issues of design organization. The more design and designing are studied, the more important a broad context becomes. The distinction among the four areas is more on the degree to which context is viewed as a tool for critical examination of concepts and practices than on the question of context per se. John Heskett's book *Industrial Design* deals with both the organizational and social strands of history writing, but his work on Germany, although emphasizing visual and organizational factors equally, is more critical in orientation. In particular, Heskett has shattered the myth of a symbiotic relationship between good design and democratic social formations. Through detailed research he has shown that equating good design only with the Bauhaus, the Weimar Republic, and the social and industrial structure of the Federal Republic of Germany, is historically untenable, as is the identification of only bad design with the Nazis and the German Democratic Republic. By showing that the Bauhaus design ethic continued into the Nazi period in the work of Wilhelm Wagenfeld and by demonstrating that the simple equations of design values and social formations (Weimar always equals modern, progress, and the rational; Nazism always equals reaction, the *Volk*, and the irrational) are mistaken, Heskett implies the need for a fundamental re-assessment of the relation of societies to types of design practice.

CLIVE DILNOT

See John Heskett, "Modernism and Archaicism in Design in the Third Reich," *Block* 3 (1980), and "Art and Design in Nazi Germany," *History Workshop* 6 (1979).

He also asserts the need for a complex of modes, performing specific functions and responding to a particular set of circumstances rather than a single mode of designing as characterizing a period.[48]

Heskett's historical approach and Bird's more theoretical one raise the central question of design's role and functioning in industrial capitalism. This vital issue surprisingly has had little direct expression. Yet it has been touched upon implicitly in most of the histories that fall within the first three areas of design history and it has been called for repeatedly by several professionals involved in design organization. Although design's role and functioning in industrial capitalism might be the real subject matter of the books by Sparke and Woodham since this relationship fundamentally underpins the particular relations they are concerned with, neither discusses the issue in any detail.

However, design historical and analytical developments in Europe have directly confronted this issue. For example, Wolfgang Fritz Haug has developed a theory of commodity esthetics (Warenästhetik) from a Marxist perspective. By differentiating between production (identified with needs) and consumption (defined as artificially created wants) and by exploring the imagery of products and advertisements and their role in capitalist production and consumption, the theory addresses the role of design in commodity production. Gert Selle has formulated a theory of design as an expression of social relations from a comparable perspective.[49]

Gert Selle, *Ideologie und Utopie des Designs* (Köln: DuMont, 1968), and *Die Geschichte des Design s in Deutschland von 1870 bis heute* (Köln: DuMont, 1978).

Both Haug's and Selle's work relate to the more general social and political aspects of art, architecture and design as manifested through the collective work of the Ulmer Verein für Kunstwissenschaft, the left-wing West German association of art and architectural historians that has been stimulating and focusing work on the sociopolitical aspects of architecture and design. This group sees the forms of art, architecture, and design as being produced within capitalism, but conversely playing a significant ideological role in capitalist culture. This group's work is directly comparable to work being produced in East Germany. In *Das Bauhaus in Weimar*, Karl-Heinz Hüter has written a detailed study of the specific economic and political conditions in Weimar and Thuringia in the early 1920s and their relation to the Bauhaus. British and American scholars are used to attacks on the left-wing or totalitarian aspects of functionalism but Hüter and Lothar Kühne reject this view, contending that the Bauhaus and 1920s Modernism are products of a phase of the capitalist economy. Kühne argues for what he regards as a genuine functionalism in *Gegenstand und Raum, (Objects and Space)* a discussion of the esthetics of architecture and practical everyday objects. Based on a detailed examination of the relation between forms of work and property relations and the design of esthetic and technical objects, he sees objects as necessarily integrated into changing social, technical, and property relations. He also emphatically rejects the determination of form by

monetary relations, as in capitalism, instead preferring a design practice based on real needs.

The issue of real needs has come under scrutiny in the more critical French tradition. The sociologist Jean Baudrillard has been interested in objects and their place in capitalist structures for a long time. Continuing the semiotic perspective, Baudrillard makes an incisive analysis of design's socioeconomic role in late capitalism and adopts a cultural approach in his attempt to break with some of the illusions of functionalism. Baudrillard's drawback is that his jargon-ridden prose is not always clear and his critique is not as grounded in history as it might be.[50]

Italian design history perhaps is even more cultural than social. Related to the dominance of high-level quasi-Marxist architectural history and criticism, design history and criticism in Italy attempt to grasp the difficult connection of designed material to sociocultural forms and relations. This approach is the thrust of the highly developed, theoretical essays in two exhibition catalogs: *Italy: The New Domestic Landscape*,[51] and *Italian Re-evolution: Design in Italian Society in the Eighties*.[52] The position is made abundantly clear in the editorial foreword to *Album*, the recent design annual edited by Mario Bellini: "If 'design' means the planning of everything connected to our built physical environment, it would be sufficient to start from this banal statement (linguistically obvious, but historically still controversial) to produce a magazine that had not yet perhaps been produced. Industrial production exists, for example, of cutlery or tables; with the discipline of Industrial Design, its related schools, profession, and industrial design journals. Interiors exist, for example dining rooms, the discipline of Interior Design, the interior designer's profession and the related schools, magazines, etc. But when we eat, work in the office, or travel by car, are we the 'inhabitants' of an architecture, are we 'users' of equipment and furniture, or are we 'characters' on a stage set for us? Or are we not, rather, the participants in a rite that has its places, its tools, its furnishings and vestments, in short, its complex culture."[53]

The emphasis on cultural aspects of design meaning, which is the real thrust of these essays, rather than design production or reception, connects Italian work to some of the new English design history, which falls on the axis between the Birmingham Center for Contemporary Cultural Studies and a group at Middlesex Polytechnic that produces the journal *Block* and runs one of the two main British Master of Arts courses in design history. The primary emphasis of this work is the study of representations, which owes its origins to the semiotic cultural criticism pioneered by Roland Barthes.

Semiotics has made considerable inroads into British and American cultural studies in fields such as literary and film criticism. In its developed forms, it is very important in media and photographic

50) Jean Baudrillard, *For a Critique of the Political Economy of the Sign* (St. Louis: Telos Press, 1981), especially chapters 1, 3, 7, and 10.

51) Emilio Ambasz, editor, *Italy: The New Domestic Landscape* (New York: Museum of Modern Art, 1972).

52) Piero Sartogo, editor, *Italian Re-Evolution: Design in Italian Society in the Eighties* (La Jolla, CA: La Jolla Museum of Contemporary Art, 1982).

53) Mario Bellini, editor, *Album 1* (Milan: Electa, 1982).

CLIVE DILNOT

image analysis. However, the thrust of the Middlesex-Birmingham work (by Lisa Tickner, Jon Bird, John Walker, Tony Fry, Phil Goodall, and Dick Hebdige) has been to use a variety of sophisticated theoretical approaches to move away from the analysis of purely graphic imagery toward analysis of material and popular culture. This shift has brought them into the field of design history. Dick Hebdige, beginning with his work on subcultures, has increasingly moved toward the study of their material elements. In a series of essays in *Block*, he has explored such issues as popular taste between 1935 and 1962,[54] the significance of the motor scooter in the style and life-style of the "Mods,"[55] and Pop style.[56] These essays have been written from the important perspective that "social relations and processes are then appropriated by individuals only through the forms in which they are represented to those individuals."[57] By forms he means designed material forms, as well as forms of ideas and ideologies.

Phil Goodall has analyzed the role of design in determining gender relations in a similar way, and Tony Fry, with a background as a cultural theorist and professional designer, has written sharp critiques of design history[58] and a very detailed case-study analysis of the Olivetti Lexicon 80 typewriter, which is considered as "a designed commodity formed at the fusion of three design object areas . . . product as form, product as representation, and typewriter as commodified labor process . . . (the whole) addressed in the economic and cultural setting of corporate capitalism."[59]

This approach is as much analytic as historical for the very good reason that to grasp the effects of designing or the possible efficacy of a designed object or image, it is necessary to understand rather than take for granted what designing as an activity is and what it achieves. However, the understanding is necessarily formal, as well. There is an interesting relationship between the asking of the question why (for example, why does this image exist, and why is a particular designed object famous?) and the immediate necessity to answer it partly by means of a functional and contextual analysis and partly by uncovering the objects or the images own workings.

The analysis of objects or images understood as cultural icons was Barthes's method in *Mythologies* and in his later studies. John Walker has undertaken an excellent analysis of the London Underground Map, which has potentially wide applicability. In a model of an analytical approach to understanding designed phenomena, Walker historically locates the emergence of the map within the context of the expansion and modernization of London transportation, explains the complex of functions that the map was intended to fill and those that it currently fills, and relates visual form and organization to the range of functions it performs by tabulating its visual elements.

The virtue of Walker's method of analysis is that it demystifies design and designing. It therefore stands at the opposite pole from

Dick Hebdige, "Towards a Cartography of Taste, 1935-1962," *Block* 4 (1981): 39-56.

Dick Hebdige, "Object as Image: The Italian Scooter Cycle," *Block* 5 (1981): 44-64.

Dick Hebdige, "In Poor Taste," *Block* 8 (1983): 54-68.

Hebdige, *Subculture*, 13.

Fry, "Design History: A Debate?" 14-18. See also his review of J. Meikle's *Twentieth Century Limited*, in *Radical Science Journal* 10 (1980): 182-85.

Tony Fry, "Unpacking the Typewriter," *Block* 7 (1982): 36-47.

John Walker, "The London Transport Diagram," *Icographic* 9/10 (1979).

the work previously mentioned in this article that increases the mystique of design and designer. The effect of the approach mentioned earlier is to marginalize design; design becomes a special activity applied only to certain phenomena. The effect of Walker's approach is to recover design as a process comprehensible by all because it is related to experiences everyone undertakes. Whereas the earlier approach exalts design as a creative activity undertaken only by magnificently talented individuals, but denies that design has wider social efficacy or ideological import, Walker reverses this proposition, too. Design, he suggests, is fundamentally an ordinary activity.

In a study of a photograph taken by Margaret Bourke-White, Walker shows the extent to which the photograph is given meaning by the potential "contents" embodied in its organization by the photographer's actions.[61] However, he also shows that this is done in the context of the editorial process in which that particular photograph was selected and not a related one by the same photographer. This kind of work leads to an increased appreciation of the power of designed images, objects, and buildings to express and determine behavioral roles. *Express, determine,* and *behavioral* are all inadequate terms. They are the continuing legacy of theoretical traditions that analytically and socially oriented histories are still struggling against.

Dick Hebdige's work, particularly *Subculture: The Meaning of Style,* deals marginally with conventional design history, but is at the center of the relation of material culture, images, and forms of representation to social relations and processes. So, too, is the emerging feminist analysis of design. The feminist analysis is particularly important to architectural history and criticism, especially in the United States, and to the analysis of images in the mass media, ranging from the study of cosmetics packaging to visual pornography. In addition, feminist design history possesses the supreme virtue of refusing the distinction between design and social life that characterizes so much design thinking, practice, and historical work. Purists who reject feminist design history on the grounds that it is insufficiently concerned with design are ignoring one of its important aspects. It is precisely the feminist analysis that relates the design of things intimately and concretely to the ways in which objects and images affect us. This should not be surprising; after all, it is the place in people's lives that design in general would claim for itself.

Acknowledgments: The following persons provided assistance in the preparation of this article. John Heskett provided information on developments in German design history and critiqued an early draft of the article, and Tim Benton, Pat Kirkham, Pauline Madge, and Victor Margolin provided assistance on specific points.

61) John Walker, "Teaching Art History," *Block* 1 (1979): 2-7.

Clive Dilnot

"*Any criticism, to do more than whining, must make a diagnosis.*"
Manfredo Tafuri,
Theories and History
of Architecture, 1980

1) Clive Dilnot, "The State of Design History, part I: Mapping the Field," *Design Issues* I (Spring, 1984): 4-23.
2) According to Stephen Bayley (*In Good Shape* [London: Design Council, 1979]), it is the art form of the twentieth century. For Victor Papanek, it is the "conscious effort to impose meaningful order." (*Design for the Real World* [London: Paladin, 1974], 17.) For Terrence Conran, the founder of the Habitat range of stores in Britain and now chairman of the Habitat-Mothercare group, design has proved to be the key to an immensely profitable business. What bedevils design discussion is that we pretend that the differences do not exist. The fact that each definition or aspect slides inextricably into the next obscures for us the need to clarify both the real level of unity between these various meanings and realities of design, if indeed one exists, and the sharp differences in reality between the design practices founded on each of these views as well as the conceptions of "what design is" contained within them.
3) Dilnot, "State of Design History," 7.
4) This strategy has enormous advantages for designers. It immediately reduces design as a whole to what they are doing at any moment in time. It is less useful for the designer's public who may well need a different kind of design to serve its requirements. The self-interest of designers then should not be allowed to curtail definitions or articulations of different forms of designing.
5) The history of the use of the word "design" in advertising, paralleling a history of the rise of the concept "good design," would be extremely revealing. It would show, first, the way that "design" has become more and more a value in its own right over the last fifty years, and second, the functions, particularly the complex symbolic functions, of design in advanced capitalist societies. On some of

The State of Design History

PART II: PROBLEMS AND POSSIBILITIES

Problems of Design History

Four problems are crucial in the movement toward creating a discipline of the history of design. First, it is clear from the survey of recent work in design history discussed in part one of this paper[1] that design historians as a whole have at best an incomplete grasp of their would-be subject matter. This situation is not wholly surprising, inasmuch as *design* has acquired several different, often seemingly contradictory, meanings and associations because of its refraction through the still incompletely charted and understood industrial, economic, and cultural developments of the past 200 years.[2] Design not only suffers from a general unwillingness of the culture to grant it the status of an activity worth studying and defining[3] — an unwillingness shared by design practitioners who want design defined merely in terms of what designers do[4] — but also from a fundamental ambiguity that the concept of design possesses. It is not clear whether the term refers to a process (the act of designing), to the results of that activity (designed objects and images), or to a value ("Design," as in the current advertising slogan in the United Kingdom, "Miles better by Design," or as in the notion of "good design").[5] That this ambiguity extends beyond thinking about design into design institutions is shown in organizations such as the British Design Council and more generally in design education. In neither case is it clear what is being promoted or taught: in both cases, and, indeed, professionally, too, design seems to be an uneasy mélange of all three meanings. The third element, design as value, is both the least acknowledged and the least defined, and yet is the one used to identify professional design and to differentiate *Design* (capitalized noun, referring to the professional versions of designing and to specific professionals or classes of objects and images) from *design* (lower case, a verb, referring to the general activity of designing, shaping, forming, or organizing things, images, or systems, whether by professionals or not).[6]

For design historians, this ambiguity manifests itself in a number of ways. The different meanings of the word *design*, themselves reflecting the development of different specialist design activities within industrial societies, have given rise to a consider-

233

these issues, see Jean Baudrillard, *For a Critique of the Political Economy of the Sign* (St. Louis: Telos Press, 1981), especially chapters 1, 3, 7, and 10.

6) For a further discussion of the issues involved here, see the useful little essay by Noel Lundgren, "Transportation and Personal Mobility," in *Leisure in the Twentieth Century* (London: Design Council, 1978), 20-23.

7) This was essentially the theme that arose from the survey of work discussed in part I of this paper. Though it can be argued that design history needs concentration rather than diversification (and disintegration?), the tendency seems to be towards the latter, with groups of historians increasingly speaking only to each other or communicating through journals with self-elected readerships. The danger here is that a fragmented coexistence inhibits real debate. Nevertheless it does seem at the moment that to talk about design history in the singular is mystificatory. I, for one, am not at all sure that a single indentifiable "design history" exists.

8) How much might a comparative study of these fields reveal to us about "mainstream" Art and Design school design? This is Noel Lundgren's point in "Transportation and Personal Mobility": "It would assist the development of a truly comprehensive design history industry to realise that, in the twentieth century, design activity has so much more to do with sustained service, an anonymously mechanical day-in, day-out solving of problems, than with the constant ferment of creative choices exercised by the lone hero-artist."

9) Necdet Teymur, "The Materiality of Design," *Block* 5 (1981): 19. There is, I agree, an apparent contradiction in this paragraph. What it tries to express is *both* the fragmentation of the subject and yet its unity around an ill-defined and almost mythical entity, "design." *Both* the fragmentation and the unity exist.

10) Teymur, "Materiality," 19.

11) This point is illustrated in almost every major design exhibition, and by all those books on design constructed on a comparable basis. As an example, see Bayley, *In Good Shape.*

12) A useful survey of these issues is in Raymond Williams, "Marxism, Structuralism and Literary Analysis," *New*

able range of design histories. On one level, it is more accurate to talk about varieties of design history rather than to see the subject as a single entity.[7] On another level, design histories have followed the same division of labor that has occurred within design practice. Thus, there is the sharp differentiation between professional design activity that self-consciously concerns itself with Design as a value; with esthetic criteria in some way, shape, or form; and with all other kinds of design activity, for example, nonesthetically motivated service, engineering, or problemsolving design and nonprofessional designing.[8] There is also a grouping of histories around the major professional fields: industrial design, graphic design, and so forth. These groups are found in the disciplines in art and design schools. In dealing with post-1945 work, in particular, they are separated from architecture, just as architectural education is so often separated, at least in Britain, from other art and design education. However, this does not mean that we see a multiplicity of histories of design *activity* or a sense of these histories exploring the *different* usages of the generic term *design*. On the contrary, distinguishing among the various professional fields is virtually the only *conceptual* differentiation that the varieties of design history make. Underlying this there is assumed to be a unifying sense of what design is, although it is not satisfactorily articulated. Unfortunately, by assuming the existence of this entity, the real multiplicity of design practice is not explored.

Necdet Teymur has argued, "by failing to distinguish the multiple content of the term 'design' . . . (and) by dumping the whole sets [sic] of distinct activities and action under one 'act,'"[9] design history only further obscures the immensely complex and varied division of labor at the basis of the design activity. A surface variety then obscures a real variety of activity and processes.

This failure has two effects. First, in glossing over what design is materially ("a noun and a verb, and also one that denotes a form of representation, an activity, a practice, a product, etc., etc., at one and the same time"),[10] the potential understanding of design, and, hence, what designed objects *are* and what designers *do* is made much more difficult, if not impossible. If it is taken as self-evident that design is a good thing, that the values of design are transparently embodied in the form of products in such a way that we do not need to articulate them, but merely illustrate the objects, then we can rapidly produce a canonical history of "good design," but we do *not* in the process produce a conscious understanding of "design."[11]

This point is of utmost importance. At Cambridge in the 1930s, I. A. Richards showed, in his famous experiments in practical criticism, that the most highly trained students of English literature could be *taught* what the canon of literature consisted of, but they could not *produce for themselves* its implicit variations.[12] These findings produced a minor crisis within the study of literature and led almost directly to the domination of criticism in literary

CLIVE DILNOT

Left Review 133 (January/February, 1984): 51-66. See also Terry Eagleton, *Literary Theory* (Oxford: Basil Blackwell, 1983), especially the introduction and chapter 1.

13) Williams, "Marxism," 53.

14) Williams describes the restriction in these terms: "So you have in sequence, first, a restriction to printed texts, then a narrowing to what are called 'imaginative' works, and then finally a circumspection to a critically established minority of 'canonical' texts. (page 53). Does the parallel to design history hold?

15) Certainly there is no historically informed design criticism. Unlike architecture, which takes both criticism and history seriously, design criticism is usually merely journalistic in scope. This may have more than a little to do with the transitory nature of most design activity (as against that of architecture, for example). As Manfredo Tafuri has asked: "What is the significance, for the artistic object, of the loss of its traditional value as a thing subject to aging, of its renunciation to a life time analogous to that of a man, to an intrinsic, meaningful historicity? Obviously an object without historic value lives only in the present. And the present, with its contingent and transient laws, completely dominates its life cycle: the rapid consumability of the object is built-in from the very first stage of planning." *Theories and History of Architecture* (London: Granada, 1980), 40.

16) The parallel is the histories of modern architecture which are always composed in terms of the modern "masters." Compare Charles Jencks's *Modern Movements in Architecture* (London: Penguin, 1973), or Kenneth Frampton's *Modern Architecture: A Critical History* (London: Thames and Hudson, 1980). The difference is the level of discussion of what makes the "masters" of modern architecture significant. To say this is not in any sense to justify this form of history which is, to say the least, seriously distorting of the real relations of architecture *as a whole* in the modern period. But it is to commend the much higher level of critical and evaluative discussion.

17) Teymur, "Materiality of Design," 19.

18) See John Walker, "The Value of a General Model of the Production, Distribution and Consumption of Artistic Signs for the Study of Art History," *Block* 9 (1963): 73-76.

studies. Literature came to be redefined in terms of literary values, and the study of literature came to be circumscribed to a critically established minority of canonical texts. This development had three consequences: first, it concealed the "element of *writing*, the linguistic composition of facts and arguments in the excluded areas";[13] second, it tended to remove from view both the history of texts themselves and the historical processes whereby the canon of English literature is not given but produced; and third, it reduced all the texts within the canon and all the diverse strands of writing actually existing, even within the restricted forms of writing now studied by literature departments,[14] to a single literary identity (even a national identity in the case of *English* literature).

True, the parallel with literary studies should not be taken too far. At present, there is no real discipline of design criticism,[15] but a canonical list of "important" designs and designers *is* rapidly being established, despite that the critical arguments for their inclusion in such a list remain almost unstated. We *are* seeing this sharp differentiation into "important" and "unimportant" design works, which is tending to exclude the unimportant works from the definition of *design* and to restrict the material we actually discuss. Therefore, the history of design in this sense is approaching a recitation of such "important" works, with the consequences that the historical processes that gave rise to them are gradually disappearing. The values that the "important" works possess are increasingly being tacitly accepted as lying outside the realm of history.[16]

Most important, the whole process tends to obscure, rather than to illuminate, the design process. Thus, the second effect of failing to distinguish the "multiple content of design," as Necdet Teymur put it, is the paradox of removing both history and design from design history![17] There is a parallel here with art history. As John Walker recently pointed out, art history long ago ceased characterizing art; its real function now is that of constructing a *particular tradition or way of looking at art* — the Great European Tradition of Oil Painting and the critical concepts associated with this tradition. In this sense, art history has as its object of study not art, but the history of art, and, strictly speaking, its production is not that of one history of art but different versions and varieties of this tradition.[18]

This parallel is uncomfortably close to design history as it is currently emerging. Are the histories being produced today genuine explorations of the history of a field or are they retrospective constructions of a tradition; that is, lineage studies whose aim it has been to extend present trends in design practice back into history, to claim history for the present? Such a motivation has produced important works; for example, Nikolaus Pevsner's *Pioneers of Modern Design* falls in this category. However, the parallel with art history is disturbing for two reasons. First, it indicates how quickly the subject of design history has renounced the ambition

of using history to *understand* design (in narratively oriented tradition-building history, the subject is *always* assumed; the historian is concerned with getting the story straight, with "telling it like it was"). Second, it illustrates another paradoxical relationship. Just as, collectively, as a culture, we are beginning to become more and more aware of design, we are simultaneously less and less intellectually conscious of it as anything but design. We have forgotten that design as a practice and as it is embodied in objects and images functions, works, and has effects in many different ways (economic functions, social effects, cultural implications), most of which lie outside the concept *Design*. And, just as there is an increasing hiatus between professional design values and social requirements, there is also an increasing gap between what the word *Design* evokes for those involved in design practice or design education and what designed objects and images actually do. In professional design practice and design education, and now possibly in design history, a mystique of design, an almost mythic and artificial set of largely esthetic values, is being created. In history, this development has the very real possibility of turning the writing of history into the writing of myth.

Contemporary myth, in this sense, is defined by Roland Barthes as "that which is charged with the task of giving an historical intention a natural justification, and making contingency appear eternal."[19] This means that the ideology of the modern capitalist West requires the naturalization of the processes and structures that characterize it. Capitalism, said Barthes, is always trying to prove that there are no alternatives. It seeks to turn what are really historical developments, which are always open to change, into natural occurrences. Myth is one mechanism of making this seem to happen. "What the world supplies to myth is an historical reality . . . what myth gives in return is a *natural* image of this reality."[20]

How does myth work? Barthes lists seven major features. First, myth is constituted primarily by "the loss of the historical quality of things: in it things lose the memory that they once were made."[21] Second, myth compensates for this loss of history by "abolishing the complexity of human acts." It gives things "the simplicity of essences."[22] Hence, third, it builds a harmonious world by organizing a world without contradictions . . . "without depth, a world wide open *and wallowing in the evident*" (emphasis added).[23] Fourth, myth "does not deny things . . . (rather) it purifies them . . . makes them innocent . . . gives them a clarity which is *not an explanation* but that of *a statement of fact*" (emphasis added).[24] Fifth, myth thus "gives (things) a natural and eternal justification."[25] Sixth, it achieves this by making "things appear to mean something by themselves."[26] Hence, seventh, if we "understand *political* in its deeper meaning, as describing the whole of human relations in their real social structure, in their power of making the world,"[27] then *myth is depoliticized speech* where the *de-* prefix has an active value representing the opera-

19) Roland Barthes, *Mythologies* (New York: Hill and Wang, 1972), 142.

20) Barthes, *Mythologies*, 142.

21) Barthes, *Mythologies*, 142. In relation to design history, where and when did design *as we now understand it* emerge? Stephen Bayley (*In Good Shape*) has it magically and unproblematically appearing in 1900. In the standard (mythic?) histories we tend to begin with the design *reformers* of the 1840s and 1850s. But do we yet have an adequate study of the "design" process in early Victorian manufacturing?

22) Barthes, *Mythologies*, 142, 143.

23) Barthes, *Mythologies*, 143. Design in twentieth century society as a phenomenon beset precisely by those contradictions and conflicts that distinguish society as a whole (for example the conflict between the role of design in corporate management, as against the role of design in serving social needs) seems to embarrass most design historians. It is notice-

able that Papanek's strictures on the profession of industrial design have not yet been taken up in a genuinely *critical* history of the profession. On the deficiencies of taking the evident "common sense" as what actually *is*, see Zygmunt Bauman, *Towards a Critical Sociology* (London: Routledge & Kegan Paul, 1976).

24) Barthes, *Mythologies*, 143. Barthes goes on to say: "If I *state the fact* . . . without explaining it, I am very near to finding that it is natural and *goes without saying*: I am *reassured*." (Emphasis added).

25) Barthes, *Mythologies*, 143.

26) Barthes, *Mythologies*, 143. As pointed out above, one characteristic of the rise of the design professions has been a consequent rise of *Design* values; design is now valued less for what it *does* (the service acts it performs) than for what it *is* (self-evidently a good thing). But the values that are proposed for design have less and less to do with the world outside of itself.

27) Barthes, *Mythologies*, 143.

28) This becomes acutely visible, both in history and in design practice, when we consider the conceptual separation of design from social affairs, summed up in the phrase we so commonly use, design *and* society, rather than, as it should be, design *in* society. There is a parallel in the separation design thinking makes between design activities and social ones. Thus design sociology does not exist, nor does an adequate social history of design, notwithstanding frequent statements to the contrary. Despite the work and attitudes listed in part I of this paper ("State of Design History," 19-23), these are still essentially marginal to much orthodox design history. As Jonathan Woodham has argued: "Design historians have frequently stated how closely their discipline is integrally linked to factors of a social, political, economic and technological nature. However, what seems to be demonstrably lacking in many exhibitions and publications, particularly those concerning the modern period, is any strong evidence to support such an outlook. The dominating ideology appears to centre on the notion of the individual genius who created designed objects with some unique aesthetic status, or, alternatively, that design is the preserve of that section of the community which possesses the adequate financial resources to indulge in it." "Editorial," *Design History Society Newsletter* 6 (1980): 1.

29) Teymur, "Materiality of Design," 19.

30) Roger Newport, "Design History: Process or Product?" in *Design History: Fad or Function?* (London: Design Council, 1980), 89.

tional moment, the sense of removing from things their contingent, historical quality and, in particular, their social origins and efficacy.

How is myth manifested in design history? Most obviously by the *reduction* of its subject matter to an unproblematic, self-evident entity (Design) in a form that also reduces its historical specificity and variety to as near zero as possible. This reduction also restructures the history of design to a repetition of designers' careers and to the past as simply *anticipating* and *legitimating* the present. In the process, the vast range of designing represented in history, professional and vernacular, industrial and preindustrial, is eclipsed to a single developmental model, and the process and activity of designing is largely sundered from its social roots.[28]

This process scarcely matters if legitimation of the present is what history is about. Tacit and essentially unexplained conceptions of what design is will suffice. But, if the ambition of a history of design is to explore the historical dimensions of what design is; if its aim is to arrive at an informed understanding of design practices with all their "dimensions, agents, variables, products, and processes which exist in a sociophysical whole not free of contradictions"[29] rather than to collapse ways of designing and different varieties of design into a single model or system, then articulation of this history's subject matter is of first priority. It is also the activity that, in *refusing* the essentialism characteristic of myth, takes the first step in removing the discipline from the web of mythical discourse.

Although the distortions involved in the mythification of design seem to focus design history on purely design issues, they actually focus design history on only design *critical* issues. As early as 1977, Roger Newport, the design historian, educator, and designer, was worried about the wider implications of this development: "As this discipline stands at the moment, I am of the opinion that we are not only in danger of becoming less relevant to our core subject than successive governments have hoped, but we are in danger of enabling design historians to talk a completely different language from designers; in danger of setting *permanent precedents* for our subject which will enable criteria for criticism to specialize away from criteria for performance."[30]

Similar to English professors who criticize literature rather than write it, design historians rarely produce the goods they discuss so avidly. Even design history's critical concepts tend to refer less to the act of designing than they do to the exemplification of design ideas in significant designed objects. What Roger Newport pointed to was the effect this has on the historians' conception of what their pedagogic role and function might be. As Newport hints, historians are actually in danger of becoming alienated both from the activity and processes of designing and, because of this, from the education context in which they largely work. The fact that some teachers achieve real educational success does not negate this

31) The problem is that we are oriented above all to the stylistic results of design activity and hardly at all to the organizational mechanism of the process itself. True, there are real problems here, as Roger Newport points out. But problems such as the reluctance to "see present day design and production as part of our subject," and that of trying to bridge the informational dichotomy between "what design students do when they are designing and the sort of information they are presented with in the name of the history of design" – a dominance of details of the "art-based" design movements and "general statements about the appearance and environment of generic groups of artifacts" – should be able to be overcome. We need a major program of research and curriculum development in this area to ascertain the character of a truly viable input into studio design teaching. The quotes are from Newport, "Design History," 89.

32) There might be considerable value in a study which for once broke with the conventional link of design history to design practice, and inquired instead what possible contributions design history might make to academic issues in general. In a subject that has remained obstinately isolationist in thought and practice, a study such as this could chart, in effect, the wider import of design activity and the wider evidential quality of designed objects and images. This process would in turn throw light on the wider significance of design activity.

33) Little has thus far been done on the relationship between history in general and the history of design, though some initial reflections are contained in Raphael Samuel, "Art, Politics and Idology," *History Workshop* 6 (Autumn, 1979): 101-106. Perhaps more interesting is Steven Marcus's marvelous essay on Engels and Manchester, "Reading the Illegible," in *The Victorian City*, vol. 2, edited by H.J. Dyos and Michael Wolff (London: Routledge & Kegan Paul, 1978), 257-76. Marcus reveals Engels as a brilliant, if early, design historian! But he also reveals the potential of a method, the materialist and, in Engels's case, theoretically informed, analysis of structures. John Summerson's *Georgian London* (London: Barrie and Jenkins, 1946) is one architectural study which wholly unites general history and architectural history.

34) The work of Barthes (e.g. *Mythologies*) and Dick Hebdidge (*Subculture: The Meaning of Style* [London: Methuen, 1979]) shows some possibilities from the

point. Such achievements are made against the grain; it is uncomfortable, but true that organizing the concepts of design history does not, at present, lend itself to the sort of pedagogic work we, as design historians, should be doing. In this sense, Roger Newport's argument is only too accurate. [31]

In the wider context, the issue refers to the second major problem facing the discipline: defining what design history's roles should be and who its potential audiences are. And *who* should they be? Should design historians write for themselves or for professional designers? Or is their role principally in design education? If so, what, if any, is the relationship between historical study and studio education? Or should design history be considered as a wholly academic discipline, [32] or, perhaps, as a contribution to design studies — the historical dimension of design studies' attempts, so far profoundly ahistorical, to analytically and logically model the design process? Or is it better to think of design history as a part of history in general? But, if so, what kind of contribution should or could it make? Is it, or would it be, merely a minor, if useful, subsection of economic, social, and technological history? Or might it be a more significant contribution, a different way of reading or comprehending history? [33] In its twentieth-century guise and its more theoretically informed aspects, does not design history potentially deserve to be linked with cultural studies and the sociologies of media and culture, even with aspects of anthropology and archeology? [34] And, finally, as a history of "things seen," what might its relationship be to art and architectural history and to the histories of the decorative arts?

One answer is that the subject, at least potentially, has some function in all or approximately all of these contexts, and some contribution to make to all or approximately all of these disciplines. To say this only strengthens the necessity of articulating and defining what these roles or functions might involve. It brings into question the issue of one design history or many design histories; of what, if the latter is the case, the central core uniting these histories might be (what are the central issues of design history?), and of what a design history that is accented in this complex way might look like. Certainly, such a history would have the potential to bridge some extrordinarily interesting interdisciplinary issues. Might this then be a more profitable direction for the subject to take than concentration on an almost entirely self-referential specialist discipline of the history of design?

This leads to the third of the central problems that design historians face. Only when we have defined possible and desirable roles for design history can we set about solving the problem of constructing a *discipline* that can address itself to roles in a specific manner and that can develop the status and meaning of the subject in relation to wider academic, public, and professional issues. [35]

The question of constructing a discipline of design history is a crucial one. At present, there is no real intellectual core that

CLIVE DILNOT

side of cultural studies. The integration of cultural studies with design history has not taken place. What could design historians bring to the study of contemporary material culture? On archaeology, D.L. Clarke's *Analytical Archaeology* (London: Methuen, 1968) is an interesting theoretical account. His models of "culture systems" and the place of artifacts in them may well be useful for constructing a theory of design history.

35) For a discussion of the problems in a comparable discipline, see Eugene Ferguson, "Towards a Discipline of the History of Technology," *Technology and Culture* 15 (Spring, 1974): 15-30.

36) But as E.D. Hirsch has pointed out with respect to a similar situation in literary studies, "that manouvre will not work, for anti-theory is itself a theoretical position and a particularly vulnerable one at that." "Derrida's Axioms," *London Review of Books* 5 no. 13 (July 21-August 3, 1983): 17.

37) For an introduction to Marxist perspectives, see Robin Blackburn, editor, *Ideology in Social Science* (London: Fontana, 1972).

38) For the Annales school, see, above all, Fernand Braudel's trilogy *Civilization and Capitalism in the 15th - 18th Century*: vol. 1, *The Structures of Everyday Life*; vol. 2 *The Wheels of Commerce*; vol. 3, *The Perspective of the World* (London: Collins, 1984). See also Lucien Febvre and Henri-Jean Martin, *The Coming of the Book* (London: NLB/Verso, 1976).

39) See the work of T.J. Clark and Michael Baxandall referred to below.

40) Gareth Stedman-Jones, "History: The Poverty of Empiricism," in *Ideology in Social Science*, 97.

41) Stedman-Jones, "History," 97.

42) On capitalism's effects on production *per se*, see G. Lukács, *History and Class*

defines the subject and its aims. The first generation of design historians working in Britain in the 1970s deliberately eschewed definitions, methodological inquiry, and theoretical self-reflection on the laudable, if somewhat misplaced, grounds of keeping the fledgling subject as open and pluralistic as possible. However, what replaced these absences could only be a self-evident empiricism that took its guiding concepts from the given assumptions about design history and design practice.

This empiricism has left the subject with several problems. It has led first to a defensiveness by design historians and to a refusal to engage in debate. Intellectual culture thrives on argument and contention, but orthodox design historians have responded to the frequent critiques of methods, aims, and approaches of the subject only by pointing out the genuine research problems it faces or, less validly, denying the importance of concepts, ideas, and methods altogether.[36]

In a similar fashion, design history has turned its back on other academic disciplines. While extolling the potential interdisciplinary nature of the subject and making some attempt to acknowledge the importance of the economic and the social by incorporating economic and social history into the syllabi of the British undergraduate design history courses, the real integration of insights and methods from other disciplines has been postponed. With some exceptions, design historians have remained markedly impervious to the conceptual schema and interpreted methods offered to historical study by classical sociology, the developments that have emerged from French structuralist and semiotic thought, and the revolutions in historiography and historical interpretation wrought by Marxism[37] and the Annales School in France.[38] Even some of the more significant developments in art history have been ignored or their potential significance has not been understood.[39]

This has had the additional effect of leaving largely intact the conceptual moribundity and the essentially Victorian epistemology that are the bases for the continuing dominant focus on "great men and the institutions they created, modified, or resisted."[40] This mixture of liberalism and positivism contributes to the emphasis on sensible empirical realities. According to this view, the job of history is to ascertain the facts, and facts are deemed to be the events that "resulted from the action of individuals producing them through the frame work of institutions."[41] Therefore, it is "commonsense" that this kind of history should focus on these events. But what this approach fails to take into account is that many of the more crucial determining issues (determining of the whole character of design in the industrial period), for example, the determination of the form of the design process by the complex necessities demanded by industrialization in general and by capitalist industrialization in particular,[42] are *not* empirically given and cannot simply be uncovered by the study of the facts.

Consciousness (London: Merlin, 1972), especially pages 83-222; Ernest Mandel, *Late Capitalism* (London: NLB/Verso, 1974); and Immanuel Wallerstein, *Historical Capitalism* (London: NLB/Verso, 1984).

43) For details of all these concepts, see especially, Mandel, *Late Capitalism*.

44) On this whole issue, see Clive Dilnot, "Design, Industry, and Economy Since 1945; An Overview," unpublished paper presented to the 1981 Annual Conference of the Design History Society, London.

45) On this complex but essential problem, see T.J. Clark, "The Social History of Art," chapter 1 in *Image of the People* (London: Thames and Hudson, 1974).

46) The phrase is Walter Benjamin's. The idea of "constellations" is discussed at length in Susan Buck-Morss, *The Origins of Negative Dialectics* (Hassocks: Harvester, 1977), 82*ff*, and in Buck-Morss, "Walter Benjamin, Revolutionary Writer," part I in *New Left Review* 128 (July/August, 1981) and part II in 129 (September/October, 1981).

47) This is literally so. The linguistic obsession of our time, which decrees that only texts or statistical groups of figures constitute "evidence," naturally decries the image or object as a source of evidence. The point is dealt with below, especially in note 68.

48) This explains why exhibitions of design are so often a failure. While one may get

Some evidence for this argument can be found when trying to understand the pattern of professional design practice since 1945. Empirical studies of, for example, the different forms of design organization that have arisen since 1945 — the rise of the consultant designer, the parallel rise of in-house design teams, and the increased investment poured into design efforts — can describe these developments but they cannot *explain* them. To move from description to explanation demands that we understand the reasons why these developments took place. To do this, we need to be acquainted with economic history: notions of "technological rents," demand management, and capital's securing of the control of the whole product cycle (not merely of the sphere of production in the nineteenth century); of the expansion of planning and organizational abilities, the demands placed on the latter by the intensification of the turnover rate of capital and the speeding up of the product cycle; and of the increasing differentiation and organization of consumption.[43] At a deeper level, these are the "collective facts" of the designer's situation. They explain, or help to explain, the powerful economic circumstances that determined, in a general sense, the directions that industry moved in after 1945, and they hint, even at this level, at the forms that design activity *necessarily* took in order to work with and help develop these circumstances.[44]

Design activity since 1945 can be explained by paying attention to the main motors of economic-industrial motivation in this period. However, resistance to "theory" and to concepts brought in from other disciplines or areas is often rooted in the dislike of the idea that the imported concepts are merely background.[45] However, factors such as those described in this article are not background: on the contrary, they are foregrounded in the actual organization of design since 1945, and they appear in the objects and images that result. If circumstances do not *coerce* form, they are certainly often *manifest* in form. Conversely, the very fact that forms, including forms of design organization, *do* manifest circumstances means that they are also evidence. In embodying the complex and diverse circumstances that gave rise to them, often in powerful and frequently unusual patterns or "constellations,"[46] designed objects and images, as well as the forms the design process takes, have an *archeological* status.[47] For example, the exhibition *Design since 1945*, held recently at the Philadelphia Museum of Art, if considered from the point of view of the history of the design professions is archeologically valueless. Such an exhibit misses the point that the significance of designed forms is *not* given by their empirical classification, but rather by the status of meaning assigned to them or won from them. In other words, designed forms possess no intrinsic value. Their import and significance is *not* given by their designer status but is achieved because of what can potentially be won from them in terms of evidence and in terms of understanding.[48] The point then, which leads to the

CLIVE DILNOT

pleasure from the contemplation of the "well designed object," it is wholly illusory of exhibition organizers to assume, like the formalist curators of art museums, that the works on display will somehow self-evidently reveal their import. In most cases they will not.

49) It therefore ultimately depends on the conception we have of the importance of design activity in the formation, organization, and ideological patterning of human societies. For a succinct debate with some reference to this point, see Hebdige, *Subculture*, chapter 1. See also Clive Dilnot, "Design as a Socially Significant Activity: An Introduction," *Design Studies* 3 (July, 1982): 139-46, and Wojcieck Gasparski, *Designing Human Society: A Chance or a Utopia?* (Warsaw: Department of Praxiology of the Polish Academy of Sciences, n.d.).

50) T.J. Clark, "The Conditions of Artistic Creation," *Times Literary Supplement* (May 24, 1974): 561-62. The quotation from Lukács's reification essay comes from *History and Class Consciousness*, p. 153.

fourth, and in some ways the most crucial, problem that design history faces, is that the significance of design history as an activity depends not on the extrinsic significance of the objects and phenomena we deal with, but on the *conception* we have of what design history is capable of revealing about design itself in all of its complexity and about the circumstances from which forms of designing emerge.[49]

Writing in 1974 on what he considered to be the crisis of art history, T.J. Clark tried to approach a precisely similar problem. Asking "why should art history's problems matter? On what grounds could I ask anyone else to take them seriously?" Clark said that to answer that question, "I have to remind you, remind myself, of what art history once was." He also stated: "There's a passage from Lukács's great essay of 1922, *Reification and the Consciousness of the Proletariat*, that will do to conjure up an alien time: 'And yet, as the really important historians of the nineteenth century such as Riegl, Dilthey, and Dvořák could not fail to notice, the essence of history lies precisely in the change undergone by those structural forms which are the focal point of man's interaction with the environment at any given moment and which determine the objective nature of both his inner and outer life. But this only becomes possible (and hence can only be adequately comprehended) when the individuality, the uniqueness of an epoch or historical figure, etc., is grounded in the character of those structural forms, when it is discovered and exhibited in them and through them.' That passage is haunting for several reasons . . . but let's simply look at that curious phrase 'the really important historians of the nineteenth century,' and the way the examples come to mind include two art historians out of three names cited! What an age this was, when Riegl and Dvořák were the real historians worrying away at the fundamental questions — the conditions of consciousness, the nature of 'representation.' And Lukács could have looked around him in 1922 and pointed to the debate going on, unresolved, sharpened, often bitter. The roll call of names — Warburg, Wölfflin, Panofsky, Saxl, Schlosser — is not what matters exactly. It is more the sense we have, reading the best art history of this period, of an agreement between protagonists as to what the important and unavoidable questions are. It is the way in which the most detailed research, the most arcane discoveries, lead back time and time again toward the terrain of disagreement about the whole nature of artistic production . . . (about the) conditions of artistic creation . . . (the questions of) the artists' resources and his materials."[50]

There are two aspects to this issue. First, Clark rightly argues that the success of a discipline is distinguished by the adequacy, range, and vigor of the questions practitioners ask of their material, not the details of research schema or debates over marginal problems and issues that historians confront in their day-to-day work. *Problems*, not empirical data, are central: it is the concep-

51) Clark, in "Conditions," page 561, has a wonderful quotation from Panofsky that he uses as an example of what he thinks are the vital, dialectical, "modes of argument, habits of mind" necessary to recovering a serious art history: "Take this example from Panofsky's marvelous *Perspective as Symbolic Form* published in 1925. He is talking here about the ambiguity of perspective, the way it makes the visual world objective, measurable, and yet makes it dependent on the most subjective point of reference, the single all seeing eye: 'It mathematizes . . . visual space, but it is still visual space that it mathematizes; it is an ordering, but an ordering of visual appearance. And in the end it is hardly more than a question of emphasis whether the charge against perspective is that it condemns "true being" to the *appearance* of things seen, or that it binds the free, and as it were, spiritual intuition of form to the appearance of *things* seen. Through this location of the artist's subject in the sphere of the phenomenal, the perspective view closes to religious art the territory of magic within which the work of art is itself wonder-worker . . . but it opens to religious art . . . the territory of the vision, within which the wonderful becomes an immediate experience of the spectator.'" Panofsky's lovely quote demonstrates the interaction of "modes of thought" and conceptions of the significance and meaning of the phenomena we explore.

52) Clark, "Conditions," 562. Of course, Clark also notes the external factors that bear on this, particularly art history's relation to the art market and the "distortions" in the subject's ambitions this has induced.

53) Fiona MacCarthy, *A History of British Design, 1830 - 1970* (London: George Allen and Unwin, 1976).

54) Walter Benjamin, "Theses on the Philosophy of History," in *Illuminations* (London: Fontana, 1970), 257.

55) Lukács, *History and Class Consciousness*, 153.

tion of what the subject is about and the modes of arguing, even "habits of mind," which are brought to the work that originate the arguments and demand answers to questions.[51]

Second, Clark contrasts this evocation directly and by implication with the current position in art history: "It seems to me that these questions have been scrapped by art history now. And perhaps we ought to ask what made it possible to pose them at all . . . and why did the problems die? Why are we left with caricatures of certain proposals, (with) arguments that have been turned into methods?" Clark's answer to this was brutally simple: "Why? Because as I have hinted already, the terms in which the paradigm problems were posed were incapable of renovation."

He continues: "The old questions of art history were structured around certain beliefs, certain unquestioned presuppositions: the notion of the Artist, of the artist as 'creator' of the work, the notion of a pre-existent feeling — for form, for space, of the world as God's or the god's creation — which the work was there to 'express.'" But, "these beliefs *eroded* the subject; they turned questions into answers . . . and needless to say the beliefs — the sheer vulgar metaphysic — are all that present-day art history is left with . . . To escape from this situation . . . we need a work of theory and practice. We need *facts* . . . but we need to know what questions to ask of the material . . . (and) we have to discover ways of putting the questions in a quite different form . . . we need to import a new set of concepts and keep them in being — build them into the method of work."[52]

In education particularly, but also in the design professions, design history is called on to legitimate particular forms of contemporary design practice. Such was the thrust of *A History of British Design: 1830-1970*, by Fiona MacCarthy,[53] and *In Good Shape*, by Stephen Bayley. The significance here is less the writing of history for a particular purpose or for declared aims and ambitions than it is the scope of the questions and the implications and issues of the material. MacCarthy's and Bayley's books are dangerous for design history because of the essential poverty of conception about the material they are dealing with. In this sense, both books try to *limit* and *reduce* design history and its potential.

Walter Benjamin put the point at its most extreme in 1940 in his final *Theses on the Philosophy of History* when he argued that "only that historian will have the gift of fanning the spark of hope in the past who is firmly convinced that even the dead will not be safe from the enemy if he wins."[54] Less messianically, Lukács, whom Clark quotes, reads the "essence of history" as lying within "those structural forms which are the focal point of man's interaction with the environment at any given moment" and which determine "the objective nature of both his inner and outer life."[55]

Lukács's "difficult and fertile" thesis argues effectively that history can be comprehended with most acuity through the developments of the cultural *forms* that mediate people's relations with

CLIVE DILNOT

56) On this point, see Raymond Williams, *Culture and Society, 1780-1950* (London: Fontana, 1981), chapter 3.

nature and with other people, rather than in terms of events.[56] When these forms are political institutions, we are used to reading history this way. However, when these forms are considered as artifacts, more particularly *designed* artifacts, we are less used to seeing history interpreted through things, much less through the *design* of things.

Yet, why not? Michael Baxandall brilliantly pointed to the possibilities of focusing on artifacts as cultural forms in *Painting and Experience in Fifteenth Century Italy*[57] and then in *The Limewood Sculptors of Renaissance Germany*.[58] In these books, Baxandall located paintings or sculptures within the culture and society in which they emerged: "A fifteenth century painting is the deposit of a social relationship. On the one side there was a painter who made the picture, or at least supervised its making. On the other side there was somebody who asked him to make it, provided funds . . . and, after he had made it, reckoned on using it in some way or other. Both parties worked within institutions and conventions — commercial, religious, perceptual, in the widest sense social — that influenced the forms of what they together made."[59] However, Baxandall also reversed the procedure, suggesting that a history, such as that of the limewood sculptors of southern Germany, can offer an introduction to the sculpture itself, as well as a means of looking through the sculpture into the social life of the period: " . . . *the carvings being sometimes addressed as lenses bearing on their own circumstances*. The suggestion is not that one must know about Renaissance Germany to enjoy the sculpture, but that the sculpture can offer a fresh focus on the cultural history of Renaissance Germany"[60] (emphasis added).

Baxandall explained some of the ways in which this two-way process occurs: "A society develops its distinctive skills and habits, which have a visual impact, since the visual sense is the main order of experience and these visual skills and habits become part of the medium of the painter: correspondingly, a pictorial style gives access to the visual skills and habits and, through these, to the distinctive social experience."[61] Of course, this quotation describes only the bones of the argument; it becomes simultaneously the introductory hypothesis and conclusion to an argument of fascinating complexity and scholarship. However, the important point, one that Baxandall himself emphasized, is that by adequately examining the circumstances surrounding artistic production and the development of visual and critical skills, a framework is created for a genuine continuity between social history and, in this case, art history, "each offering insights into the other."[62]

57) Michael Baxandall, *Painting and Experience in Fifteenth Century Italy: A Primer in the Social History of Pictorial Style* (London: Oxford University Press, 1972).
58) Michael Baxandall, *Limewood Sculptors of Renaissance Germany* (New Haven: Yale University Press, 1980).

59) Baxandall, *Painting and Experience*, 1.

60) Baxandall, *Limewood Sculptors*, vii.

61) Baxandall, *Painting and Experience*, 152.

62) Baxandall, *Painting and Experience*, 1.

Possibilities of a History of Design
What Clark and Baxandall have in common is the commitment to reading the objects and images they deal with as *evidence*.[63] For

63) At the end of *Painting and Experience*, Baxandall quotes the opening lines of a play by Feo Belcari of Florence, acted in 1449: "The Eye is called the first of all gates/Through which the Intellect may learn and taste/The Ear is second, with the attentive Word/That arms and nourishes the Mind." (page 153.)

64) Buck-Morss, "Walter Benjamin," (I), 70.

65) Buck-Morss, "Walter Benjamin," (I), 70.

66) Clark, "Conditions," 8.

67) Baxandall, *Painting and Sculpture*, 152-53.

68) On the latter, see Lukács, *History and Class Consciousness*, 103. Lukács explains that in the process of the development of special skills and techniques, capitalism creates the role of the specialist who then, as a part of the development of the division of labor, constructs in ever increasing autonomy the apparatus of the "independent" professions. This independence is both genuine, yet determined; it certainly gives the illusion of the autonomous profession holding to its "own" values, yet it is the development of the system that has created this apparent autonomy and independence. This, perhaps, accounts for the reason why design, so often the handmaiden of the economy, can often appear (but only appear) to distance itself from it.

69) Phil Goodall, "Design and Gender," *Block* 9 (1983): 58.

both of them, art provides "a critical iconography for deciphering material history,"[64] and for both, "the relationship of material reality to esthetic expression (is) one of mutual demystification. Elements of material history (were) required in order to interpret artworks so that these cultural 'treasures' ceased to be ideological accoutrements of the ruling class. But the obverse (is) true as well."[65] The image or the object provides a crystallization of the complex and subtle processes of cultural formation. For Clark, "the process of work creates the space in which, at certain moments, an ideology can be appraised."[66] For Baxandall, the work (for example, a fifteenth-century painting) offers "an insight into what it was like, intellectually and sensibly, to be a Quattrocento person. Such insights are necessary if the historical imagination is to be fed, and the visual is here the proper complementary to the verbal."[67]

But what of design? The most significant aspect about design is that it is produced, received, and used within an emphatically *social* context. The social is *not* external to the activity, but internal to it and determining of its essential features, even of its sense of relative autonomy.[68] As Phil Goodall has recently argued, "Design values, whether they are defined as utility, functional form, or an esthetic of appearance, are produced by cultural, social, and economic priorities, policy, and action. They themselves act to produce and *prescribe* the social relations of the sphere of reproduction, the material form of the home and the social relations of household members . . . put simply, design *for* use is design *of* use; as such design deposits preferred users, defines them within the parameters of the material and technical possibilities of the object."[69]

The essential field of design's meaning and import, therefore, is *not* the internal world of the design profession, but the wider social world that produces the determining circumstances within which designers work, as well as the conditions that lead to the emergence of designers. Although historians of the specialist professions may wince, the potential field of the history of design can be widened further, encroaching, perhaps, on their territory. Possibilities of a history of design hinge almost entirely on the significance that design as an activity has had in human societies. From this perspective, to the extent that design is viewed only as a professional activity autonomous from social developments, the activity loses meaning and significance. The paradox here is that it is just at this point, at the rise of industrial society, that the import of design activity, measured in terms of its effects on people's lives, radically increases. This is a ludicrous situation that suggests our whole comprehension of design must alter radically. We need to move from perceiving design as a set of values and esthetic or stylistic criteria embodied in certain groups of objects and in certain individuals, but essentially *always* within the locus of the design professions, to an alternative view, to one that considers

CLIVE DILNOT

design in the much broader Papanekian sense as, "the conscious attempt to impose meaningful order . . . the planning and patterning of any act toward a desired foreseeable end,"[70] and that sees professional design as a particular historical form of this more fundamental activity.

What value might this shift in perspective have? The first and most important issue is that it immediately makes the status of professional design activity relative.[71] It is arguable anyway that the importance of this activity has been exaggerated. As a number of architecture and design theorists have recently pointed out, the vast majority of buildings, objects, and images have not been built or designed by architects or professional designers.[72] Professional design, therefore, becomes simultaneously less important and more important. It is less important because the world has survived in the past almost without it, and certainly without it *in its current form*, which is the crucial issue, and because even its achievements (for example, those of architecture) pale by the side of the colossal vernacular design effort that built much of the world, at least, before the beginning of this century. It becomes more important, in an ontological sense, because although this perspective ridicules the internalist disputes and issues of professional designing, it also brings out the fact that the age of vernacular designing is over. The cultural modernization and rationalization of European societies, when wedded to an active and free capitalism, set in motion a series of events, including most dramatically industrialization, that broke the cultural conditions under which vernacular design operated.[73] This means that there is no choice now but to accept design in its industrial sense.[74]

However, the critical perspective being developed here makes evident the need to be more skeptical and to interpret the recent history of industrial design*ing* as very nearly a catastrophe.[75] Despite achievements by individual designers or in certain small and usually exclusive sectors, whether it be housing, transportation systems, or the utilitarian, symbolic, and esthetic failures of most consumer goods, industrial designing does not deserve approbation.[76] This point is essential. Without accepting that fact, a critical perspective on designing in the industrial age cannot be developed. On the positive side, without this wider view there is no standard to measure the (largely symbolic) successes of various individuals, design groups, or companies: genuinely good design simply is assimilated to a weak tradition of professional "good design," and the human aspects of genuine design success are lost.

On the negative side, ignoring reality and concentrating wholly on the glossy professional world produces a stultifying complacency; not only do success and failure become measured simply by professional standards rather than by those of any larger group (and both become all too often assimilated to fashion and to a simplistic notion of progress), but the one-dimensionality of this approach inhibits the development of a more adequate critical lan-

70) Victor Papanek, *Design for the Real World* (London: Paladin, 1974), 17.

71) It also returns the activity to history. Rather than seeing the emergence of industrial designing as a given evolutionary fact, a view that both tends to annihilate the history of pre-industrial designing as irrelevant to understanding industrial or professional designing, and to separate professional designing from its roots in older and wider processes of planning and making buildings and objects, the reinsertion of professional designing into this wider context allows us to have a critical perspective, to measure both what was gained *and what was lost* for designing in the evolution from the complex of craft designing processes to industrial designing. So far, save for nostalgic laments for the loss of craftsmanship, design historians have shown little interest in this problem. The issue, as an important historical problem, has been opened up by concerned designers. See, for example, David Walker and Nigel Cross, *Design: The Man-Made Object*, units 33 and 34 of course T100, "The Man-Made World: A Foundation Course" (London: The Open University Press, 1976), and Nigel Cross, *Design and Technology*, unit 9 of course T262, "Man-Made Futures: Design and Technology" (London: The Open University press, 1975). See also Christopher Alexander, *Notes on the Synthesis of Form* (Cambridge: Harvard University Press, 1964).

72) The most popular version of this view is probably Bernard Rudofsky, *Architecture Without Architects* (London: Academy Editions, 1973), which is quaintly sub-titled, in a way that perfectly illustrates our prejudices: *A Short Introduction to Non-pedigreed Architects*.

73) The most obvious of these conditions are the factory system and the division of labor. For useful surveys of the industrial system and some of its implications, see Maurice Dobb, *Studies in the Development of Capitalism* (London: Routledge & Kegan Paul, 1963), and Eric Hobsbawm, *Industry and Empire* (Harmondsworth: Penguin, 1969).

74) But do we have to accept also the form that this takes in our societies? Uncritical history would in effect argue that what we do for it is written as if what had happened was destined to happen *and could not have been otherwise*. But in that case, it removes from history both the possibility of alternatives, and the *fact*, as

Stephen Yeo says, that development, progress, and evolution involve "power, struggle, interests," and that such "competition and struggle involve loss and defeat as well as growth: presents [sic] involve running over unrealized but partly surviving pasts and temporarily blocked futures." (Stephen Yeo, "State and Anti-State: Reflections on Social Forms and Struggles from 1850," in *Capitalism, State Formation and Marxist Theory*, edited by Philip Corrigan [London: Quartet Books, 1980], 113].) In other words, uncritical history removes from view the fact that the form of things is always contingent, always *produced*, from special interests, circumstances, and struggles; that is to say, it tries to describe how and why they have come about and it shows how other alternatives might have been possible. Above all, it tries to stop the "closure between possibility and what *is*." It does this by using history to demonstrate that institutional and organizational forms, like visual ones, are never eternal and contain the seeds of alternative forms buried within them.

75) By the term "industrial designing" I mean *all* professional design activities carried on in industrial societies, not just the specific industrial design profession.

76) Consider a parallel example from the case of architecture: "No account of recent developments in architecture can fail to mention the ambivalent role that the profession has played over the last decade – ambivalent not only in the sense that while professing to act in the public interest it has sometimes assisted uncritically in furthering the domain of optimised technology, but also in the sense that many of its more intelligent members have abandoned traditional practice, either to resort to direct social action or to indulge in the projection of architecture as a form of art." Frampton, *Modern Architecture*, 280.

77) Compare the product designer Jay Doblin: "Although I designed hundreds of successful products for major corporations, it suddenly occurred to me that I didn't know what I had been doing." Jay Doblin, "What Designers Do," *Designer* (June, 1980).

78) Note Michael Baxandall's list of some of the circumstantial realities operating for the limewood sculptors of Southern Renaissance Germany: "The forms and potentialities lying hidden in their limewood, the functions the sculpture served which are complex and sometimes unexpected, the mixed satisfactions looked for in the pre-reformation image, the patterns of professions and markets in which its makers lived, the different kinds of roles open to craftsmen in a European market moving untidily away from a late medieval guild, some vernacular skills and habits of visual discrimination peculiar to South Germany

guage and of understanding itself. After all, why understand design, when it clearly produces an endless succession of "great product design"?[77] Why worry about the bizarre distortion of talent that sucks many of the most inventive young designers into the expensive production of baked-bean ads and the like, when these designers produce glossy textbook images to illustrate the "currently high level of graphic design"?

These are *historical* questions. Behind them lurk massive historical implications. At the most extreme, the writing of a history of design in the industrial period that essentially celebrates the succession of "name" designers and the rise of the design professions, but that carefully selects its images, eschews real critical comment. While snuggling intimately with the *idea* and the *image* of the professions, it keeps its distance from many if not most of the circumstantial realities of design in the industrial period.[78] On the less extreme side, the more difficult and more important kind of history would have as its task to understand this dichotomy between the failure on the large scale and the brilliant successes occasionally achieved, to map the central historical features of the contradictory implications of design in the industrial period, and to explain the historical origins of this bizarre situation.[79]

What are the collective facts of the circumstances surrounding design in the past two centuries? How do they differ from those dominant in the preceding periods? What circumstances have produced the extraordinary flashes of design creativity that have periodically lit up the post-eighteenth century design worlds? Equally, what has prevented their generalization? What force has intervened to separate such dramatically "high" and "low" design? By comparison, what conditions in the preindustrial world enabled a working continuity to be formed between the values of "high" design, as represented by the major architects, their patrons, and the most fashionable decorators and tastemakers, and the vernacular abilities of everyday making and building? What cultural rift intervened to construct design as a distinct profession? What function was design meant to fulfill, and could that function be fulfilled within the possibilities given by the economic circumstances of current design (circumstances that in the industrial period have acted to force ways of working that have been almost wholly inimical to the development of an adequate process and ethic of industrial designing)? Or, does the wider political-economic context in which designers must operate so distort the collective circumstances of design that in the wider public sphere, at least, the very possibilities of design in any meaningful sense virtually disappear?[80]

Using Clark and Baxandall as examples provided two emphases: one was the importance of the overall critical orientation of the subject (what matters is the questions asked and the definition of problems) and the other was the importance of the continuity of art or design history and social history, if properly handled. In

Clive Dilnot

in 1500, a period of group character and even of individuality itself." (Baxandall, *Limewood Sculptors*, vii and 164, composite quotation by the author.) It is instructive to mentally compare this list, which is not exhaustive, with the *range* of phenomena discussed in some recent works of design history.

79) The word is deliberately chosen. Perhaps we cannot easily see just how extraordinary a culture we have spawned since we are immersed in it. What would archaeologists in a thousand years make of a "Pompeii" of any Main Street USA? Design, which has helped to produce the material culture we are surrounded by, is no exception. The present organization and functioning of the design professions, as Papanek has pointed out (Papanek, *Design in the Real World*, 32-35) is almost criminal in its irrationality and waste of talent and resources. The precondition of genuine history writing may be the necessity to critically stand outside, as well as within, the phenomena we try to explain.

80) What then of a history of design of those production circumstances where there has been virtually no recognized input of professional designers? What would such a study tell us *in absentia*, as it were, of the character and actual range of influence of modern-day professional design? This is perhaps the real import of Pevsner's *An Enquiry Into Industrial Art in England* (Cambridge: Cambridge University Press, 1937).

81) Baxandall, *Limewood Sculptors*, vii.

82) Goodall, "Design and Gender," 58.

83) Just how much so is given by the case of design studies. In fifteen or twenty years of work on design methods and design research, design sociology remains wholly undeveloped. Bruce Archer, Professor of Design Research at the Royal College of Art in London, does not include the social study of design within his review of the possible field of design research. (Bruce Archer, "A View of the Nature of Design Research, in *Design: Science: Method*, edited by Robin Jacques and James Powell [Guilford: Westbury House, 1981], 30-47.) More recently, Nigel Cross of the British Open University's design discipline, in an otherwise very interesting editorial in *Design Studies*, referred to three areas of design knowledge: design epistemology, design methodology, and design phenomenology (i.e. the knowledge of "how people design . . . [of] the tactics and strategies of designing . . . [and that residing] in the products themselves." (Nigel Cross, *Design Studies* 5 no. 1 [1984]: 1), but not to the *context* in which all this takes place, namely the social. On this, see Clive Dilnot, "Design as a Socially Significant Activity," 139-46.

84) One interesting example of this approach is Manfredo Tafuri's *Architecture and*

addition, objects or images were presented as evidence: in Baxandall's words, as "lenses bearing on their own circumstances."[81]

Yet Clark and Baxandall are art historians, although Baxandall, emphasizing as he did the *functions* of images, can be brought easily and productively into the sphere of design history. This article has presented the idea that what distinguishes design is its continuity with the social, not just in terms of representation, but in terms of a more active role with designed phenomena. Designed forms "act to produce and prescribe . . . social relations . . . design *for* use is design *of* use."[82] But does assuming the full implications of this fact create something of a crisis in design history's comprehension of design? This article has argued that it is very difficult to hold simultaneously an orientation to the design professions, whose entire value system eschews the social, and to the wider, social sense of the activity and its human, rather than simply design professional, import.[83] The solution posited was to view these issues in a wider setting, to hold to the wider Papanekian concept of design, and to view professional design as a specific historical form intimately related to and shaped by the cultural, industrial, and economic revolutions of the modern period.

In the investigation of these two concepts, both a critical understanding of what was gained and lost in the evolution of industrial designing processes, habits, and skills and a more sensitive historical understanding could be gained. Rather than presenting a one-dimensional, exclusive study of the *internal* development of the design professions, the article has posited a critical debate focusing in particular on the relationship between the design professions and the circumstantial realities that determine their character and the relationship of the profession to the society in which it operates.[84] It has referred to a complex, critical, and multidimensional form of history that takes its significance from the Papanekian view of design "as the primary underlying matrix of life"[85] and from the argument that design is "arguably the only way that man decides his material future."[86] It balanced this against the specific historical study of two events: the rise of the design professions within the history of industrial capitalism, including the history of the rise of a design *culture*[87], and the changing form and character of the design process itself. The latter was examined from the point of view of its professional institutional form and in relation to the wider, more diffuse understanding of it as a complex of processes by which an environment or object is transformed, first, according to some apperception of a desired result[88] and, second, with *meaning*,[89] so that its transformation is not merely quantitative but qualitative; its new meaning and functions are embodied in a new *form*.[90]

Three concepts are important here. The first is the idea of the historical matrix, the determination to ground, within the history of industrial capitalism, the history of design as a history of design professions and of professionally designed and evolved objects,

Utopia: Design and Capitalist Development (Cambridge: The MIT Press, 1976).

85) Papanek, Design for the Real World, 7.

86) Newport, "Design History," 89.

87) The interaction of this culture with culture in general seems a specialist subject of study by Italian historians and critics. See, for example, essays in Emilio Ambasz, editor Italy: The New Domestic Landscape (New York: Museum of Modern Art, 1972), and Piero Sartogo, editor, Italian Re-evolution: Design in Italian Society in the Eighties (La Jolla, CA: La Jolla Museum of Contemporary Art, 1982).

88) This means that design is a matter of knowledge: of values, schema, desires, hopes, aspirations, facts. The technicist approach of our culture has tended to make light of this component of designing. Design too is taught essentially as technique. One job of the history of design is to recover design-as-knowledge. For an excellent essay on this theme, see Edwin T. Layton, "Technology as Knowledge," Technology and Culture 15 (1972): 31-41.

89) The same point applies to the question of meaning. A technicist culture has tried to erode meaning from design, to make design like technology, which in our time is wizened, dangerous, and corrupt precisely because it has lost the dimension of meaning. But design is distinguished from technology, which in truth is merely an aspect of design, precisely because its job is to endow technical solutions to material problems without human meaning, significance, and content.

90) On functions, and for the most useful little diagram and concept the historian can begin from, see "the function complex," in Papanek, Design for the Real World, 17-31.

91) Tafuri, Architecture and Utopia, 7.

92) On technology as such a projection, see Herbert Marcuse, "Industrialization and Capitalism in the Work of Max Weber," in Herbert Marcuse, Negations (London: Penguin, 1968), 201-226.

93) A useful discussion of these kinds of issues is contained in Dolores Hayden, Redesigning the American Dream: The Future of Housing, Work, and Family Life (New York: Norton, 1984). Together with the same author's Seven American Utopias: The Architecture of Communitarian Socialism, 1790-1975 (Cambridge: The MIT Press, 1976) and The Grand Domestic Revolution: A History of Feminist Design for American Homes, Neighborhoods, and Cities (Cambridge: The MIT Press, 1981), this book is a model of critical, involved design history applying itself to real socio-economic, political, cultural and design problems.

images, and forms of design activity. Despite the attempts that some designers have made to wrest design away from determination by the twin demands of industrial organization and the capitalist market, and despite the professional "relative autonomy" enjoyed by the design disciplines, design in the industrial age is inconceivable outside of this matrix. What this matrix limits and enables has determined the sphere of mainstream design practice since the beginning of the modern period. What is of interest, to paraphrase Manfredo Tafuri, is the identification of those tasks that capitalist and industrial development have given to and taken from design.[91] Equally, as a way of writing a history of industrial capitalism, a history of the socio-economic forces that have shaped everyone's life during the past two centuries, design becomes the evidence of the complex ways in which both rulers and ruled have projected ideas about technology, progress, and, above all, ways of life, into objects and environments.[92] Design has been the major agent in this shaping or endowing process, if not the force determining the content of what has been projected through objects, buildings, and so forth.[93] Therefore, how design has mediated this process is of great interest.[94]

However, the distinction between the design process and what is projected through it is somewhat illusory. In the modern period, the rise of "independent" design values, the "autonomy" of design, and the changing forms of design organization should be taken into account. The rise of design as a significant factor on its own account has given great importance to the patterns of how design has been organized and promoted.[95]

At this point, the evident and much-discussed art-design values and the openly stated professional values, as well as the more epistemological, ideological, cultural, and political presuppositions that guide design work, should be examined.[96] These presuppositions and their teasing out from the design material that we work with are what supply the public raison d'être of this historical study. This process makes people aware of the crucial importance of the form of things.[97]

The concept of form is so basic to design and so denuded in meaning in the formalist tradition that designers and design historians have not realized the full implication or importance of the concept. Design as we are most familiar with it is focused on giving import to the form of things. At worst, this focus degenerates into pure design estheticism; a valid, stock criticism of the most banal versions of design history is that this focus deals only with the most superficial issues of form and style.

We might also realize that the obsession with form that distinguishes the design professions hides deeper and more important implications. Historians of material and social culture have shown that it is the forms in which needs are met that characterize a society or culture. Stephen Yeo provides an example with respect to production: "Cooperative factories of the laborers themselves, the

CLIVE DILNOT

94) Mediation is a crucial concept in cultural studies. See Raymond Williams, *Culture* (London: Fontana, 1981), and *Marxism and Literature* (Oxford: Oxford University Press, 1977). See also, Janet Woolf, *The Social Production of Art* (London: Macmillan, 1981).

95) A history of the rise of the design journal as the vehicle for projecting the ideology or the value of "design" would be an enormous contribution to understanding the profession's self-promotion of design values. To map the changing values, ideas, and beliefs expressed or communicated in text and graphic layout could, in a sense, map the history of the professions. Is the history of design literally contained in the glossy pages of *Domus* or *Industrial Design*?

96) Compare much of the work discussed in part one of "The State of Design History," 19-23. But this work is largely in its infancy. We are still at the stage of searching for adequate concepts and methods.

97) Form is a wholly neglected area of study. When not reduced to formalism (as in American art criticism of the 1950s and 1960s,) it is generally ignored. The new work in cultural studies, such as the work of Dick Hebdige listed in part one of this paper, is exploring the field, whose first real investigators were the Critical Theorists of the Frankfurt School, especially Benjamin and Adorno. See, for example, Theodor Adorno, *Minema Moralia* (London: NLB/Verso, 1974), Walter Benjamin, *Charles Baudelaire: A Lyric Poet in the Era of High Capitalism* (London: NLB/Verso, 1973), and *One Way Street* (London: NLB/Verso, 1979). For an introduction to the Frankfurt School, see Martin Jay, *The Dialectical Imagination* (London: Heinmann, 1973), and the anthology of writings of the school, edited and with an introduction by Paul Connerton, *Critical Sociology* (Harmondsworth: Penguin, 1979).

98) Yeo, "State and Anti-State," 112.

99) One curious designer who has not is Buckminster Fuller. See J. Mellor, editor, *The Buckminster Fuller Reader* (London: Cape, 1970).

100) Newport, "Design History," 89.

101) On this, see Mike Cooley, *Architect or Bee: The Human/Technology Relationship* (Slough: Langley Technical Services, 1979), for a very important discussion of the design and human implications of new technology and work patterns.

102) See Cristopher Freeman and Marie Jahoda, *World Futures* (Oxford: Martin Robertson, 1978).

103) See Clive Dilnot, "Transcending Science and 'Anti-Science' in the Philosophy of Design," in *Design: Science: Method*, edited by Robin Jacques and James Powell (Guilford: Westbury House, 1981).

Cooperative Wholesale Society (1863), and local retailing co-ops have been ways of producing, distributing, and using basic goods such as food, soap, or clothes, as have Marks and Spencer and Unilevers. However, they are obviously *not the same ways* . . . a society in which one was dominant and the other recessive would not be the same as one in which the rules were reversed."[98] It would be a mistake to read this example of forms and forming as belonging to a different order from the material and esthetic forming of things that design deals with. This conscious ordering of materials and elements of social life for human ends is indivisible from the essence of humans as transformative beings, defined by their ability to transform a given environment in congruence with desired patterns of organization and meaning. This, in turn, is fundamentally identical to the design process. The professional design process is a particular variant that has narrowed its global scope in favor of the development of special skills and abilities.[99]

Designed things or images mirror or embody all three levels of this process; they are thus unique interpretive records not only of the design process, but also of forming in the wider sense. Roger Newport's vital statement that design is "arguably the only way that man decides his material future"[100] explains why this concept is so potentially significant for the public and for designers. What he meant is simply that design is the only way to determine the quantifiable level of material development and the form, the shape, the character, and, therefore, the human implications.[101] In a culture in which, of necessity, more and more decisions about the future character of large-scale technical and environmental systems will be made in the face of increasing complexity and adversity, with greater implications for human lives,[102] the importance of design as a process that can potentially enable a rational but *qualitative* decision to be made can hardly be overexaggerated. This is an historical move. If the first four-fifths of this century were dominated by the image of beneficial technical progress such that all rights to determine the character of things and system were abrogated to technology pure and simple, then the growing disillusion with the human and systemic results of this process have been sufficient to impel greater interest in alternative, yet rational, schemes of technical organization and the shaping of material culture. Design has then *necessarily* come to the fore. In this context, where a much fuller and more adequate conception of design needs to be articulated (given that the dominant models conform either to the technological image of design as science or design as technology or refuse this and model design as purely an expressive art),[103] studies of design's history could scarcely be more important. Therefore, several fundamental issues need to be recovered and elucidated. These are the material efficacy of design activity and designed systems,[104] the ideological implications of design, the significance of forming as an activity, and ther significance of the forms of objects and systems in relation to their social

104) See Teymur, "Materiality of Design," for a detailed discussion of this.

and human implications. In addition, other important issues are the skills, knowledge, and abilities built up within professional and nonprofessional design practices and the significance of the form of things. All of these aspects have a history and all of these histories are relevant to the comprehension and then the construction of a design process or a designing attitude that can, perhaps, take society out of its current crisis.

If who said what to whom at the Museum of Modern Art in 1956 is all that design history is about, then the problems discussed in this article do not matter. However, if what design historians are doing is adding vital socio-historical understanding to the attempts to understand design activity, then their role is very important indeed. Certainly, the full comprehension of design, despite the hopes of ahistorical, asocial design researchers awaits the historical dimension. Without the grounding that only historical study can give, prescriptions for design are incidental; they cannot be redeemed because they lack the necessary immersion in real historical complexity. Too many utopias have died in this century by ignoring or repudiating history. If design historians are to create what Wojciech Gasparski has called the "designing society"[105] we are going to need a subtle and sophisticated comprehension of designing to carry through the ambition. This comprehension in turn needs history. That is why history is significant to design futures, although not at all to the question of "design as the art form of the twentieth century."[106]

105) Gasparski, Designing Human Society.

106) This definition, as cited earlier, is Stephen Bayley's. Just as Christopher Alexander has insisted that design methods cannot and should not be studied in isolation from designing, (Notes on the Synthesis of Form, preface, 1971 edition), should we equally insist that history cannot and should not be studied in isolation from the urge to design and shape things?

CLIVE DILNOT

Cheryl Buckley

Made in Patriarchy: Toward a Feminist Analysis of Women and Design

1) See, for example, Nikolaus Pevsner, *Pioneers of Modern Design: From William Morris to Walter Gropius* (London: Penguin, 1975); Reyner Banham, *Theory and Design in the First Machine Age* (London: Architectural Press, 1975); Fiona MacCarthy, *A History of British Design, 1830-1970* (London: George Allen and Unwin, 1979); Open University, *History of Architecture and Design 1890- 1939* (Milton Keynes: Open University, 1975); John Heskett, *Industrial Design* (London: Thames and Hudson, 1980). In these basic textbooks of design history, two or three women are consistently mentioned. Some books, such as those forming the Open University series, acknowledge more women designers, although in all cases the work of the women who make it into the history books could be described as modernist. More recently, Adrian Forty has acknowledged a few more women in his book *Objects of Desire: Design and Society 1750-1980* (London: Thames and Hudson, 1986). Some historians have been careful to declare their biases when analyzing a particular period. For example, Penny Sparke, in the preface to her book, *An Introduction to Design and Culture in the Twentieth Century* (London: Allen and Unwin, 1986), states, "I should also declare my bias where its subject matter is concerned. As I am dealing solely with the period after 1900, and with design in its most democratic sense, my main concern is with the relationship of design with mass-production industry" (p. xvi). She explains that she does not find craft or fashion irrelevant; indeed, she argues that they are extremely important. However, she focuses on specific areas of design and their relationship to one mode of production.

2) Consider as an example the near silence about women's involvement in the Bauhaus. Although women were trained and taught at the Bauhaus, the vast literature on the subject makes scant reference

Women have been involved with design in a variety of ways – as practitioners, theorists, consumers, historians, and as objects of representation. Yet a survey of the literature of design history, theory, and practice would lead one to believe otherwise. Women's interventions, both past and present, are consistently ignored.[1] Indeed, the omissions are so overwhelming, and the rare acknowledgment so cursory and marginalized, that one realizes these silences are not accidental and haphazard; rather, they are the direct consequence of specific historiographic methods.[2] These methods, which involve the selection, classification, and prioritization of types of design, categories of designers, distinct styles and movements, and different modes of production, are inherently biased against women and, in effect, serve to exclude them from history. To compound this omission, the few women who make it into the literature of design are accounted for within the framework of patriarchy; they are either defined by their gender as designers or users of feminine products, or they are subsumed under the name of their husband, lover, father, or brother.[3] The aim of this paper is to analyze the patriarchal context within which women interact with design and to examine the methods used by design historians to record that interaction.

To a certain extent, this paper is also an attempt to pinpoint some of the key debates to have emerged in design history in Britain concerning the role of women and design. Most of these have taken feminist theory as their starting point. Feminist theory has been particularly useful in that it delineates the operation of patriarchy and the construction of the "feminine."[4] It has shown how femininity is socially constructed and how sexuality and gender identity are acquired at conscious and unconscious levels in the family and through language acquisition. The work of feminist historians and art historians has also been important, especially the critiques of the discipline of history revealing the ideological reasons for the silence about women.[5] As Parker and Pollock have argued in their book *Old Mistresses: Women, Art and Ideology*, "To discover the history of women and art is in part to account for

to their presence: (I include here Gillian Naylor's recent updated version of her early book on the Bauhaus.) We know a great deal about Marcel Breuer, Walter Gropius, László Moholy-Nagy, Johannes Itten, and Wassily Kandinsky, but how much do we know about their female counterparts?

3) The Irish-born designer Eileen Gray has been defined by her gender as a feminine designer. Unlike her contemporary Le Corbusier, her work has been consigned to the so-called decorative arts. It is only more recently that historians have noted her role in the European avant-garde as a modernist designer and architect. Margaret Macdonald and Louise Powell are examples of women designers whose work has been subsumed under their husband's names. Louise Powell was a pottery designer at Josiah Wedgwood and Sons in the early twentieth century. She worked with her husband Alfred Powell, and, until recently, he alone was credited with their joint contribution to new design development at Wedgwood. Margaret Macdonald is another woman designer whose work has been ignored in the history books. When she is acknowledged, it is only to account for a decorative element in work produced by her husband Charles Rennie Mackintosh, which debt is inconvenient to a historical analysis of Mackintosh as a full-fledged modernist. See, for example, Thomas Howarth, *Charles Rennie Mackintosh and the Modern Movement* (London: Routledge and Kegan Paul, 1977).

4) See, for example, Kate Millet, *Sexual Politics* (London: Abacus, 1972); Germaine Greer, *The Female Eunuch* (London: Granada, 1981); Juliet Mitchell, *Psychoanalysis and Feminism* (London: Penguin, 1975); Michèle Barrett, *Women's Oppression Today: Problems in Marxist Feminist Analysis* (London: Verso, 1980).

5) See, for example, Sheila Rowbotham, *Hidden From History* (London: Pluto Press, 1980); Jill Liddington and Jill Norris, *One Hand Tied Behind Us: The Rise of the Women's Suffrage Movement* (London: Virago, 1978); Judith L. Newton, Mary P. Ryan, and Judith R. Walkowitz, eds., *Sex and Class in Women's History* (London: Routledge and Kegan Paul, 1983).

6) Rozsika Parker and Griselda Pollock, *Old Mistresses: Women, Art and Ideology* (London: Routledge and Kegan Paul, 1981), 3.

7) Griselda Pollock, "Vision, Voice and Power: Feminist Art History and Marxism," *Block* 6 (1982): 5. Conferences have been organized on the theme of "Women and Design" at the Institute of Contemporary Arts, London, 1983; Leicester University, 1985; and Central School of Art and Design, London,

the way art history is written. To expose its underlying values, its assumptions, its silences, and its prejudices is also to understand that the way women artists are recorded and described is crucial to the definition of art and the artist in our society."[6] In their writings, feminist historians have challenged the centrality of individuals as agents of history and the focus on professional structures and modes of activity. Instead, they have pinpointed domestic labor and non-professional activities as crucial areas of women's history, and they have located alternative information, such as oral sources, to counterbalance the great weight of "official" documentation.

In recent years, a feminist approach to design history has been placed firmly on the agenda. Feminist design historians, theorists, and practitioners have attempted to coordinate their activities through teaching strategies, the organization of conferences, and in publications, because, as Griselda Pollock has stated, a feminist approach is neither a side-issue nor a novel historical perspective – it is a central concern of contemporary design history. As she has pointed out, "we are involved in a contest for occupation of an ideologically strategic terrain."[7]

Women designers

Central to a feminist analysis of women's role in design is an examination of patriarchy.[8] Patriarchy has circumscribed women's opportunities to participate fully in all areas of society and, more specifically, in all sectors of design, through a variety of means – institutional, social, economic, psychological, and historical. The resulting female stereotypes delineate certain modes of behavior as being appropriate for women. Certain occupations and social roles are designated female, and a physical and intellectual ideal is created for women to aspire to. These stereotypes have had enormous impact on the physical spaces – whether at home or at work – which women occupy, their occupations, and their relationship with design. Design historians who examine women's role in design must acknowledge that women in the past and women today are placed within the context of patriarchy, and that ideas about women's design abilities and design needs originate in patriarchy. Recent debate within feminist history and theory has highlighted the dependent relationship between patriarchy and capitalism and the ability of both to reshape and reformulate society in order to overcome potentially transforming processes.[9]

To what extent, then, does patriarchy form the framework for women's role as designers? In a patriarchy, men's activities are valued more highly than women's. For example, industrial design has been given higher status than knitted textiles. The reasons for this valuation are complex. In an advanced industrial society in which culture is valued above nature, male roles are seen as being more cultural than natural; female roles are seen as the reverse of this.

252

CHERYL BUCKLEY

1986. Several papers have been published from these conferences, including Cheryl Buckley, "Women Designers in the North Staffordshire Pottery Industry," *Woman's Art Journal* (Fall 1984/Winter 1985): 11-15; Anthea Callen, "The Sexual Division of Labour in the Arts and Crafts Movement," *Woman's Art Journal* (Fall 1984/Winter 1985): 1-6; Lynne Walker, "The Entry of Women into the Architectural Profession in Britain," *Woman's Art Journal* (Spring/Summer 1986): 13-18. See also issues of *Feminist Art News* that concentrate on Women and Design: Textiles and Fashion in Vol. l, No. 9 and Design in Vol. 2, No. 3. One can also consult Tag Gronberg and Judy Attfield, eds. *A Resource Book on Women Working in Design* (London: The London Institute, Central School of Art and Design, 1986). The editors of this book were the organizers of the Central School's 1986 "Women and Design" conference.

8) Patriarchy as a concept has been defined by various feminist theorists. An early definition is found in Millet, *Sexual Politics*, 25: "Our society . . . is a patriarchy. The fact is evident at once if one recalls that the military, industry, technology, universities, science, political offices, finances – in short, every avenue of power within society, including the coercive force of the police, is in entirely male hands." The central problem with this definition of patriarchy is that it is a universal and trans-historical form of oppression that is being described. It presents specific problems for a Marxist feminist approach located in historical analysis. Sheila Rowbotham has argued in her essay "The Trouble with Patriarchy," *New Statesman* 98 (1979): 970, that this "implies a universal form of oppression which returns us to biology." A useful definition of patriarchy that attempts to overcome this problem of universal oppression is outlined by Griselda Pollock: "patriarchy does not refer to the static, oppressive domination of one sex over another, but a web of psycho-social relationships which institute a socially significant difference on the axis of sex, which is so deeply located in our very sense of lived, sexual identity that it appears to us as natural and unalterable," in "Vision, Voice and Power," 10.

9) This debate is especially useful for the development of a feminist approach to design history and design practice within Western capitalist countries. (This paper does not aim to examine manifestations of patriarchy in non-capitalist countries, nor does it aim to examine design history and practice in those countries.) For useful discussions of the relationship between patriarchy and capitalism, see, for example, Heidi Hartmann, "Capitalism, Patriarchy and Job Segre-

As a consequence of their biological capacity to reproduce and their roles within patriarchy of caring for and nurturing the family, women are seen as being close to nature. As Sherry Ortner has argued, "female is to male as nature is to culture."[10] Even women designers, who through the design process transform nature into culture, are tied to their biology by patriarchal ideology, which defines their design skills as a product of their sex – as natural or innate. Women are considered to possess sex-specific skills that determine their design abilities; they are apparently dexterous, decorative, and meticulous. These skills mean that women are considered to be naturally suited to certain areas of design production, namely, the so-called decorative arts, including such work as jewelry, embroidery, graphic illustration, weaving, knitting, pottery, and dressmaking. Linking all these activities together is the notion that they are naturally female; the resulting design products are either worn by women or produced by them to fulfill essentially domestic tasks. Significantly, men can be the designers of clothes, textiles, or pottery, but first the design activities have to be redefined. Dressmaking, for example, has been seen as a "natural" area for women to work in. It is viewed as an obvious vehicle for their femininity, their desire to decorate, and their obsession with appearances. Fashion design, however, has been appropriated by male designers who have assumed the persona of genius – Christian Dior, Yves Saint Laurent, and, more recently, Karl Lagerfeld. Fashion as a design process is thought to transcend the sex-specific skills of dexterity, patience, and decorativeness associated with dressmaking. Instead, it involves creative imagination, and the aggressive business and marketing skills that are part of the male stereotype.

This practice of defining women's design skills in terms of their biology is reinforced by socially constructed notions of masculine and feminine, which assign different characteristics to male and female. Sonia Delaunay, the painter and designer, is noted by historians for her "instinctive" feeling for color, whereas her husband, Robert, is attributed as having formulated a color theory. Robert Delaunay embodies the male stereotype as logical and intellectual, Sonia embodies the female stereotype as instinctive and emotional. To compound this devaluation of women designers' work, designs produced by women in the domestic environment (their natural space within a patriarchy) are seen to represent use-value rather than exchange-value. The designs produced by women in a domestic environment (embroidery, knitting, and appliqué) are used by the family in the home rather than exchanged for profit within the capitalist marketplace. At this point capitalism and patriarchy interact to devalue this type of design; essentially, it has been made in the wrong place – the home, and for the wrong market – the family.[11]

So, one result of the interaction of patriarchy and design is the

gation by Sex," in Martha Blaxall and Barbara Regan, *Women and the Workplace: The Implications of Occupational Segregation* (Chicago: University of Chicago Press, 1976), 137-169. Also, Rowbotham, "The Trouble with Patriarchy," 970-971.

10) Sherry B. Ortner, "Is Female to Male as Nature is to Culture?" *Feminist Studies* 2 (Fall 1972): 5-31.

11) See Parker and Pollock, *Old Mistresses*, 68-71, for an interesting account of how women's domestic designs can be upgraded to fine art status by dissociating them from home production and the gender of the maker.

12) Fewer than one percent of industrial designers working in Britain today are women. From research carried out by the Design Innovation Group, Open University, Milton Keynes, Britain, from 1979 onward.

establishment of a hierarchy of value and skill based on sex. This is legitimized ideologically by dominant notions of femininity and materially by institutional practice. British art and design education at degree level, for example, reinforces this hierarchical and sexist split between male and female design activities. Because of sexism few women industrial design students survive to the end of their courses which are outside the female stereotype. They succeed well with fashion and textile courses which are considered to be suited to female abilities, but fare badly with industrial design, which is considered male.[12]

Design historians play an important role in maintaining assumptions about the roles and abilities of women designers by their failure to acknowledge the governance of patriarchy and its operation historically. As a result, women's design is ignored and unrepresented in the history books. Clearly, then, one of the main issues for historians to tackle, if they are to account adequately for the role of women designers, is patriarchy and its value systems. First, the terms by which inferior status is assigned to certain design activities must be analyzed and challenged. The ideological nature of terms such as feminine, delicate, and decorative should be acknowledged within the context of women's design. Second, it is crucial that design historians recognize the patriarchal basis of the sexual division of labor, which attributes to women certain design skills on the basis of biology. Third, they must acknowledge that women and their designs fulfill a critical structuring role in design history in that they provide the negative to the male positive – they occupy the space left by men. If, for instance, historians describe men's designs as bold, assertive, calculated, then women's designs are described as weak, spontaneous, or lacking in rationale. Design historians, then, should recognize that "because of the economic, social, and ideological effects of sexual difference in a western, patriarchal culture, women have spoken and

13) Parker and Pollock, *Old Mistresses*, 49.

acted from a different place within that society and culture."[13] By their failure to acknowledge patriarchy, design historians ignore the real nature of women's role in design, both for women designing outside of mainstream industrial design and for those few who have found employment within it. Both produce designs formed within patriarchy. Fourth, historians must take note of the value system which gives privilege to exchange-value over use-value, because at a very simple level, as Elizabeth Bird has pointed out, "the objects women produce have been consumed by being used, rather than preserved as a store of exchange-value. Pots get broken and textiles wear out."[14]

14) Elizabeth Bird, "Threading the Beads: Women Designers and the Glasgow Style 1890-1920," unpublished conference paper, 1983.

Historians must also beware of regarding the professional site of production more highly than the domestic site of production, because this inevitably leads to a focus on the value of design as it contributes to the capitalist system. This is problematic, irrespective of the sex of the designer, as it excludes an important area of

CHERYL BUCKLEY

design production from history. Finally, historians should heed Sheila Rowbotham's point, in *Hidden From History*: "[U]nbiased history simply makes no declaration of its bias, which is deeply rooted in existing society reflecting the views of the people of influence."[15]

Central to a feminist critique of design history is a redefinition of what constitutes design. To date, design historians have esteemed more highly and deemed more worthy of analysis the creators of mass-produced objects. Subsequently, they have argued that "design history . . . is a study of mass-produced objects."[16] Feminists have challenged this definition as prejudging the nature of design by emphasizing only one mode of production and thereby excluding craft production. This challenge is complicated by the development of craft history as an academic discipline distinct from design history, although, to date, craft historians have not dealt adequately with women's craftwork.[17] In fact, it has been dealt with in a cursory way and mirrors the approach of design historians by seizing upon a few famous names.[18] Arguably, if a feminist approach to women's design production is to be articulated, it must cut across these exclusive definitions of design and craft to show that women used craft modes of production for specific reasons, not merely because they were biologically predisposed toward them. To exclude craft from design history is, in effect, to exclude from design history much of what women designed. For many women, craft modes of production were the only means of production available, because they had access neither to the factories of the new industrial system nor to the training offered by the new design schools. Indeed, craft allowed women an opportunity to express their creative and artistic skills outside of the male-dominated design profession. As a mode of production, it was easily adapted to the domestic setting and therefore compatible with traditional female roles.[19]

Women as consumers and objects

To date, most historical analysis has dealt solely with the role of women designers, even though women interact with design in a variety of ways. Feminist design historians have thereby adopted the methodologies of mainstream design history, which esteems the activities of designers and emphasizes their role as agents of history. (As I describe in the next section, there are serious problems inherent in this methodological technique.) Most important for this discussion is the point that design is a collective process involving groups of people beside the designer. In order to determine the meaning of a given design at a specific historical moment, it is necessary to examine these other groups.

Probably the most historically neglected group is the consumer; indeed, it can be no accident that the consumer is often perceived by design organizations, retailers, and advertisers to be female.

15) Rowbotham, *Hidden From History*, xvii.

16) Attributed to Penny Sparke in Anne Massey's review of the 1983 Women in Design conference at the Institute of Contemporary Arts, London, in *Design History Society Newsletter* 20 (January 1984): 8. This view has been reinforced by Stephen Bayley, director of the Boilerhouse project at the Victoria and Albert Museum, London, and is quoted by Judy Attfield in "Feminist Designs on Design History," *Feminist Art News* 2 (No. 3): 22. More recently, Clive Dilnot has addressed the issue of the diversity of meanings of design and the designer. See "The State of Design History, Part I: Mapping the Field," *Design Issues* I/1 (Spring 1984): 4-23, and "The State of Design History, Part II: Problems and Possibilities," *Design Issues* I/2 (Fall 1984): 3-20.

17) In his discussion of craft history, Philip Wood does not consider the issue of gender. See Philip Wood, "Defining Craft History," *Design History Society Newsletter* 24 (February 1985): 27-31.

18) This can be seen in two ways. First, Edward Lucie-Smith, in his survey book *The Story of Craft* (London: Phaidon, 1981) makes few references to women beyond the usual handful, for example, Vanessa Bell, Marion Dorn, Elizabeth Fritsch, Jessie Newberry. Second, some craft historians, like their colleagues in design history, have written monographs of major women craftpersons. For example, see Margot Coatts, *A Weaver's Life: Ethel Mairet 1872-1952* (London: Crafts Council, 1983). Although such a monograph is informative and provides a much needed account of the work of an important woman craftworker, as I explain later, the monograph is a problematic vehicle for writing design or craft history.

19) This is especially true of textiles (knitted, woven, quilted, appliqued, and embroidered). Some women, however, such as Katherine Pleydell Bouverie and Norah Bradon (contemporaries of Michael Cardew and Bernard Leach in the British studio pottery movement) or Jessie Newberry and May Morris, developed craft modes of production for philosophical reasons. These women had the financial independence, social background, and educational training to do so.

20) Heidi Hartmann, "The Unhappy Marriage of Marxism and Feminism: Toward a More Progressive Union," in Lydia Sargent, *Women and Revolution. The Unhappy Marriage of Marxism and Feminism* (London: Pluto Press, 1981), 16.

21) A good illustration of this process of flux can be seen during wartime when female labor is required to meet the shortages resulting from male conscription. Women are employed in work normally considered the preserve of men, for example engineering, ship-building, munitions. In peacetime this process is reversed, and women are encouraged back into the traditional female roles of housewives and mothers as prescribed by patriarchy.

22) For example, John Ruskin, *Sesame and Lilies*, (London: Collins, 1913). More recently, successive British governments have reiterated the importance of the woman's role in the preservation of the family. For example, the Conservative party social services spokesman, Patrick Jenkin, told the Conservative annual conference in 1977, "the pressure on young wives to go out to work devalues motherhood itself. . . . Parenthood is a very skilled task indeed, and it must be our aim to restore it to the place of honour it deserves." Quoted from Anna Coote and Beatrix Campbell, *Sweet Freedom: The Struggle for Women's Liberation* (London: Picador, 1982), 85.

23) Banham, *Theory and Design in the First Machine Age*, 10.

24) Philippa Goodall, "Design and Gender," *Block* 9 (1983): 50-61.

Just as patriarchy informs the historian's assumptions about women designers' skills, so it defines the designer's perceptions of women's needs as consumers. Two basic ideas inform the designer's assumptions about women consumers. First, women's primary role is in domestic service to husband, children, and home; and second, domestic appliances make women's lives easier. The first assumption stems from the central classification of patriarchy – the sexual division of labor. As Heidi Hartmann has argued, "the sexual division of labor is . . . the underpinning of sexual subcultures in which men and women experience life differently; it is the material base of male power which is exercised (in our society), not just in not doing housework and in securing superior employment, but psychologically as well."[20] According to Hartmann, the sexual division of labor is not static, but in a state of flux, changing as required by economic, political, and social developments.[21] A relatively constant feature of the sexual division of labor, however, is the delineation of women's role as housewives and as carers for the family. This role is basically the same one that the Victorian social critic John Ruskin identified and glorified in his writings.[22] As a result of this sexual division of labor, designers assume that women are the sole users of home appliances. Product advertising presents women as housewives who use domestic appliances and family-oriented products. When British advertisers make the rare representation of women driving motorcars, it is significant that they are not shown speeding along in a Porsche. Rather, they are shown parking their modest and convenient hatchback near the supermarket.

Design historians have played their part in reinforcing women's position in the sexual division of labor. In Reyner Banham's well-known celebration of the first machine age, he identified two sexes – men and housewives. Banham defined the female sex as housewives whose lives are transformed by "woman-controlled machinery," such as vacuum cleaners.[23] Informing this paean to woman-controlled appliances is the belief that these products make women's lives easier. Banham, like other historians and theorists of design, fails to acknowledge that designs take on different meanings for the consumer than those designated by the designer, the manufacturer, and the advertiser. Philippa Goodall has outlined the reasons for these shifts of meaning.[24] She cites the microwave oven and freezer as products designed ostensibly to lighten household chores but which have ultimately created more work. Both products have been widely introduced into the home under the pretext of convenience. The question, however, is convenience for whom – the housewife or the family? Convenience to the family means having rapid access to food at all times. To the housewife, this is not convenience. It is instead a duty, a duty to provide food at all times, even when the shops are shut or the market closed and most of the family has already eaten. Goodall

CHERYL BUCKLEY

argues that, "In numerous such ways women's work is increased, the qualitative demands raised. The tyranny of the whiter-than-white-wash is now for many a daily event, rather than a weekly one. 'Simplicity,' 'convenience,' 'serving the loved ones better' are slogans motivating and directing our work as consumers and producers."[25]

25) Goodall, "Design and Gender", 53.

Advertising serves to enforce the meaning of design as defined by the designer or manufacturer. It stereotypes women as mothers, cleaners, cooks, and nurses in order to define and direct the market. In effect, the category *woman*, as constituted in patriarchy, is appropriated by advertising. *Woman* is either the *subject* of patriarchal assumptions about women's role and needs as consumers, or the *object* in sexist advertising. As Jane Root has argued in relation to representations of women in TV advertising, "Women are often made absurdly ecstatic by very simple products, as though a new brand of floor cleaner or deodorant really could make all the difference to a lifetime."[26] Advertising creates both an ideal use for a product and an ideal user. The actuality of the use and user are unimportant when confronted with a powerful fantasy – the immaculate designer kitchen with superwoman in control, combining with ease the roles of careerist and perfect wife. Like television and cinema, advertising appropriates women's bodies. Women are objects to be viewed; they are sexualized things whose status is determined by how they look. "These advertisements help to endorse the powerful male attitude that women are passive bodies to be endlessly looked at, waiting to have their sexual attractiveness matched with active male sexual desire."[27]

26) Jane Root, *Pictures of Women: Sexuality* (London: Pandora Press, 1984), 55.

27) Root, *Pictures of Women: Sexuality*, 68.

It is clear that analyses of patriarchy and the issue of gender are central to the debate concerning women's role in design.[28] Historians should map out the operation of patriarchy and make gender as a social construct distinct from sex as a biological condition. Gender is embodied in historical and contemporary representations of women as consumers, objects, and designers; but it does not remain fixed, having changed historically. They must remember that as a consequence of patriarchy, the experiences of male and female designers and consumers have been quite different. Design historians should outline the way that patriarchal definitions of women's roles and design needs, which have originated in the sexual division of labor, have shaped design in the past and present. A feminist critique of design history must confront the problem of patriarchy, at the same time addressing itself to the exclusion of women in the historiographic methods used by design historians. Though many of these methods are problematic for design history in general, not just a feminist design history, feminist intervention, as in other disciplines, has demarcated the basic ones. Rozsika Parker described them as "the rules of the game."[29]

28) See Millet, *Sexual Politics*, 29-31, for discussion of gender.

29) Quoted by Pollock in "Vision, Voice and Power," 5.

The rules of the game

Methodologically, the pivot of contemporary design history is the designer, whose central role has been legitimized by art historical precedent in which the figure of the artist is all-important. Some art historians, such as Nicos Hadjinicolaou, T. J. Clark, and Griselda Pollock, have noted that; the last wrote, "The central figure of art historical discourse is the artist, who is presented as an ineffable ideal which complements the bourgeois myth of a universal, classless man . . . our general culture is furthermore permeated with ideas about the individual nature of creativity, how genius will always overcome social obstacles."[30]

30) Pollock, "Vision, Voice and Power," 3.

Numerous biographies of designers have focused the production and meaning of design on the contribution of the individual. In this approach, design history mirrors art history in its role as attributor and authenticator. First, it attaches meaning to a name, thereby simplifying the historical process (by de-emphasizing production and consumption) and at the same time making the role of the individual all-important (by aiding and simplifying attribution). Second, as a direct consequence of this first strategy, historians have analyzed the design in terms of the designers' ideas and intentions and in terms of the formal arrangement of elements (just as formalist art history analyzes a painting or sculpture), rather than as a social product. The design is thereby isolated from its material origins and function, and if it conforms to dominant definitions of "good" design, it and its designer are obvious candidates for the history books. At this point, the design has been firmly positioned within the confines of the individual designer's oeuvre, aiding attribution and authentication of the design as art object and simplifying historical analysis.[31] The history of design is reduced to a history of the designer, and the design is seen to mean and represent what the designer identifies. Extraordinary designs are judged in terms of creativity and individual extraordinariness. This is problematic for women, because "creativity has been appropriated as an ideological component of masculinity, while femininity has been constructed as man's and, therefore, the artist's negative."[32]

31) Note the saleroom prices of design objects, especially the "classics," such as furniture by Charles R. Mackintosh or pottery by Keith Murray.

32) Pollock, "Vision, Voice and Power," 4.

The notion that the meaning of design objects is singular and is determined by the designer is simplistic, ignoring the fact that design is a process of representation. It represents political, economic, and cultural power and values within the different spaces occupied, through engagement with different subjects. Its meaning is therefore polysemic and involves the interaction of design and recipient. Designs, as cultural products, have meanings encoded in them which are decoded by producers, advertisers, and consumers according to their own cultural codes. "All these codes and subcodes are applied to the message in the light of general framework of cultural references; in other words, the way the message is read depends on the receiver's own cultural codes."[33]

33) Janet Wolff, *The Social Production of Art* (London: Macmillan, 1981), 109.

CHERYL BUCKLEY

These cultural codes are not absolute and are not controlled by the designer's intentions. Indeed, these intentions are constrained by the existing codes of form and representation, which shape cultural products. In effect, the designer has to use these to design. The dominant codes of design are both esthetic and social; the former "operate as mediating influences between ideology and particular works by interposing themselves as sets of rules and conventions which shape cultural products and which must be used by artists and cultural producers;"[34] the latter are governed by modes of production, circulation, and use within a specific social situation. The codes or signs by which design is understood and constituted, in an industrial, capitalist society such as our own, are the product of bourgeois, patriarchal ideology. This ideology seeks to obscure its codes by presenting its designs as neutral and ideology-free and the receiver of these codes as universally constituted, that is, the singular and unproblematic user or producer. "[T]he reluctance to declare its codes characterizes bourgeois society and the culture issuing from it; both demand signs which do not look like signs."[35] This obscureness presents problems for the historian who attempts to take account of the designer or consumer as gendered individuals with specific class allegiances who then bring particular sets of meaning to designs.

The focus on the designer as the person who assigns meaning to design is seriously challenged by developments in the fields of sociology, film studies, and linguistics, where debates on authorship have arisen. These critiques have questioned the centrality of the author as a fixed point of meaning. As Roland Barthes put it, "A text's unity lies not in its origins but in its destination . . . the birth of the reader must be at the cost of the death of the author."[36] The centrality of the designer as the person who determines meaning in design is undermined by the complex nature of design development, production, and consumption, a process involving numerous people who precede the act of production, others who mediate between production and consumption, and those who use the design. The success or failure of a designer's initial concept depends on the existence of agencies and organizations which can facilitate the development, manufacture, and retailing of a specific design for a distinct market. Design, then, is a collective process; its meaning can only be determined by an examination of the interaction of individuals, groups, and organizations within specific societal structures.

The monograph, the primary method used by historians to focus on the designer, is an inadequate vehicle for exploring the complexity of design production and consumption. It is especially inadequate for feminist design historians in that the concentration on an individual designer excludes from the history books unnamed, unattributed, or collectively produced design. Historical casualties of this exclusion are the numerous craft works produced

34) Wolff, *The Social Production of Art,* 64-65.

35) Roland Barthes, "Introduction to the Structural Analysis of Narratives," *Image, Music, Text* (New York: Hill and Wang, 1977), 116.

36) Barthes, "The Death of the Author," *Image, Music, Text,* 148.

37) This type of craftwork is still produced by women today; note particularly the production of knitted textiles in Britain.

38) Here I do not intend to deny the possibility of an autonomous realm of creativity; rather, I want to suggest that the designers' meanings are combined with a series of meanings gained from the interaction of the design with other groups and agencies. To understand design at a specific historical moment requires rather more from the historian than an analysis of what the designer thought.

39) Goodall, "Design and Gender," 50.

40) Matrix, *Making Space: Women and the Man-Made Environment* (London: Pluto Press, 1984), 47.

41) Matrix, *Making Space*, 11.

by women in their own homes, often in collaboration with other women.[37] Nor can women's relationship with design as consumers and as objects of representation figure in the construction of the monograph. The recent critiques of authorship have proved useful to feminist design historians by highlighting the inadequacy of the monograph as a method of analyzing design and by showing that designers do not design merely by courtesy of innate genius, but that they have been constituted in language, ideology, and social relations. The designer can usefully be considered as the first of many who will affix meaning to design.[38]

From this discussion emerge two other important points for analyzing women's relationship to design. First, women's cultural codes are produced within the context of patriarchy. Their expectations, needs, and desires as both designers and consumers are constructed within a patriarchy which, as I have argued, prescribes a subservient and dependent role to women. The other side of that point is that the codes of design, as used by the designer, are produced within patriarchy to express the needs of the dominant group. They are, therefore, male codes. As Philippa Goodall has observed, "We live in a world designed by men. It is not for nothing that the expression 'man-made' refers to a vast range of objects that have been fashioned from physical material."[39] In *Making Space: Women and the Man-Made Environment*, the Matrix group of feminist architects argue that male architects and planners design urban and domestic spaces using a language which defines women's role according to patriarchal values: "[T]he physical patterning of this 'natural' setting contains many assumptions about women's role outside the home. It leads, for instance, to housing layouts based on 'rural' meandering paths which imply that the journeys of women . . . are without presence. . . . The implication is that journeys that are not fast or in straight lines are not really going anywhere."[40] Matrix point out that this patriarchal design language has implications for women training to be architects, as well as for those who use buildings. Women architects are expected to adopt values and codes of form and representation formulated within the context of patriarchy. They are expected to "acquire an outlook similar to that of middle-class males, the dominant group in the architectural profession."[41]

The second point is this: to legitimize this process of cultural coding, the language of design is presented as a universal truth. Exclusive definitions of good and bad design are constructed, based almost entirely on esthetics. These definitions serve to isolate design products from the material and ideological conditions of production and consumption. Inevitably, these definitions also serve the interests of the dominant group, which attempts to disguise its interests with the mask of universality. Design historians have played a central role in the acceptance and reiteration of these definitions of good design, presenting them as unproblematic. As

42) Rosalind Coward, *Female Desire: Women's Sexuality Today* (London: Virago, 1984), 65.

43) See, for example, Pierre Bourdieu, "The Aristocracy of Culture," *Media, Culture and Society* 2 (1980): 225-254; also, Pierre Bourdieu, *Distinction* (London: Routledge and Kegan Paul, 1979).

Rosalind Coward explained, these are in fact "nothing other than the individual expression of general class taste and the particular ideas promoted in that class."[42] Pierre Bourdieu has argued that taste is determined through specific social conditions, such as education level, social class, and gender.[43] He has shown that dominant groups retain their positions of power and enhance their status by specific mechanisms, one of which is to invent the "esthetic" category as a universal entity.

The esthetic theory which informed these dominant notions of good design and good taste, and which legitimized the analysis of design as distinct objects, was modernism. The theory of modernism has had an enormous impact on design history by emphasizing both formal and technical innovation and experimentation as the significant features of design. Although designers now operate in a postmodernist context, many design historians unconsciously adopt modernist criteria when deciding what should enter the history books. The concept of differentness is still privileged by historians, thus revealing the structural relationship between historians and the designs they promote within capitalism. Innovative and new designs have a crucial role to play in capitalist production, a system that demands greater production and consumption stimulated by designer-created difference and codified by design historians and theorists.

44) This type of historical account does exist at the level of doctoral theses. Unfortunately, they rarely seem to get published. More recently, there is some evidence that things are changing, for example Fran Hannah's book *Ceramics* (London: Bell and Hyman, 1986).

45) Consider, for example, the work of the women designers at Josiah Wedgwood and Sons in the 1920s and 1930s. These designers produced work ranging in its style of decoration and shape from traditional to moderne. Most historians have given these designers little acknowledgment in the history books, choosing instead to concentrate on the formally and technically innovative work of the designer Keith Murray, whose work fits neatly into a modernist analysis of pottery design.

46) This point must be qualified in that several designers – notably Yves Saint Laurent and Karl Lagerfeld – have declared themselves to be uninterested in fashion and more interested in "classic" style. See the Metropolitan Museum of Art catalog, *Yves Saint Laurent* (New York, 1983), 17. The implications of this are clear: These designers are distancing themselves from the transitory nature of fashion and are instead aligning themselves with universal style and good taste.

47) See Elizabeth Wilson, *Adorned in Dreams: Fashion and Modernity* (Lon-

The theory of modernism has had significant implications for historical evaluations of both mass-produced design, which is traditional in style, form, material, or production techniques, and for craft. These evaluations are largely nonexistent because design that is not innovative and experimental has rarely been analyzed by design historians.[44] Women's design, which often falls under the label of traditional, has been especially ignored.[45] Another area of design associated with women to have fared badly in the hands of modernist design historians is fashion design, arguably the most extreme manifestation of modernism, in that throughout the twentieth century it has been continuously innovative and experimental. Like modernist art and design, its meaning is tied to that of its predecessors. It is therefore possible (though highly undesirable) to analyze fashion in purely formal terms, and here the problem lies. Unlike other modernist cultural forms, fashion makes no claims to represent universal truth and good taste.[46] Indeed, the converse is true, in that fashion subverts dominant notions of good design by eagerly accepting what was previously considered ugly. It undermines universal concepts of quality and taste, and it foregrounds the relativism in notions of beauty. Furthermore, fashion as an important area of design is trivialized because of its association with women. It is seen as a marginal design activity because it caters to women's socially constructed needs and desires.[47] For these reasons, design historians have tended to avoid the study of fashion.[48]

don: Virago, 1985), for a full discussion of these issues.

48) Note that fashion design is not included in any of the basic surveys of nineteenth- and twentieth-century design history, even though it is undoubtedly the product of social, technical, political, and cultural developments which parallel other areas of design.

49) See Isabelle Anscombe, *A Woman's Touch. Women in Design from 1860 to the Present Day* (London: Virago, 1984). This is an example of such an account. See my review in *Art History. Journal of the Association of Art Historians* Vol. 9, No. 3 (September 1986): 400-403.

Women and design as a subject of study highlights a whole set of issues and problems that must be confronted by historians if a feminist design history is to be articulated. The desire for a feminist design history grows increasingly urgent as we acknowledge the paucity of histories of women and design that have taken proper account of patriarchal notions of women's skills as designers, the stereotyped perceptions of women's needs as consumers, and the exploitative representation of women's bodies in advertising. It is crucial that these historical analyses of women and their relationship with design are based on feminism. Without recourse to feminist theory to delineate the operation of patriarchy, and to feminist history to map out women's past, it is impossible to understand fully the way women interact with design and the way historians have recorded that interaction. Attempts to analyze women's involvement in design that do not take issue with gender, the sexual division of labor, assumptions about femininity, and the hierarchy that exists in design, are doomed to failure.[49]

Feminist design historians must advance on two fronts. First, we must analyze the material and ideological operation of patriarchy in relation to women and design. This effort must be combined with an examination of the relationship between capitalism (if we are discussing design in capitalist societies) and patriarchy at specific historical conjunctures to reveal how women's role in design is defined. Second, we must critically assess "the rules of the game" to understand why design historians have excluded women from the history books, and then to enable us to develop a history that does not automatically exclude women. This history must acknowledge the various locales where design operated and the various groups involved with its production and consumption. It must reject the temptation to analyze the individual designer as sole determiner of meaning in design. Finally, historians must not lose sight of their central objective: To develop and expand the body of historical research which seeks to account for women's relationship to design and then set this research firmly within a historical framework of feminist design.

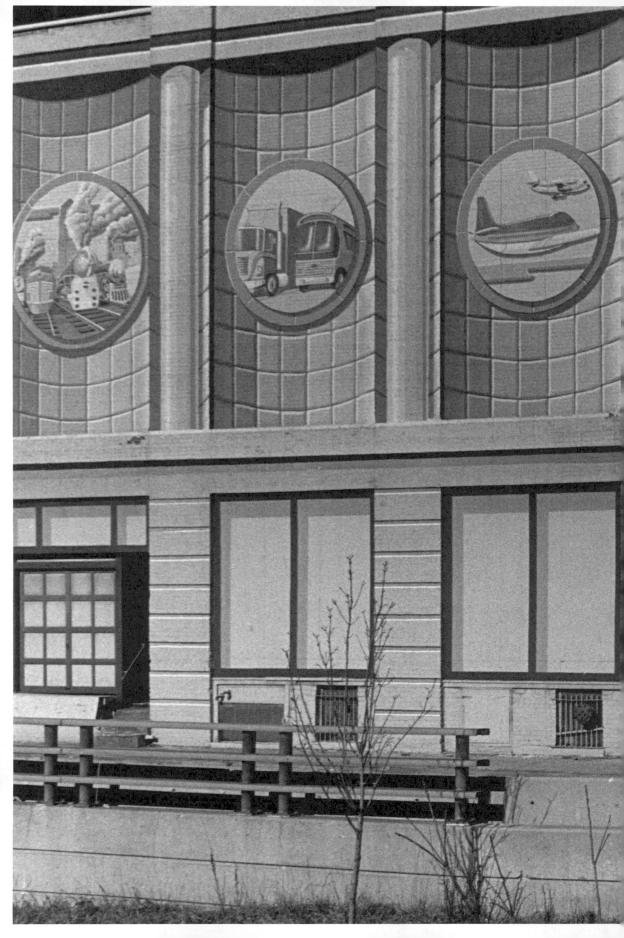

Victor Margolin

Postwar Design Literature:
A Preliminary Mapping

My intention in this essay is to present the many strands of design writing as they have developed since the end of World War II. I have used the war's end as a watershed because I believe it marks the commencement of a new historical phase in which many of the forces that shape our present economy and culture became dominant. These include pervasive advertising, television, life-threatening technology, a realignment of developed, developing, and underdeveloped nations, the swift international circulation of capital, the staking out of global markets, the rise in consumer expectations, the breakdown of distinctions between high and popular culture, and a new wave of intelligent machines.

During this period, design writing has also changed drastically and has come to challenge the often reductive and uncritical assumptions that were espoused by the prewar modernists and their postwar followers. Current writing about design expresses a multitude of tensions, resistances, and alternatives. Neither optimists nor pessimists are ascendant. We live in a time of questioning; certainties are not always unequivocally espoused. The diversity of contemporary thought about designing and design has finally brought to the surface many issues that had been previously repressed or set aside.

Bibliographies that simply list titles, even if they are annotated, never convey the drama of the way in which new ideas develop, nor do they enable the reader to locate the texts spatially, to see them in relation to other texts. I have therefore woven my citations into a narrative that groups texts by geography, where pertinent; by historical moments; and by intentions, where possible. This essay therefore provides some sense of national differences in design thinking and pinpoints those geographic centers where it has been most intense. Encountering the citations in a historic framework, the prospective reader can more easily see connections between them and get some sense of their place in the unfolding of various postwar design discourses.

This mapping is extremely preliminary and I make no claim to comprehensiveness. For the sake of manageability, I have concentrated on books rather than on the myriad articles in design magazines and journals, although I do mention some of these. In general,

I have included only English translations. Therefore, the present essay does not give a complete sense of all the books that have shaped design thinking in a particular milieu, since many of them are translations. It does, however, delineate the kinds of texts that were and are being produced in different places.

While most of the books were written by designers and critics or are about designing, a growing body of literature is not specifically about design practice but about design as a cultural activity which provides evidence of how people live. Increasingly, scholars from fields such as anthropology, psychology, sociology, and esthetics are addressing questions in their research that are related to design. This is clearly a postwar phenomenon, and one that has become particularly evident in the past twenty years.

Most of the texts I have cited were produced in only a few countries. A number of books have been translated and distributed in other parts of the world, but many have not–their influence remains within their own linguistic sphere. Thus, there is still a German debate as well as an Italian and a Polish one, although they are infused by writing from abroad. As more books and articles are widely translated, these debates will become increasingly international.

The United States: Good Design and its Critics

Beginning in the late 1930s, a number of European designers associated with the avant-garde and the modern movement came to the United States. In Chicago, László Moholy-Nagy was the director of the New Bauhaus, which, after several incarnations, became the Institute of Design.[1] He brought Gyorgy Kepes, a Hungarian colleague, to teach there, and Kepes became the first author in a new series of design and architecture books that was originally published by Paul Theobald, a Chicago bookseller, and later by his wife Lola.[2] Books in this series included Kepes's *Language of Vision* (Chicago: Paul Theobald, 1944); Moholy-Nagy's *Vision in Motion* (1947); Joshua Gordon Lippincott's *Design for Business* (1947); Bernard Rudofsky's *Are Clothes Modern?: An Essay on Contemporary Apparel* (1947); *Seven Designers Look at Trademark Design*, edited by Egbert Jacobson (1952); editor Gyorgy Kepes's *The New Landscape in Art and Science* (1956); and Paul Jacques Grillo's *What is Design?* (1960). Although the books by Kepes and Moholy-Nagy, to some degree, set European modernist thinking into an American framework, those by Lippincott, Jacobson, Rudofsky, and Grillo did not embody that philosophy nor were they consistent with each other.

Kepes eventually left Chicago and began to teach at the Massachusetts Institute of Technology. There he founded the Center for Advanced Studies in the Visual Arts, where he and others explored the relation between art and technology. Kepes edited seven books in a series entitled *Vision + Value* which was published by George Braziller in New York: *Education of Vision* (1965), *The Nature and Art of Motion* (1965), *Structure in Art and Science* (1965), *The*

1) The first American publication of a book by Moholy-Nagy was *The New Vision: From Material to Architecture* (1932), a translation of his second Bauhaus book, *Vom Material zu Architektur*. It subsequently reappeared in several revised editions: *The New Vision: Fundamentals of Design, Painting, Sculpture, and Architecture* (1938) and *The New Vision and Abstract of an Artist* (1947). Some years later, an English translation of Moholy-Nagy's first Bauhaus book, *Malerei, Fotographie, Film* was published as *Painting, Photography, Film* (Cambridge: MIT Press, 1969).

2) For a history of Paul Theobald and Company, see Victor Margolin, "Paul Theobald: Publisher With a New Vision," *Printing History* 9, no. 2 (1987): 33-38.

Man-Made Object (1966), *Module, Proportion, Symmetry, Rhythm* (1966), *Sign, Image, Symbol* (1966), and *Arts of the Environment* (1972). One significant contribution of the *Vision + Value* series was that it helped to familiarize Americans with the work of European design theorists such as Gillo Dorfles and Tomás Maldonado.

The writing of European designers was more theoretically inclined than that of the Americans in the early postwar period. The few books published by American designers in the 1950s were based on experience, intuition, and sometimes self-promotion. Before the war, works such as Norman Bel Geddes's *Horizons* (1932), Walter Dorwin Teague's *Design This Day: The Technique of Order in the Machine Age* (1940), and Raymond Loewy's *The Locomotive: Its Esthetics* (1937) optimistically promoted the contribution of design to a streamlined, mechanized future. After the war, Loewy, who, with Bel Geddes, had pioneered the image of the consultant designer as a celebrity, published his autobiography, *Never Leave Well Enough Alone* (New York: Simon and Schuster, 1951). In 1955 Henry Dreyfuss, another consultant designer who began to work in the 1930s, published *Designing for People* (New York: Simon and Schuster, 1955),[3] in which he recounted his experiences as an industrial designer while also attempting to explain his own principles of practice. There was a strong element of self-promotion in Dreyfuss's book, but he was noted for his sense of responsibility to the product user, and he did promulgate standards for other designers to consider.

Unlike the consultant designers of the 1930s, George Nelson studied architecture before he began to work as an industrial designer, and his early writing was on architectural subjects. Shortly after the war, Nelson and Henry Wright published *Tomorrow's House: A Complete Guide for the Home-Builder* (New York: Simon and Schuster, 1946), which advocated the application of modern design to the home. Nelson also published two books of essays, *Problems of Design* (New York: Whitney Library of Design, 1957) and *George Nelson on Design* (New York: Whitney Library of Design, 1979). He was a pragmatist who believed that good design could make a contribution to quality of life and he promoted its value. In a similar vein, the graphic designer Paul Rand published *Thoughts on Design* (New York: George Wittenborn, 1947), in which he introduced a set of modern principles for advertising design. Like Kepes's *Language of Vision*, Rand's book was one of the few that related graphic design to modern art rather than presenting it in terms of traditional layout techniques.

After the war, the Museum of Modern Art pursued its role as the leading propagator of a functional design esthetic based on the geometric and organic examples of the European avant-garde. Edgar Kaufmann, Jr., who started to work in the museum's new industrial design department in the early 1940s, published a statement of principles entitled "What is Modern Industrial Design?" in *The Bulletin*

3) A revised edition of Dreyfuss's book was brought out by Grossman Publishers in 1967 and issued as a paperback in 1974 by Viking Compass.

of the Museum of Modern Art 14, no. 1 (Fall 1946). This was a prelude to his essay, "Introduction to Modern Design" (1950) and to his manifesto, "What is Modern Design?" (1950).[4] The phrase, "In the collection of the Museum of Modern Art" continues to be an assertion of quality due to the design department's heavy promotion of its position. The attempt to make the museum's own taste the basis for contemporary design standards is evident in Arthur Drexler and Greta Daniel's *Introduction to 20th Century Design from the Collection of the Museum of Modern Art* (New York: Museum of Modern Art, 1959).

The International Design Conference, first held in 1951 in Aspen, Colorado, was motivated by the same impulse to promote design quality as was found in the Museum of Modern Art's Good Design exhibitions of the early 1950s, or in the writings of Dreyfuss, Nelson, Rand, or Kaufmann. Originally oriented toward businessmen, the annual Aspen forum eventually represented radical and controversial opinions as well. C. Wright Mills, the sociologist, sharply criticized industrial design in a talk which was later published as "The Designer: Man in the Middle," in *Power, Politics, and People: The Collected Essays of C. Wright Mills*, edited by Irving Louis Horowitz (New York: Oxford University Press, 1963). Other talks from Aspen can be found in *The Aspen Papers: Twenty Years of Design Theory from the International Design Conference in Aspen*, edited by Rayner Banham (New York: Praeger, 1974).[5]

The International Design Conference may also have inspired some of the books that promoted the value of design to a popular audience from the 1960s on. These include *Who Builds America?* edited by Laurence B. Holland (New York: Anchor Books, 1966); Richard Saul Wurman, Ralph Caplan, Peter Bradford, and Jane Clark, *The Design Necessity* (Cambridge and London: MIT Press, 1973); *The Art of Design Management: Design in American Business* (New York: Tiffany and Company, 1975); and Ralph Caplan's *By Design: Why There are no Locks on the Bathroom Doors in the Hotel Louis XIV and Other Object Lessons* (New York: St. Martin's Press, 1982).

Amidst the optimism of postwar prosperity in America, however, there were also critiques of excessive consumption, and particularly of the advertising industry, which authors such as Vance Packard held accountable for persuading people to buy things they didn't need. Packard mounted his strong attacks on American consumerism and the excessive use of resources in *The Hidden Persuaders* (New York: McKay, 1957) and *The Waste-Makers: A Startling Revelation of Planned Wastefulness* (New York: McKay, 1960). These polemical tracts were followed by Ralph Nader's exposé of deficiencies in American automobile design, *Unsafe at Any Speed: The Designed-in Dangers of the American Automobile* (New York: Grossman, 1965).[6]

The critiques of Packard showed some results in the 1960s, when

4) Both of these pieces were reprinted in Edgar Kaufmann, Jr., *Introduction to Modern Design. What is Modern Design? What is Modern Interior Design?* (New York: Arno Press, 1969). The history of the Museum of Modern Art's design polemic up to 1950 is presented in "Declaration of Function: Documents from the Museum of Modern Art's Design Crusade, 1933-1950," introduced by Sidney Lawrence, *Design Issues* 2, no. 1 (Spring 1985): 65-77.

5) The International Design Conference archives, which consist primarily of audiotapes rather than typed or printed texts, are now housed in the Robert Hunter Middleton Design Collection at the University of Illinois, Chicago.

6) A revised and expanded edition appeared in 1972.

VICTOR MARGOLIN

many young people rejected their elders' dreams of material prosperity and sought to build an alternative culture based on community life and reduced consumption. The model designer of this movement was R. Buckminster Fuller, the brilliant engineer who had tried to industrialize the American building industry in the late 1920s, and whose geodesic domes were widely adopted by many after initial applications by the U.S. Marine Corps and several large corporations. At Southern Illinois University, where he taught, Fuller helped to inaugurate the World Design Science Decade, 1965-1975. Prior to that, in 1963, Southern Illinois University began to publish documents by Fuller and others that were to lay the groundwork for their activities. First came R. Buckminster Fuller et al., *Inventory of World Resources: Human Trends and Needs* (Carbondale, Ill.: World Resources Inventory, 1963 [WDSD Phase-1963–document 1]), which was followed by Fuller's *The Design Initiative* (Carbondale: World Resources Inventory, 1964 [WDSD Phase 1-1964–document 2]). Other writings of Fuller's include *No More Secondhand God and Other Writings* (Carbondale: Southern Illinois University Press, 1963), *Operating Manual for Spaceship Earth* (Carbondale: Southern Illinois University Press, 1969), and *Utopia or Oblivion: The Prospects for Humanity* (New York: Overlook Press, 1972).

Fuller was also the inspiration for Stewart Brand's *The Whole Earth Catalog* (Menlo Park, Calif.: Portola Institute, 1969-1971), a semiannual publication dedicated to the tireless inventor and featuring a collection of low-tech tools for living, as well as publications intended to foster a multifaceted alternative lifestyle. In its representation of the artifacts or tools for such a lifestyle, the catalog was a counterdocument to Drexler and Daniel's catalog of elegant objects in the Museum of Modern Art's collection. The notion of tools rather than possessions was also central to Ivan Illich's *Tools for Conviviality* (New York: Harper and Row, 1973). Charles Jencks and Nathan Silver celebrated vernacular design and the resistance to professionalism in *Adhocism: The Case for Improvisation* (Garden City, N.Y.: Doubleday, 1972).

The book that was most important in the promotion of an alternative design ethic based on social needs rather than consumer demands was Victor Papanek's *Design for the Real World: Human Ecology and Social Change* (New York: Pantheon, 1972; Chicago: Academy Editions, 1985, 2d rev. ed.). Among the subsequent books by Papanek were *How Things Don't Work* (New York: Pantheon, 1977), which was coauthored with James Hennessey, and *Design for Human Scale* (New York: Van Nostrand Reinhold, 1983). Robert M. Pirsig's *Zen and the Art of Motorcycle Maintenance* (New York: William Morrow, 1974) was not explicitly about design but focused on the close relation between humans and machines, while Harry Petroski dealt with the design process in *To Engineer is Human: The Role of Failure in Successful Design* (New

York: St. Martin's Press, 1985). Donald Norman offered a profound critique of industrial design from the user's point of view, echoing the assertions of Papanek and Hennessey, in *The Psychology of Everyday Things* (New York: Basic Books, 1988).

West Germany: The Rationalist Revival and its Resistance

West Germany's foremost preoccupation after the war was to get its once-efficient industry running again. Wilhelm Braun-Feldweg was among the first to promote the contribution of design to industrial production in *Normen und Formen Industrieller Produktion* (Ravensburg: Maier, 1954). He followed this book with a number of others that extolled the virtues of industrial design to the public, and espoused his belief in "gute Form," the German version of the "good design" movement: *Gestaltete Umwelt: Haus, Raum, Werkform* (Berlin: Rembrandt Verlag, 1956), *Beiträge zur Formgebung* (Essen: Heyer, 1960), and *Industrial Design Heute: Umwelt aus der Fabrik* (Reinbeck bei Hamburg: Rowohlt, 1966). Other books that either promoted "gute Form" or stressed the importance of design in industry were Josef A. Thuma, *Schönheit der Technik–die gute Industrieform* (Stuttgart, 1955) and Udo Bauer, *Industrial Design* (Würzburg: Vogel, 1977), as well as Bernd Löbach's *Industrial Design: Grundlagen der Industrieproduktgestaltung* (München: Thiemig, 1976) and *Produktgestaltung: Auseinandersetzung mit Industrial Design* (Stuttgart, Metzler, 1981).

The first major attempt to develop a postwar design theory in West Germany came from the Hochschule für Gestaltung in Ulm, which opened its doors in 1955. Max Bill, the Swiss artist and designer, was its first director. Bill was hoping to continue the Bauhaus project of uniting art and industry, but this approach was opposed by Tomás Maldonado and others on the faculty. Bill resigned after a relatively short tenure and the school moved in a more theoretical and technological direction. Maldonado and Gui Bonsiepe were among the first to look at design from a semantic point of view, and Maldonado taught one of the first semiotics courses offered in a design school. Both he and Bonsiepe wrote articles for *Ulm*, the school's journal. Among those by Maldonado were "Communication and Semiotics," *Ulm* 5 (July 1959) and "Comments: Design-Objects and Art-Objects," *Ulm* 7 (January 1963); Bonsiepe's writings include "Visual/Verbal Rhetoric," *Ulm* 14/15/16 (December 1965) and "Semantic Analysis," *Ulm* 21 (April 1968).[7] An earlier version of Bonsiepe's article on visual rhetoric was published in England as "Persuasive Communication: Towards a Visual Rhetoric," *Uppercase* 5 (London: Whitefriars, 1961), and the same publication contained Maldonado's "Glossary of Semiotics."

A number of other books, all of which promoted rational planning and analysis as the basis for designing, were published by former Ulm faculty members, both in Germany and abroad. Martin Krampen, who taught psychology and design at the Hochschule für

7) For an analysis of the Hochschule für Gestaltung's philosophy as derived primarily from articles in the school's journal, see Kenneth Frampton, "Apropos Ulm: Curriculum and Critical Theory," *Oppositions* 3 (May 1974): 17-36. See also Herbert Lindinger, ed., *Die Morale der Gegenstände* (Berlin: Ernst and Sohn, 1988).

Gestaltung and later at the University of Waterloo in Canada, where he was involved with the Design Studies Group, edited two collections of conference papers from Waterloo, *Design and Planning* (New York: Hastings House, 1965) and, with Peter Seitz, *Design and Planning 2: Computers in Design and Communication* (New York: Hastings House, 1967). In "Signs and Symbols in Graphic Communication," *Design Quarterly* 62 (Minneapolis: Walker Art Center, 1965), Krampen continued the work on visual rhetoric that Maldonado and Bonsiepe had begun in Ulm. With Otl Aicher, one of the founders of the Hochschule and a professor of visual communication there, Krampen also wrote *Zeichensysteme der Visuellen Kommunikation: Handbuch für Designer, Architekten, Planer, Organisatoren* (Stuttgart: Verlags Anstalt Alexander Koch, 1977). Aicher is the author of *Kritik am Auto: Schwierege Verteidigung des Autos gegen seins Anbeter: Eine Analyse* (München: Callwey, 1984).

Until the Hochschule für Gestaltung closed in 1968, its faculty attempted to model design thinking on precedents in science and technology. Afterwards, other researchers continued to work on the problems of theory and methodology raised at Ulm. Max Bense explored the relation between information theory, semiotics, and esthetics in *Zeichen und Design: Semiotische Ästhetik* (Baden-Baden: Agis Verlag, 1971). Others focused more on design theory and planning methodology. Among the books published on these subjects, particularly during the 1970s, were B. E. Bürdek, *Design-Theorie: Methodische und Systematische Verfahren im Industrial Design* (Stuttgart, 1971) and *Einführung in die Designmethodologie* (Hamburg, 1975); V. Baehr and J. Kotik, *Gesellschaft–Bedürfnis–Design* (Ulm: Institut für Umwelt Planung, Universität Stuttgart, 1972 [IUP 4]); Siegfried Maser, *Einige Bemerkungen zu einer Theorie des Design* (Braunschweig, 1972; English ed. *A Few Comments on the Problem of a Design Theory* [Halifax: Nova Scotia College of Art and Design, 1979 (Design Papers 2)]); Friedrich G. Winter, *Planung oder Design: über die Chancen der Phantasie in einer sich wandelnden Gesellschaft* (Ravensburg: Maier, 1972); and Klaus Hohmann, *Produktdesign: Anleitung auf einem Methodischen Gesamtdesign* (Essen: Girardet, 1979).

But there were others in West Germany who opposed the development of systematic design and planning theories. The International Design Center (IDZ) in Berlin, founded in 1969, became a site for critical debates and exhibitions, many of which challenged the rationalist model of design theory. Among the publications that resulted from IDZ symposia were *Design? Umwelt wird in Frage gestellt* (Berlin: Internationales Design Zentrum, 1970) and *Mode-das Inszenierte Leben* (Berlin: Internationales Design Zentrum, 1974); Bernd Löbach and Helmut Schmidt, *Was ist Industrial Design?* (Berlin: Internationales Design Zentrum, 1977) and *Design-Theorien 1* (Berlin: Internationales Design Zentrum, 1978); *Design im Wandel: Chance für neue Produktionsweisen*, edited by Hans

Ulrich Reck (Berlin: Internationales Design Zentrum, 1985); *Stilwandel als Kulturtechnik, Kampfprinzip, Lebensform oder Systemstrategie in Werbung, Design, Architektur, Mode*, edited by Bazon Brock and Hans Ulrich Reck (Köln: DuMont, 1986); and *Design der Zukunft: Architektur–Design–Technik–Ökologie*, edited by Lucius Burkhardt (Köln: DuMont, 1987). Lucius Burkhardt is also the author and Bazon Brock the editor of *Die Kinder Fressen Ihre Revolution: Wohnen–Planen–Bauen–Grünen* (Köln: DuMont, 1985). Brock's theories are further developed in his book *Ästhetik als Vermittlung: Arbeitsbiographie eines Generalisten* (Köln: Fohrbeck, 1977) and in various articles that include "Umwelt und Sozio-Design," *Format* 36 (1972).

Another strand of the West German design debate is the strong Marxist critique of consumption, advertising, and elitist taste by Hermann K. Ehmer, Wolfgang Fritz Haug, Gert Selle, and others. Ehmer is the author of *Visuelle Kommunikation: Beiträge zur Kritik der Bewusstseinindustrie* (Köln: DuMont, 1971). Several related books on mass media, in which the power of the poster as a medium for social criticism is discussed, are Klaus Staeck and Ingeborg Karst's *Die Reichen Müssen Reicher Werden* (Reinbek bei Hamburg: Rowohlt, 1973) and Klaus Staeck and Dieter Adelmann, *Die Kunst Findet Nicht im Salle Statt: Politische Plakate* (Reinbek bei Hamburg: Rowohlt, 1976). Both of these books feature the political posters that Staeck produces himself and posts on the public hoardings.

Among Haug's books are *Kritik der Warenästhetik* (Frankfurt am Main: Suhrkamp Verlag, 1971; English ed. *Critique of Commodity Aesthetics: Appearance, Sexuality and Advertising in Capitalist Society* [Minneapolis: University of Minnesota Press, 1986]), *Ideologie/Warenästhetik/Massenkultur: Beiträge zu einer Theoretischen Synthese* (West Berlin: Argument, 1979), *Warenästhetik, Kultur und Ideologie im Alltag* (Hagen: Fernum–Universität, 1982 [Kurseinheit 3: Produktion, Warenkonsum und Lebensweise]), and *Commodity Aesthetics: Ideology and Culture* (New York and Bagnolet: International General, 1984). Gert Selle is the author of *Ideologie und Utopie des Design–Zur Gesellschaften Theorie der Industriellen Formgebung* (Köln: DuMont, 1973) and *Kultur der Sinne und Ästhetische Erziehung: Alltag, Sozialisation, Kunstunterricht in Deutschland vom Kaiserreich zur Bundesrepublik* (Köln: DuMont, 1981), and, with J. Boehe, of *Leben mit den Schönen Dingen: Anpassung und Eigensinn im Alltag des Wohnens* (Reinbek bei Hamburg: Rowohlt, 1986). Another book that examines design in everyday life is Bernd Meurer and Hartmut Vinçon, *Kritik der Alltagskultur* (Berlin: Ästhetik und Kommunikation, 1979).

Switzerland: The Typography of Order
The leading proponent of the "gute Form" movement in Switzerland after the war was Max Bill, the former Bauhaus student who worked

in architecture, painting, and sculpture, as well as graphic and product design. He developed his argument in various exhibitions and in his book of photographs, *Form: Eine Bilanz über die Formentwicklung um die Mitte des XX Jahrhunderts* (Basel: Werner, 1952 [Text in German, English, and French]). Although Bill's argument for a clean functional esthetic was evident in Swiss product designs, it was most strongly manifested in the rational typography and layouts that came to be known as the Swiss style.

Designers in Switzerland had already begun to produce examples of the new functional graphics before the war but Emil Ruder, a typography teacher at the Applied Arts School in Basle, first articulated the principles of the Swiss graphic style in a manifesto, "The Typography of Order," *Graphis* 89 (1959). That same year, a group of designers in Zurich started the trilingual illustrated journal *Neue Graphik*, which published examples of new Swiss work. The journal also included articles on the prewar avant-garde movements such as Futurism, de Stijl, and Constructivism. These articles were intended to establish a lineage for the idea of the Swiss style, which was buttressed by a series of books its practitioners produced. Also in 1959, two Zurich designers Karl Gerstner and Markus Kutter published *Die Neue Graphik* (Teufen: Arthur Niggli, 1959 [Text in German, English, and French]), a visual history of advertising art that began in the late nineteenth century and ended with contemporary work in the new Swiss style. Gerstner also wrote *Designing Programmes: Four Essays and an Introduction* (Teufen: Arthur Niggli, 1964) and *Kompendium für Alphabeten: Eine Systematik der Schrift* (English ed. *Compendium for Literates: A System of Writing* [Cambridge: MIT Press, 1974]).

Josef Müller-Brockmann, one of the editors of the journal *Neue Graphik*, compiled several books of pictures and captions that served as a lineage for the Swiss designers' work: *A History of Visual Communication/Geschichte der Visuellen Kommunikation* (Teufen: Arthur Niggli, 1971) and, with Shizuko Müller-Brockmann, *Geschichte des Plakates* (Zurich: ABC Verlag, 1971 [Text in German, English, and French]). In addition Müller-Brockmann wrote several books about design practice: *Gestaltungs-probleme des Grafikers* (Teufen: Arthur Niggli, 1971; English ed., revised and expanded, is *The Graphic Artist and His Design Problems* [New York: Hastings House, 1984]), and *Grid Systems in Graphic Design* (Teufen: Arthur Niggli, 1981 [Text in German and English]). An earlier book that promoted functional graphics was Anton Stankowski's *Funktion und ihre Darstellung in der Werbegrafik* (Teufen: Arthur Niggli, 1960). Stankowski, a German designer, worked in Switzerland in the 1930s, and his later projects remained closely related to the problem-solving methods favored by the Swiss designers.

The Swiss approaches are forcefully expressed in several books that have exerted a great influence on graphic design students inside and outside Switzerland. The most notable of these books are by

teachers at the Applied Arts School in Basle: Emil Ruder's *Typographie: Ein Gestaltungslehrbuch* (Niederteufen: Arthur Niggli, 1967 [Text in German, English, and French]), Armin Hofmann, *Methodik der Form- und Bildgestaltung: Aufbau, Synthese, Anwendung* (Teufen: Arthur Niggli, 1965; English ed. *Graphic Design Manual: Principles and Practice* [New York: Van Nostrand Reinhold, 1965]), and Manfred Maier, *Die Grundkurse aus der Kunstgewerbeschule Basel, Schweiz*, 4 vols. (Bern: Verlag Paul Haupt, 1977; English ed. *Basic Principles of Design*, 4 vols. [New York: Van Nostrand Reinhold, 1977]). Armin Hofmann brought his ideas to the United States, where he has taught part-time at Yale University for a number of years. A recent summation of his methods is "Thoughts on the Study and Making of Visual Signs: Basle School of Design/Yale School of Art, 1947-1985," *Design Quarterly* 130 (Minneapolis: Walker Art Center, 1985). This document broadens Hofmann's earlier, more formal approach by also including concepts from semiotics. The issue of *Design Quarterly* is divided between Hofmann's presentation and one by Wolfgang Weingart entitled "My Typography Instruction at the Basle School of Design/Switzerland 1968 to 1985." Weingart, who became a major international figure in the 1970s because of his departure from the traditional Basle approach, presents samples of his current teaching exercises and describes his film-collages and computer-aided designs. In *Der Mensch und seine Zeichen*, 3 vols. (Echzell: Horst Heiderhoff Verlag, 1979-81), a publication of quite a different sort, Adrian Frutiger, a prominent Swiss designer, explores the diversity of cultural symbols and their typographic meanings.

Great Britain: From Tradition to Technology
Britain has a long tradition of design reform that began in the nineteenth century. In the years preceding World War II, writers such as Anthony Bertram, Noel Carrington, John Gloag, Nikolaus Pevsner, and Herbert Read continued the arguments begun much earlier for bringing values from art and the crafts to bear on improving the quality of industrial products. Among the books they published were Gloag's *Design in Modern Life* (1934), Carrington's *Design in Civilization* (1935), Read's *Art and Industry* (1937), Pevsner's *An Enquiry into the Industrial Arts in England* (1937), and Bertram's *Design* (1939).[8]

8) An extensive listing of books and articles on British design reform and other topics can be found in Anthony J. Coulson, *A Bibliography of Design in Britain, 1851-1970* (London: Design Council, 1979).

The prewar reformers continued to be strong voices after the war. Nikolaus Pevsner published *Visual Pleasures from Everyday Things: An Attempt to Establish Criteria by Which the Aesthetic Qualities of Design Can be Judged* (London: B. T. Batsford, 1946). In a small book, *The English Tradition in Design* (London and New York: Penguin, 1947), John Gloag argued that traditional English values could be instilled in contemporary products. Noel Carrington revised *Design in Civilization* (London: The Bodley Head, 1947) in

order to support the postwar push to improve British design. Herbert Read edited *The Practice of Design* (London: Lund Humphries, 1946), which included essays by Milner Gray, Misha Black, and others. Gray and Black were founders of the Design Research Unit, the first office in Britain to use the American consultant designers of the 1930s as their model. Two collections of Black's lectures and articles were published in later years: *The Misha Black Australian Papers*, edited by Trevor Wilson (Sydney: Industrial design Council of Australia, 1970), and the *The Black Papers on Design: Selected Writings of the Late Sir Misha Black*, edited by Avril Blake (Oxford) and New York: Pergamon Press, 1983). Several graphic designers who published books were Tom Eckersley, *Poster Design* (London: Studio, 1954), Ashley Havinden, *Advertising and the Artist* (London: Studio, 1956), and Abram Games, *Over My Shoulder* (London: Studio, 1960). A later collection of statements by prominent designers was *Royal Designers on Design: A Selection of Addresses by Royal Designers for Industry* (London: Design Council, 1986).

By the 1960s, a number of British design firms had begun to work on corporate identity problems, generating several books on the subject, notably F. H. K. Henrion and Alan Parkin's *Design Coordination and Corporate Image* (London: Studio Vista, 1967) and Wally Olins's *The Corporate Personality: An Inquiry into the Nature of Corporate Identity* (London: Design Council, 1978). A related problem was the management of design within the corporation. Michael Farr's *Design Management* (London: Hodder and Staughton, 1966) was an early book on this subject.

As the Council for Industrial Design, which was founded in 1944, continued to promote design quality after the war, two other groups introduced the public and design professionals to more critical and theoretical ways of thinking about design. Central to the first was the historian and critic Rayner Banham, a founder of the Independent Group, which began meeting to discuss popular culture around 1951. Banham started to write design criticism, particularly on Pop design and the "throwaway esthetic," in the early 1950s, and helped to lay the groundwork for the British Pop movement of the 1960s. His articles on design and architecture appeared in numerous magazines, newspapers, and journals. A number of them have been collected in *Design by Choice*, edited by Penny Sparke (London: Academy Editions, 1981).[9] Other members of the Independent Group such as Richard Hamilton published occasional articles on design topics, but none wrote anywhere near as much as Banham.

The second group seeking an alternative to traditional "good design" arguments was the design methods theorists, whose central figure initially was Bruce Archer. Originally trained as an engineer, Archer taught for a number of years at the Royal College of Art. His books include *Training of the Industrial Designer* (Paris, 1963),

Design by Choice contains a bibliography of all Banham's books and articles published between 1952 and 1978. An extensive bibliography on the British Pop movement can be found in Nigel Whiteley, *Pop Design: Modernism to Mod* (London: Design Council, 1987).

A Systematic Method for Designers (London: Council for Industrial Design, 1965), *Design and the Community* (Vienna, 1965), and his doctoral thesis at the RCA, *The Structure of the Design Process* (London: Royal College of Art, 1968). Archer also wrote *Technological Innovation–A Methodology* (Surrey: Frimley, 1971), *The Predicament of Man* (London, 1971), *Design Awareness and Planned Creativity in Industry* (Ottawa and London, 1974), and *Time for a Revolution in Art and Design Education* (London: Royal College of Art, 1978). He has been a principal advocate for design planning in industry as well as for the establishment of design as a separate academic discipline independent of the humanities and sciences.

During the 1960s the Design Research Society took the initiative in promoting more systematic theoretical and research methods. Several younger designers began to develop Archer's ideas and a number of books were published. Christopher Jones and D. G. Thornley edited *Conference on Design Methods* (Oxford: Pergamon Press, 1963), which included papers by Christopher Alexander, W. Gosling on systems engineering, and Joseph Esherick, as well as Jones's essay on "A Method of Systematic Design." Sidney Gregory edited *The Design Method* (London: Butterworths, 1966), which included Jones's paper "Design Methods Reviewed" as well as R. D. Watts's "The Elements of Design." This literature also began to connect with ergonomic approaches to new intelligent machines.[10] In 1970 Jones published *Design Methods: Seeds of Human Futures* (London and New York: Wiley-Interscience, 1970).[11] Collections of subsequent research papers can be found in the Design Research Society's journal, *Design Studies*, which was founded in the late 1970s, and in volumes such as *Design: Science, Method, Practice*, edited by Robin Jacques and James A. Powell (London: Westbury House, 1981). In later years Jones and others lost their faith in design methods as a systematic theory and moved towards a more intuitive way of talking about design. This is evident in J. Christopher Jones and Edwin Schlossberg, *Letters in Communication* (1974), and in J. Christopher Jones, *Essays in Design* (Chichester: John Wiley, 1984).

A leading figure in the broadening of the original design methods program has been Nigel Cross, an editor of *Design Studies* and a member of the Open University faculty. Cross played a major role in developing an Open University course on design and technology and has edited a number of related publications including *Designing the Future* (1975), *Design and Technology* (1975), *Design Methods Manual* (1975), *Design: The Man-Made Object* (1976), *Design Products and Processes: an Introduction to Design* (1983), and *Everyday Objects, Ergonomics, Evaluation* (1983). All of these books were published by the Open University Press in Milton Keynes, England. In addition, Cross has edited *Man-Made Futures: Readings in Society, Technology, and Design* (London: Hutchinson,

10) Jones, for example, published a paper on "The Designing of Man-Machine Systems" in *Ergonomics* 10 (1967). During the same year his article, "The Design of Man-Machine Systems" appeared in *The Human Operator in Complex Systems*, ed. W. T. Whitehead, R. S. Easterby, and D. Whitfield (London: Taylor and Francis, 1967).

11) The author brought out an expanded version of this book in 1980.

VICTOR MARGOLIN

1974), *Design Participation: Proceedings of the Design Research Society's 1971 Conference* (London: Academy Editions, 1972), and *Developments in Design Methodology* (New York: John Wiley, 1984). While not strictly related to design methods, Philip Steadman's *The Evolution of Designs: Biological Analogy in Architecture and the Applied Arts* (Cambridge: Cambridge University Press, 1979) offers a related theoretical framework that considers the affinity of design to natural processes rather than to the ideological foundations of human invention. An earlier book that connects design more closely to a tradition of craftsmanship is David Pye's *The Nature of Design* (New York: Reinhold, 1964), expanded as *The Nature and Aesthetics of Design* (New York: Van Nostrand Reinhold, 1978).

Whereas the design methods theorists tended to focus on issues of planning and production, at least during their first phase, others began to think about the design audience, particularly in the climate of intense social change during the 1960s. An early book on this subject was Ken Baynes's *Industrial Design and the Community* (London: Lund Humphries, 1967). A decade later Julian Bicknell and Liz McQuiston edited *Design for Need: The Social Contribution of Design* (Oxford: Royal College of Art, 1977), a collection of papers from a 1976 conference at the Royal College of Art. In *Architect or Bee? The Human/Technology Relationship*, compiled and edited by Shirley Cooley (Slough, England: Langley Technical Services, 1980), Mike Cooley addressed a different social issue, the potentially destructive effect of advanced technology on labor and design processes in industry. Since the publication of that book, Cooley has published a number of additional articles in various journals and anthologies.

In 1982 the Royal College of Art organized an international conference on design policy that attempted to join together a diverse range of issues related to theory, technology, industry, and social concerns. The proceedings were published in six volumes in 1984 by the Design Council in London. The volumes were *Design and Society*, edited by Richard Langdon and Nigel Cross; *Design and Industry*, edited by Richard Langdon; *Design Theory and Practice*, Richard Langdon and Patrick Purcell; *Evaluation*, Richard Langdon and Sydney Gregory; *Design Education*, Richard Langdon, Ken Baynes, and Phil Roberts; and *Design and Information Technology*, Richard Langdon and George Mallen (London: Design Council, 1984).

Italy: The Emergence of a Design Culture

No country has generated more discussion and writing about design than Italy, nor has any nation forged such a close alliance between designers, industry, critics, theorists, and the public.[12] Design dialogue in Italy in the early postwar years ranged widely from the problems of industry to esthetics and politics. An important impe-

2) An extensive bibliography of postwar Italian design history, theory, and criticism can be found in Alfonso Grassi and Anty Pansera, *L'Italia del Design: Trent'Anni di Dibattito* (Casale Monferrato: Marietti, 1986).

tus to the broad scope of this dialogue was the Triennale, an exhibition which began in 1927 and provided an international forum for postwar discussions. In addition, a number of design magazines, journals, and book publishers gave designers, critics, and theoreticians a chance to speak out. Besides the more widely read magazines like *Domus* and *Casabella*, smaller journals such as *La Casa*, *Comunità*, *Civiltà delle Macchine*, and *Stile Industria* made it possible for theoreticians and critics like Giulio Carlo Argan, Gillo Dorfles, Enzo Frateili, and Filiberto Menna to bring their esthetic and political concerns to bear on the problems of design.

The Italian debate in the postwar years developed a number of offshoots. In the early 1950s, Argan led the call for a stronger integration of design and planning as a way of removing design from the exclusive realm of consumer markets. His book *Gropius e la Bauhaus* (Torino: Einaudi, 1951) held up the modern movement as a model for this effort and he argued more explicitly for it in his article "Planning e Design," *Civiltà delle Macchine* 6 (1954). At the same time, Gillo Dorfles began to apply theories of esthetics to the study of design. Following his initial articles in several journals, Dorfles's early books on design were among the first scholarly approaches to the subject and were translated and extensively published abroad, where their influence has been significant. Dorfles addressed the issue of public taste in *Le Oscillazioni del Gusto* (Milano: Lerici, 1958). In his broad study of esthetics, *Il Divenire delle Arti* (Torino: Einaudi, 1959), he included a chapter on architecture and industrial design, thus linking design to other art forms. *Simbolo, Comunicazione, Consumo* (Torino: Einaudi, 1962) dealt with the relation between public symbols and attitudes towards consumption. Dorfles's first book devoted exclusively to design was *Il Disegno Industriale e Sua Estetica* (Bologna: Capelli, 1963), which was followed by *Introduzione al Disegno Industriale* (Torino: Einaudi, 1971). He also included a section on urban planning and industrial design in *Artificio e Natura* (Torino: Einaudi, 1968). Dorfles returned to the issue of taste in a book he edited, *Kitsch: The World of Bad Taste* (New York: Bell, 1968).

Dino Formaggio made a strong impact on designers with his work on the esthetics of phenomenology, particularly with his theory that artistic quality has a technical as well as an esthetic function. An early statement of this theory, which helped to redefine the industrial designer's role as a communicator rather than a cosmetician, was *Fenomologia della Tecnica Artistica* (Milano: Nuvoletti, 1953). This was followed by *L'Idea di Artisticità* (Milano: Ceschina, 1962). Filiberto Menna continued to explore the relations between design, mass communication, and esthetics in articles such as "Design, comunicazione estetica e mass-media," *Edilizia Moderna* 85 (1964) and "Design e integrazione estetica," *Arte Oggi* 10 (1966), as well as in his book *Profezia di una Società Estetica* (Milano: Lerici, 1969). Silvano Tintori also took a cultural approach to design in

Cultura del Design (Milano: Tamburini, 1964). On the subject of taste, Galvano Della Volpe's *Critica del Gusto* (Milano: Feltrinelli, 1961; English ed. *Critique of Taste* [London: NLB, 1978]) was a major contribution. Several designers also added to the discourse on design's relation to esthetics and mass communication, notably Bruno Munari, who wrote *Design e Comunicazione Visiva* (Bari: Laterza, 1968) and *Artista e Designer* (Bari: Laterza, 1971; English ed. *Design as Art* [Harmondsworth: Penguin, 1971]), and Enzo Mari, who published *La Funzione della Ricerca Estetica* (Milano: Ed. di Comunità, 1970).

Although Giulio Carlo Argan and others had been propounding a rationalist approach to design in Italy since the early 1950s, it was not until Tomás Maldonado arrived in 1967, after having left the Hochschule für Gestaltung, that an articulate argument for the integration of design, high technology, and theory became part of the Italian debates. Maldonado engaged in these as an editor of *Casabella*, as a teacher, and as a participant at conferences where he consistently upheld the value of rationality against its attack by the Italian design avant-garde.[13] He first stated his position in two articles, "Verso un nuovo design," *Casabella* 301 (1966) and "La nuova funzione dell'industrial design," *Casabella* 303 (1966). He expanded his ideas in *La Speranza Progettuale* (Torino: Einaudi, 1970; English ed. *Design, Nature, and Revolution* [New York: Harper and Row, 1972]) and published a collection of his earlier and later writings in *Avanguardia e Razionalità: Articoli, Saggi, Pamphlets, 1946-1974* (Torino: Einaudi, 1974).[14] Maldonado's rationalism was supported by the publication of Gui Bonsiepe's *Teoria e Pratica del Disegno Industriale* (Milano: Feltrinelli, 1975).[15] Bonsiepe had taught with Maldonado at the Hochschule für Gestaltung, but subsequently went to work for the Allende government in Chile and then moved on to Brazil after Allende's assassination. Following the appearance of Bonsiepe's book, Maldonado published *Il Disegno Industriale, un Riesame* (Milano: Feltrinelli, 1976) and, most recently, *Il Futuro della Modernità* (Milan: Feltrinelli, 1987), which addresses the broad issue of cultural modernity but includes several essays related to design.

Concomitant with the intervention of Maldonado's rationalist position in the late 1960s was the emergence of a radical avant-garde discourse that, on the one hand, critiqued the limitations of conventional objects and, on the other, challenged the prevailing mode of capitalist production. Groups like Archizoom Associati, Superstudio, Gruppo Strum, and Global Tools began to produce manifestos, articles, and conceptual projects. Alessandro Mendini's articles in *Casabella* were among the early writings of the avant-garde. These included "Miseria e nobilta dell'oggetto," *Casabella* 321 (1967), "Socializzare la produzione," *Casabella* 352 (1970), "Autodeterminazione: design tra elargizione e lusso," *Casabella* 354 (1970), and "Radical Design," *Casabella* 367 (1972).[16] Related ar-

3) See, for example, Alessandro Mendini, "Caro Tomás Maldonado," *Domus* 613 (1981), and "Casabella and the Reading of History: An Exchange of Correspondence between Maurice Culot and Leon Krier with Tomás Maldonado, and Andrea Branzi with Tomás Maldonado, *Casabella* 445, March 1979," published in *Oppositions* 24 (Spring 1981): 93-101.

4) *La Speranza Progettuale* was an extremely important book in Italy. When Harper and Row published it in the United States, it was barely noticed. Ironically its publication coincided with the large design show, *Italy: The New Domestic Landscape* at the Museum of Modern Art, and was overshadowed by the show's emphasis on elegant objects and avant-garde projects.

5) In its Spanish translation, Bonsiepe's book made an important contribution to design discourse in Latin America.

6) Mendini became editor of *Casabella* in 1970. In 1977 he took over as editor of *Modo*, and stayed there until 1981, when he went to *Domus*. He was eventually replaced at *Domus* by Mario Bellini, who has focused more on mainstream production for industry than Mendini, who emphasized experimental projects and the avant-garde.

ticles by other designers were Ricardo Dalisi, "La tecnica povera in rivolta," *Casabella* 365 (1972), and Andrea Branzi, "A Long-Term Strategy," *Casabella* 370 (1972). In 1972 the Italian avant-garde received international attention for its participation in the Museum of Modern Art's exhibition, "Italy: The New Domestic Landscape," whose catalog, *Italy: The New Domestic Landscape: Achievements and Problems of Italian Design*, edited by Emilio Ambasz (New York: Museum of Modern Art, 1972), featured avant-garde projects and manifestos.

Although the MOMA exhibition was a kind of watershed for the avant-garde, designers have continued to develop new strategies as the movement has changed from a polemical and activist one in the late 1960s and early 1970s to a more critical one today. Mendini has published a number of books since the late 1970s: *Paesaggio Casalingo* (Milano: Editoriale Domus, 1978), *Architettura Addio* (Milano: Shakespeare & Co., 1981), *Nuove Intenzioni del Design* (Milano: Richerche Design Editrice, 1982), and *Progetto Infelice* (Milano: Richerche Design Editrice, 1983). Andrea Branzi, a founder of Archizoom Associati and later an editor of *Modo*, has also been an active writer. His books include *Moderno, Postmoderno, Millenario: Scritti Teorici, 1972-1980* (Torino: Studio Forma; Milano: Alchymia, 1980), *Merce e Metropoli: Esperienze del Nuovo Design Italiano* (Palermo: Facoltà di Architettura di Palermo, Edizioni EPOS, 1982), *La Casa Calda: Esperienze del Nuovo Design Italiano* (Milano: Idea Books Edizioni, 1984; English ed. *The Hot House: Italian New Wave Design* [Cambridge: MIT Press, 1984]), *Animali Domestici: Lo Stilo Neo-Primitivo* (Milano: Idea Books Edizioni, 1987; English ed. *Domestic Animals* [Cambridge: MIT Press, 1987]), and *Pomeriggi alla Media Industria* (Milano: Idea Books Edizioni, 1988; English ed. *Learning from Milan: Design and the Second Modernity* [Cambridge: MIT Press, 1988]). Among the books by other avant-garde designers and critics are *Elogio del Banale*, edited by Barbara Radice (Torino: Studio Forma, 1980), and Ugo La Pietra's *Promemoria* (Milano: Katà, 1982) and *Abitare la Città* (Firenze: Alinea, 1983). Ettore Sottsass stated his ideas in *Storie e Progetti di un Designer Italiano: Quattro Lezioni di Ettore Sottsass, Jr.*, edited by Antonio Martorana (Firenze: Alinea, 1983). Additional critics and designers of the contemporary avant-garde such as Claudia Donà, Maurizio Morgantini, and Studio Alchymia have also published actively, not just in magazines such as *Modo* and *Domus* but in numerous exhibition catalogs. In 1983 the Domus Academy was founded as a graduate school of design. In its first phase it became a meeting ground for experimental work and projects that related more closely to the needs of industry. Among the books by its faculty members are Clino Trini Castelli, *Il Lingotto Primario* (Milano: Arcadia Edizioni, 1985) and Ezio Manzini, *La Materia dell'Invenzione* (Milano: Arcadia Edizioni, 1986; English ed. *The Material of Invention* [Cambridge: MIT Press, 1986]).

A third tendency that influenced Italian design thinking in the late 1960s, in addition to Maldonado's Ulm philosophy and the avant-garde, was the interest in design methods. An Italian translation of J. Christopher Jones and D. G. Thornley's *Design Methods* was published as *La Metodologia del Progettare* in 1967, and several Italian books on the subject came out at approximately the same time or slightly later. These included M. Petrignani et al., *Disegno e Progettazione* (Bari: Dedalo, 1967), G. Susani, *Scienza e Progetto* (Padova: Marsilio, 1967), and *I Metodi del Design*, edited by Alberto Rosselli (Milano: Clup, 1973).

Other books that contained diverse reflections on design were Pierluigi Spadolini, *Design e Società* (Firenze: Le Monnier, 1969), Achille Castiglioni, *Design e la Sua Prospettive Disciplinari* (Milano, 1977), and *Design: ne'Arte ne'Industria*, edited by Corrado Gavinelli and Giordano Pierlorenzi (Roma: Edizioni Kappa, 1982). More theoretical approaches to design were reflected in Corrado Maltese, *Semiologia del Messaggio Oggettuale* (Milano: Mursia, 1970) and L. Bernardi, *Sociologia dell'Oggetto e Disegno Industriale* (Firenze: D'Anna, 1974).

The International Scene
Outside the countries already mentioned, design writing has varied greatly, both in the themes authors have addressed and in the level of theory and critical thinking they have brought to bear on the problems raised. While much of the writing continues to be produced as a response to national debates, several anthologies have appeared bringing together essays from different countries on related themes. The most ambitious of these is the mammoth catalog *Design ist Unsichtbar*, edited by Helmuth Gsöllpointner, Angela Hareiter, and Laurids Ortner (Wien: Löcker Verlag, 1981). Published in conjunction with the exhibition "Forum Design," held in Linz, Austria, in 1980, the catalog is a veritable marketplace of contemporary design positions including Lucius Burkhardt's "invisible design," Bazon Brock's "Sozio-Design," essays by members of the Italian avant-garde such as Alessandro Mendini and Ugo La Pietra, and articles by Jochen Gros, Victor Papanek, Giulio Carlo Argan, Abraham Moles, and many others. A more focused volume is *Design After Modernism: Beyond the Object*, whose editor is John Thackera (New York and London: Thames and Hudson, 1988), and which also includes an international group of authors.

Looking at various countries individually, one finds significant differences in the modes and topics of discourse. France, for example, has until recently not had a strong industrial or graphic design movement, and consequently has produced few books about issues in designing. But French scholars were among the first to recognize the importance of design as a subject of social reflection and research. In *Mythologies* (Paris: Éditions du Seuil, 1957; English ed. *Mythologies* [New York: Hill and Wang, 1972]), Roland Barthes

pioneered the semiotic analysis of industrial objects as part of a continuum of cultural phenomena. Beginning in the late 1950s, Abraham Moles began to look at designed objects from a sociological point of view. Moles, who taught courses at the Hochschule für Gestaltung, was among the first in France to explore the relation between information theory and esthetics in his book *Théorie de l'Information et Perception Esthétique* (Paris: Flammarion, 1958; English ed. *Information Theory and Aesthetic Perception* [Urbana: University of Illinois Press, 1966]). Among his other books are *L'Affiche dans la Société Urbaine* (Paris: Dunod, 1969), *Théorie des Objets* (Paris: Éditions Universitaires, 1972), *Kitsch: l'Art du Bonheur* (Paris: Denoël-Gonthier, 1976), and *L'Image: Communication Fonctionelle* (Paris: Casterman, 1981).

Other authors who have discussed design either from an esthetic or sociological perspective are Denis Huisman and Georges Patrix, *L'Esthétique Industrielle*, 3d ed. (Paris: Presses Universitaires de France, 1971 [Qui sais-je?]), Laurent Wolf, *Ideologie et Production: Le Design* (Paris: Éditions Anthropos, 1972), Georges Patrix, *Design et Environment* (Paris: Casterman, 1973), Adelie Hoffenberg and Andre Lapidus, *La Société du Design* (Paris: Presses Universitaires de France, 1977 [Qui sais-je?]), and Patrick Brunot, *La Contrefaçon* (Paris: Presses Universitaires de France, 1986 [Qui sais-je?]). Pierre Bourdieu has discussed the issue of taste in *La Distinction: Critique Social du Jugement* (Paris: Éditions du Minuit, 1979; English ed. *Distinction: A Social Critique of the Judgement of Taste* [Cambridge: Harvard University Press, 1984]).

A major figure in the debates about poststructuralism is Jean Baudrillard, who has dealt with a range of problems related to the use of objects, consumption, images, and simulation. His books include *Le Système des Objects* (Paris: Denoël-Gonthier, 1968), *La Société de Consommation: Ses Mythes, Ses Structures* (Paris: Gallimard, 1970), and *Simulacres et Simulation* (Paris: Galilée, 1981). Portions of these books are translated in Jean Baudrillard, *Selected Writings*, edited by Mark Poster (Stanford: Stanford University Press, 1988). Other related publications by Baudrillard include *Pour un Critique de l'Economie Politique du Signe* (Paris: Gallimard, 1972; English ed. *For a Critique of the Political Economy of the Sign* [St. Louis: Telos Press, 1981]), and *The Evil Demon of Images* (Sydney: Power Institute of Fine Arts, 1987 [Power Institute Publications 3]).

With the appointment of François Burkhardt as Director of the Centre de Création Industrielle (CCI) at the Centre Pompidou, some of the issues that Burkhardt had raised while director of the Internationales Design Zentrum in Berlin were introduced to France. The CCI has become a focal point for exhibitions and symposia on postmodernism, and for advanced technology and its implications for design. This is evident in one of the CCI exhibition catalogs, Hélène Larroche and Yan Tucny's *L'Objet Industriel en Question*

(Paris: Éditions du Regard, 1985), as well as in the special issue of the CCI journal "Design: Actualités Fin de Siécle," *Cahiers du CCI 2* (1986), which included articles by Philippe Lemoine, Thierry Chaput, Marc Chopplet, and Marie-Christine Loriers, among others. As part of a series of books, entitled *Alors*, that features interdisciplinary approaches to cultural topics, the CCI has also published some books related to design: Robert Lafont et al., *Anthropologie de l'Ecriture* (Paris: Centre de Création Industrielle, 1984) and Philippe Jarreau, *Du Bricolage: Archéologie de la Maison* (Paris: Centre de Création Industrielle, 1985).

Two centers that have promoted industrial design and its relation to technology are the Université de Compiègne, which has strong programs in industrial design and engineering, and the Centre de Recherche sur la Culture Technique (C.R.C.T.), whose director Jocelyn de Nobelet edits the C.R.C.T. journal, *Culture Technique*. Several faculty members at the Université de Compiègne have written books about industrial design: Danielle Quarante, *Eléments de Design Industriel* (Paris: Maloine, 1984), and Yves Deforge, *Technologie et Génétique de l'Objet Industriel* (Paris: Maloine, 1985).

Unlike France, the Scandinavian countries have a stronger tradition of designing than of producing design theories, hence the literature about design, rather than about designers or the history of design, is rather sparse. Among the books published in the postwar years, one can mention Olle Eksell, *Design-Ekonomi* (Stockholm: Bonniers, 1964); L. Anisdahl, *Refleks* (Oslo: AnChris, 1984); Jens Bersen, *Design: The Problem Comes First* (Copenhagen: Danish Design Council, 1986); C. T. Christensen, *Symbol* (Oslo: AnChris, 1987); S. E. Moller, *Den Dybe Tallerken Er Allerede Opfundet* (Copenhagen: Mobilia Press, 1978); Mike Cooley, Leif Friberg, and Claes Sjöberg, *Alternativ Produktion* (Stockholm: Liber Förlag, 1978); and *Form and Vision*, edited by Susan Vihma (Helsinki: University of Industrial Arts, 1987), the latter being the proceedings of an international conference held at the University of Industrial Arts in Helsinki.

In Japan, some leading designers have published books on their personal philosophies of designing, but there has been little momentum for developing broad theories or critical perspectives. Among the books by graphic designers are Kiyoshi Awazu's *What Could Design Do?* (Tokyo, 1969) and *Talks on Design* (Tokyo, 1974); and, along with Ikko Tanaka, *The Environs of Design: Essays* (Tokyo, 1980). Those by industrial designers include Iwataro Koike, *Talk on Design—From Daily Life* (Tokyo, 1974), and several publications by Kenji Ekuan: *Industrial Design: The World of Dogu, Its Origins, Its Future* (Tokyo, 1971), *Design: The Relation of Man and Technology* (Tokyo, 1972), and *The Philosophy of Tools* (Tokyo, 1980). Ekuan is the head of GK Industrial Design Associates, the largest design consulting firm in Japan and, among Japanese industrial designers, he is the most active internationally.[17]

Ekuan participated in the International Conference on Design Policy, held at the Royal College of Art, London, in 1982. His paper, "Smallness as an Idea," was published in volume 2 of the proceedings, *Design and Industry*, ed. Richard Langdon (London: Design Council, 1984), 140-43.

Within the socialist countries of Eastern Europe, the Poles have carried on an active discussion of design theory and methodology. Polish theorists have devoted much discussion to planning methodology; thus, some of their work, notably that of Wojciech Gasparski, has intersected with British research in design methods.[18] Gasparski is affiliated with the Design Methodology Unit, Department of Praxiology, in the Polish Academy of Sciences. Books he has written or edited include *Projektowanie–Koncepcyjne Przygotowanie Działań* (Warszawa: Polski Wydawnictwo Naukowe, 1978) and *Zarys Metodyki Projektowania*, editors W. C. Dorosiński, W. Gasparski, and S. Wrona (Warszawa: Arkady, 1981). Another theorist who has influenced the Polish discussions is the late Andrzej Pawlowski, formerly a professor of industrial design at the Academy of Art in Cracow. Janusz Krupiński, who was a student of Pawłowski's, has edited a collection of Pawłowski's essays entitled *Inicjacje. O Sztuce, Projektowaniu i Kształceniu Projektantów* (Warszawa: Biblioteka Wzornictwa IWP, 1987). Additional books by Polish theorists on methodology are Czesław Babiński, *Elementy Nauki o Projektowaniu* (Warszawa: Wydawnictwo Naukowo Techniczne, 1972), Janusz Dietrych, *Systemy i Konstrukcja* (Warszawa: Wydawnictwo Naukowo Techniczne, 1985), and Tadeusz Kotarbiński, *Traktat o Bobrej Robocie* (Wroclaw: Ossolineum, 1985).

Design writing in East Germany has reflected some of the concerns evident in the West, but has also emphasized the problem of developing appropriate design policies for a socialist country. An early example is *Wesen und Gestalt der Dinge um Uns* (Potsdam, 1948) by Wilhelm Wagenfeld, a former Bauhaus student. In the 1960s the question of a design theory that centered on the problems of function, form, and quality was addressed in S. H. Begenau, *Funktion, Form, Qualität: Zur Problematik einer Theorie der Gestaltung* (Berlin, 1967). Martin Kelm took on the issue of socialist design policy in *Produkt Gestaltung im Sozialismus* (Berlin: Dietz Verlag, 1971), while some of the esthetic issues raised by the West German Marxist left were addressed in Hagen Bächler et al., *Ästhetik–Mensch–Gestaltete Umwelt* (Berlin: Deutscher Verlag der Wissenschaften, 1982) and by Herbert Letsch in *Der Alltag und die Dinge um Uns* (Berlin: Dietz, 1983) and *Plädoyer für eine Schöne Umwelt* (Berlin, 1985).

There has been little published on design in the other Eastern European socialist countries except the Soviet Union, where VNIITE, The USSR Research Institute of Industrial Design, has a major research and publications program. The Institute has focused on several areas, notably the issues related to integrating design into the structure and culture of Soviet society, and on modes of professional creativity. VNIITE also publishes a journal, *Tekhnicheskaya Estetika*, where theoretical articles sometimes appear.

18) Gasparski is an advisory board member of the Design Research Society's journal *Design Studies*. His articles in English include "Humanistic View on Design," in *Design: Science, Method, Practice*, ed. Robin Jacques and James A. Powell (London: Westbury House, 1981) and "A Designing Human Society: A Chance or a Utopia," in *Design Theory and Practice*, ed. Richard Langdon and Patrick Purcell (London: Design Council, 1984).

VICTOR MARGOLIN

9) I use the term "Third World" provisionally to include those countries outside the sphere of the industrially developed nations. Perhaps a better term is "countries of the periphery," which is used by Gui Bonsiepe and others. The latter offers a better description of where these countries are actually located in the world economy.

Little writing on design has appeared in Third World countries.[19] In Cuba, which initiated an extremely active graphic design program after the revolution, Félix Beltran, who headed the program for some years, published *Desde el Diseño* (Havana, 1970) and *Acerca del Diseño* (Havana: Ediciones Union, 1975). Gui Bonsiepe, who went to Chile shortly after the Hochschule für Gestaltung closed, has continued to work in Latin America and to speak out about issues of design in developing countries. He initially undertook a series of projects for the socialist government of Salvador Allende, publishing at least one brief report of his work, "Design in Südamerika–in Chile," in *form* 59 (1972). After the Allende government fell, Bonsiepe published a more extensive assessment of his own work in Chile, *Design im Übergang zum Sozialismus: Ein technisch-politischer Erfahrungsbericht aus dem Chile der Unidad Popular, 1971-1973* (Hamburg: 1974 [Design Theorie Band 1]). He also addressed the problem of design and underdevelopment in an Italian article, "Design e sottosviluppo," *Casabella* 285 (1974). Two design schools in India, the Industrial Design Center at the Indian Institute of Technology near Bombay and the National Institute of Design at Ahmedabad, are both generating research material and occasional publications. At the Industrial Design Center, there is a strong interest in design theory with special attention being paid to semantics and rhetoric.

Although national associations for graphic and industrial designers have long been established in a number of countries, there was no move to form international organizations of these groups until the 1960s, when two associations for graphic and industrial design were established. The International Council of Societies of Industrial Design (ICSID) was founded in 1957, and the International Council of Graphic Design Associations (ICOGRADA) was formed in 1963. Both groups hold international congresses every two years, to which speakers of various backgrounds are invited. Occasionally, though not often, the proceedings are published. Several volumes of the ICSID proceedings include *Official Report of ICSID '73, Kyoto*, edited by Kazuo Kimura (Tokyo, 1973) and *Industrial Design and Human Development*, editors Pedro Vasquez Ramirez and Alejandro Lazo Margain (Amsterdam, Oxford, and Princeton: Excerpta Medica, 1979 [Proceedings of the XI ICSID Congress, Mexico City, 1979]). Among the ICOGRADA publications are *Dialogue on Graphic Design Problems in Africa*, edited by Haig David-West (London: ICOGRADA, 1983), the report of a UNESCO-ICOGRADA Regional Seminar on "Design for Development," held in Nairobi in 1987.

Design Studies as an Academic Discipline
Although there is not yet a strong movement within academia to bring the research on design and related topics together within a dis-

tinct disciplinary framework, there is nonetheless much valuable work being done. Because this work remains fragmented, many important questions are still unanswered, particularly those that have to do with the cultural and ideological grounding of design theory and policy. Hence, there remains a fairly sharp bifurcation between theories of design, and studies of design as a part of culture.

On the side of theory, Herbert Simon, in *The Sciences of the Artificial* (Cambridge: MIT Press, 1969 [The Karl Taylor Compton Lectures at MIT]), looked at the potential of a unified science of design, but he did so from a process view only, without examining the ideological and cultural dimensions of theory. Necdet Teymur, however, addressed the relation between ideology and theory in *Environmental Discourse* (London: ?uestion Press, 1982). The most active research on theory is currently in the fields of semantics, semiotics, and rhetoric. A leading researcher is Hanno Ehses, who has been working on the relation of rhetoric to visual communication. In addition to publishing a number of articles, Ehses has edited the occasional *Design Papers* at the Nova Scotia College of Art and Design, and contributed three publications to this series: *Semiotic Foundations of Typography* (Halifax: Nova Scotia College of Art and Design, 1976 [Design Papers 1]), *Design and Rhetoric: An Analysis of Theater Posters* (Halifax: Nova Scotia College of Art and Design, 1986 [Design Papers 4]), and, with Ellen Lupton as editor, *Rhetorical Handbook: An Illustrated Manual for Graphic Designers* (Halifax: Nova Scotia College of Art and Design, 1988 [Design Papers 5]).

Reinhard Butter and Klaus Krippendorf have taken on a prominent role in the development of product semantics, the application of theories of communication to the design of product forms. Butter edited "The Semantics of Form," a special issue of *Innovation* (Spring 1984), and, with Klaus Krippendorf, "Product Semantics," a special volume of *Design Issues* (Spring 1989).

In the study of design as culture, much of the initial work has been done on advertising and consumption. An early book that suggested the potential of analyzing advertisements was Marshall McLuhan, *The Mechanical Bride: Folklore of Industrial Man* (New York: Vanguard Press, 1951). Other authors who have developed a critical approach to interpreting advertisements are Erving Goffman, *Gender Advertisements* (New York: Harper and Row, 1979) and Judith Williamson, in *Decoding Advertisements: Ideology and Meaning in Advertising* (London: Marion Boyars, 1978), in addition to several essays in her subsequent book *Consuming Passions: The Dynamics of Popular Culture* (London and New York: Marion Boyars, 1986). Also included are William Leiss, Stephen Kline, and Sut Jally, *Social Communication in Advertising* (Toronto and New York: Methuen, 1986), Kathy Myers, *Understains: The Sense and Seduction of Advertising* (London: Comedia, 1986), and Diane Barthel, *Putting on*

For a reflective history of the Center for Contemporary Cultural Studies by one of its central figures, see Stuart Hall, "Cultural Studies and the Centre: Some Problematics and Problems," in *Culture, Media, Language: Working Papers in Cultural Studies, 1972-79* (London: Hutchinson, 1980), 15-47.

Appearances: Gender and Advertising (Philadelphia: Temple University Press, 1988).

In England, scholars identified with the field of cultural studies, which received its impetus from the work done at the Center for Contemporary Cultural Studies at the University of Birmingham, have come to recognize advertising and design as significant manifestations of culture, and have promoted a critical interpretation of their significance that pays close attention to the way they express ideological values.[20] Dick Hebdige's *Subculture: The Meaning of Style* (London: Methuen, 1979) represents this perspective, as do a number of the articles about design in *Block*, the cultural journal published at Middlesex Polytechnic.

For studies of consumption, one can look as far back as the late nineteenth century to the work of Thorstein Veblen. An early study of postwar consumption was George Katona, *The Mass Consumption Society* (New York: McGraw-Hill, 1964), while William Leiss brought a new approach to the definition of consumer needs in *The Limits to Satisfaction: An Essay on the Problem of Needs and Commodities* (Toronto: University of Toronto Press, 1976). Several recent studies have focused on the symbolic aspect of objects and object exchange. These include Mary Douglas and Baron Isherwood, *The World of Goods* (New York: Basic Books, 1975), Mihalyi Csikszentmihalyi and Eugene Rochberg-Halton, *The Meaning of Things: Domestic Symbols and the Self* (Cambridge: Cambridge University Press, 1981), and Grant McCracken, *New Approaches to the Symbolic Character of Consumer Goods and Activities* (Bloomington: Indiana University Press, 1988). Other books on the subject include Colin Campbell, *The Romantic Ethic and the Spirit of Modern Consumerism* (Oxford and New York: Basil Blackwell, 1987), and Daniel Miller's *Material Culture and Mass Consumption* (Oxford and New York: Basil Blackwell, 1987), a sociological study of how people impose their own needs on objects and environments.

As in other areas of research, there is some movement in design studies towards crossing disciplinary boundaries to address larger issues. A good example is the special double issue of *Design Issues* (1987), edited by Marco Diani and devoted to "Designing the Immaterial Society." The contributions of sociologists, historians, philosophers, designers, artists, and others to this topic make evident the value of broadening the framework in which we discuss design. This type of interdisciplinary approach, which brings together theorists, historians, critics, and designers, holds great promise for the study of design, while design studies itself, a body of research that has the potential to coalesce into a new discipline, promises to bring design into the center of economic, political, and cultural debates—where it belongs.

List of Contributors

Clive Ashwin is dean of faculty and professor at Middlesex Polytechnic in England. He studied fine art at the University of Reading and subsequently took postgraduate qualifications in art education at the University of London. His publications include articles and books on art, design, and education.

Andrea Branzi is an architect and designer in Milan. Formerly director of the Domus Academy, he is the author of numerous articles and several books, including *The Hot House: Italian New Wave Design*, *Domestic Animals*, and *Learning from Milan: Design and the Second Modernity*.

Richard Buchanan is assistant professor of English at the University of Illinois at Chicago, where he teaches the history and philosophy of rhetoric. He is a graduate of the Committee on Ideas and Methods at the University of Chicago.

Cheryl Buckley is senior lecturer in design history at Newcastle-upon-Tyne Polytechnic. She is currently at work on several publishing projects related to women in the design professions.

François Burkhardt is director of the Centre de Création Industrielle at the Centre Pompidou in Paris. Formerly director of the International Design Center in Berlin, he is the author of numerous articles and books on design, including a book on Czech Cubist architecture, which he coauthored, and *Produkt Form Geschichte: 150 Jahre Deutsches Design*.

Francis Butler is a small-scale entrepreneur exploring alternatives in industrial design (fabric and furniture), modes of reading (through *Poltroon Press*), and garden design (shadow gardens and pantographs). She also writes on the social use of the design image to support ideology. *Colored Reading: The Graphic Art of Francis Butler*, a book of her posters, prints, and fabric designs, was published in 1979.

Marco Diani is *Chargé de recherche* at CNRS in Paris and visiting professor in French and Italian studies and sociology at Northwestern University. His extensive publications include *Déplacements*

Quotidiens de Main d'Oeuvre et Conflits dans la Région Milanaise; *Stendahl, Saint-Simon e gli Industriali*; and *Restructuring Architectural Theory*, which he edited with Catherine Ingraham.

Clive Dilnot is a historian and theorist of visual culture teaching at Harvard University. He has written widely on aspects of design and is currently at work on several projects including a study of visual representation.

Hanno H. J. Ehses is chairman of the design division at the Nova Scotia College of Art and Design in Halifax, Canada. He has written articles on semiotics and visual rhetoric, is a contributor to the series *Design Papers*, published by the Nova Scotia College of Art and Design, and has lectured internationally.

Robin Kinross is a freelance editorial typographer in London. He did postgraduate research on Otto Neurath and Isotype at the University of Reading and has since written widely for the design press in Britain, including *Information Design Journal* and the *Journal of Design History*.

Ellen Lupton is a graphic designer and curator of the Herb Lubalin Study Center of Design and Typography at The Cooper Union in New York. She is working on a Ph.D. in art history, with a concentration on design history, at the Graduate Center, City University of New York.

Abraham Moles is the founder of the Institute of Social Psychology of Communications at the Université Louis Pasteur in Strasbourg, France, where he has taught sociology for many years. He is the author of numerous books and articles, including *Théorie des Actes: Vers une Ecologie des Actions* and *Psychologie de l'Espace*, both in collaboration with Elizabeth Rohmer.

Maurizio Morgantini is professor of industrial design at the University of Illinois in Chicago and maintains a design practice in Chicago and Milan. He is the author of numerous articles on design as well as the curator of various exhibitions. He is active in the cultural debate on man's relation to the artificial environment.

Richard Porch is a British designer with a special interest in shopping mall design and the redevelopment and use of historic sites. He has published numerous case studies and papers on retail planning and written articles on various aspects of design for the British press.

Dieter Rams is director of the design department for the Braun Company in West Germany. He is also a professor at the Hochschule für Bildende Kunst in Hamburg and is president of the German Design Council.

Gert Selle is professor of art education at Oldenburg University in West Germany. He has studied painting, art history, German language and literature, and art education, and is the author of nu-

merous articles and books including *Design–Geschichte in Deutsch-
land: Produktkultur als Entwurf und Erfahrung* and *Leben mit den
Schönen Dingen: Anpassung und Eigensinn im Alltag des Wohnens.*

Maurizio Vitta teaches at a Higher Institute of Art in Milan and has
published various books and essays on the esthetics of design, con-
temporary art, and architecture. He is a consultant to the Milanese
architecture and design journal *l'Arca* and to the contemporary art
magazine *D'Ars.*

Jack Williamson is director of Design Michigan, a program of the
Cranbrook Academy of Art that promotes increased awareness and
use of the different design professions in Michigan. He is also an
adjunct professor at the University of Michigan where he teaches
design history, criticism, and ethics.